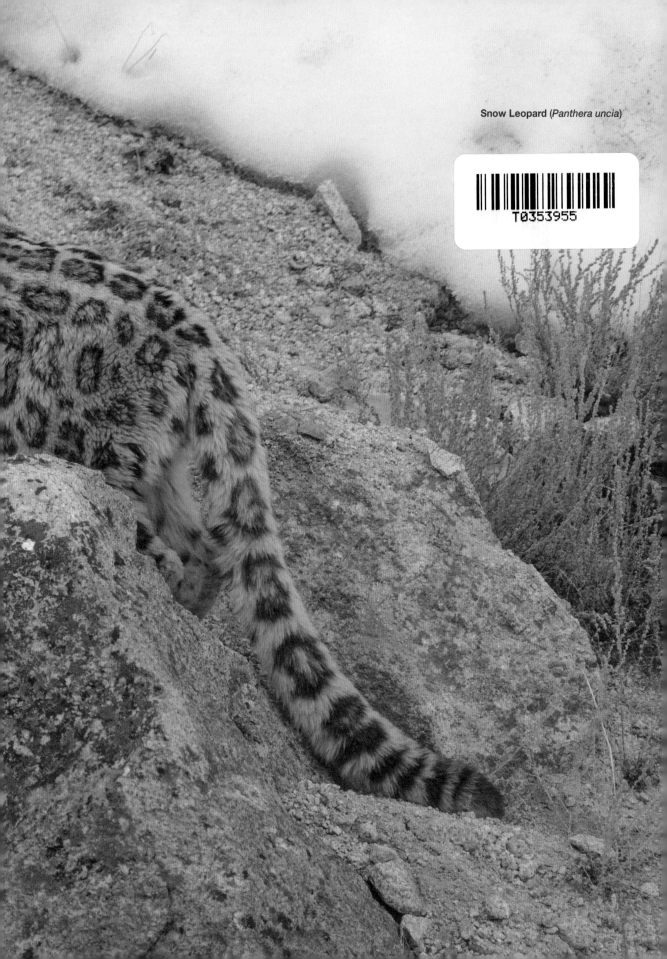

Snow Leopard (*Panthera uncia*)

T0353955

ASIA'S GREATEST WILDLIFE SANCTUARIES

Fanny Lai & Bjorn Olesen

Edited by Yong Ding Li

TUTTLE Publishing

Tokyo | Rutland, Vermont | Singapore

Great Argus (*Argusianus argus*)

Contents

A Reminder of Asia's Wonderful But Fragile Natural Diversity

Home to more than three thousand bird species and countless more mammals, plants, and insects, Asia is truly a continent of superlatives for biodiversity. Many more species, such as our migratory birds, are the shared natural heritage of Asian countries—traversing national boundaries, and therefore connecting peoples and cultures separated by land and sea. Some of our best-loved migratory birds are the Spoon-billed Sandpiper and the Red-crowned Crane—species that many conservationists along their flyways are working hard to protect, and they rightfully feature strongly in this portfolio of natural wonders and the places where they are found.

In this magnificent tour of Asia's most vital protected areas, Fanny Lai and Bjorn Olesen have succeeded in showcasing the continent's biological diversity through a selection of images, many from their own travels across Asia, others from leading wildlife photographers. Few other books on this subject have encompassed such a broad geographical spread, which takes us from the Himalayas and the Tibetan Plateau to the temperate forests of Korea and my own native Japan.

Most importantly, the book brings to light much conservation work in biodiversity-rich landscapes across Asia, many of these Important Bird and Biodiversity Areas (IBAs) identified by BirdLife International, local NGOs and the wider network of scientists and experts around the region. As one travels through Asia, through the lens of Bjorn and others, the importance of conservation efforts on the ground becomes ever more obvious, whether through the management of national parks or through the work of local communities. A lot of these efforts are not immediately apparent, but without them many of the continent's most charismatic animals, including a huge suite of far less well-known creatures and plants, would be on the brink of extinction.

Lovers of nature are well aware of the immense threats faced by Asia's biodiversity. Every day we read about forests being cleared, peatlands being drained and reclamation eating into the region's wonderful coastal wetlands. The situation for biodiversity across much of Asia is grim and significant effort is required to address these negative trends. That said, it is equally important for us to highlight our successes in preserving biodiversity, and to celebrate the many people involved in driving these successes. It is through the experience gained from these conservation achievements that we can learn how better to protect our vanishing species, and find new inspiration to safeguard wildlife. Fanny and Bjorn have truly, in their travels through Asia, brought these stories to the fore, and I hope this book will motivate its readers to join the struggle to secure the wilderness and species on this wonderful continent.

HIH Princess Takamado
Honorary President of BirdLife International

The unusual bony casque and colourful neck skin and wattles of the **Northern Cassowary** (*Casuarius unappendiculatus*) gives this magnificent species a rather dinosaur-like appearance. Southeast Asia's largest flightless birds, the cassowaries of which there are three species, occurs across the lowlands and montane forests of Indonesian New Guinea, including a number of satellite islands.

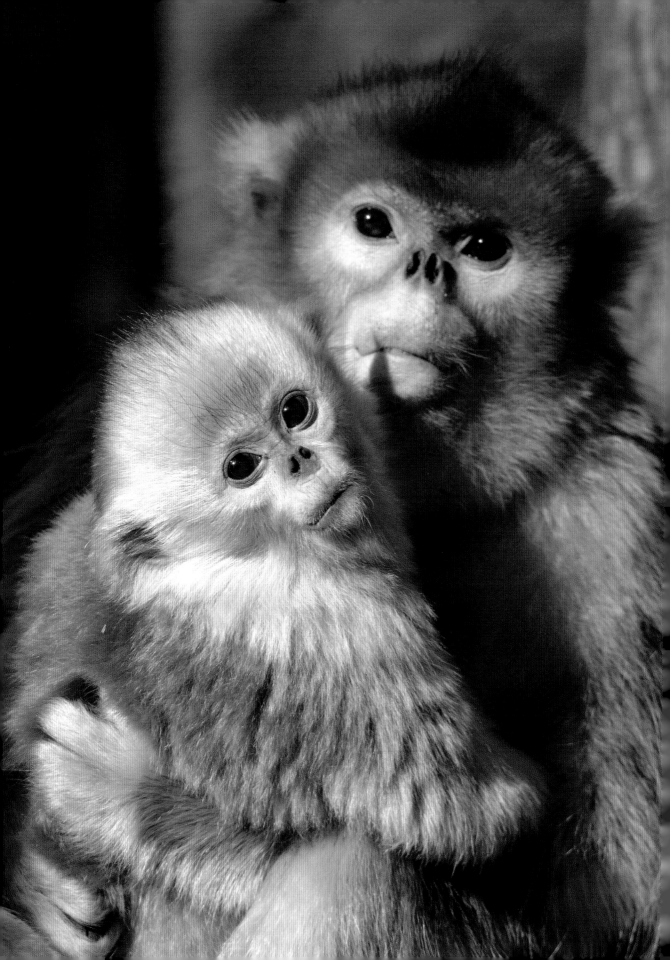

Why We Wrote This Book

Asia is the largest of all the earth's continents. It stretches from below the equator to beyond the Arctic circle. It is a continent of superlatives; home to the highest mountains, some of the hottest deserts and oldest rainforests. One of the most exciting biodiverse regions on the planet, Asia is a perfect starting point for exploring the natural world. Even with more than 300 pages in this publication, it has been a massive call to do justice to the sheer biological diversity in Asia. The selection of the featured wildlife sanctuaries has been another huge challenge; we have never meant for it to be exhaustive, but rather to inspire readers to get out there and visit some of Asia's most spectacular wildlife sanctuaries.

This publication encapsulates our travels, spanning more than 20 years of wildlife sojourns in Asia. During this period, nature photography has matured from an exclusive hobby of a few individuals to a formidable tool to advance conservation.

If people have little knowledge of the marvels of nature, how can we expect them to care and support nature conservation? With *Asia's Greatest Wildlife Sanctuaries,* it is our hope that we can convince our readers of the many adventures that await them in Asia's protected landscapes. Once people have visited these wildernesses, they will discover how precious wild places are, and realise why we need to continue to protect them.

Asia's Greatest Wildlife Sanctuaries is an odyssey through 27 wildlife sanctuaries across 14 Asian countries. The objective of this project is to encourage responsible eco-tourism while supporting local communities and nature conservation efforts. At the same time, we want to convey the message that not everything in wildlife conservation in this region is doom and gloom. A constant stream of bad news gives the mistaken impression that there are no success stories for wildlife protection in this part of the world. This is inaccurate. We feel that showcasing such success stories can provide incentives for more impactful conservation work.

Through our travels in Asia, we see many examples of successful conservation projects. Several animal and plant species have been brought back from the brink of extinction. We have encountered resourceful and passionate conservationists tackling tricky problems, and not giving up. Many unique protected areas exist today because of notable conservation efforts by local and international conservation NGOs such as BirdLife International. These are the stories that deserve profiling, as they give people hope and optimism to do more to protect our shared natural heritage, and without which we could fall into apathy and do nothing. Moreover, people are unlikely to want to protect something they have never heard of, or had a connection with.

The scientific grounding of this book has been distilled from more than 100 papers and reference books, as well as unpublished data, which under normal circumstances would have a limited reach. Our greatest desire is to share the wonders of the natural world with a wide audience.

One of the best ways to support nature conservation in Asia, as well as most other parts of the world, is to visit wildlife sanctuaries and back the initiatives of local communities. Spending time in protected areas to observe and photograph wildlife demonstrates clear economic value of biodiversity that governments and local people would understand. During one's visit, explain to the locals that you want to see animals in the wild. Plan your trip and logistics through domestic companies, use local guides and hotels, and eat local food. These actions will create economic incentives to protect the area's biodiversity. Afterwards, write about your travels so that others will be inspired to follow.

It is our genuine hope that this book will raise much needed awareness and appreciation of the many threatened species found in Asia, and highlight the need to preserve these biological treasures for the benefit of generations to come.

We have published *Asia's Greatest Wildlife Sanctuaries* to raise funds in support of BirdLife International's nature conservation work in Asia. In addition, we wish to raise public awareness of wildlife conservation and the importance and value of sustainable eco-tourism. On our part, we have contributed our time and resources on a pro bono basis for the production, research and field travel for this project.

Golden Snub-nosed Monkey (*Rhinopithecus roxellana*), Endangered.

Fanny & Bjorn

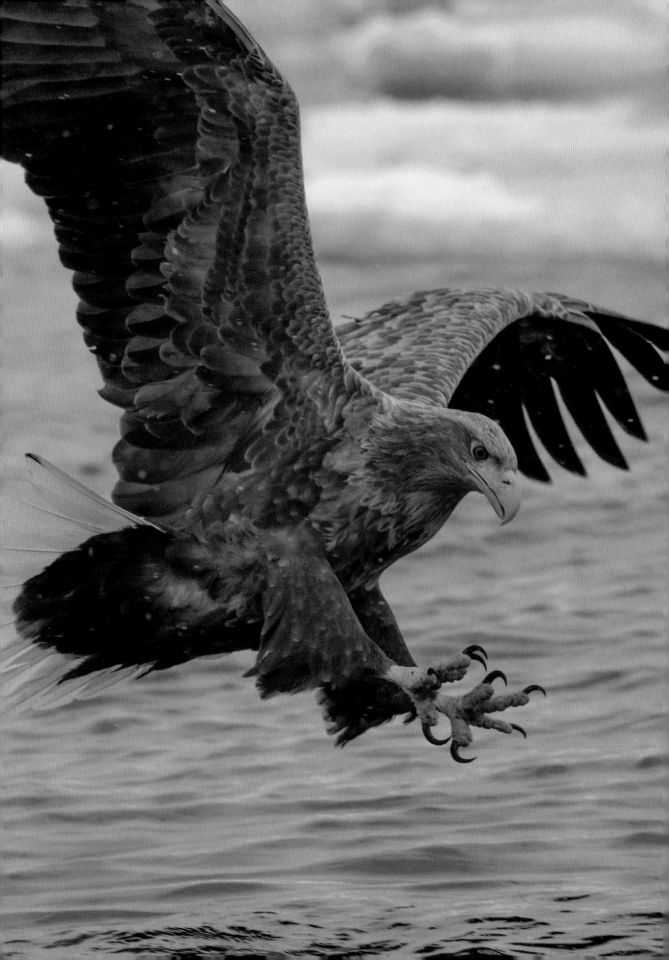

China
Gaoligongshan National Nature Reserve
Sanjiangyuan National Park
Yancheng and Dafeng Milu National Nature Reserves

Japan
Shiretoko National Park

South Korea
Demilitarized Zone (DMZ) & Civilian Control Zone (CCZ)

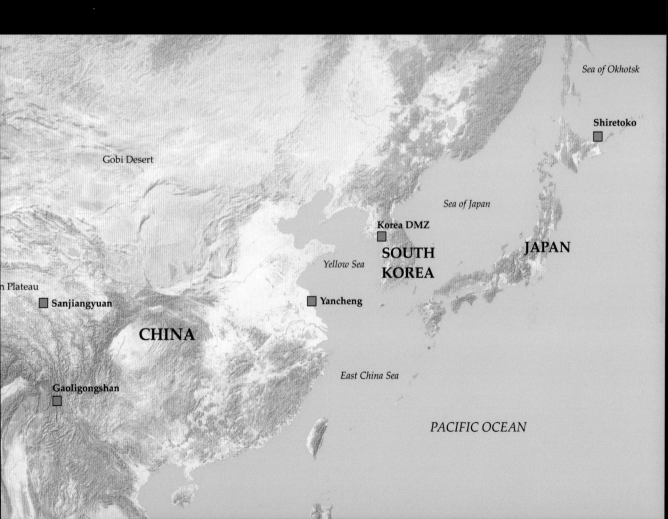

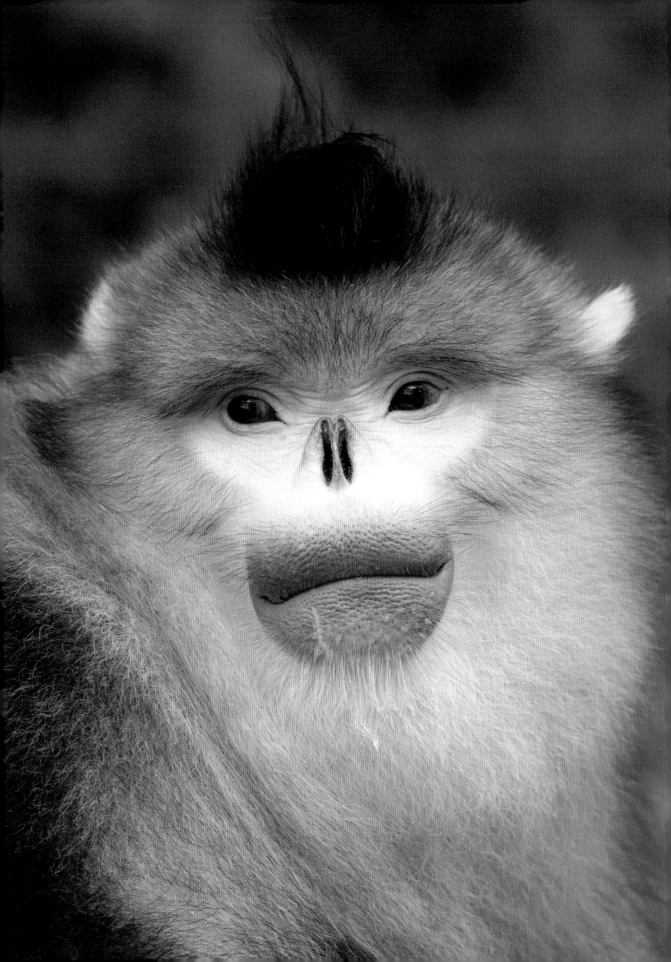

China

China is the second largest country in the world by land area, spanning close to 10,000,000 km² (3,860,000 mi²). It is home to a population of more than 1.4 billion people. China is a land of extremes from having the highest peaks in the world including Mount Everest and the ranges of the Tibetan Plateau, to hosting the Turpan Depression which sits amongst the world's lowest points below sea level to encompassing the arid Taklamakan Desert and the lush forests of Yunnan and Sichuan. In addition, China boasts wide grasslands and extensive wetlands as well as a full range of forest types from boreal taiga in the extreme north to tropical forests in the far south.

China can be broadly divided into three geographic regions. The first is the Tibetan (Qinghai-Xizang) Plateau. This plateau is one of the highest and most desolate landscapes on earth, with elevations averaging between 3,000 m and 5,000 m (9,800 ft and 16,400 ft). It covers roughly 25 per cent of China. Around 70 per cent of the plateau is alpine grasslands or semi steppe vegetation while the remaining area is mostly mountainous. Soils are generally infertile and the human dwellers lead mostly pastoral lifestyles.

The second region is defined by the arid deserts of the country's northwest, covering around 30 per cent of China's land area but supporting only some five per cent of the population. One of the world's driest deserts, the Taklamakan can be found north of the Tibetan Plateau. Because of its huge distance from any sea, the influence of summer monsoons here is very weak, resulting in extremely arid conditions.

The **Yunnan Snub-nosed Monkey** (*Rhinopithecus bieti*) is found in evergreen forests in northwestern Yunnan and south-eastern Tibet. This stunning primate occurs at alpine elevations from 2,500 m (8,200 ft) to nearly 5,000 m (16,400 ft) above sea level, the highest altitude known for nonhuman primates.

The Yunnan Snub-nosed Monkey lives in troops in multi-level societies ranging from 20 to some 200 individuals. Each troop may include many families composed of one adult male and three to five females with their offspring, called one-male units. All-male units exist on the outskirts of the troops. When the mother moves around, the baby clings to her belly by her fur. If an infant is lost, a grieving mother may continue to carry the corpse for a few days. The population of the Yunnan Snub-nosed Monkey appears to be stable now, with about 1,000 mature individuals. Many local people, especially those from minority groups in this part of China have sustained traditions of wildlife hunting. This remains the primary threat to the species, especially in view of its low reproductive rate.

The eastern third of the country is broadly defined as the 'Eastern Monsoon' region and has a climate that is heavily influenced by Asia's monsoon system. This region occupies about two fifths of the country's area but is home to 95 per cent of its human population. Most of the land here is low in elevation, and the bulk of its natural vegetation has been converted into agriculture, urban areas and other forms of land use. There are however numerous pockets of forests and mountains across this region, many supporting interesting and unique flora and fauna. Over time, reforestation efforts can be expected to increase the forest cover in this part of China.

China's rich and diverse biota includes more than 500 species of amphibians, about 500 species of reptiles, 1,400 bird species and some 550 mammals. China's immense biodiversity is well reflected in the over 600 Important Bird and Biodiversity Areas identified to date, standing amongst the highest in Asia.

Nature-based tourism has grown rapidly in the past two decades. Today, China's national parks, forest parks and other scenic spots are visited by hundreds of millions annually.

The driving force behind the heavy use of many national parks is the rapidly growing middle class. Mass tourism is a quick fix in raising revenue for local governments and park managements. To cater to large volumes of tourists, many parks in China have quickly expanded their tourism facilities. However, this may lead to habitat degradation and biodiversity loss if done without careful consideration for the ecological integrity of natural areas.

China has made considerable progress in expanding its new national park system. It currently includes 10 pilot national parks in 12 provinces across China, established for the purpose of protecting natural landscapes and threatened species. These parks cover an area of more than 200,000 km² (77,200 mi²). This initiative is a step in the right direction for China's network of protected areas. It will hopefully strengthen the ecological integrity and connectivity of the country's most spectacular landscapes. These parks include several high profile protected areas such as the Sanjiangyuan National Park.

One of the main goals of these pilot national parks is to protect some of China's flagship species such as the Giant Panda, Siberian Tiger, Asian Elephant and Snow Leopard.

There is no other animal so closely identified with China as the **Giant Panda** (*Ailuropoda melanoleuca*). The panda has been the focal point of one of the most comprehensive and high profile conservation efforts of any threatened species. Thanks to several decades of collaboration among the Chinese Government, local communities and NGOs, the panda population is today on the rise, with a recent estimate of around 1,800 individuals and growing. These successes in the conservation of the Giant Panda show what can be achieved when political will and science converge.

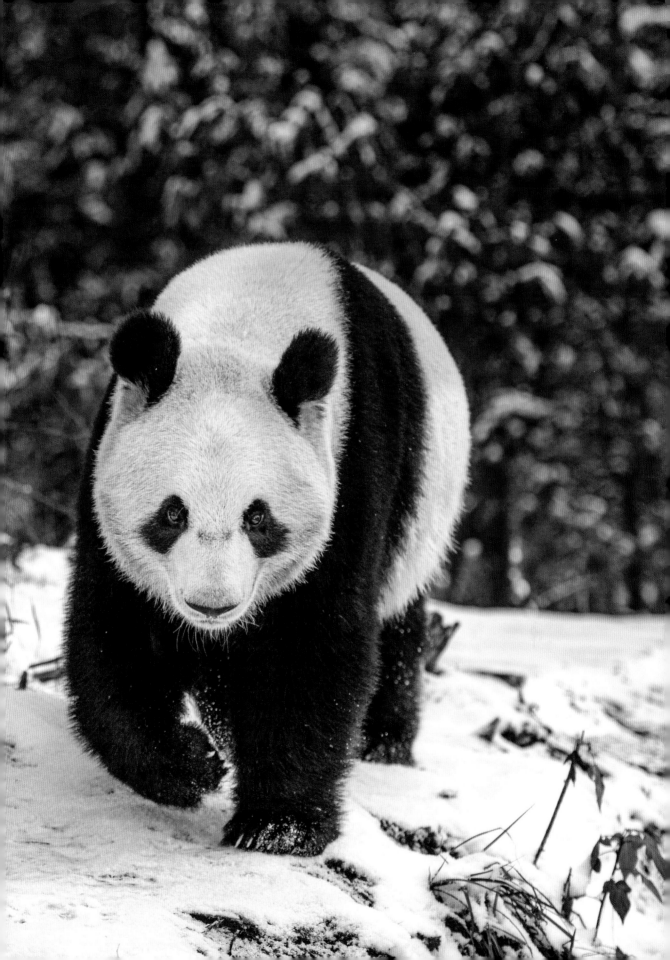

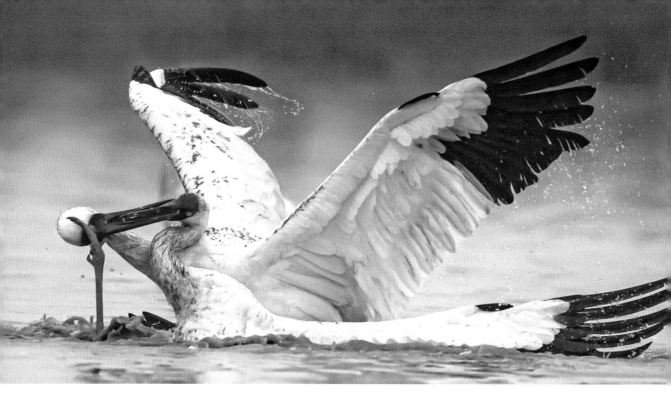

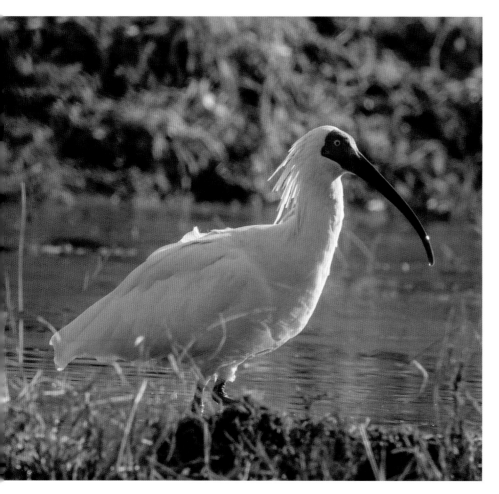

ABOVE Territorial fight between two **Siberian Cranes** (*Leucogeranus leucogeranus*).

The Siberian Crane is one of nine crane species in China. Five of these species breed in in the country. The Siberian Crane ranks amongst the world's rarest and most endangered cranes, with a total population of less than 4,000 birds. Nearly the entire population of the Siberian Crane winters at Poyang Lake and other freshwater wetlands in central China's Yangtze valley. Poyang is a critically important stopover site but is today prone to massive changes to its hydrology and ecosystems as a result of wider human modification of the Yangtze River. At times, key foraging areas lie either submerged or become entirely desiccated, putting large populations of wintering waterbirds at risk.

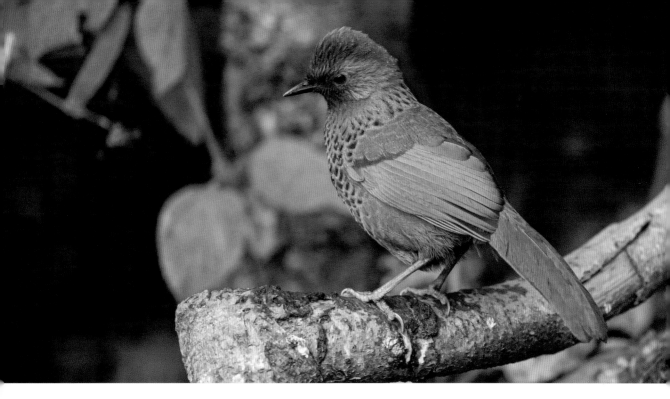

LEFT BOTTOM Historically, populations of the **Crested Ibis** (*Nipponia nippon*) were found in China, the Russian Far East and Japan. Today, the largest wild breeding population is in Shaanxi Province in central China. Conservation efforts to reintroduce the species into several areas within China have been successful.

Wild populations now appear to be on the increase. Reintroduction programmes are also in place in Japan and South Korea.

ABOVE **Assam Laughingthrush** (*Trochalopteron chrysopterum*). China is the world centre of laughingthrush diversity, boasting well over 60 species of this highly recognisable and vocal group of forest birds.

RIGHT The female **Tibetan Macaque** (*Macaca thibetana*) reaches sexual maturity in about five years. After a gestation period of six months, she gives birth to a single infant. The offspring spends four years almost entirely reliant on its mother. The Tibetan Macaque occurs in upland forests in southern and central China, to the eastern fringe of the Tibetan Plateau. It is one of several primate species endemic to China.

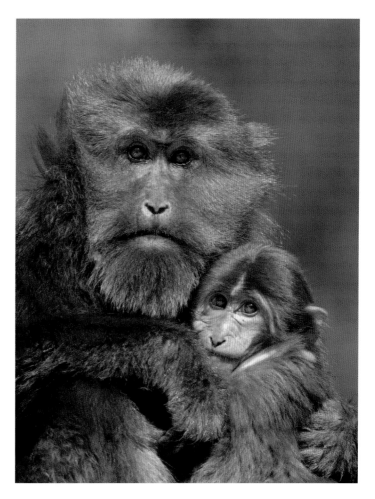

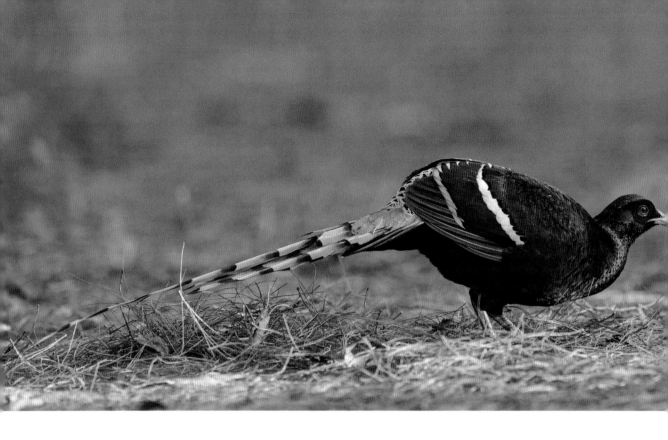

Gaoligongshan National Nature Reserve

The Gaoligongshan National Nature Reserve is a well-known biodiversity hotspot and a centre of plant endemism in Asia. The rugged Gaoligong Mountains run 500 km (310 mi) along the Yunnan-Myanmar border. It is one of the most biologically diverse regions in Asia. As a result of its unique location and north-south orientation extending northwards towards the edges of the Guizhou and Tibetan Plateau, the Gaoligong Mountains are where the biota of the Eastern Himalayas, Southeast Asia and eastern China converge.

The reserve covers an area of over 4,000 km² (1,500 mi²) with about 80 per cent of this under forest cover. The core zone comprises a nine km (six mi) wide belt stretching from west to east and measuring around 135 km (80 mi) from north to south. With an altitude range from 1,500 m to 4,000 m (4,900 ft to 13,100 ft), the Gaoligong Mountains support a diverse range of vegetation types. This includes tropical rainforest, as well as subtropical and temperate evergreen broad-leafed forest in the lower elevations. At higher altitudes, subalpine conifer forest, alpine woodland and meadows can be found.

The complex biogeography of the Gaoligong

Mountains has made it an ideal destination for biologists and ecologists to conduct biodiversity research. In addition, it is one of the top birding destinations in China with more than 500 bird species recorded. The mountain villages of Hanlong and Baihualing, located in the southern part of the reserve, serve as the main bases for many birdwatchers and bird photographers visiting the park. A section of the historical Southern Silk Road passes through Hanlong village before winding through the Gaoligongshan National Nature Reserve and stretching westward towards Myanmar. In recent years, the Gaoligong Mountains have witnessed a nature-tourism boom thanks to the area's unique scenery and rich birdlife.

Some of the best birdwatching may be found above Hanlong village. For the past decade, farmers have discreetly built birdwatching hides in more than 30 locations at the edges of the forest. Some of the hides are just off the road leading up the mountain and easy to reach. Others need some trekking to get to. Each hide is complete with water features, natural perches and feeders to attract the birds. Hides in the different areas may attract a different mix of bird species. Here,

it is possible to view notoriously skulking species that would otherwise be very hard to observe under normal field conditions.

Thousands of visitors, mainly bird photographers visit the village every year, contributing significantly to the livelihoods of the community. At the same time, important local employment opportunities have been created. This has greatly reduced the local villagers' dependence on the harvesting of forest products, including the trapping of wild birds for food.

Visitors to the Gaoligong Mountains can find hotels, homestays, restaurants, access to birdwatching hides, transportation and guiding at these tourist enclaves. Over the years, new knowledge, skills and networks have been acquired by the locals. Working closely with NGOs, the local government has supported these efforts. In many parts of China, nature parks depend heavily on tourist income. This has resulted in pressure to develop visitors' facilities like hotels, shops and landscaped gardens that do not always benefit the local people. However, in Baihualing it appears to have worked well.

Most visitors fly into Baoshan or Tengchong Airports in Yunnan Province, and from here hire a private vehicle to Baihualing.

As mentioned in the Myanmar chapter on page 158, the Myanmar Snub-nosed Monkey was first discovered in the forested mountains of Kachin State, not far from the Gaoligong Mountains. It was described as a new species in 2011. In the same year, a breeding population of some 70 individuals was found in Pianma on the rugged eastern slopes of the Gaoligong Mountains. Subsequently, 14 km (9 mi) south-east of Pianma, another group was discovered at Luoma in the core zone of the Gaoligong Mountain National Nature Reserve. Snub-nosed monkeys live in a structured society composed of one-male harem breeding groups that move together as a band. One or more all-male groups usually follow the band. The forests in the area are mostly pristine, comprising mainly mixed broadleaf Hemlock forest or Hemlock-Rhododendron forest between 2,600 m to 3,300 m (8,500 ft to 10,800 ft).

The Skywalker Gibbon (Hoolock tianxing) is another new species that was discovered in the forests of the Gaoligong Mountains. It was described in a paper in the American Journal of Primatology in 2017. The total population of this narrowly-distributed primate is likely less than 200 individuals.

The area also harbours other threatened mammals such as the Himalayan Red Panda (*Ailurus fulgens*), Mishmi Takin (*Budorcas t. taxicolor*), Phayre's Langur (*Trachypithecus phayrei*), Sambar (*Rusa unicolor*) and Asiatic Black Bear (*Ursus thibetanus*).

Based on field surveys in Gaoligongshan National Nature Reserve from 2014 and 2018, human disturbances appear to have decreased somewhat over the past 30 years. However, poaching and illegal logging are still real threats, particularly near the border with Myanmar, where such activities can be difficult to monitor. Livestock grazing and farming encroachment are also issues that need to be addressed.

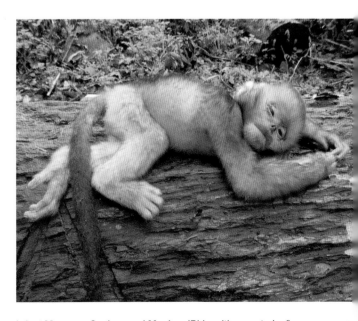

Infant **Myanmar Snub-nosed Monkey** (*Rhinopithecus strykeri*) dropped by its mother after being pursued by hunters.

ABOVE The **Red-tailed Laughingthrush** (*Trochalopteron milnei*) is commonly seen in the forests of the Gaoligong Mountains. This stunning species occurs in the understorey of broadleaf evergreen forest, dense secondary growth and bamboo patches from 900 m to 2,500 m (3,000 ft to 8,200 ft). This laughingthrush is among the many species described by French missionary priest, Pere Armand David, whose productive zoological career in China led to the discovery of numerous plants and animals, most famously the Giant Panda.

LEFT The diet of the **Red-tailed Minla** (*Minla ignotincta*) is mainly insects and their larvae. This colourful 'babbler' can be found in parties of considerable size, and is often seen in bird waves. Like a treecreeper, it methodically searches branches and moss for prey items. The Red-tailed Minla occurs from 1,000 m to around 3,000 m (3,300 ft to around 9,800 ft).

RIGHT The **Black-tailed Crake** (*Zapornia bicolor*) is a skulker that is most active in the early mornings and evenings. If alarmed, it retreats quickly for cover. This rail is one of the few species associated with the region's uplands and may occur at elevations as high as 3,600 m (11,800 ft) above sea level. With luck, it may be encountered at some of the birdwatching hides in the Gaoligong Mountains.

BELOW The **Great Barbet** (*Psilopogon virens*) lives in deciduous and evergreen forests, on wooded valleys and mountain slopes. It is usually found at altitudes from 800 m to 2,400 m (2,600 ft to 7,900 ft) in southern China, the Himalayas and parts of Southeast Asia.

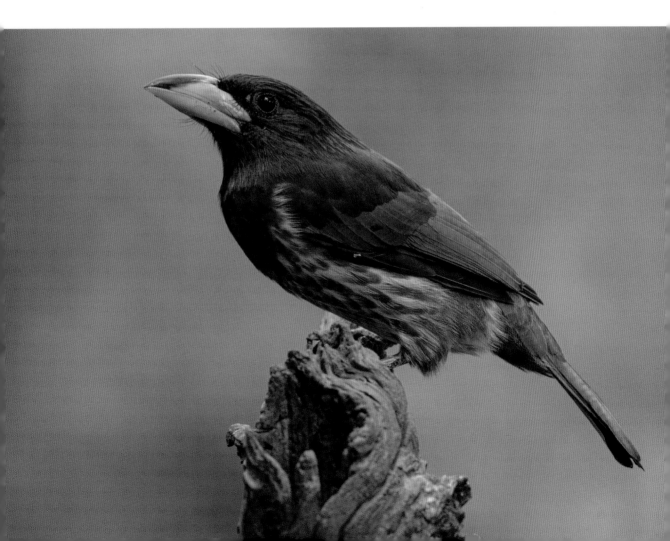

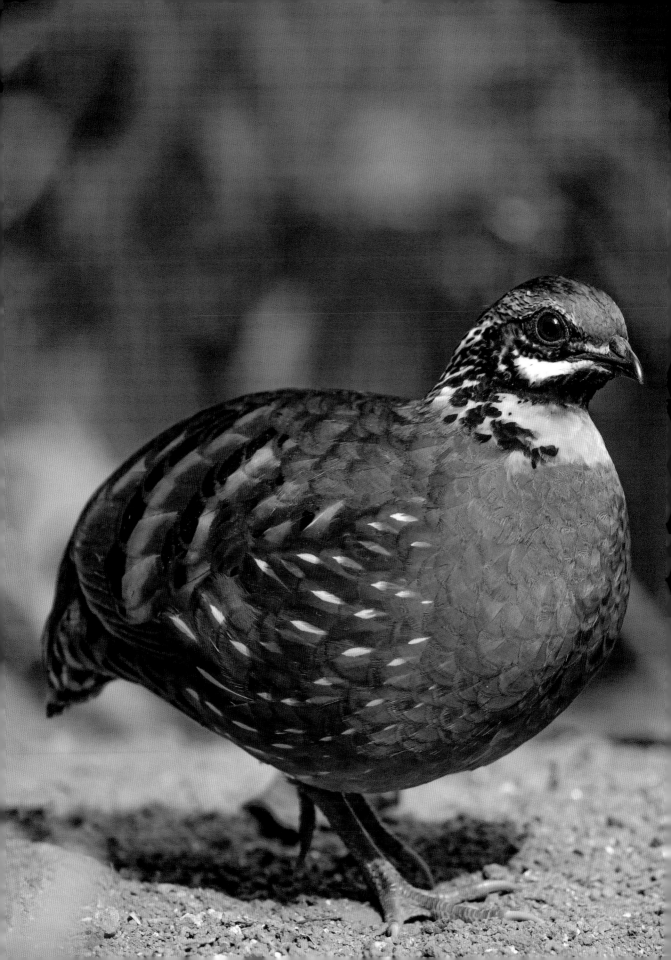

LEFT The **Rufous-throated Partridge** (*Arborophila rufogularis*) escapes from danger by running rather than flying. It roosts in trees and occurs in evergreen forests with thick undergrowth at altitudes ranging from 600 m to 3,000 m (2,000 ft to 9.800 ft). Although generally shy, the Rufous-throated Partridge can be regularly encountered at the birdwatching hides in Baihualing.

RIGHT In Yunnan, the **Chestnut-vented Nuthatch** (*Sitta nagaensis*) is found in coniferous forests dominated by spruce, fir and rhododendron at altitudes from 1,500 m to 4,600 m (4,900 ft to 15,100 ft). The species regularly forms mixed flocks with tits and warblers.

BOTTOM The tiny **Chestnut-headed Tesia** (*Cettia castaneocoronata*) forages on or close to the ground usually among dense vegetation, making it difficult to observe. It is normally encountered alone or in pairs. As a particularly colourful member of the bush warbler family, its high-pitched 'tsip' calls are usually the first signs that betray its presence in the forest undergrowth.

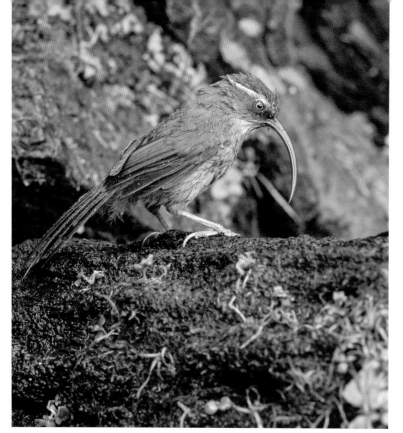

LEFT The **Slender-billed Scimitar-Babbler** (*Pomatorhinus superciliaris*) dwells in bamboo thickets in temperate forest and wooded areas with dense undergrowth. This striking babbler, with its scythe-like bill, is typically seen in mixed flocks with other babblers and laughingthrushes in the mid-elevations of Gaoligong. A few lucky visitors have observed this species in some of the visitor hides at Baihualing.

BELOW The **Yunnan Fulvetta** (*Alcippe fratercula*) is usually seen in small noisy parties. It forms the core members of many mixed species flocks in Yunnan's forests.

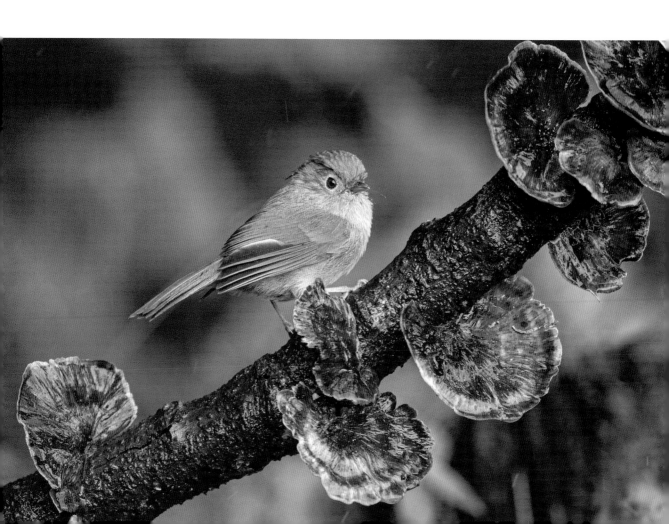

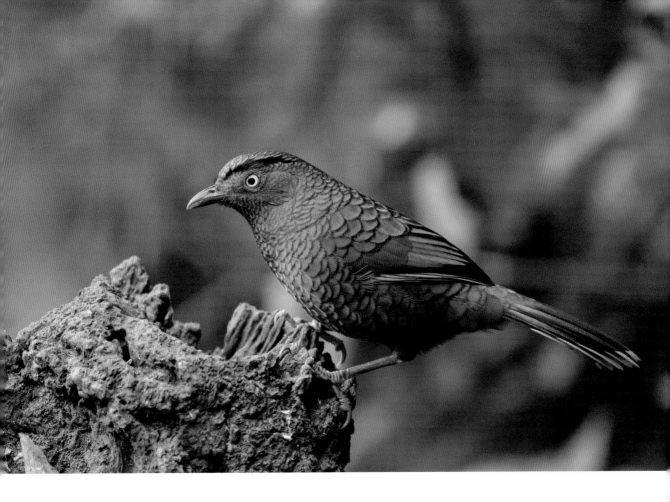

ABOVE The skulking **Blue-winged Laughingthrush** (*Trochalopteron squamatum*) has a preference for habitats with dense understorey and undergrowth in open broadleaf evergreen forests near streams at 900 m to 2,500 m (3,000 ft to 8,200 ft). More than 10 species of laughingthrushes are regularly encountered in the birdwatching hides in Baihualing.

RIGHT The **Greater Yellownape** (*Chrysophlegma flavinucha*) is a readily observed large woodpecker in the Gaoligong Mountains, together with the Bay Woodpecker. Visitors often cross paths with it in the forest understorey and canopy, where pairs creep up and down branches and tree trunks in search of ants, termites and insect larvae hiding in the wood.

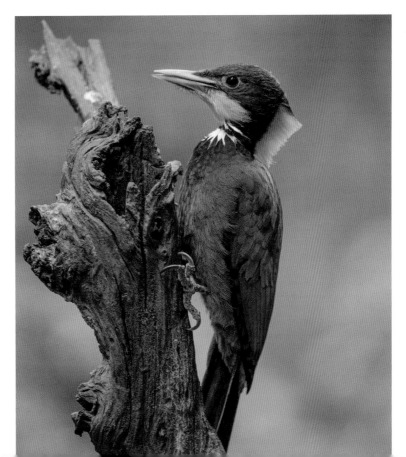

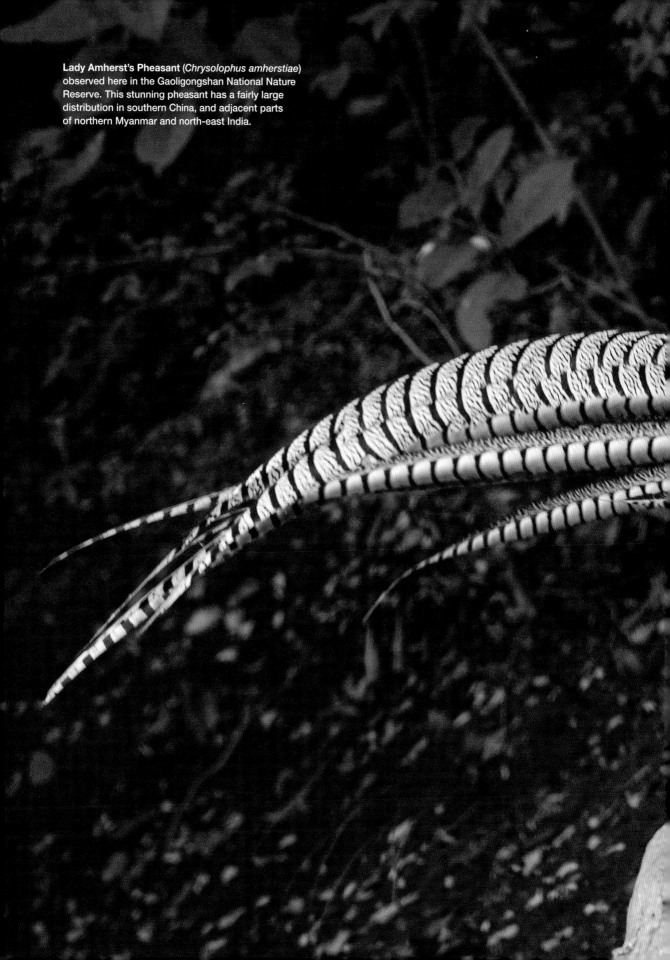

Lady Amherst's Pheasant (*Chrysolophus amherstiae*) observed here in the Gaoligongshan National Nature Reserve. This stunning pheasant has a fairly large distribution in southern China, and adjacent parts of northern Myanmar and north-east India.

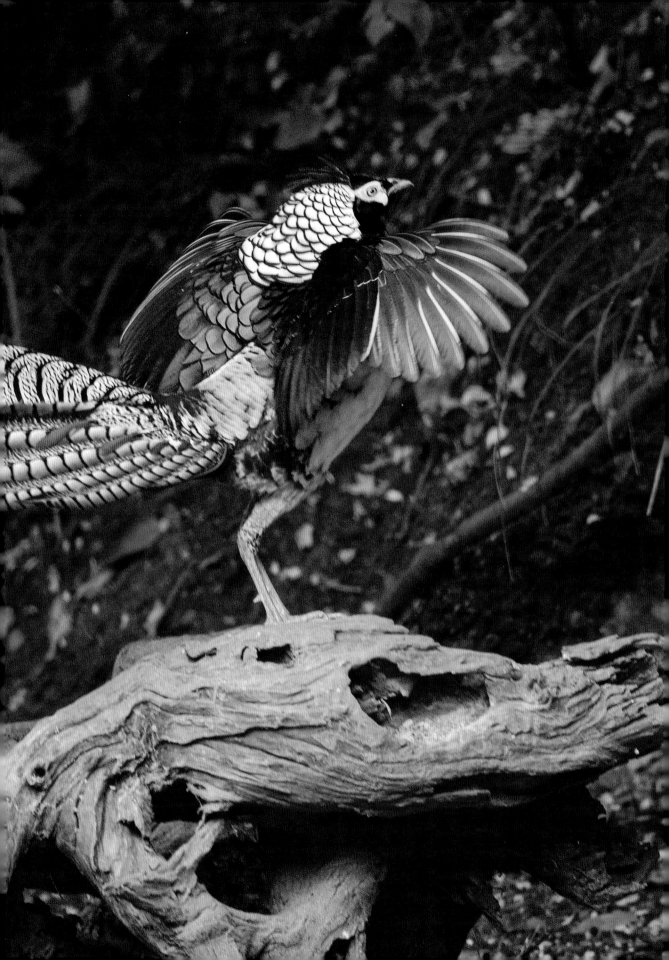

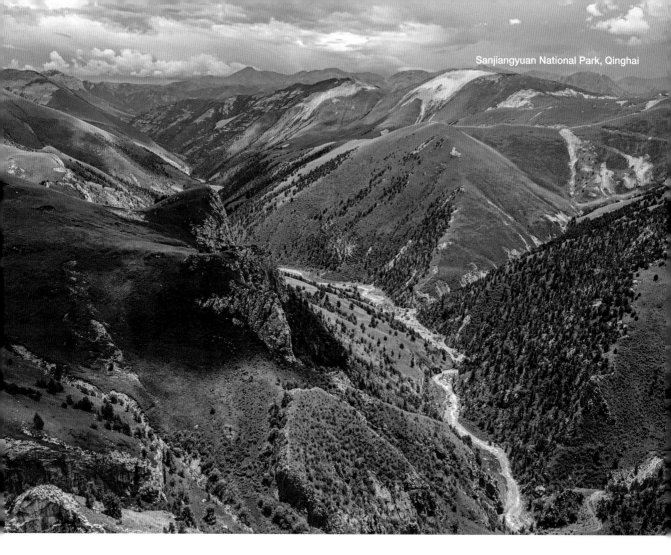

Sanjiangyuan National Park, Qinghai

The Sanjiangyuan National Park covers 123,100 km² (47,500 mi²) of the southern half of mountainous Qinghai province. It is located in a remote and diverse region characterised by alpine woodland to high-altitude wetlands and grasslands of the Tibetan Plateau. It is about the same size as England, and is among the largest protected areas in China.

The Chinese name of the park, "Sanjiangyuan", means "Source of Three Rivers", referring to three major rivers namely the Yangtze, Yellow and Mekong rivers, all of which originate here. These waterways provide freshwater to more than a billion people across Asia. The goal behind the Sanjiangyuan National Park is to protect and celebrate the important water resources and diverse wildlife of the Tibetan Plateau including its flagship Snow Leopard. In the past, Snow Leopards

have been trapped and persecuted in retaliation to livestock kills. The park's administration seeks to develop conservation measures that can engage local Tibetan communities and the public to find solutions that allow humans and large predators to co-exist.

The area is home to a remarkable variety of wildlife, and possibly some of the highest known densities of the Snow Leopard, in addition to important populations of the Tibetan Fox, White-lipped Deer, Brown Bear, Lynx, Bharal (Blue Sheep), Pallas's Cat and Tibetan Argali.

An excellent example of an ecotourism project benefiting local livelihoods can be found in the 'Valley of the Cats', close to the town of Angsai ('Namsei' in Tibetan) in the province of Qinghai. From 2017, some 20 local Tibetan families have been trained to host and guide visiting tourists. Subsequently, small groups of

visitors have been given accommodation in homestays. Transport, accommodation and meals are part of this community-based tourism project co-ordinated by two NGOs, namely Shan Shui Conservation Center and Beijing Birding, together with the local government.

The 'Valley of the Cats' project has a strong focus in improving the livelihoods of rural communities, with all proceeds from eco-tourism staying within the community. A rotation system for incoming tourists ensures that visitors and income are shared equitably among the households.

Of the total amount paid by visitors, 45 per cent goes to the host family. Another 45 per cent is allocated to the local community fund to support health insurance, road maintenance and compensation to families for losing livestock to predators such as the Snow Leopard. The remainder goes to bolster local Snow Leopard conservation projects. Given their low incomes, wildlife watching tourism is an ideal way for each household to supplement their livelihoods while maintaining their traditional way of life.

According to Beijing-based conservationist Terry Townshend, *"The Valley of the Cat" project demonstrates how, if managed effectively, it is possible to conduct tourism in environmentally sensitive areas and improve the livelihoods of local people without lasting negative impacts. Conservation is sustainable only if it involves and benefits the local community."*

It is important to keep in mind that conditions at the 'Valley of the Cats' are very basic, where accommodation in local homesteads have no running water or bathing facilities and offer only simple food. With the highest elevations coming close to 5,000 m (16,400 ft) good physical fitness is needed to hike in this fantastic landscape. The risk of altitude sickness is real. Spending two to three days of acclimatisation at lower elevations is recommended. Many visitors do an excursion to Qinghai Lake in the north, which is more than a thousand metres lower in elevation, and offers excellent birdwatching.

The 'Valley of the Cats' is around four hours' drive from Yushu Town, reachable by air from Xining, the capital of Qinghai or Chengdu in Sichuan. Access to the core area of Sanjiangyan National Park is strictly controlled and independent travel is not allowed. However, access may be obtained from https:// valleyofthecats.org/contact/.

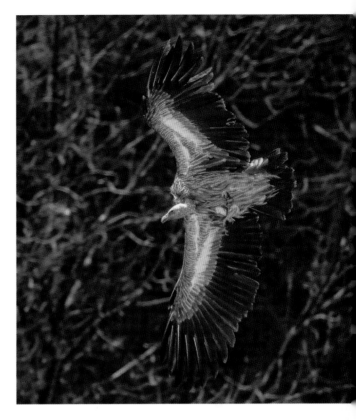

The massive **Himalayan Vulture** (*Gyps himalayensis*) is commonly seen across the Tibetan Plateau. It locates food visually, when gliding high up in the air, sometimes at altitudes welll above 5,000 m (16,400 ft). The Himalayan Vulture typically nests alone or in small groups on cliff walls.

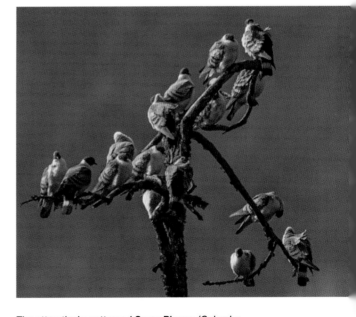

The attractively-patterned **Snow Pigeon** (*Columba leuconota*) is often seen in small parties at higher elevations in the 'Valley of the Cats.'

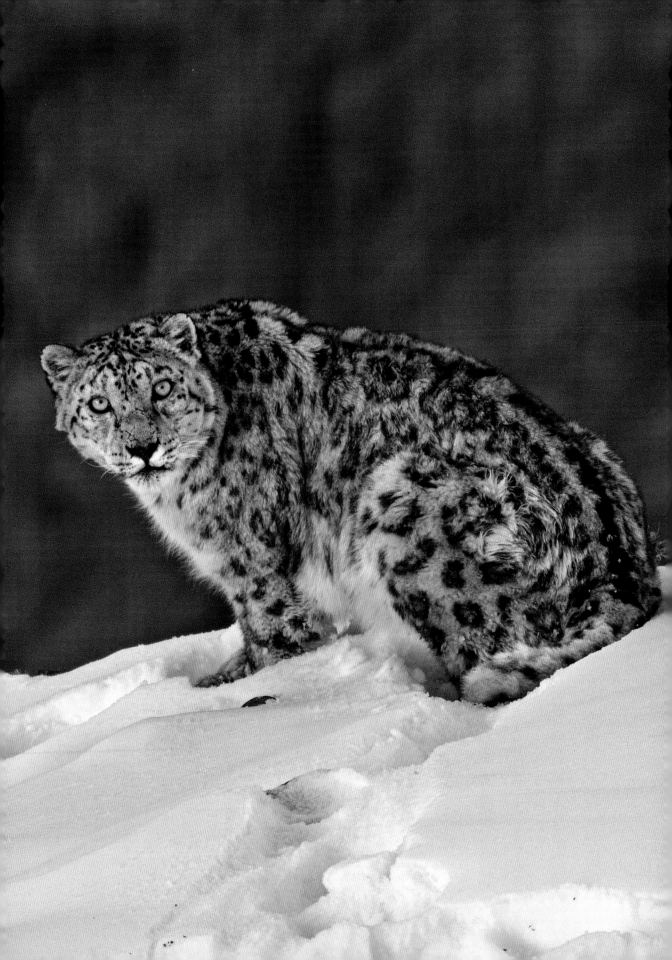

LEFT The **Snow Leopard** (*Panthera uncia*) can be found throughout the mountains of Central Asia and the Himalayas, as well as north to Mongolia's Gobi. According to some estimates, about 60 per cent of its population lives in China, particularly on the Tibetan Plateau and the slopes of the Himalayas.

Like most feline species, Snow Leopards are usually solitary except when females are raising cubs. Mating occurs during winter between January and March, when male and female pairs come together for a few days. The cubs are born some 100 days later. The mother raises her offspring (usually in litters of two or three) on her own, providing shelter and food. Once the cubs are around two years old, they start to forage interdependently.

BELOW The **Kiang**, also called the **Tibetan Wild Ass** (*Equus kiang*), is one of the most conspicuous large mammals of the Tibetan Plateau. It occurs widely in the plains across the Plateau, south to the Nepali and Kashmir frontier in Ladakh. Wolves are the Kiang's main natural predators.

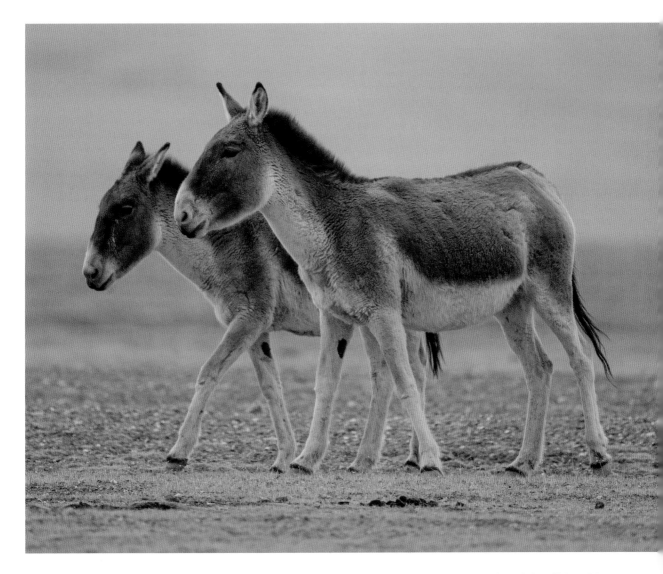

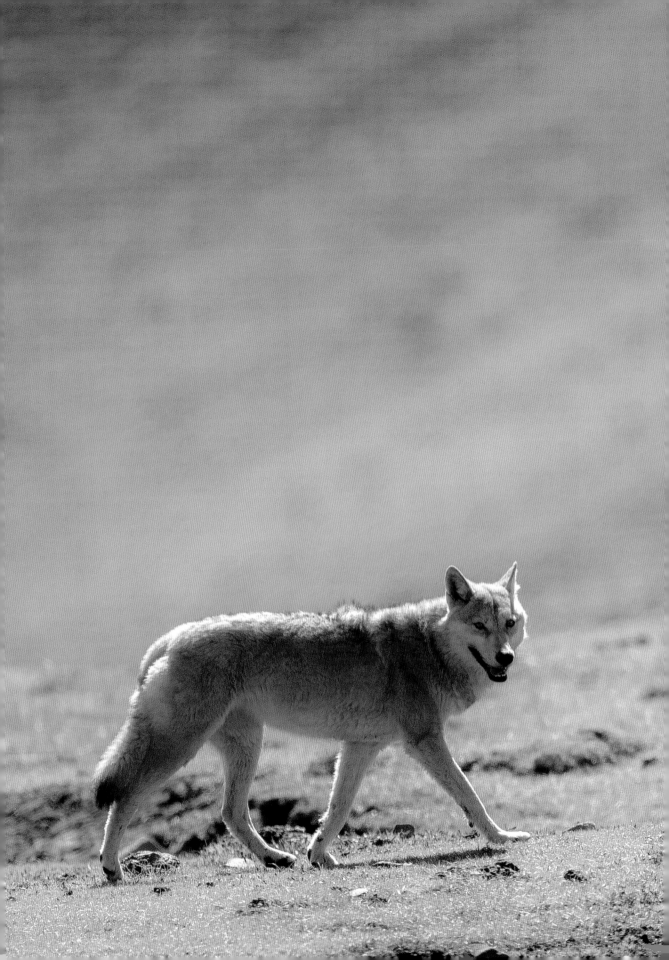

LEFT The **Tibetan Wolf** (*Canis lupus chanco*) is present across many parts of China, including Qinghai. It is not uncommon on the Tibetan Plateau and lone individuals or small groups can be regularly spotted on the mountain slopes and alpine meadows in Sangjianyuan.

RIGHT The **Tibetan Fox** (*Vulpes ferrilata*) is found in low densities throughout the Tibetan Plateau. These wizened-looking foxes spend much of their time on the high Tibetan plains from 3,000 m to 4,000 m (9,800 ft to 13,100 ft) above sea level. Their diet consists largely of pikas. Although the foxes are most active at dawn and dusk, they can be observed throughout the day.

BELOW The **White Eared-Pheasant** (*Crossoptilon crossoptilon*) is one of several striking looking pheasants that can be seen at Sanjiangyuan National Park. Small parties of these pheasants may be observed around the Tibetan hamlets where visitors to Sanjiangyuan stay in the early mornings and evenings.

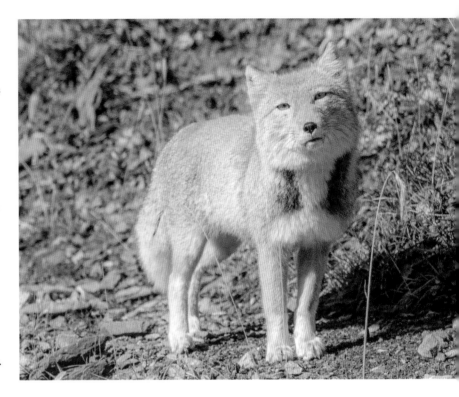

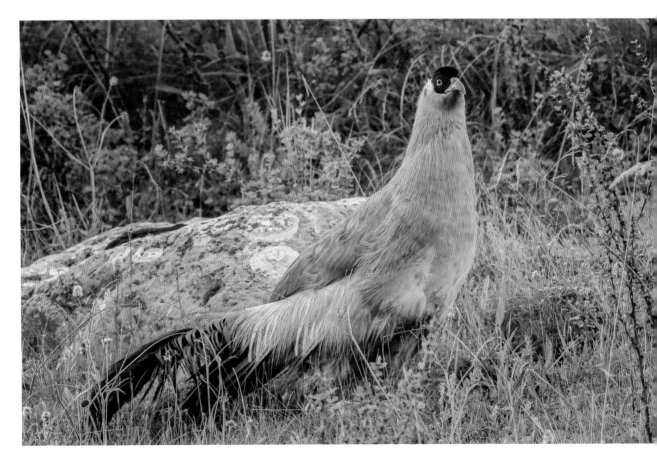

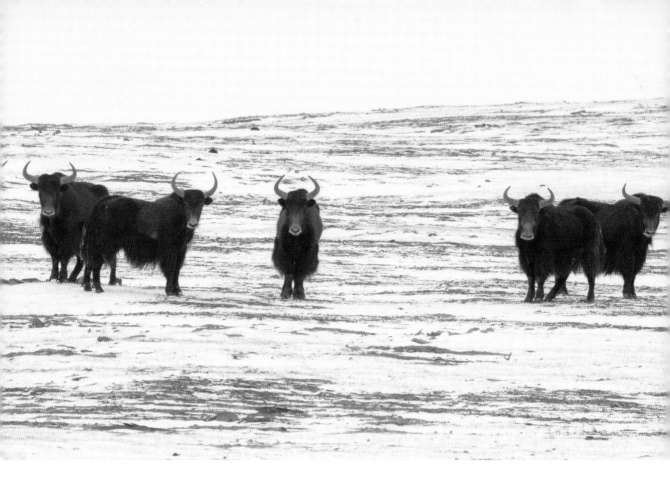

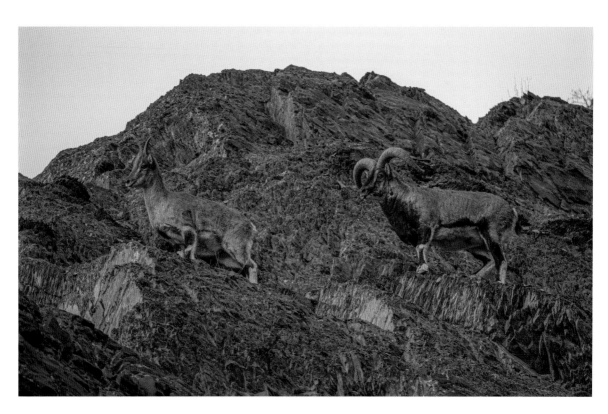

LEFT The **Wild Yak** (*Bos mutus*) inhabits the alpine grassland and cold desert regions of the Tibetan Plateau occurring at elevations of up to 6,000 m (19,700 ft). Across many parts of the Plateau, livestock grazing and hybridisation with domestic yak pose direct threats to Wild Yaks. Today, remaining populations are found largely in the remotest parts of the Tibetan Plateau, including here in Sanjiangyuan.

BOTTOM LEFT The **Bharal** (*Pseudois nayaur*), also known as the Blue Sheep, thrives across the Himalayas and the Tibetan Plateau, to as far north as Ningxia Province where it is one of the main prey of the Snow Leopard. It inhabits treeless slopes and the shrubby zone above the timberline where it feeds on grasses, lichens and mosses. The Bharal typically lives in herds containing some 30 animals and is probably the commonest large mammal in Sanjiangyuan.

BELOW The **Tibetan Argali** (*Ovis ammon hodgsoni*) ranges throughout the Tibetan Plateau at elevations from 3,000 m to 5,000 m (9,800 ft to 16,400 ft). In winter it descends to lower altitudes in search of food. With its impressive scythe-like horns, it is among the largest wild sheep in the world. The Tibetan Argali forms small herds of 10-15 individuals though larger groups of over 100 sheep have been seen as well.

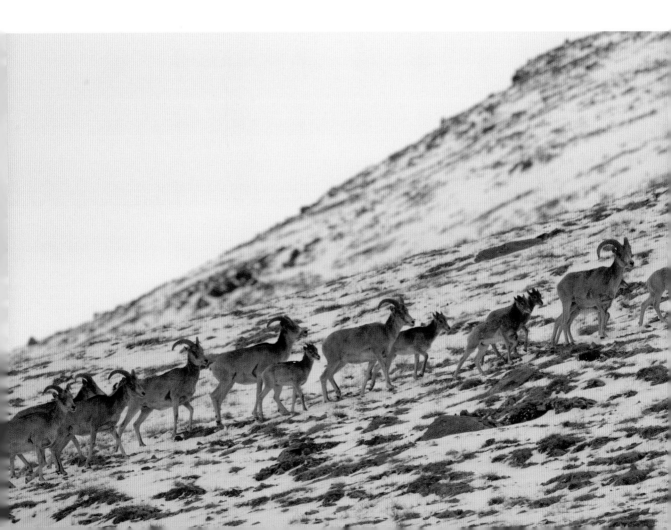

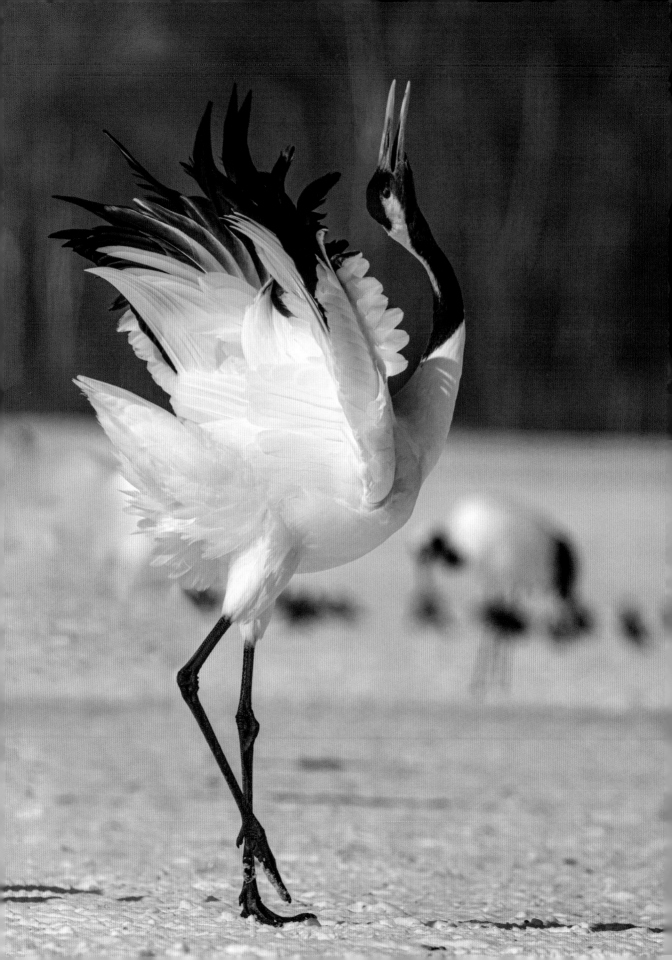

Yancheng and Dafeng Milu National Nature Reserves

The Yellow Sea and Bohai Gulf coast hold some of the world's largest intertidal mudflats. Together, they form a very important staging and wintering habitat for migratory birds in the East Asian-Australasian Flyway. Among the main flyways, the East Asian-Australasian Flyway is used by the highest number of migratory bird species and holds more threatened species than any other flyway.

In 2019, two major wetland sanctuaries along the Jiangsu coast of the Yellow Sea-Bohai Bay were inscribed as UNESCO World Heritage Sites. They are the Yancheng and Dafeng Milu National Nature Reserves and are critical sites for the conservation of migratory birds in the East Asian-Australasian Flyway. The inscribed sites cover a combined area of around 189,000 hectares (467,000 acres) with buffer zones of 80,000 hectares (198,000 acres) of coastal wetland ecosystems comprising salt marshes, intertidal mudflats, and creeks.

The core areas of Yancheng are largely uninhabited and in good condition. In contrast, the buffer and experimental zones have rice fields as well as fish and shrimp farms, with many human communities living in and near these farmland and aquaculture areas. A key highlight of Yancheng's coasts is its very extensive mudflats. These dynamic areas of sandy and muddy flats have been built up over thousands of years, from the vast amount of sediments pumped into the sea by the Yellow and Yangtze rivers. Towards the southern end of Yancheng, in Dongtai district, are the famed mudflats of Tiaozini and Dongsha. These flats are part of the radial sand ridges system, a peculiar underwater geological formation that extends over 20 km (12 mi) into the Yellow Sea. When exposed at low tide, these nutrient rich flats draw hundreds of thousands of shorebirds during the migratory season including the Spoon-billed Sandpiper.

Key habitats of the Yancheng National Nature Reserve include coastal wetland ecosystems, home to Red-crowned Cranes, Spoon-billed Sandpipers and other rare and endangered migratory waterbirds. It is among the largest coastal wetland nature reserves in China. The area's biodiversity includes more than 400 species of birds, 40 species of mammals and 30 species of amphibians and reptiles.

Other threatened species recorded in Yancheng include the Baer's Pochard, Oriental Stork, Scaly-sided Merganser, Far Eastern Curlew, Great Knot and Nordmann's Greenshank. Yancheng is a critically important staging and refueling stop for migratory birds along the East Asian-Australasian Flyway. Hundreds of thousands of migratory shorebirds stop over here every year. As many as 200,000 birds spend their winter in this Important Bird and Biodiversity Area (IBA).

Yancheng is located in central Jiangsu Province along the coasts of the Yellow Sea. It is about four to five hours' drive from Shanghai, and three hours by car from Nanjing and Suzhou. The most popular time to watch birds here is between October and early April, during which period there is little rain. From December to February, sub-zero temperatures are normal.

LEFT The Yancheng National Nature Reserve is particularly well known for its **Red-crowned Cranes** (*Grus japonensis*), which is among Asia's rarest cranes with a global population of less than 3,000 individuals. The reserve supports a large proportion of the Chinese/Russian breeding population during the northern winter, and flocks of the birds here typically intermingle with large groups of Common Crane. The cranes often forage in cultivated areas, and in the buffer zones of the reserve.

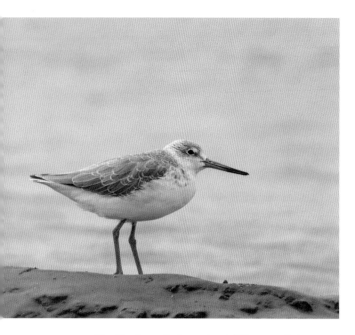

ABOVE The **Nordmann's Greenshank** (*Tringa guttifer*) is one of the most threatened shorebirds in the world and is classed as Endangered. It is thought to have a population of just 600-1,300 individuals. Large numbers of this rare waterbird congregate on the wetlands of Tiaozini during its migration stopovers on its way to and from the breeding sites in eastern Russia.

When we think of China, mountain landscapes often come to mind, but hardly coastal wetlands. The coastal marshes and mudflats of Yancheng are home to incredible diversity of intertidal species. Like wetlands throughout the world, these habitats are threatened by the increasing development of fish farms and other commercial uses of limited water and land resources, as well as by the reclamation of coastal mudflats. In addition, the expansion of other land uses, including the development of ports and industrial areas, continues to encroach on coastal wetlands in China. The reserve is also impacted by the spread of the alien Smooth Cordgrass (*Spartina alterniflora*) an invasive plant that can outgrow native species, affecting biodiversity and altering habitats.

The significance of the Yancheng and Dafeng Milu Nature Reserves being inscribed as UNESCO World Heritage Sites is hugely important. These are major steps in the right direction for coastal wetland conservation in Asia. This success story shows that the challenges to secure the long-term future of coastal habitats are not unsurmountable. Within the inscribed UNESCO sites, the Chinese government is committed to monitor and enforce strict laws in order to safeguard the conservation of these ecosystems. This would also help pave the road ahead for Phase II of the Nomination process which is expected to bring more areas of wetlands under stringent protection.

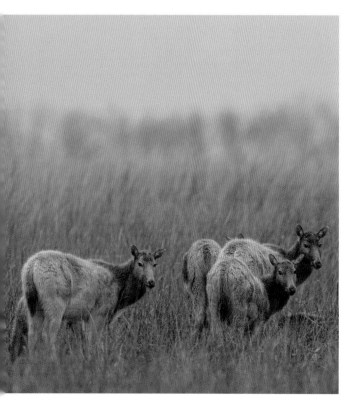

LEFT Père David's Deer (*Elaphurus davidianus*) is native to eastern and southern China (to Hainan). It is known in Mandarin as Milu and was long extinct in the wild until its reintroduction. In 1865, the French missionary Pere Armand David found a herd in the Imperial hunting park in Beijing. He became the first person to make the species known to the West. Some specimens were later sent to Europe. This act saved the species, as floods and subsequent hunting wiped out the entire captive population in China during the Boxer rebellion at the turn of the 20th Century. Around the same time, the last few surviving adult animals in European zoos were entrusted to the Duke of Bedford, who bred them on his estate in the United Kingdom. All the living Père David's Deer in the world today hail from that remnant population.

Almost a century later, successful reintroductions in China have taken place. Given the small gene pool, the re-introduced population has exceeded all expectations. The herds built from reintroduced individuals are now several thousand strong. The Dafeng Milu National Nature Reserve in Yancheng provides one of the largest habitats for the Père David's Deer.

RIGHT The Endangered **Oriental Stork** (*Ciconia boyciana*) is a regular winter visitor to Yancheng National Nature Reserve and can be seen on the mudflats and in fish ponds. Over the years, there have been successful captive breeding and reintroduction programmes in Japan and South Korea using birds sourced from Russia and Germany. The world population is estimated at less than 2,500 mature individuals.

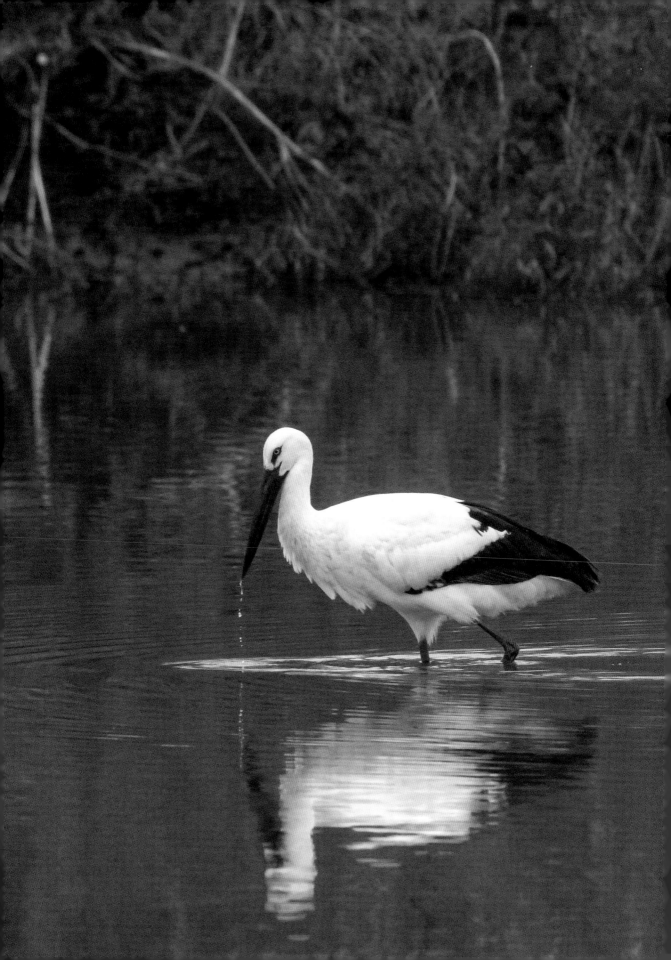

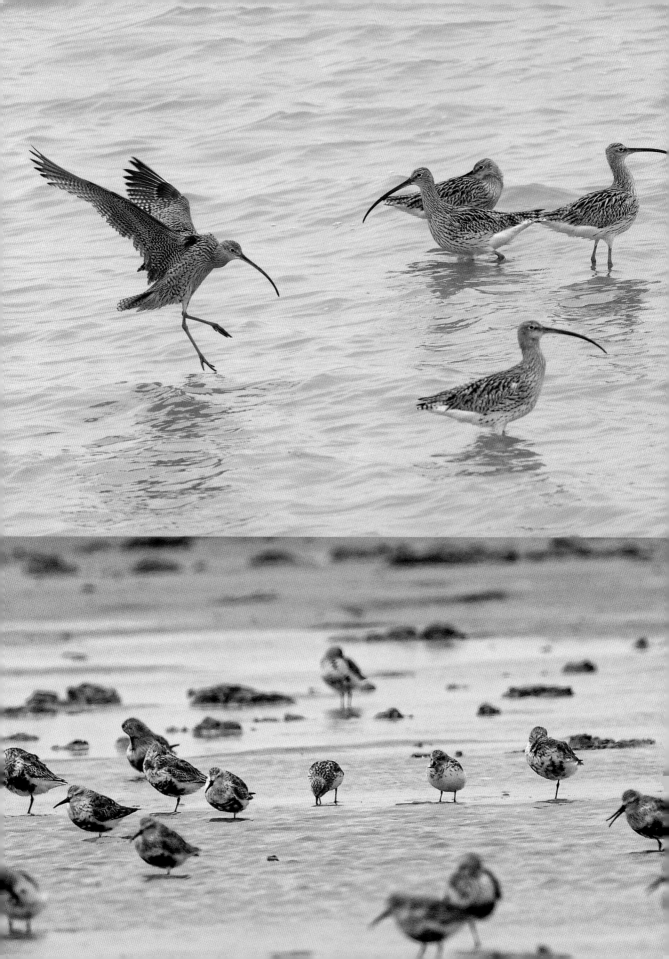

LEFT TOP To the left is the Endangered **Far Eastern Curlew** (*Numenius madagascariensis*), which holds the distinction of having some of the longest bills by proportion in the shorebird world. The four birds on the right are the more common **Eurasian Curlew** (*Numenius arquata*).

RIGHT TOP/LEFT BOTTOM Half of the world's Critically Endangered **Spoon-billed Sandpipers** (*Calidris pygmaea*) make long stopovers, feed, or even moult in Yancheng, particularly at the intertidal flats at Tiaozini. This individual is in breeding plumage.

As one of the most charismatic of the world's threatened shorebirds, it has garnered considerable attention from conservationists. The main breeding grounds are located in Chukotka in the extreme northeast of Russia. Several conservation NGOs led by Birds Russia and the Wildfowl and Wetlands Trust are involved in research and conservation activities in the main breeding areas, which are closely monitored during the breeding season.

In the Russian tundra, when lemmings (*Dicrostonyx torquatus*) experience favourable conditions, the successful hatching rates of the Spoon-billed Sandpiper increase significantly. This is because when predators like Arctic Foxes, skuas, and stoats feed on Lemmings, they are less inclined to go for the eggs and chicks of water birds.

Responding to a dramatic population decline observed in the 2000s, a captive breeding programme was started in 2011. The aim was to safeguard the species while threats in the wild could be addressed. Subsequently, a 'head-starting' programme was established in Chukotka. Head-starting involves the collection and artificial incubation of eggs, allowing the chicks to be temporarily reared in captivity and subsequently releasing them into the wild. This helps to minimise the losses in eggs and chicks due to predation and other threats.

At present, the population of the Spoon-billed Sandpiper likely numbers less than 490 mature individuals worldwide, although conservation efforts may be slowing down its decline.

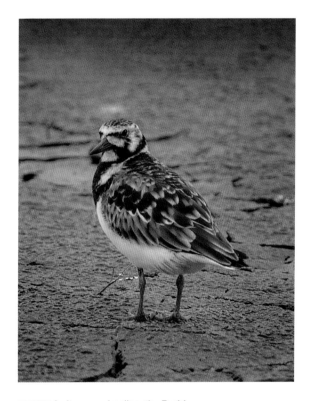

ABOVE As its name implies, the **Ruddy Turnstone** (*Arenaria interpres*) flips over stones and clumps of seaweed with quick jerking movements to look for prey underneath. Several birds may work together to overturn larger objects. Here in Yancheng, good numbers are present annually, often joining large flocks of smaller sandpipers such as Dunlins, Broad-billed Sandpipers and Sanderlings.

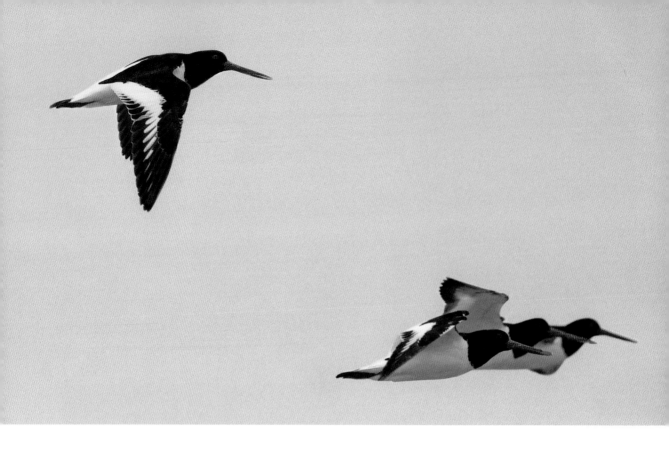

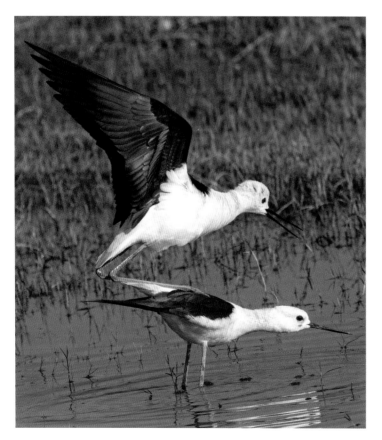

ABOVE The **Eurasian Oystercatcher** (*Haematopus ostralegus*) is a scarce shorebird on the coasts of China. Small flocks congregate in winter on the tidal flats of Yancheng. The East Asian populations of the Eurasian Oystercatcher (ssp. *osculans*) are the smallest, numbering perhaps a little more than 10,000 individuals.

RIGHT The **Reed Parrotbill** (*Paradoxornis heudei*) is a unique species found only in the wetlands of eastern China and south-east Russia. Along the coast of east China, there has been a large-scale clearance of reedbeds for paper pulp and reclamation of wetlands for cultivation. In addition, areas of habitat are now taken over by the invasive Smooth Cordgrass, resulting in extensive habitat loss for the bird. Studies show that the Reed Parrotbill does not nest in areas dominated by this invasive plant, and the bird generally avoids using them.

LEFT The **Black-winged Stilt** (*Himantopus himantopus*) has a huge range spanning the Americas, Europe, Africa and Asia. In Yancheng, it is a breeding visitor. Usually single brooded, its average clutch size is four eggs, with incubation taking up to a month. The chicks fledge a month later and become independent after two to four weeks of fledging.

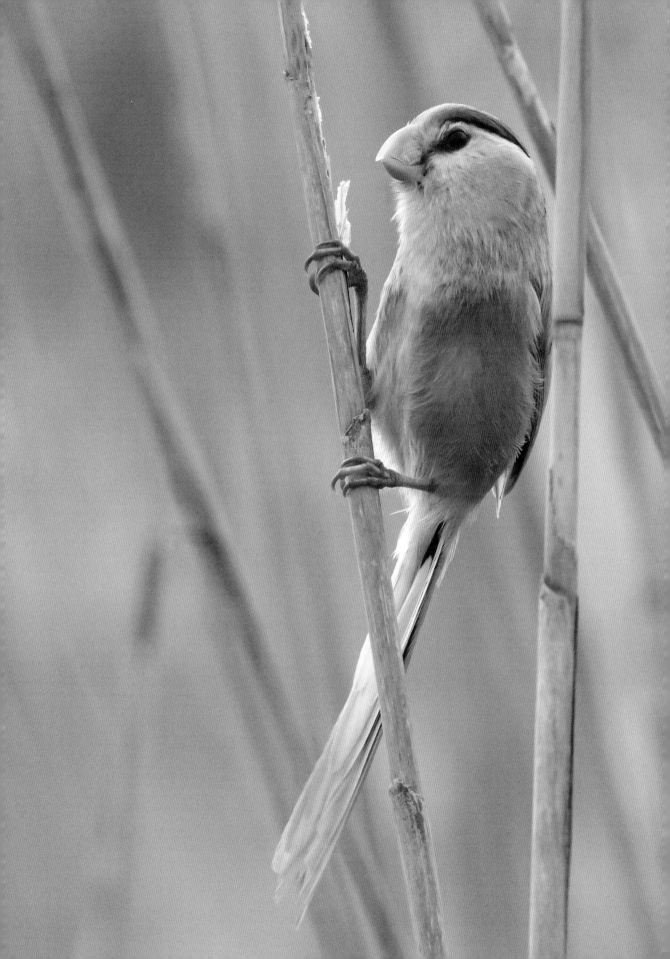

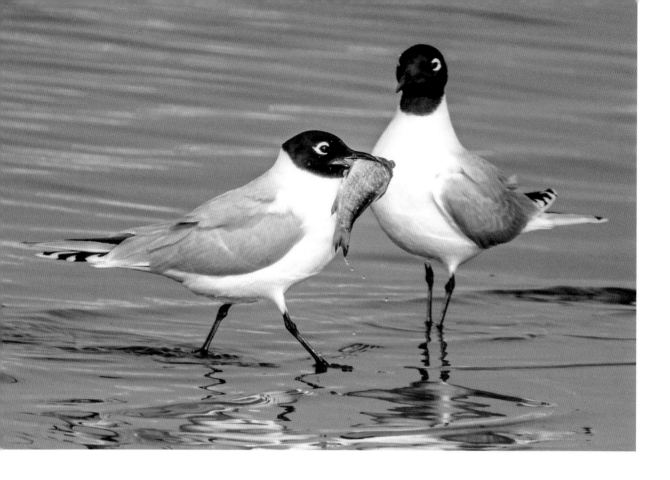

ABOVE Saunders's Gulls (*Saundersilarus saundersi*) seen here in breeding plumage. The reserve is an important breeding and wintering area for this gull. In parts of its breeding grounds, including in Yancheng, the Saunders's Gull is impacted by the loss of its Seepweed-dominated (*Suaeda glauca*) habitat, which is encroached by aquaculture expansion and proliferation of the the Smooth Cordgrass.

LEFT The **Chinese Penduline-tit** (*Remiz consobrinus*) breeds in eastern China and the Russian Far East, and is a regular winter visitor to Yancheng National Nature Reserve. As seen here, it spends much time hopping from reed to reed in *Phragmites* reedbeds searching for insects. Outside the breeding season, it is found in a variety of marshy and open woodland habitats.

BELOW The **Light-vented Bulbul** (*Pycnonotus sinensis*) has a striking head pattern. It eats a variety of berries, soft fruits and vegetables, as well as insects sometimes caught in flight. The Light-vented Bulbul is a ubiquitous bird in cultivated and settled areas in much of eastern and southern China, tolerant of highly degraded habitats.

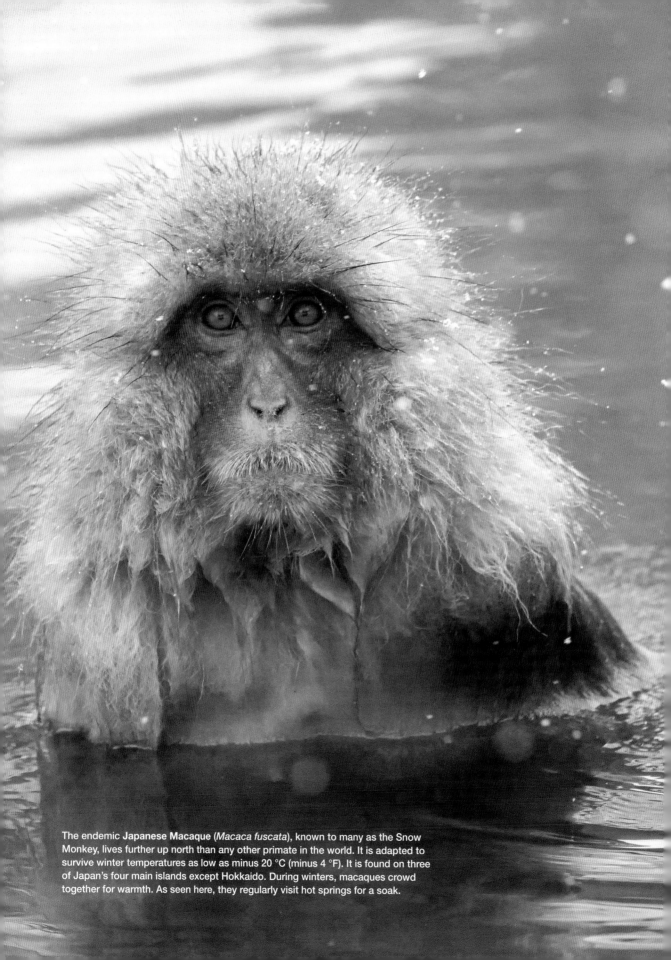

The endemic **Japanese Macaque** (*Macaca fuscata*), known to many as the Snow Monkey, lives further up north than any other primate in the world. It is adapted to survive winter temperatures as low as minus 20 °C (minus 4 °F). It is found on three of Japan's four main islands except Hokkaido. During winters, macaques crowd together for warmth. As seen here, they regularly visit hot springs for a soak.

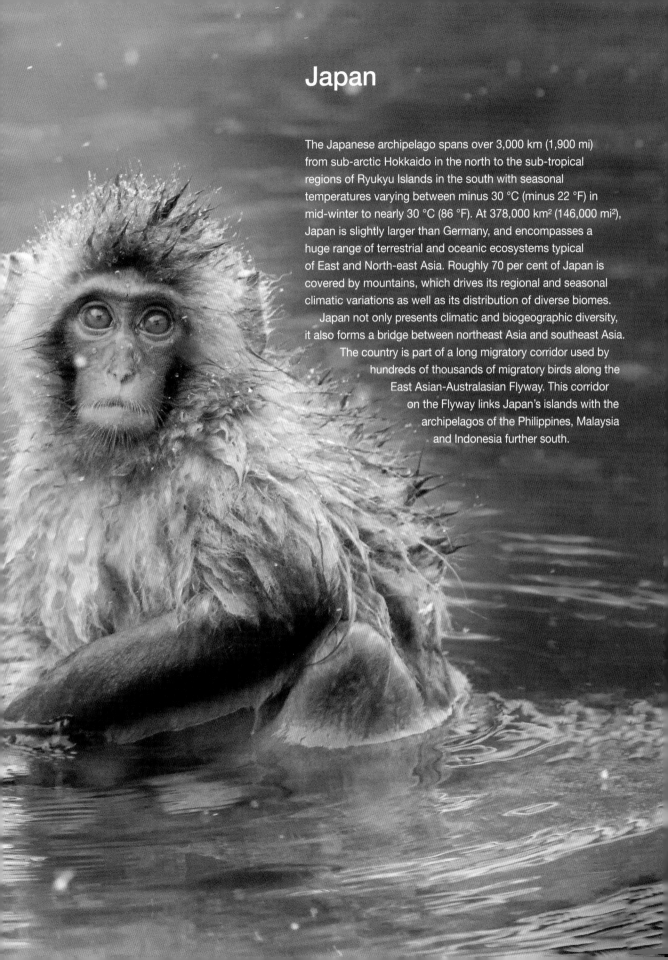

Japan

The Japanese archipelago spans over 3,000 km (1,900 mi) from sub-arctic Hokkaido in the north to the sub-tropical regions of Ryukyu Islands in the south with seasonal temperatures varying between minus 30 °C (minus 22 °F) in mid-winter to nearly 30 °C (86 °F). At 378,000 km^2 (146,000 mi^2), Japan is slightly larger than Germany, and encompasses a huge range of terrestrial and oceanic ecosystems typical of East and North-east Asia. Roughly 70 per cent of Japan is covered by mountains, which drives its regional and seasonal climatic variations as well as its distribution of diverse biomes.

Japan not only presents climatic and biogeographic diversity, it also forms a bridge between northeast Asia and southeast Asia. The country is part of a long migratory corridor used by hundreds of thousands of migratory birds along the East Asian-Australasian Flyway. This corridor on the Flyway links Japan's islands with the archipelagos of the Philippines, Malaysia and Indonesia further south.

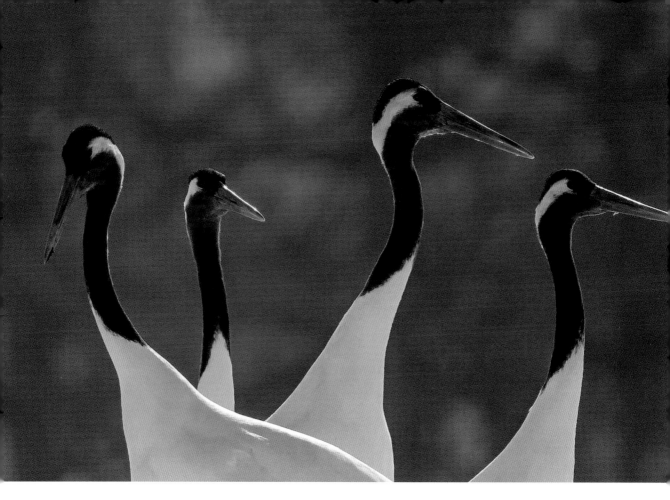

A century ago, the Red-crowned Crane was on the brink of extinction because of indiscriminate hunting. At that time, Japan's Red-crowned Crane population was believed to number less than 20 surviving birds in the marshes of Kushiro in eastern Hokkaido.

In the 1950s, conservation efforts in the form of stronger protection for wintering sites and the provision of food enabled a dramatic recovery of the population. With a secured food supply in winter, many more young cranes survived the winter. By the end of the decade, the population had grown to over 150 individuals. The sustained conservation efforts have enabled a steady recovery of the populations on Hokkaido. Today, Hokkaido is home to more than half of the known global population of some 2,000 mature individuals. The recovery of the Red-crowned Crane is one of many conservation success stories in Japan. A combination of a strong conservation ethos, culture, and other factors have resulted in Japan having one of the highest forest cover by proportion in the world. Dedicated efforts by Japanese conservationists have saved many species from extinction, including the

ABOVE In eastern Hokkaido, visitors can observe the Endangered **Red-crowned Crane** (*Grus japonensis*). It is undoubtedly Japan's most iconic bird, manifesting its image on Japan Airline's logo and on the 1,000 yen note.

RIGHT The **Steller's Sea-Eagle** (*Haliaeetus pelagicus*) is a powerful raptor with a massive bill, striking appearance and a wingspan of up to 2.5m (8.2 ft). One of the heaviest eagles in the world, it breeds in eastern Russia around the Sea of Okhotsk, Sakhalin Island and the Kamchatka Peninsula. Every year, around 2,000 individuals arrive in Hokkaido with large numbers gathering on the sea ice in the Nemuro Channel between Shiretoko and the island of Kunashir. The Steller's Sea-Eagle is classified as Vulnerable with less than 3,800 mature individuals globally.

Short-tailed Albatross, Oriental Stork, and Okinawa Rail. In 2020, the Environmental Performance Index (EPI) ranked Japan as the best performing country in Asia and 12th in the world.

Shiretoko National Park

Hokkaido is the northernmost of Japan's main islands, and form the country's largest prefecture. With three stunning national parks, eastern Hokkaido is a popular place to visit for birdwatchers and nature lovers.

The Sea of Okhotsk northeast of Hokkaido is home to around a dozen species of whales. Sperm Whales (*Physeter macrocephalus*) and Baird's Beaked Whales (*Berardius bairdii*) are often seen in the waters around Shiretoko, while Common Minke Whales (*Balaenoptera acutorostrata*) typically pay a visit in spring and summer. Killer Whales (*Orcinus orca*) and Sea Otters (*Enhydra lutris*) also patrol the Nemuro Strait.

Located in the northeastern part of Hokkaido, the Shiretoko Peninsula protrudes 70 km (40 mi) into the Sea of Okhotsk. The many fast-flowing rivers that drain the peninsula feed the waters of the Straits of Nemuro with rich nutrients. This enables phytoplankton and other marine organisms to thrive. In February and March each year, a massive amount of drift ice from the frozen Sea of Okhotsk covers the sea near the fishing town of Rausu. This makes Rausu the southernmost place in the Northern Hemisphere for the sea to be covered in ice.

During the winter months, the area offers exciting opportunities for close-up observations of many species including Red-crowned Cranes, Steller's Sea-Eagles and Whooper Swans, as well as the spectacular Blakiston's Fish Owl.

Indeed, Japan is an amazing country with a rich culture and tradition, as well as a wealth of landscapes. With a developed infrastructure and a cuisine that is hard to beat, Japan proves to be a very attractive destination for travelling naturalists. Outside the standard tourist circuit, there is a wild Japan that stays mostly hidden from foreign visitors.

From November to April, thick snow blankets the island of Hokkaido and many areas of northern Honshu, which experience severe winters caused by cold winds

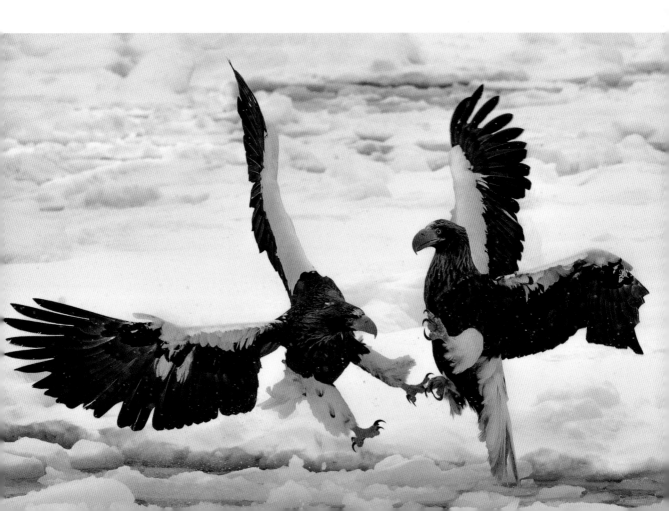

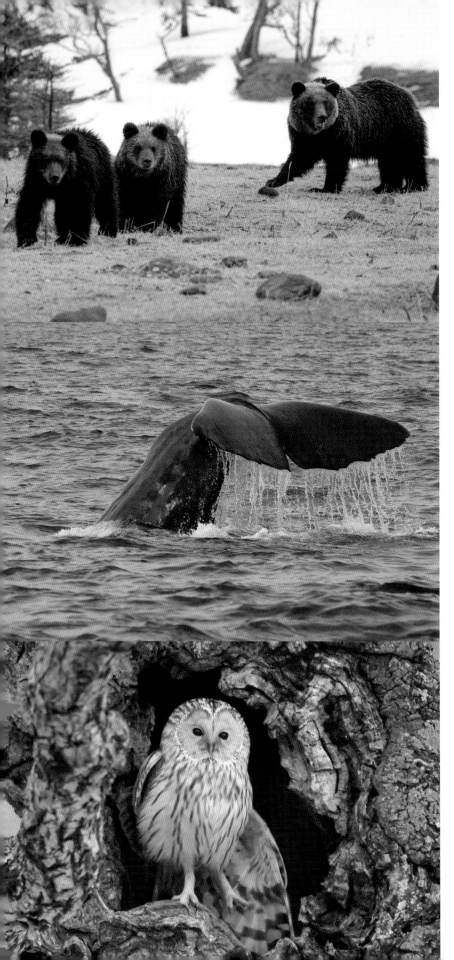

RIGHT The common **Ezo Red Fox** (*Vulpes vulpes schrencki*) occurs in Hokkaido from grasslands to alpine areas, where it feeds on rodents, birds and carrion. In autumn, the diet also includes fruits and nuts. They dig tunnels to make their dens. The female gives birth to cubs in the early spring, and by late autumn the cubs are grown and independent. Males do not contribute to the raising of offspring.

LEFT TOP The **Ussuri Brown Bear** (*Ursus arctos lasiotus*) is one of Hokkaido's most iconic mammals. There is a large population on the Shiretoko Peninsula with unusually high densities. The bear can be seen from April when it comes out of hibernation till autumn in September. Ussuri Brown Bears give birth during the winter. In spring, they are usually accompanied by cubs as seen here. In autumn, the bears are busy catching salmon from the rivers.

LEFT MIDDLE The **Sperm Whale** (*Physeter macrocephalus*) is the largest of the toothed whales. Mature males can reach up to 20 m (60 ft) in length, with the head representing up to one third of its length. It can dive as deep as 1,000 m (3,300 ft) in its hunt for squid. These giants can hold their breath for up to 90 minutes on such dives. They consume around 1,000 kg (2,200 lb) of squid and fish a day.

Sperm Whales were once commercially valuable. They were hunted for centuries with up to one million whales killed by various whaling nations. The population is now on the mend. Sperm Whales are not the easiest of whales to watch because of their long dive times. However, the chances of encountering these giants on boat tours from Rausu are good during the summer months.

LEFT BOTTOM The **Ural Owl** (*Strix uralensis japonica*) is a fairly common resident in Hokkaido's forests. Population levels are dependent on its rodent prey density. A paucity of small mammals will impact breeding success. The owl is active around dusk and just before dawn, mostly hunting from a perch. Prey is located by sound, with the owl being able to detect rodents under 20-30 cm (8-12 in) of snow.

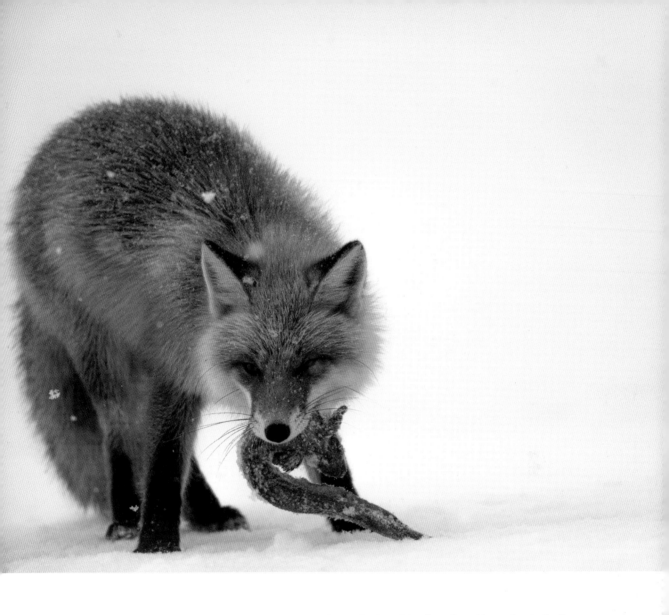

from continental Asia. Summers are mild and brief. From Tokyo and other major cities, there are several daily flights to Memanbetsu and Kushiro in the eastern parts of Hokkaido.

Excursions to the wetland and marsh habitat of the Kushiro Shitsugen National Park and the Akan International Crane Centre are recommended. If time permits, continue to Akan Mashu National Park including Lake Kussharo. The narrow 28 km (17 mi) long Notsuke Peninsula situated about 60 km (40 mi) south of Rausu is worth a visit, with good chances of spotting red foxes, Sika deer and a nice diversity of birds.

Roads end halfway up on both sides of the Shiretoko Peninsula. Boat tours from the town of Utoro allow you to explore the area further. On the opposite side of the peninsula sits the small town of Rausu. The Shiretoko Pass cutting across the peninsula between Utoro and

Rausu is closed in winter from November to April.

Summer time at Rausu is an exciting period to go whale watching. The peak season to encounter Sperm Whales is from mid July to early September. Ussuri Brown Bears are best seen on a cruise in spring and late summer through autumn, when intensive runs of salmon take place in the rivers of Shiretoko.

Birdwatching is excellent in Hokkaido throughout the year. In February, sea ice accumulates in the Sea of Okhotsk, drifting south to the Shiretoko Peninsula and the Nemuro Channel. This is the prime period to catch the Steller's Sea-Eagle and White-tailed Eagle on the drift ice, as well as the Red-crowned Crane at its east Hokkaido feeding grounds. The iconic Blakiston's Eagle-owl and the widespread Ural Owl can also be observed at their winter roost sites during this time.

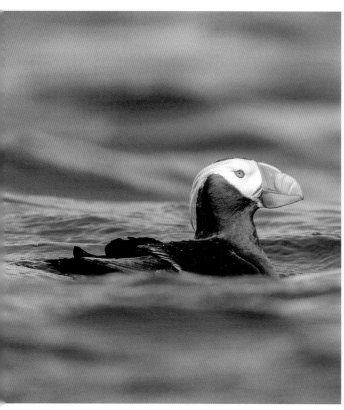

In Spring, a rich diversity of seabirds can be seen in the waters off Nemuro. One such bird is the charismatic Tufted Puffin, which breeds on a number of small islands off north-east Hokkaido, together with the Rhinoceros Auklet and the Spectacled Guillemot. This is also the time when forest jewels like the Siberian Blue Robin, Narcissus Flycatcher and the Siberian Rubythroat start to breed.

The Shiretoko National Park was inscribed as a UNESCO World Heritage Site in 2005. It covers an area of around 720 km^2 (280 mi^2) including the hills from the central part of the peninsula to Cape Shiretoko. The boundaries of the park extend three kilometres (two miles) from the shoreline and embrace all of the area's ecosystems including key marine habitats.

Across the wider eastern Hokkaido region, research and conservation work are being driven by a variety of stakeholders such as universities and government agencies. Work here has focused on forest and wetland management, crane conservation, eagles, seabirds (on offshore islets), sea otter, waterfowl, the Blakiston's Eagle-owl, and many other species. Concerted work on the owl, for instance, has enabled its recovery. Similarly, tracking studies on the Steller's Sea-Eagle, have improved our understanding of its migration between Hokkaido and Russia.

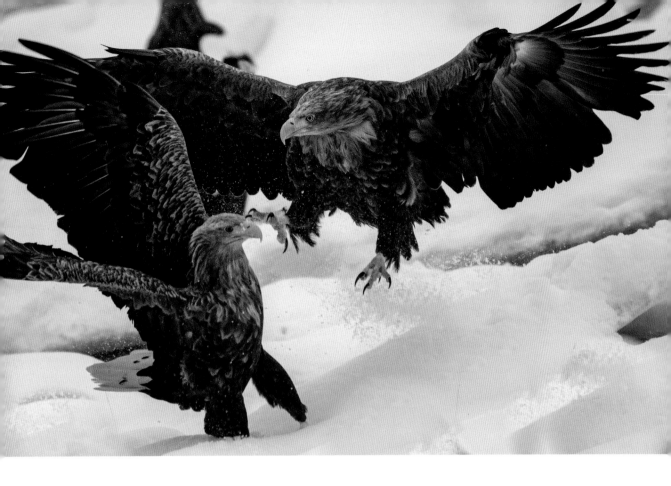

ABOVE The **White-tailed Eagle** (*Haliaeetus albicilla*) breeds in Japan only on Hokkaido. It can be found at the northern and eastern coastlines of the island. Our encounter with this robust eagle occurred in the month of February on the sea ice outside the town of Rausu.

RIGHT The **Spectacled Guillemot** (*Cepphus carbo*) is a seabird with a restricted range in north-eastern Asia. It arrives at its breeding grounds in the Shiretoko Peninsula in March after the sea ice has cleared the coast and leaves in August when the nestlings have fledged.

LEFT TOP Cruises through the drift ice in winter are popular from the small fishing town of Rausu.

LEFT BOTTOM The charismatic **Tufted Puffin** (*Fratercula cirrhata*) is now a rarity in Japan and near extinction, and only breeds on two small offshore islands in north-eastern Hokkaido.

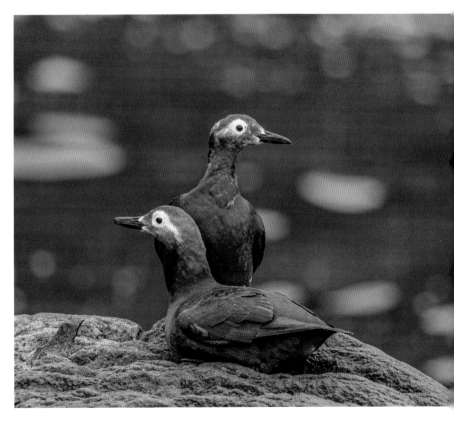

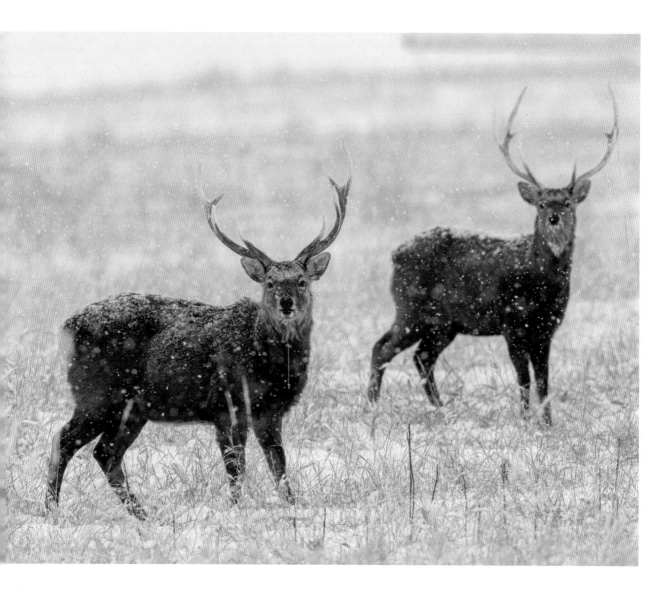

ABOVE The **Yezo Sika Deer** (*Cervus nippon yesoensis*) is the only indigenous ungulate species inhabiting Hokkaido. It is one of the largest subspecies of Sika Deer. Its population has jumped by more than 2.5 times between 1994 to 2015 in eastern Hokkaido. The increase in deer numbers has impacted plant biomass and changed plant species composition, altering areas of woodland and farmlands. Efforts are being made for a more effective management of the Yezo Sika Deer population, through controlled hunting to reduce the effects of over-grazing on Hokkaido's woodland plant communities.

RIGHT TOP The Endangered **Blakiston's Eagle-owl** (*Bubo blakistoni*) is one of the world's rarest, and until recently, most poorly studied owls. Its limited distribution covers the coastal provinces of eastern Russia, Sakhalin and the southern Kuril (Kunashir) Islands, north-east China as well as Hokkaido. Recent genetic studies show that populations on the mainland in Russia may represent a distinct species.

In the past, the Blakiston's Eagle-owl occurred throughout the forests of Hokkaido. Today, it is confined to the eastern and central parts of the island, where the population has gradually risen to about 140 birds over the past 30 years. Around half the population lives in Shiretoko National Park. The population boost is attributed to the provision of artificial nest boxes and feeding. Even then, only 20 pairs may breed in any one year. The Blakiston's Eagle-owl hunts mostly at night and takes primarily fish, which they catch with their powerful talons.

RIGHT BOTTOM Every winter, hundreds of **Whooper Swans** (*Cygnus cygnus*) stay in Lake Kussharo, where hot springs prevent ice from forming around the edges of the lake. Good numbers of this wildfowl also winter in the wetlands across Hokkaido. This area includes Furen Lake, a large brackish wetland north of Nemuro.

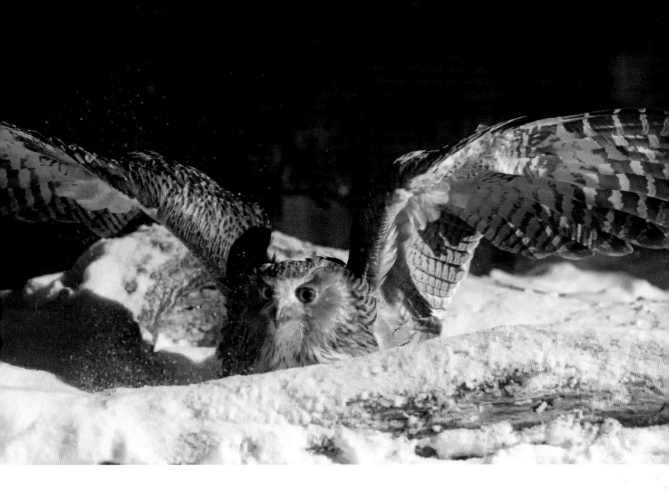

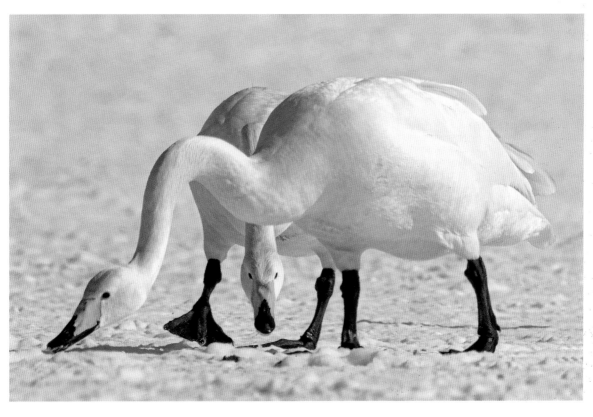

The **Siberian Rubythroat** (*Calliope calliope*) is a summer breeding visitor to Hokkaido. It is often found in coastal grasslands with bushes and scattered shrubs. As seen here, it forages mainly on the ground for insect prey.

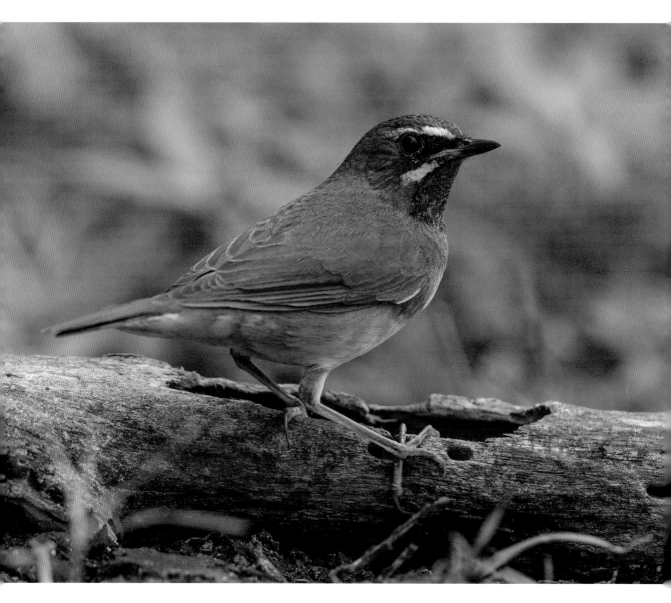

The **Solitary Snipe** (*Gallinago solitaria*) is an uncommon winter visitor to Hokkaido from the middle of October to late April. It occurs in river valleys, swampy areas near unfrozen waterbodies and along mountain streams, including streams linked to hot springs in Hokkaido. It feeds by probing the wet ground for worms, snails and other invertebrates. While doing so, the whole body bobs up and down in a comical fashion.

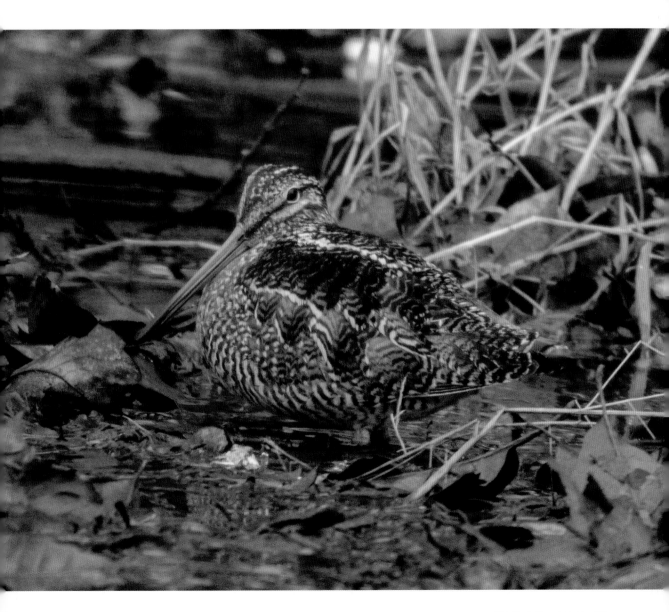

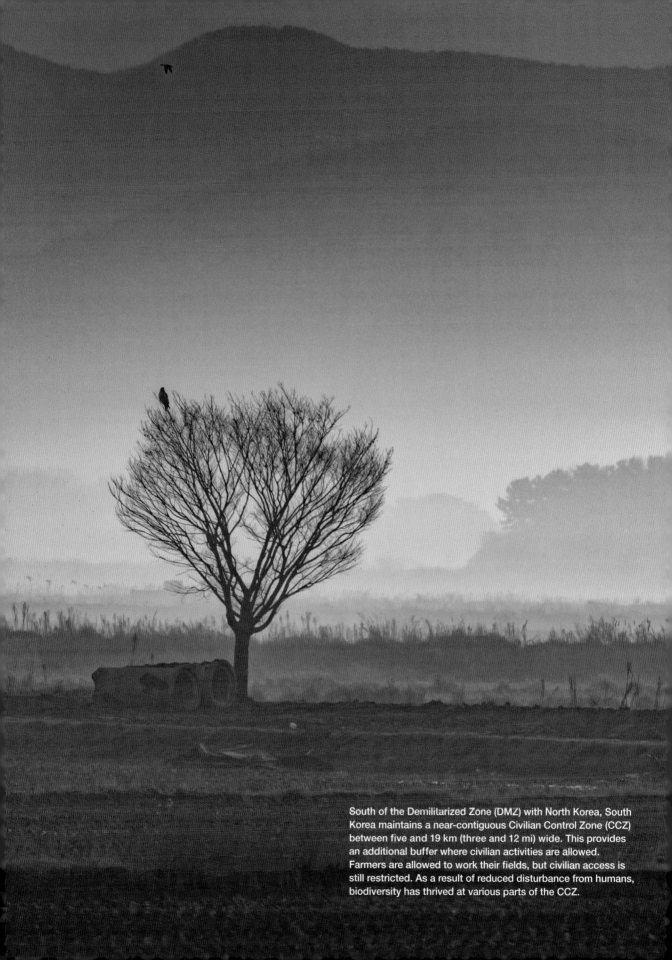

South of the Demilitarized Zone (DMZ) with North Korea, South Korea maintains a near-contiguous Civilian Control Zone (CCZ) between five and 19 km (three and 12 mi) wide. This provides an additional buffer where civilian activities are allowed. Farmers are allowed to work their fields, but civilian access is still restricted. As a result of reduced disturbance from humans, biodiversity has thrived at various parts of the CCZ.

South Korea

South Korea (also known as the Republic of Korea) is located in the southern half of the Korean Peninsula on the north-eastern seaboard of the Asian continent. The country is traditionally divided into four physiographic regions. Korea's west is defined by extensive coastal plains, river basins, and hill country while its eastern region is characterised by mountain ranges and coastal plains. A mountainous southwest and a southeastern region with the expansive basin of the Nakdong River and its tributaries make up the rest of the country. At around 98,000 km² (38,000 mi²), South Korea is somewhat smaller than England.

The country has a temperate climate with four seasons. Springtime from April to June is pleasant with daily temperatures hovering around 15-19 °C (59-66 °F). It is a popular period for visits. July and August are the hot summer months with temperatures soaring above 25 °C (77 °F), and it is also the wettest time of the year. Autumn stretches from September to November with mild average temperatures of around 20 °C (68 °F). During the months of December to March, the dry winter often brings a sudden drop in temperatures to well below freezing point. This is the peak period for seeing wintering cranes.

Over 500 species of birds have now been recorded in South Korea, of which around 380 birds are considered by ornithologists as 'regularly occurring'. Interestingly, less than a quarter of these birds are considered resident species, meaning that they can be found all year round. More importantly, South Korea holds some of the most significant wintering grounds for threatened waterbird species like the White-naped Crane, Red-crowned Crane, Hooded Crane, Scaly-sided Merganser, Baikal Teal, Bean Goose, Saunders's Gull, Great Knot and more.

The distinctive looking **Baikal Teal** (*Sibirionetta formosa*) is one of South Korea's most charismatic migratory birds, arriving en masse in mid-October. In some winters, over a million birds have been recorded, accounting for a large majority of the world's population. The ducks are largely nocturnal, spending most of the day loafing on calm bodies of water before flying out to feed in rice fields at night.

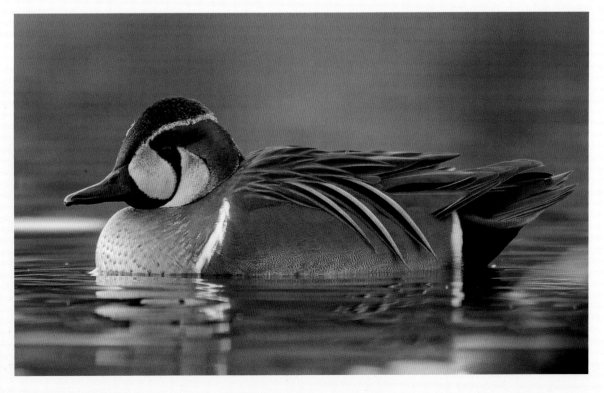

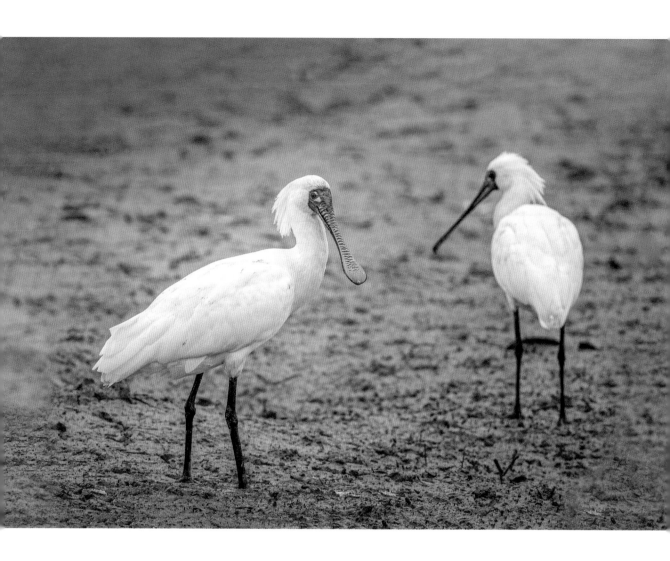

ABOVE Black-faced Spoonbills (*Platalea minor*) in breeding plumage. The main breeding areas of this Endangered species are on islets off the west coast of North and South Korea, and in Liaoning province in China. The spoonbill breeds in mixed colonies with gulls and egrets from March to August. Based on the annual Black-faced Spoonbill census, there has been a steady increase in the global population over the past 20 years, with a record count of close to 5,000 individuals in 2020. This census has been carried out since 1994, co-ordinated by the Hong Kong Bird Watching Society (HKBWS).

RIGHT The wild population of the extraordinarily ornate **Mandarin Duck** *(Aix galericulata)* is largely migratory. It winters widely across South Korea and much of southern China. Large feral populations occur in Europe. For many Asians, the Mandarin Duck represents fidelity because the birds are often paired-up throughout much of the year although ironically, the birds do not pair for life as commonly assumed.

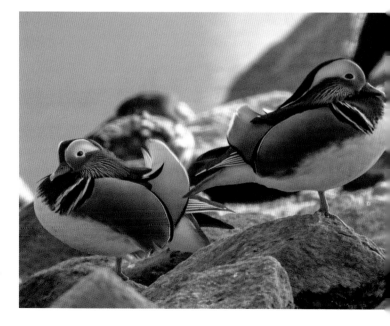

Over the past hundred years, the landscapes of South Korea and its ecosystems have been extensively altered by man. This includes long stretches of the coast, with two-thirds of all tidal flats converted to other uses in the last 50 years. Although legislation to conserve biodiversity has been passed, there remains major limitations. Many laws are focused on preventing harm to individual animals rather than protecting populations and their habitats. Public support and awareness for nature conservation runs deep. There are also more environmental groups than ever before. Yet, massive infrastructure projects like the Four Rivers Project and the Saemangeum land reclamation project have resulted in large scale habitat loss and degradation. Despite this, South Korea has made massive strides in protecting its natural environment. It was rated the 2nd best country in Asia Pacific and 28th in the world in the 2020 Environmental Performance Index (EPI) covering 180 countries. In 2021, four areas of coastal wetlands on South Korea's south-west coast were inscribed as World Heritage Sites by UNESCO.

ABOVE The stunning **Yellow-rumped** (or perhaps better named the **Korean**) **Flycatcher** (*Ficedula zanthopygia*) is the only member of a closely-related group of colourful East Asian flycatchers that breeds in the forests of the Korean Peninsula. The Yellow-rumped Flycatcher is a species associated with good quality mixed evergreen forests in close proximity to water, and can be found across the DMZ. In autumn, these birds depart South Korea's forests and head to Southeast Asia for the winter.

BELOW During the breeding season, the Vulnerable **Hooded Cranes** (*Grus monacha*) are very secretive, nesting in remote wetlands in the Russian taiga, as well as in the mountain valleys of northern China and Mongolia. The bulk of its world population migrates through the coastal areas of the Korean Peninsula on their journey to Kyushu Island in southern Japan. An increasing number of close to 2,000 individuals spend their winter in Suncheon Bay, a UNESCO-listed wetland site that holds the largest wintering population of Hooded Cranes in South Korea. The global population for this species is estimated at 14,500 – 16,000 birds.

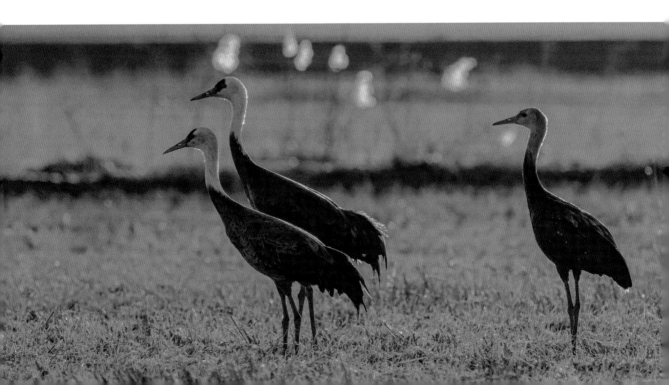

Demilitarized Zone (DMZ) & Civilian Control Zone (CCZ)

The heavily fortified frontier area that demarcates the territories of the Koreas has been off limits to human habitation for almost seven decades. It is among the last major land buffers left over from the Cold War. Up to four km (2.5 mi) wide and 248 km (150 mi long, the Korean Demilitarized Zone contains diverse landscapes of forests, mountains, marshlands, lakes and riverine plains. It stretches across the Peninsula from the Imjin River in the west to the deep East Sea (Sea of Japan). It remains one of the most heavily guarded regions on earth.

The DMZ is an excellent example of how nature can recover when there is little human disturbance for long periods. The Korean DMZ and adjoining areas have become an accidental sanctuary for biodiversity to flourish. One can find mammals such as the Water Deer, Asiatic Black Bear and Raccoon Dog. The Long-tailed Goral, a goat-antelope that lives in the mountains, also occurs in this untouched landscape.

South of the DMZ, South Korea maintains a contiguous Civilian Control Zone (CCZ) that provides an additional land buffer with restricted access but where locals are allowed to cultivate rice. These extensive rice fields are critical to wintering birds that depend on grains, frogs and invertebrates in the harvested paddies for food. The CCZ has become among the best places to observe cranes globally. In particular, the Cheorwon basin is renowned for large concentrations of wintering Red-crowned and White-naped Cranes. It is perhaps one of few places on the planet where as many as seven crane species have been recorded in one day.

South Korea is a highly accessible country with modern infrastructure. Although it is not regularly visited by international birdwatchers, the country hosts varied habitats spanning mudflats and coniferous forests on mountains. It also supports an amazing diversity of species including a large number of waterbirds. South Korea offers the opportunity to see many rare East Asian species and regional endemics. Little English is spoken in many parts of the country outside major cities. Likewise, most up to date birding information is available primarily in Korean. As such, joining a birding tour or travelling around with a knowledgeable local guide is the best way to maximise your Korean nature experience.

Cheorwon, which is a couple of hours drive from Seoul, is considered by many birdwatchers to be among

The majestic **White-naped Crane** (*Antigone vipio*) is a large species that breeds in grassy marshes, wet meadows and croplands in the broad river valleys of Mongolia, southern Russia, and northeastern China. It has a grey body, a grey and white neck, and distinctive red facial skin. Several thousand birds migrate through the Korean Peninsula, making their wintering and staging areas in and near the DMZ. Some of these individuals continue on to southern Japan, where they join a large wintering population of Hooded Cranes in the fields of Arasaki.

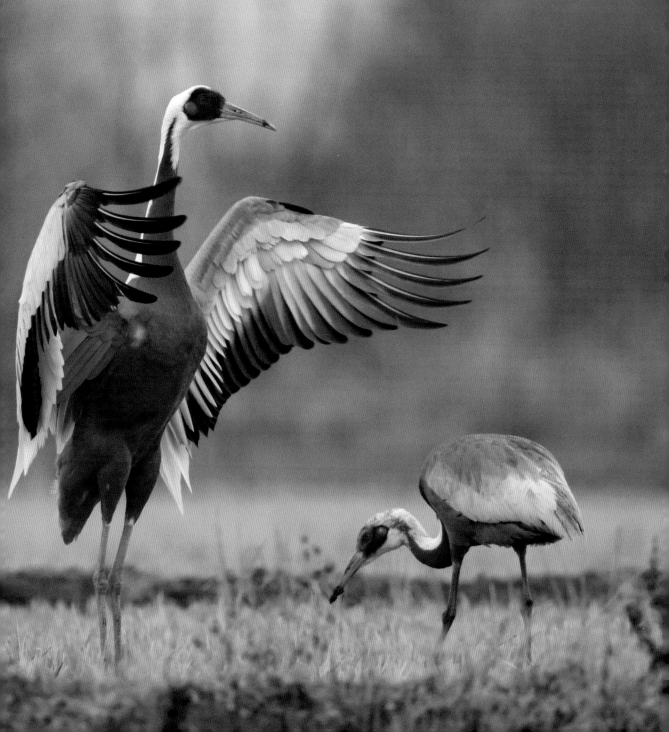

ABOVE The **Korean Raccoon Dog** (*Nyctereutes procyonoides koreensis*) is usually solitary, but may live in family groups and forage in pairs. It is generally nocturnal, spending a big part of the day hidden in dense forest and woodland. The Raccoon Dog is an opportunistic omnivore with a food selection that is much wider than many canids, taking anything from berries to insects and fish.

LEFT The **Water Deer** (*Hydropotes inermis argyropus*) is the only species of deer in which the males lack antlers. Instead, as can be seen here, it grows two long downward-pointing canine teeth that protrude from the mouth. The Water Deer is a prolific breeder, having two to three fawns each time. In the CCZ and DMZ, the Water Deer is associated with wet marshy areas, including reed beds along river banks and on the coasts and can be seen easily at the Imjin River in the CCZ.

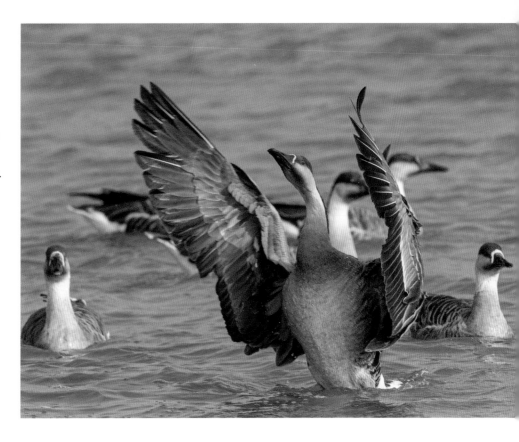

RIGHT The Vulnerable **Swan Goose** (*Anser cygnoides*) generally spends winter at brackish and freshwater marshes, as well as in wet areas such as rice fields and tidal mudflats. Its wetland wintering grounds in China and Korea are under increasing pressure from development and pollution.

the best crane watching sites in East Asia. It is also an Important Bird and Biodiversity Area. As it is bordering the DMZ, a local guide is necessary to help you obtain an advance permit for entering the Civilian Control Zone where several crane species can be seen.

As a result of successful partnerships with local farmers to restore habitats, establish feeding programmes and reduce persecution, Cheorwon county now supports large groups of wintering White-naped and Red-crowned Cranes. The stage is set for scientists and farmers to drive ecologically and economically sustainable agricultural practices that benefit both people and cranes. A new educational centre for cranes has been built. For some of the rice fields, screens have been put up by the local crane protection association to reduce disturbance to foraging birds.

Ecotourism and eco-education are making headways in this part of Korea. Day tours can now be easily arranged from Seoul to visit areas south of the DMZ to observe nature and enjoy the fascinating landscapes. Should peace be formalised between the North and the South, many hope that the DMZ and CCZ will one day be preserved as a protected landscape to secure the biodiversity of the Korean peninsula.

ABOVE Far Eastern Russia forms a critically important refuge for several threatened species including the Endangered **Scaly-sided Merganser** (*Mergus squamatus*). Dependant on old-growth forests for nesting, the Scaly-sided Merganser is increasingly impacted by logging and disturbance to the rich mixed forests of north-eastern China and eastern Russia.

This beautifully plumaged duck winters mainly in central and southern China where little-disturbed stretches of rivers still remain. The merganser is considered by many conservationists to be an indicator of healthy rivers. Between 100-200 birds spend the winter in South Korea. It has also been recorded around the DMZ. The global population of mature individuals is estimated at 2,400-4,500 by BirdLife International.

ABOVE The **Brown-eared Bulbul** (*Hypsipetes amaurotis*) is a large, boisterous, and highly conspicuous species that is common across many parts of eastern Asia. In some areas, they are not appreciated by farmers, as their feeding sometimes inflict damage on orchard and field crops. On the other hand, they are truly friends of the forest, acting as seed dispersal agents for a variety of tree species.

Found in pairs and family groups during the summer months, the species often flocks during winter, when many hundreds can be seen together.

LEFT The **White-backed Woodpecker** (*Dendrocopos leucotos*) ranges widely from Europe to Korea and Japan where it lives in open deciduous and mixed forests. It is often overlooked because of its shy habits and low densities. The White-backed Woodpecker has disappeared from areas with intense forest management which typically leads to a reduction of dead trees.

RIGHT TOP The **Varied Tit** (*Sittiparus varius*) is a familiar bird of woodlands in Japan, the Korean peninsula, and a number of intervening small islands. It prefers mature deciduous, mixed and evergreen broadleaved forests with a dense undergrowth. The Varied Tit feeds mostly on invertebrates, seeds, nuts and berries. It used to be a popular cage bird in Japan. Some were even utilised by fortune-tellers in shrines.

RIGHT BOTTOM The **Vinous-throated Parrotbill** (*Sinosuthora webbiana*) is a widespread resident in large parts of China and the Korean peninsula. It has adapted well to semi-natural and human modified habitats, including dense shrubbery and reed beds. It is the only representative of the parrotbill family in the Korean peninsula and can be easily seen in dense areas at the edge of wetlands.

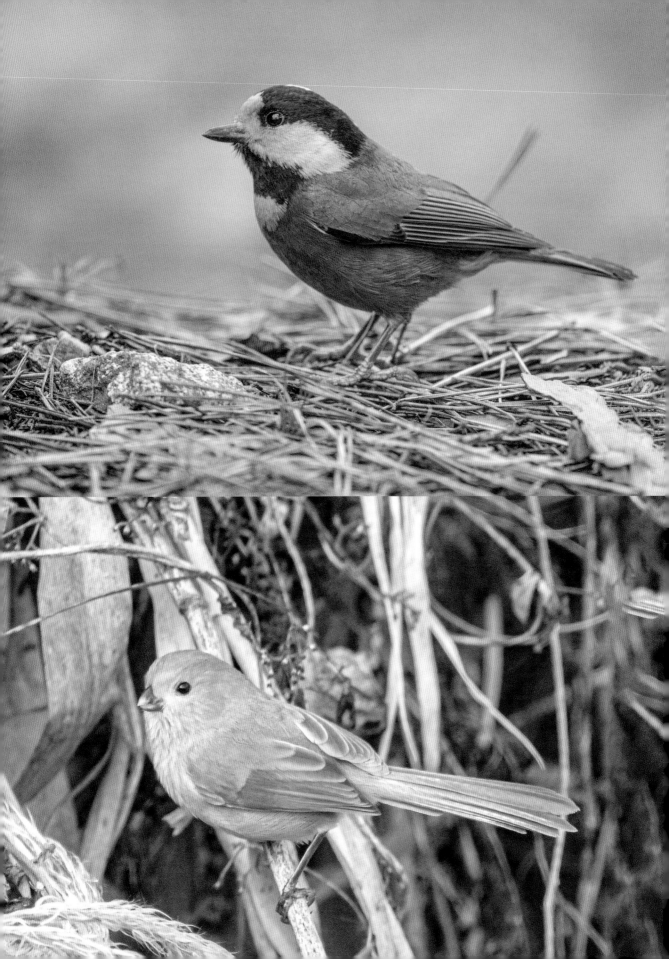

The **Amur Leopard Cat** (*Prionailurus bengalensis euptilurus*) is an ambush predator, often found in forested habitats close to water. It is occasionally observed during daylight hours, although it is primarily nocturnal. The main prey consists of small terrestrial vertebrates. As a good swimmer, it may also catch aquatic prey opportunistically. Unlike its kin in the tropics, the Amur Leopard Cat has a duller pelage, and is differently marked. It may one day be considered a distinct species in its own right. Amur Leopard Cats are found only in the thick forests and woodlands of north-east China, south-east Russia and the Korean peninsula. They are also larger and heavier than leopard cats in the tropics.

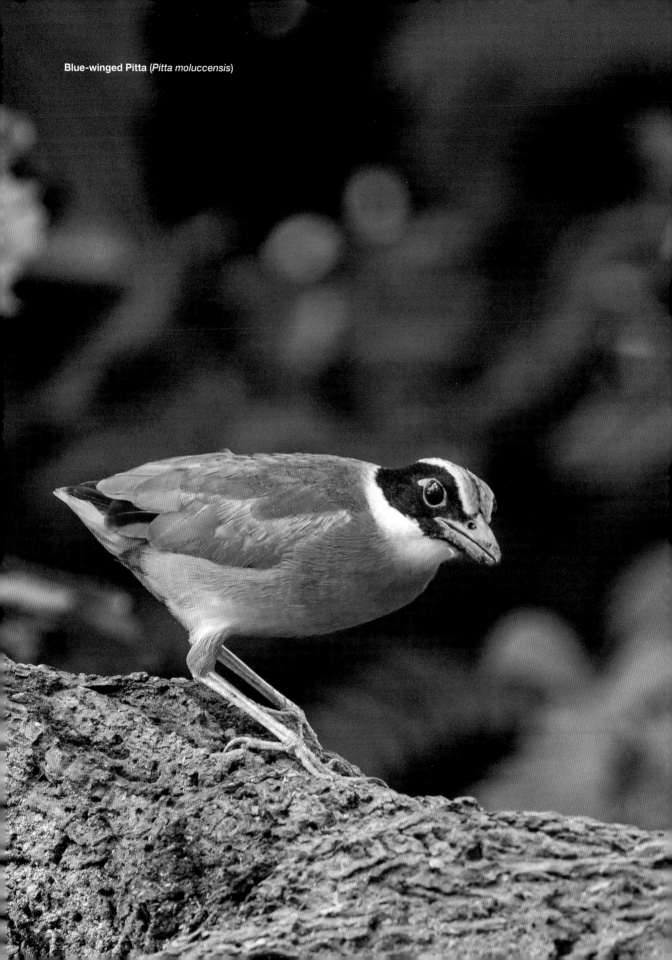

Blue-winged Pitta (*Pitta moluccensis*)

Siem Pang Wildlife Sanctuary

Indonesia
Baluran National Park
Kerinci Seblat National Park
Raja Ampat Islands
Tangkoko Batuangus Nature
 Reserve

Belum-Temengor Forest Complex
Danum Valley Conservation Area
Kinabatangan Wildlife Sanctuary

Myanmar
Indawgyi Lake Wildlife Sanctuary

Singapore
Central Catchment and Bukit Timah
 Nature Reserves
Sungei Buloh Wetland Reserve

Dong Phayayen-Khao Yai
 Forest Complex
Kaeng Krachan National Park

Vietnam
Cat Tien National Park
Da Lat Plateau

Indawgyi Lake

MYANMAR

PACIFIC OCEAN

THAILAND VIETNAM

Khao Yai Siem Pang

CAMBODIA South China Sea

Kaeng
Krachan Da Lat

Andaman Sea Cat Tien

Gulf of
Thailand

Kinabatangan

Belum-Temengor MALAYSIA

MALAYSIA Danum Valley

Tangkoko

Singapore Borneo

Raja Ampat

Sumatra Molucca Sea

Kerinci-Seblat

INDONESIA INDONESIA

Java Sea Banda Sea

Baluran

Java

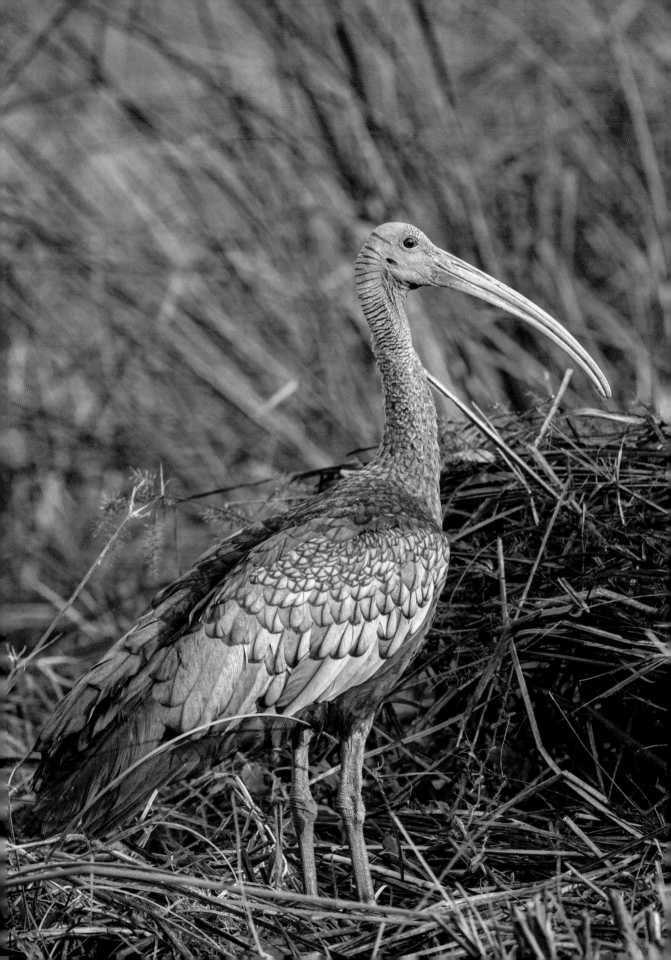

Cambodia

The Kingdom of Cambodia is bordered by Laos to the north, Thailand to the west and Vietnam to the east. It covers an area of around 181,000 km² (70,000 mi²) comprising mainly lowland plains that rises in the southwest at the Cardamom Mountains. The most striking landscape features of Cambodia are the wetlands of the huge Tonle Sap Lake, and the Mekong River flowing from north to south. This mighty river meanders through eastern Cambodia and southern Vietnam before emptying into the South China Sea.

The Tonle Sap is the largest freshwater lake in Southeast Asia. It is a natural flood water reservoir for the Mekong river system as a whole, boasting one of Asia's richest inland fishing grounds. The Tonle Sap regulates the floods downstream from the Cambodian capital of Phnom Penh during the monsoons. In addition, it provides a critical supplement to the dry season flow of the Mekong River through the Tonle Sap River.

Some of the most spectacular congregations of waterbirds in Southeast Asia can be found at Tonle Sap. Prek Toal is a bird sanctuary and a Ramsar-listed wetland located within the Tonle Sap Biosphere Reserve in the north-west corner of the lake. It is the principal site for the conservation of large waterbirds in Southeast Asia. Across Cambodia, unsustainable harvesting, encroachment and land use change pose considerable threats to its biodiversity. Many species are in decline.

The Critically Endangered **Giant Ibis** (*Thaumatibis gigantea*) is the national bird of Cambodia. Standing at over a metre tall, it is the largest ibis in the world, and well over twice the weight of many other ibis species. There were no sightings of the Giant Ibis for several decades and it was only 'rediscovered' in Cambodia in 1993. Once widespread in parts of Southeast Asia extending to nearly Peninsular Malaysia, the species is now restricted to the northern and eastern parts of Cambodia as well as southern Laos, with a single recent record in Vietnam.

However, careful protection of numerous sites have allowed wildlife and waterbird population numbers to recover and thrive, especially at Prek Toal. A good number of destinations in and around the Tonle Sap also offer eco-tourists the opportunity to observe rare species that have been decimated in neighbouring countries.

Several excellent birding sites in northern Cambodia can be reached from Siem Riep, gateway to the famous Angkor Wat complex. One such site is Kulen Promtep Wildlife Sanctuary, a large forest landscape surrounding the village of Thmat Bouy where both the Giant and White-shouldered Ibises can be easily observed.

Typically, a monthly vulture restaurant is arranged at Boeng Toal within the Chhep Wildlife Sanctuary. This feeding station is situated close to the village of Dangphlet in Preah Vihear Province. The supplementary feeding programme benefits the White-rumped, Slender-billed and Red-headed Vultures and is largely driven by the Cambodian Government and NGOs.

Cambodia was for many years off limits because of conflict. Today, this nation is open and easily accessible to the outside world, having put its brutal revolutionary past behind. However, some parts of Cambodia remain affected by landmines and unexploded ordnance. Although warning signs are erected at most former minefields, this may not be the case in remote areas. Travellers are strongly reminded not to stray off walking paths, and to always follow the directions of local rangers.

Ten years ago, the Wildlife Conservation Society (WCS) launched an exciting initiative called Ibis Rice to help local farmers market their certified organic and wildlife-friendly rice. This programme has been instrumental in promoting biodiversity-friendly rice farming in Cambodia. In Siem Pang Wildlife Sanctuary for instance, over 650 families have joined this initiative, committing themselves to preserve the environment through zero deforestation, zero poaching and zero use of agricultural chemicals. In turn, all participating farmers are assured of a premium price for their rice harvest.

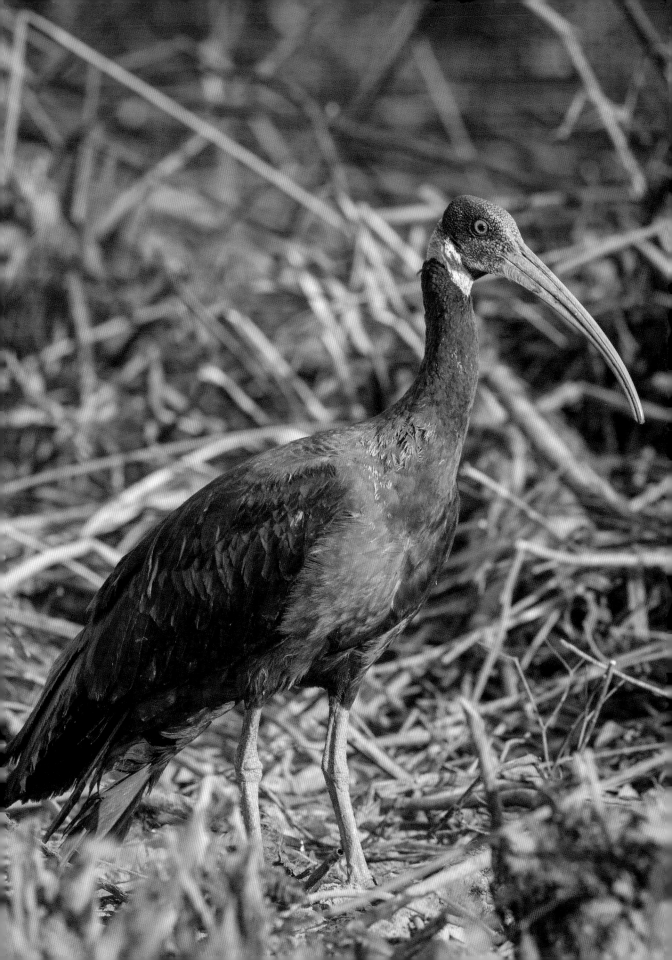

Siem Pang Wildlife Sanctuary

Siem Pang Wildlife Sanctuary is part of a 11,000 km² (4,200 mi²) network of protected landscapes spanning north-east Cambodia, southern Laos, and south-west Vietnam.

This lowland sanctuary is located in the remote north-eastern corner of the country in Stung Treng province. The main vegetation in Siem Pang consists of deciduous dipterocarp forest and semi-evergreen forest in the hilly northern areas. In addition, the landscape includes a mix of degraded forests, open areas of grassland as well as riverine forests linked to the Sekong River.

Numerous seasonal waterholes, called *trapeangs* in the Khmer language, can be found throughout the forests. These *trapeangs* provide an important source of water and food for wildlife during the dry season. Many local villagers depend on the forest and *trapeangs* for water and for harvests of frogs, fishes and non-timber products. Local people have traditionally used extensive areas in these open forests for the grazing of cattle and water buffalo. Interestingly, domestic herds may fill an ecological function previously provided by wild bovid species, most of which are now extirpated.

The forests of Siem Pang are home to breeding populations of five Critically Endangered bird species as well as threatened mammals and reptiles. The White-shouldered Ibis and Giant Ibis are largely dependent on the dry forests in the northern and eastern parts of the country. An estimated 50 per cent of the global population of the White-shouldered Ibis, numbering more than 300 birds, can be found in Siem Pang. For the Giant Ibis, around 50 individuals or 25 per cent of the world's population are estimated to occur here.

In total, over 300 bird species are present in Siem Pang Wildlife Sanctuary, which is classified as an Important Bird and Biodiversity Area (IBA).

High profile threatened species found in Siem Pang include the Great Slaty Woodpecker (*Mulleripicus pulverulentus*), Green Peafowl (*Pavo muticus*), Indian Spotted Eagle (*Clanga hastata*), Black-necked Stork (*Ephippiorhynchus asiaticus*) and Asian Woollyneck (*Ciconia episcopus*).

For close to 20 years, BirdLife International has worked with government partners and local communities to protect Siem Pang. Set up as a social enterprise, Rising Phoenix has been established to gradually take over the conservation and enforcement operations on site. Rising Phoenix has set up a small camp at the sanctuary to host visitors and support research work. At this point, there is limited accommodation and infrastructure at the sanctuary for general visitors and birdwatchers. However, this is expected to change soon when more facilities are developed.

In the dry season from November to April, the **White-shouldered Ibis** (*Pseudibis davisoni*) is dependent on seasonal pools in the forests of Cambodia's Northern Plains for feeding. Towards the beginning of the rainy season in May and June, the Ibis can been seen forming large communal roosts outside the sanctuary.

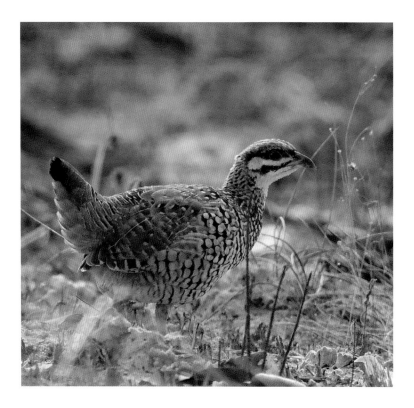

ABOVE The gaudily patterned **Chinese Francolin** (*Francolinus pintadeanus*) is often observed during early morning walks in dry forests, foraging for seeds, shoots and insects.

RIGHT Siem Pang Wildlife Sanctuary is a stronghold for the Endangered **Eld's Deer** (*Rucervus eldii*) with a population of more than 50 individuals. Elsewhere across its Southeast Asian range, they are widely hunted for food. Their antlers are used in traditional medicine. Eld's Deer feeds on grass and also take fallen fruits and flowers. Stags are generally solitary except during the rut, while hinds congregate throughout the year.

Other mammals living in the sanctuary include Northern Red Muntjac (*Muntiacus vaginalis*), Eurasian Wild Pig (*Sus scrofa*), Golden Jackal (*Canis aureus*), Common Palm Civet (*Paradoxurus hermaphroditus*) and Annamese Silvered Langur (*Trachypithecus margarita*).

In the past, the dry forests of Indochina supported a high diversity of large mammal species. Many of these are now increasingly rare or are extirpated. As has been the case in other parts of Southeast Asia, the main reasons driving their declines are habitat loss and fragmentation. In particular, forest conversion for agriculture, and the unsustainable harvesting of wildlife for food and other uses are the key drivers of species decline.

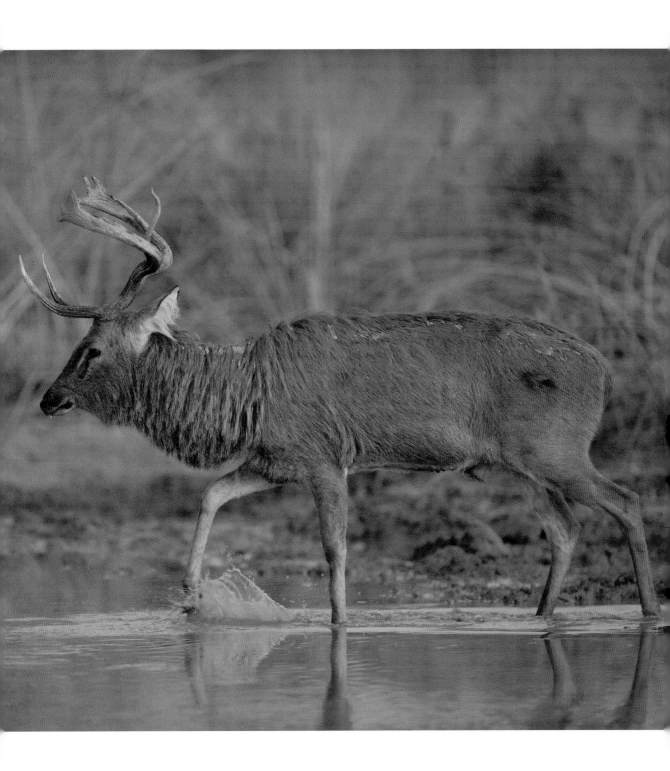

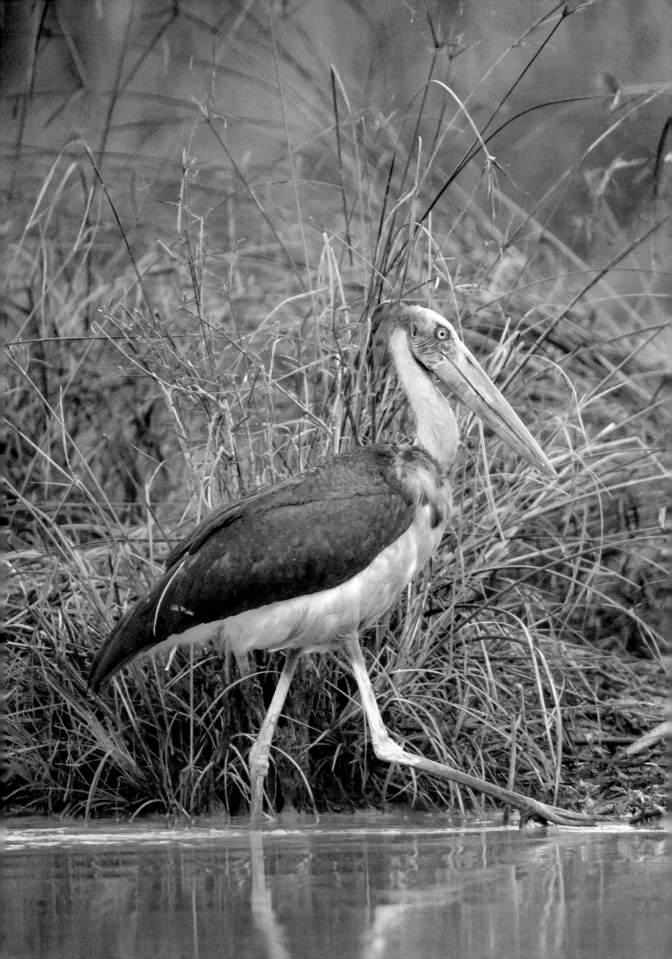

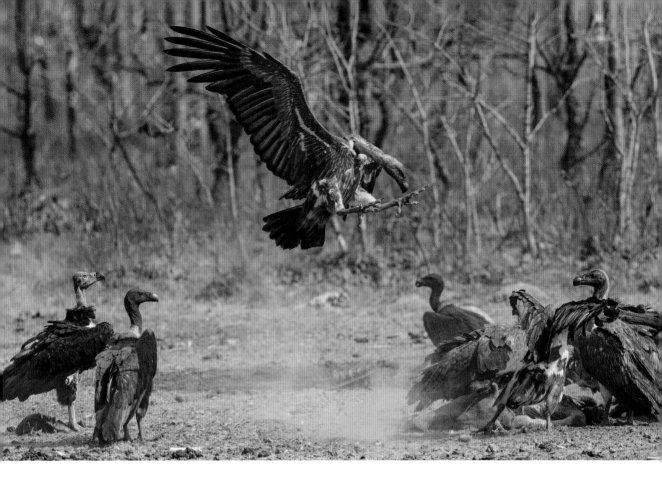

LEFT The **Lesser Adjutant** (*Leptoptilos javanicus*) is reliably seen at *trapeangs* across the Northern Plains of Cambodia, a known stronghold for the species across its wide distribution range.

ABOVE Cambodia is the last major stronghold in Southeast Asia for three Critically Endangered vulture species. Sadly, these majestic scavengers have become effectively isolated from populations in Myanmar, having gone extinct from Thailand. Comprising of the **White-rumped Vulture** (*Gyps bengalensis*) **Slender-billed Vulture** (*Gyps tenuirostris*) and **Red-headed Vulture** (*Sarcogyps calvus*), these three species are regularly seen throughout the year at vulture restaurants in Cambodia, including Siem Pang Wildlife Sanctuary. Recent tracking studies showed some White-rumped Vultures seen in Cambodia breed in adjacent sites across the border in Laos.

Vultures perform important ecosystem services. They get rid of carrion and by doing so, contribute to nutrient cycling. In addition, they play a crucial role in stemming disease transmission particularly through feral dogs, a major reservoir of disease like rabies.

Until recently, the vulture population of Cambodia was presumed to be stable. However, the latest studies reveal a trajectory of rapid decline, possibly a result of the use of poison in hunting practices. This reinforces the importance of promoting public awareness and local engagement programmes, and the need for continued work to monitor remaining populations. Regular supplementary feeding is also increasingly important given the scarcity of large wild mammal carcasses.

BELOW Based on regular population monitoring at vulture restaurants, the total number of the Critically Endangered **Red-headed Vulture** (*Sarcogyps calvus*) in Cambodia may number less than 50 individuals.

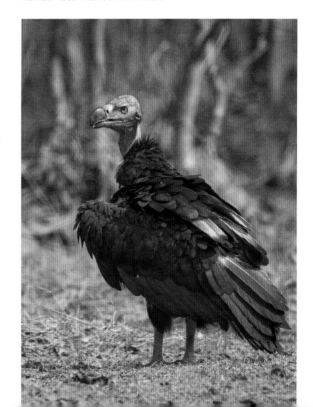

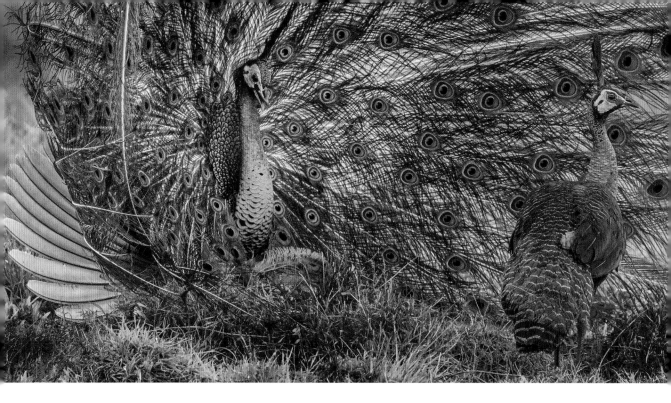

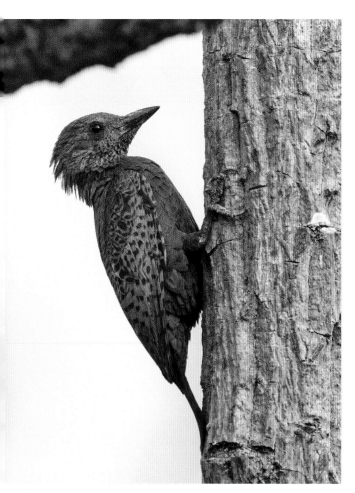

ABOVE Green Peafowl (*Pavo muticus*) pair in display

The plains of north-eastern Cambodia is one of the key landscapes for the Endangered Green Peafowl in mainland Southeast Asia. This spectacular pheasant, the largest in the world, is usually encountered close to water. It can be seen in the riverine habitat along the Sekong River that runs through Siem Pang. Widespread hunting and habitat destruction have however decimated the population in Southeast Asia. This peafowl was one of the commonest large ground birds in the region a century ago. Thankfully, it appears to have made a comeback in recent years in northern Thailand and remains locally common in parts of Cambodia.

LEFT The **Rufous Woodpecker** (*Micropternus brachyurus*) is one of 16 species of woodpeckers that can be found in Siem Pang Wildlife Sanctuary. Its diet consists chiefly of ants. This woodpecker readily accepts a variety of secondary habitats provided that nests of arboreal ants are present. It is almost always on the move, and only stays put if abundant ants are available.

RIGHT TOP The **Asian Woollyneck** (*Ciconia episcopus*) is predominantly carnivorous. Its diet consists of frogs, fishes, lizards, snakes and insects. Steep population declines have been recorded since the mid 20th century in Southeast Asia, including Cambodia, although populations in many parts of India appear to be thriving.

RIGHT BOTTOM A small population of the **Black-necked Stork** (*Ephippiorhynchus asiaticus asiaticus*) can be found in the dry forests and open grassy woodlands of northern Cambodia. In Southeast Asia, this stork has vanished from most areas during the past decades. The remaining Southeast and South Asian population is thought to be fewer than 1,000 individuals.

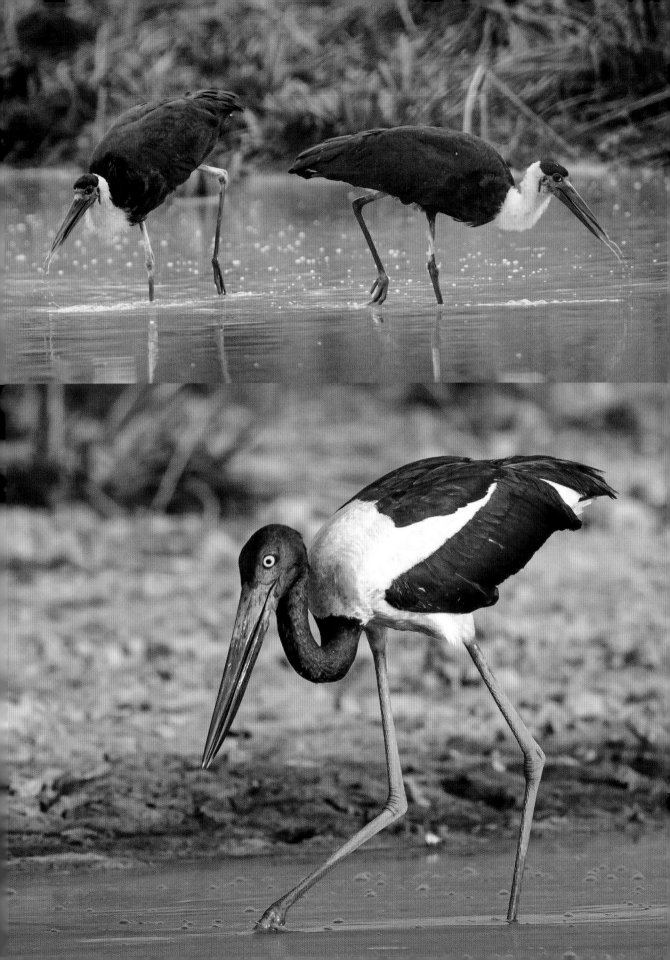

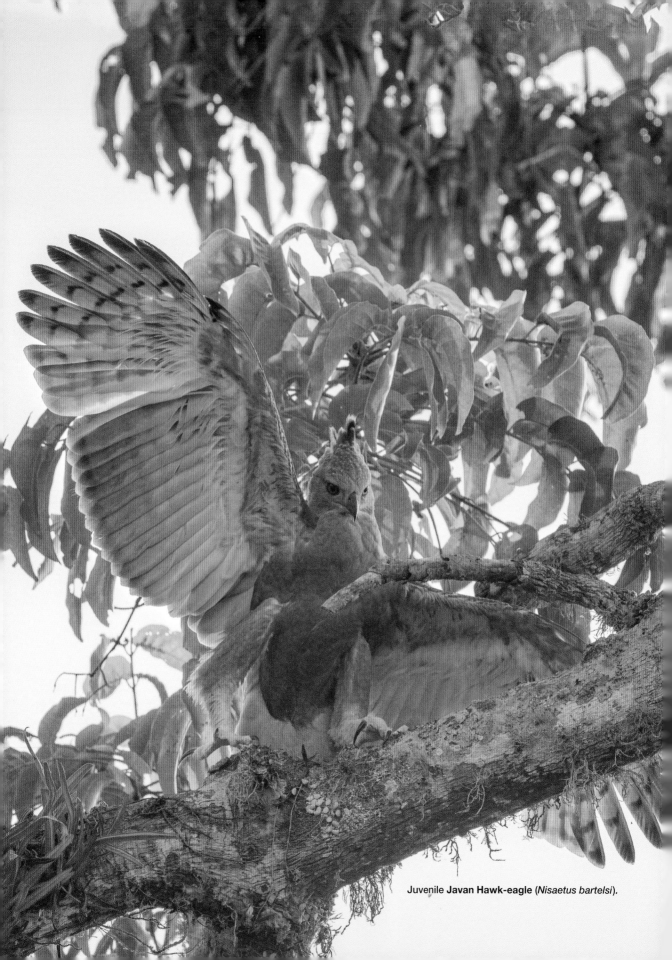

Juvenile **Javan Hawk-eagle** (*Nisaetus bartelsi*).

Indonesia

Indonesia is the largest archipelagic country in the world. With some 17,000 islands, it extends more than 5,000 km (3,100 mi) from east to west and some 1,800 km (1,100 mi) from north to south.

Indonesia is considered by many experts to be the third most biodiverse country in the world, with some 360 amphibians, 750 reptiles, 4,700 fishes, 670 mammals and 29,000 vascular plants. Around 1,800 bird species have been recorded, of which some 530 species are endemic. New species are discovered nearly every year, the latest being the Peleng Jungle Flycatcher and several other birds in 2020.

Straddling the Equator, Indonesia has a predominantly tropical climate. Annual temperatures are quite stable with limited variation. Daytime temperature in the coastal plains averages 28 °C (82 °F) throughout the year, with steady decreases at higher altitudes. Humidity is normally between 70 to 90 per cent. Daylight hours vary little during the year, with the longest day around one hour more than the shortest. Annual wind patterns interact with the local topography, producing substantial variation in rainfall throughout the archipelago.

Much of Indonesia is characterised by dense tropical and subtropical forests. There are also extensive areas of savanna. However, as we look closely at Indonesia's forests and grasslands, we discover a great deal of diversity resulting from differences in rainfall patterns, elevation, and substrate type, as well as biogeographical processes. With a large and rapidly growing population and extensive industrialisation, Indonesia faces numerous threats to its biodiversity including unsustainable agricultural expansion, illegal logging, man-made forest fires, air and water pollution as well as poaching. The country has a large network of protected areas. However, high poverty levels and weak governance make law enforcement in many large national parks a challenge.

In spite of the diverse and complex challenges faced in conserving its biodiversity, Indonesia still offers naturalists some of the most spectacular wildernesses in Asia. The tropical rainforest of Sumatra, the dry monsoon forests and open grasslands of Java, the endemic-filled biodiversity hotspots of Sulawesi and Halmahera, and the lush rainforests of West Papua, all promise visitors unforgettable wildlife experiences.

Most international travellers arrive in Indonesia through its capital, Jakarta. Others enter via Denpasar on the island of Bali or Manado in Sulawesi which is convenient when exploring the eastern parts of the archipelago. Crime rates are generally low but travelling to certain parts of Sulawesi and West Papua can be complicated due to political unrest. Visitors are encouraged to check travel advisories with their embassy and local contacts.

It has been announced that the location of Indonesia's new capital, Nusantara, will be situated in East Kalimantan Province on Indonesian Borneo. This may hopefully improve access to some of the best areas of wild landscapes in Borneo, although it is also expected to drive deforestation. The government is targeting this move to begin in 2024.

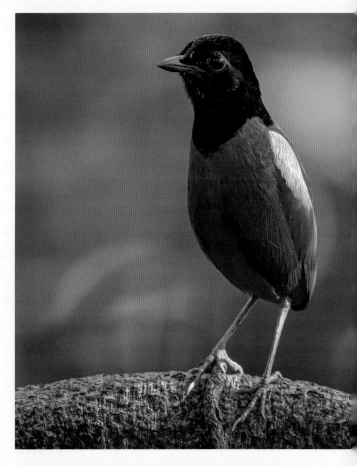

The colourful **Biak Hooded Pitta** (*Pitta rosenbergii*) is endemic to the islands of Biak and Supiori in Cenderawasih Bay off the northern coast of Indonesian New Guinea.

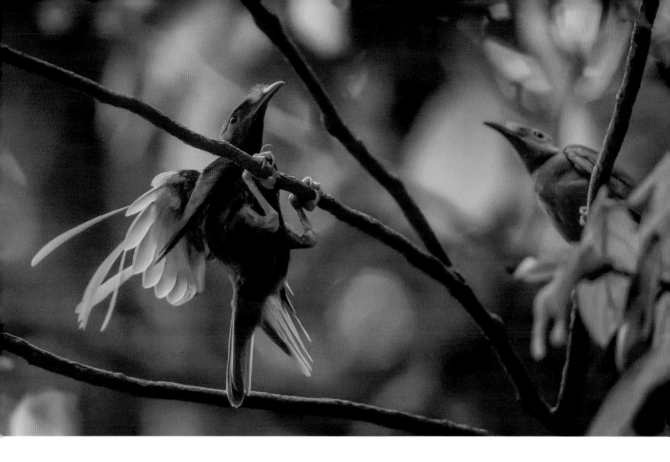

Displaying male and female **Wallace's Standardwing Bird-of-Paradise** (*Semioptera wallacii*) on the island of Halmahera, situated in Indonesia's Wallacea region.

Wallace's Standardwing was discovered by the British naturalist Alfred Russel Wallace in 1858 on the island of Bacan. This is what he wrote in his book The Malay Archipelago: *I saw a bird with a mass of splendid green feathers on its breast, elongated into two glittering tufts; but, what I could not understand was a pair of long white feathers, which stuck straight out of each shoulder..... I now saw that I had got a great prize, no less than a completely new form of the Bird of Paradise, differing most remarkably from every other known bird....*

Following its initial discovery, the Wallace's Standardwing was not seen for almost half a century until it was spectacularly rediscovered by ornithologist K. David Bishop in 1983, and subsequently filmed for the first time in 1986 by BBC for their nature documentary "Birds for all Seasons".

The rare **Lowland Anoa** (*Bubalus depressicornis*) is a dwarf relative of the familiar Water Buffalo. It reaches a shoulder height of up to 90 cm, and weighs 200 kg to 250 kg (440 lb to 550 lb). The Lowland Anoa is endemic to the islands of Sulawesi and Buton. Its total population is estimated at below 2,500 individuals. Surveys suggest that it is now locally extinct in Tangkoko Nature Reserve in northern Sulawesi. It occurs in lowland swampy forests with dense undergrowth and access to water. The diet consists of aquatic plants, grasses, ferns and fallen fruits. The Lowland Anoa has been observed to drink seawater, thought to fulfil their mineral needs in areas that lack salt licks. As with other species of wild buffalo, anoas regularly wallow and immerse themselves in pools of water and mud.

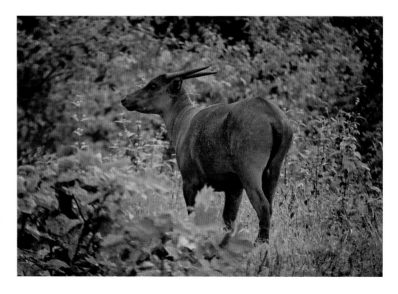

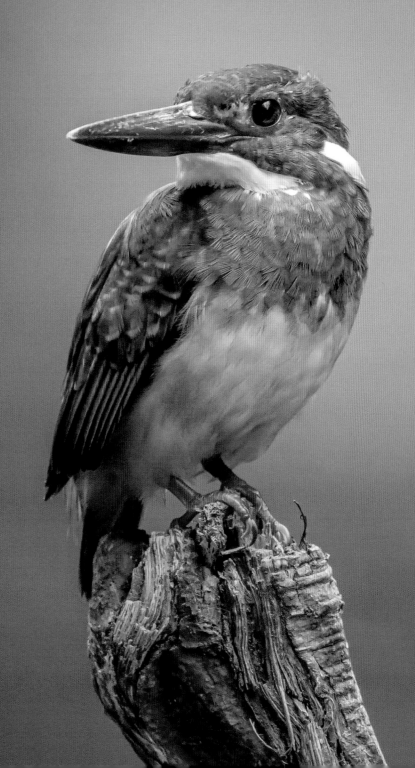

The Critically Endangered **Javan Blue-banded Kingfisher** (*Alcedo euryzona*) is one of Asia's rarest kingfishers. The population of perhaps less than 250 individuals is restricted to rivers in the lowland and hill forests on the island of Java.

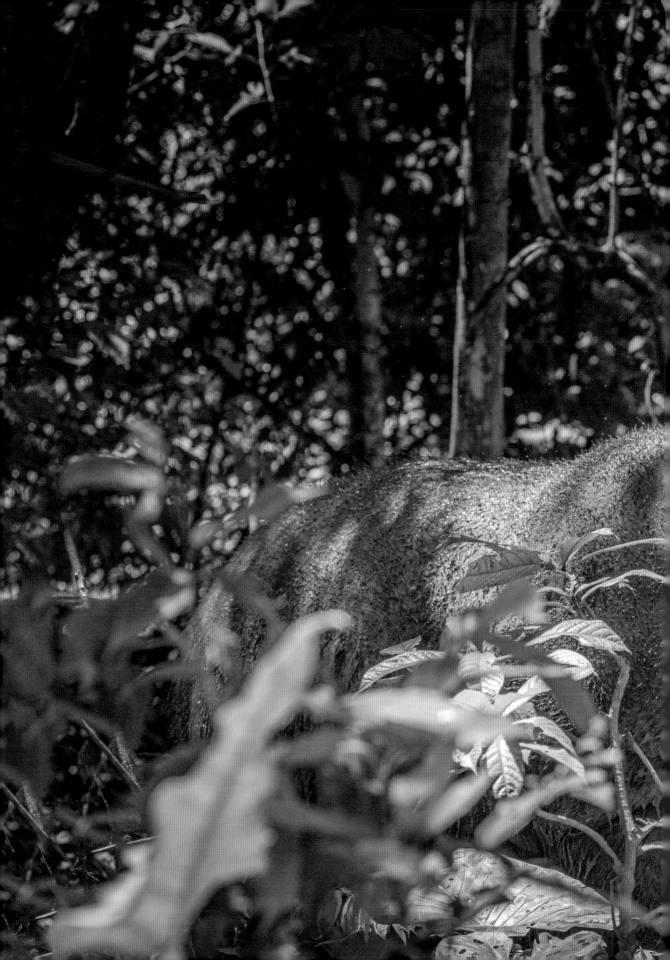

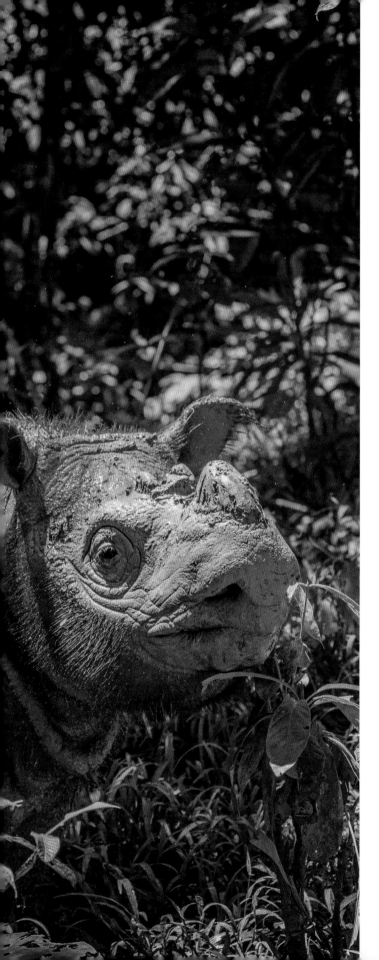

The rare **Sumatran Rhinoceros** (*Dicerorhinus sumatrensis*) inhabits dense lowland and highland primary rainforests near water sources and salt licks. It now only occurs in Sumatra and Indonesian Borneo (Kalimantan). The species is a browser and an opportunistic feeder with a broad diet of some 100 plant species. It is an impressive creature measuring up to 1.5 m (5 ft) tall at the shoulder with a body length of around 2.5 m (8.2 ft) and a life span of 35-40 years. An adult can weigh up to 950 kg (2,100 lb). Males are solitary, whereas females can be found with offspring.

The number of Sumatran Rhinoceroses have declined precipitously over the past few decades. They are now locally extinct in Peninsular Malaysia, Malaysian Borneo, and many parts of Sumatra. The principal threats are human disturbance and poaching. It is now the most endangered of all rhinoceros species, with fewer than 80 individuals surviving in fragmented pockets of forests. The isolated small populations as well as severe reduction of numbers, make it perhaps the most threatened large mammal on Earth.

Despite mixed success with captive breeding, most rhinoceros experts agree that the only way to bring the Sumatran Rhinoceros back from the brink of extinction is to relocate them to safe, managed breeding facilities designed for their care and propagation.

Baluran National Park

Baluran National Park is located on the northern coast of East Java. It occupies 250 km² (97 mi²) of dry lowland forest, hill forest as well as an extensive area of grasslands. The open landscapes here are somewhat reminiscent of the savannas of East Africa. Another spectacular feature is Mount Baluran, an extinct volcano rising to just over 1,200 m (3,900 ft) above sea level in the centre of the park.

For decades, local people at Baluran have made use of fires annually to improve grazing pasture for their livestock. At times, these fires have spread into the adjacent deciduous forests. Subsequently, local authorities decided to plant *Acacia nilotica* trees to act as fire breaks. The fire-resistant acacia trees have acted as barriers and blocked the spread of fires into areas of natural forests.

As is often the case with poorly-planned introduction of alien species, unintended environmental harm can occur. The *Acacia nilotica* trees have spread rapidly, affecting extensive parts of the Baluran savanna. It has transformed open grassland into a dense thorny scrub forest. This has reduced the grazing areas for savanna dwelling species.

The park is perhaps more easily accessed from Bali, where it is a six hours' drive from Denpasar airport, including a one-hour ferry crossing into east Java. Bali Barat National Park, the Bali Myna's stronghold, can also be visited along the way. Baluran can likewise be reached from Surabaya, taking around eight hours by car. The entrance to the park is in the village of Batangan, where the park headquarters and ticket

office are located. A local guide can be hired from here. The rainy season lasts for about three months at Baluran, and falls between November and April each year, peaking in December and January. The best time to visit is from May to October.

From the entrance gate at Batangan, it is a 15 km (9 mi) drive into the park at Bekol. Here, one can find the main visitor's centre, park offices, simple accommodation and an observation tower. Bekol is surrounded by savanna, and is a good place to see the Green Peafowl and Green Junglefowl. From Bekol, there is a track heading east for four kilometres (three miles) to the coast at Bama which holds evergreen forests.

Apart from the peafowl and junglefowl, some of the avian highlights in Baluran include the Grey-backed Myna, Javan Banded Pitta, Lesser Adjutant, Javan and Cerulean Kingfishers, Javan Hawk-eagle, Rhinoceros Hornbill and Asian Woollyneck.

In spite of national legislation that aims to protect many species, these laws may not be easily enforceable in many circumstances. In Baluran National Park, people from surrounding villages continue to encroach into the park to harvest resources. To make matters worse, poaching and bird trapping are still taking place. The practice of songbird keeping continues to flourish across Indonesia, particularly on Java, putting enormous pressure on wild bird populations. As with many protected areas in Indonesia, encroachment is widespread and borders of large parks can be difficult to police.

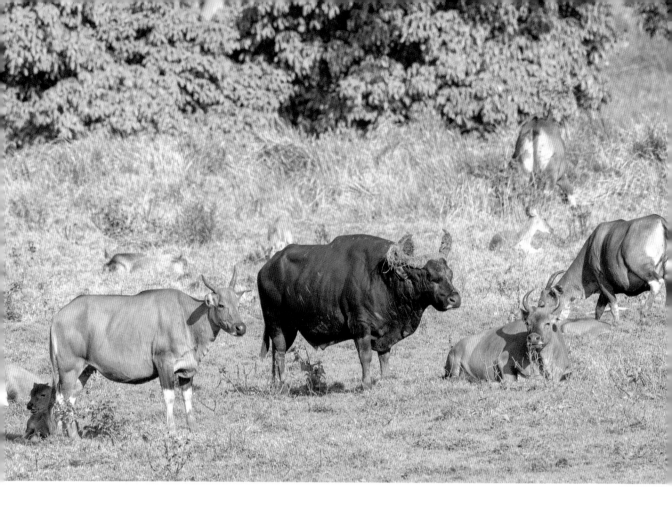

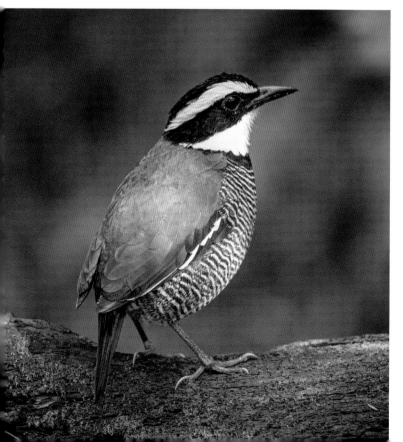

ABOVE The Endangered **Java Banteng** (*Bos j. javanicus*) is the flagship species of Baluran National Park. Once occurring throughout Southeast Asia, the banteng is now only found in small fragmented populations in Borneo, Java and mainland Southeast Asia. In Indonesia, the Banteng is restricted to a handful of national parks on the island of Java, while small populations probably persist in parts of Kalimantan.

Over the past two decades, the number of Java Banteng in Baluran National Park has declined. The main reasons are poaching, competition with other species like feral Water Buffalo (*Bubalus bubalis*), and degradation of its savanna habitat. The Endangered Dholes, also known as the Asian Wild Dog (*Cuon alpinus*), have also impacted the population by preying on juveniles and pregnant cows.

Male Banteng can reach a shoulder height of 1.6 m (5 ft) with an impressive body weight of 600-800 kg (1,300-1,800 lb). The Banteng has been widely domesticated and can be found in many parts of Asia. Its global population is currently estimated at 4-8,000 mature individuals.

LEFT The gaudy **Javan Banded Pitta** (*Hydrornis guajanus*) is endemic to Java and Bali, and dwells in the monsoon forests of Baluran.

RIGHT Tail and wing feathers of a displaying male **Green Peafowl** (*Pavo muticus muticus*). The courtship dance of this bird is one of the most impressive avian displays in Southeast Asia. Baluran National Park is perhaps among the easiest places to see this globally threatened species, which is also the avian icon of the park. Amid wider declines in the region, Baluran continues to be a stronghold of the species in Java, together with Meru Bertiri and Ujong Kulon. In some traditional Javan dances, elaborate peacock feather decorations are used.

BELOW The Critically Endangered **Javan Leopard** (*Panthera pardus melas*) is one of the most threatened subspecies of leopards, with only several hundred individuals left in the wild. It is now the largest wild cat roaming the island of Java, after the Javan Tiger went extinct four decades ago. The Javan Leopard can be highly adaptable. Close to half of all encounters on record have occurred outside protected areas and primary forests, indicating an ability to survive in modified habitats. This individual was photographed at night in Baluran National Park.

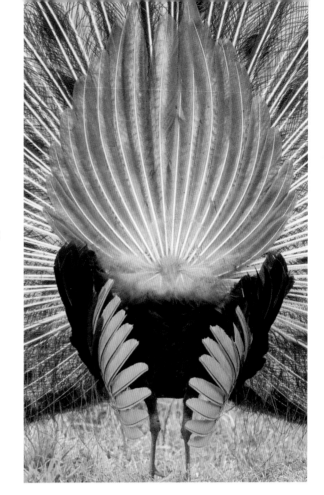

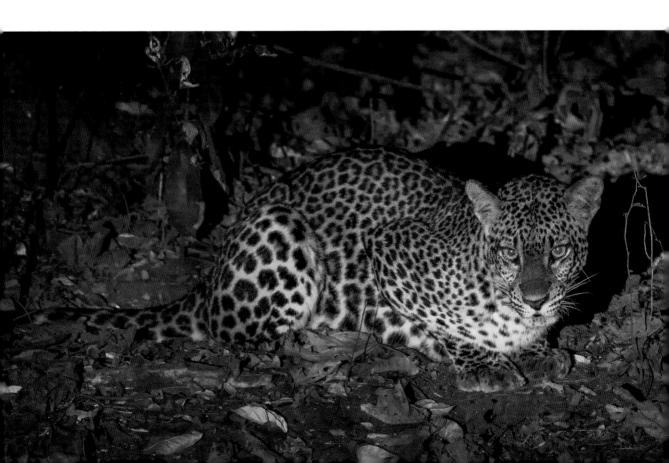

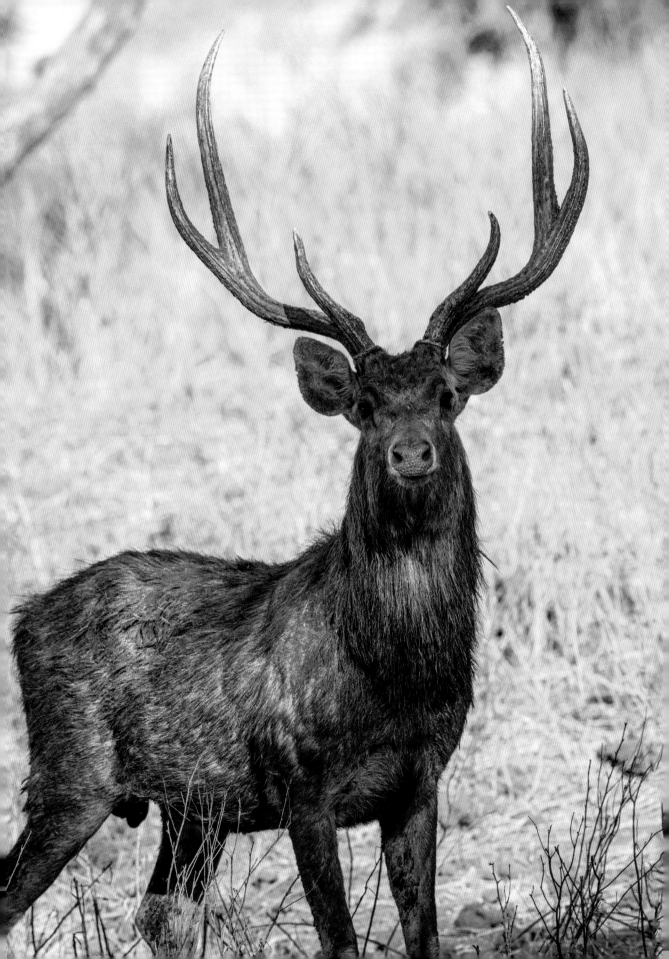

LEFT The Vulnerable **Javan Rusa** (*Rusa timorensis russa*) is endemic to the islands of Java and Bali, but has been widely introduced elsewhere. The global population is estimated to be fewer than 10,000 individuals. Herds are separated by sex, except when mating, and this segregation may occur throughout the year. Its population has declined over the past decade. This deer remains vulnerable to habitat loss, given that a significant part of its population occurs outside protected areas.

RIGHT The endemic **Green Junglefowl** (*Gallus varius*) is unmistakable with its iridescent plumage and multi-hued wattles. Sightings are easy to come by at the Bekol savanna in Baluran. It is not globally threatened, but is affected by illegal trapping for the pet trade.

BELOW The Endangered **Javan Hawk-eagle** (*Nisaetus bartelsi*) is the national bird of Indonesia. It is often associated with the Garuda, a mythical bird that lends its name to Indonesia's national airline. It is one of the rarest raptors in Asia with a population of possibly no more than 300-500 mature individuals. The Javan Hawk-eagle is endemic to the island of Java, where it occurs across various forest types. This raptor ranges over the forested mountains of Java. In Baluran, it inhabits the tree-clad slopes of Baluran volcano.

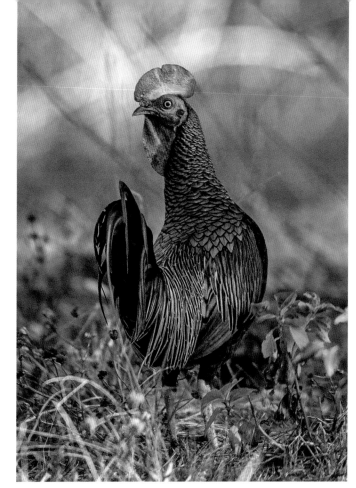

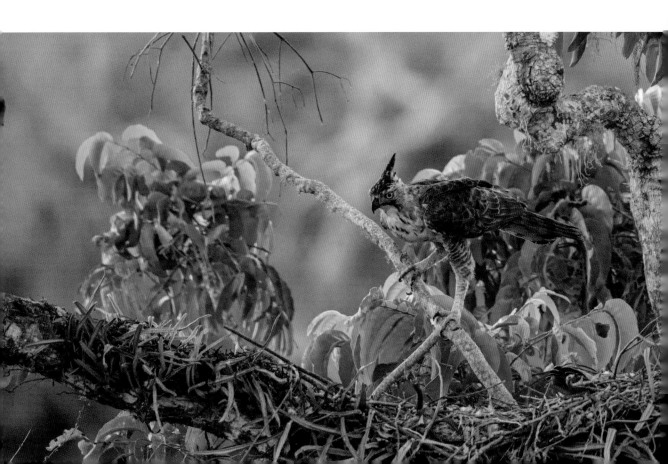

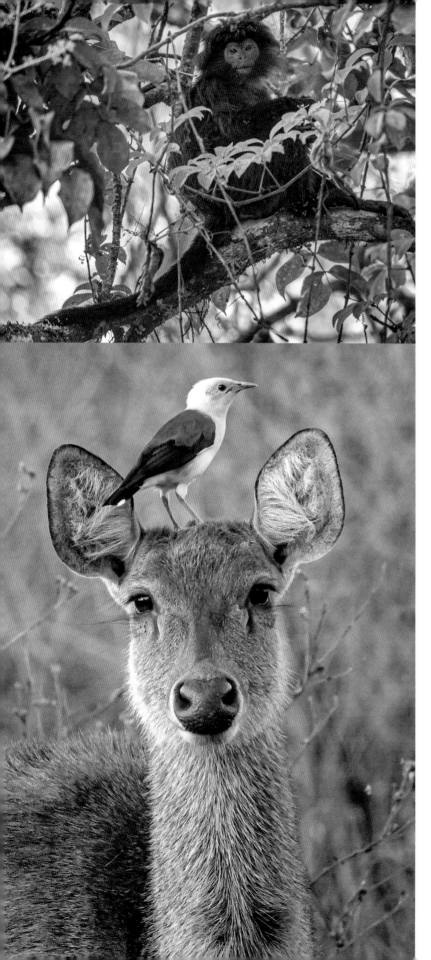

RIGHT TOP The Critically Endangered **Bali Myna** (*Leucopsar rothschildi*) is endemic to the island of Bali, where it came close to extinction two decades ago when only a handful of birds were recorded in the wild. This was primarily driven by indiscriminate trapping for the pet bird trade. The recovery of the Bali Myna has been supported by a successful breeding programme and the release of captive bred birds in Bali Barat National Park and on the island of Nusa Penida. This vital recovery plan is being led by the Bengawan Foundation, Mandai Nature, formerly Wildlife Reserves Singapore, and other conservation organisations. This individual was photographed at Bali Barat National National Park, which is on the way to, and not far from Baluran National Park.

RIGHT BOTTOM In Baluran, the **Cerulean Kingfisher** (*Alcedo coerulescens*) is often seen in coastal mangrove forests and around fish ponds perched on mangrove stilt roots. From a suitable vantage point, it dives into the water to catch aquatic insects and fishes. It also takes prey from open water bodies by hovering for up to 30 seconds before diving in.

LEFT TOP The **Javan Lutung** (*Trachypithecus auratus*) can be particularly vocal. A short alarm call is given by an adult male or female to warn other group members of danger. A 'cohesion' call keeps the troop together. Adult males also emit a whooping sound to alert other groups of their presence. The Javan Lutung may use rock caves for resting in the dry season. Otherwise, the group roosts together nightly on one or two trees with thick branches.

LEFT BOTTOM A Critically Endangered **Grey-backed Myna** (*Acridotheres tricolor*) getting a vantage point on a Javan Rusa. Like the Bali Myna, the population of this starling has been decimated as a result of unsustainable exploitation for the cage bird trade. It is estimated that there may be 50 individuals in Baluran National Park, out of an estimated global population of no more than 250 birds.

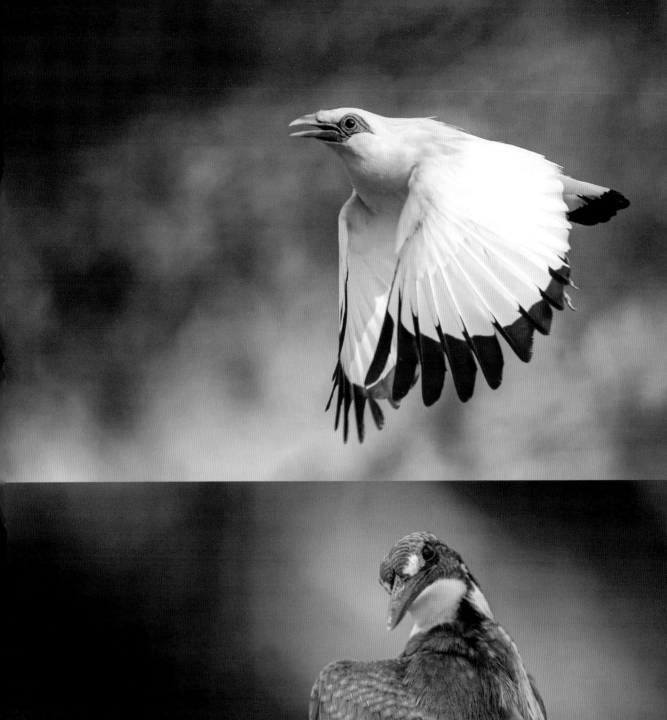

Kerinci Seblat National Park

Kerinci Seblat National Park is one of the largest protected areas in Southeast Asia. It extends over 14,000 km² (5,400 mi²) of mountainous landscapes in central and western Sumatra, running through four provinces. The park occupies a significant portion of the Bukit Barisan mountain range, and is part of a UNESCO World Heritage Site. The forests of Kerinci safeguard the source of some of Sumatra's most important rivers. These forests are also home to more than 80 species of mammals, including the enigmatic Sumatran Striped Rabbit, and close to 400 species of birds.

Kerinci Seblat is well known for being one of Sumatra's most accessible places to see the island's magnificent fauna. For birdwatchers, there is a good chance of encountering many of Sumatra's endemic montane species, including the Red-billed Partridge, Salvadori's Pheasant, Schneider's Pitta, Graceful Pitta, Cream-striped Bulbul, Sumatran Peacock Pheasant, Sumatran Trogon, Sumatran Frogmouth and Sumatran Whistling-thrush.

The Kerinci Seblat Sumatran Tiger Project 2000-21 is a successful collaboration between the park management of Kerinci Seblat and Fauna & Flora International. There are signs that the tiger population in the wider Kerinci landscape is recovering. Over the course of 2019, 116 forest patrols took place with a total of 101 tigers recorded (vis-à-vis 84 tigers in 2018 and 98 in 2017). Other measures include successful prosecution of tiger poachers and traders, law enforcement support, human-tiger conflict mitigation and training and counselling of villagers. Despite encouraging signs that conservation activities are yielding results, maintaining the integrity of the park, controlling encroachment by rogue farmers, illegal logging and poaching remain a challenge.

The most convenient way to get to Kerinci Seblat National Park is by flying to Padang's Minangkabau International Airport, which takes one hour 40 minutes from Jakarta. From Padang, it is a 7 hours drive to the village of Kersik Tua in Jambi Province. Kersik Tua is the main entry point to Kerinci Seblat. Here, you will find a range of homestays, guest houses, shops and cafes. Some of these homestays can assist with arranging logistics from Padang, qualified guides, and park entry permits. Engaging a local guide may greatly increase your chances of seeing wildlife, while at the same time help support the local community.

The Mount Kerinci Summit Trail and Tapan Road are reliable and popular sites to view the park's wild denizens. The Summit Trail starts from the tea plantations near Kersik Tua and continues to the summit of Mount Kerinci. The lower part of this trail from the forest edge to around 2,500 m (8,200 ft) offers excellent potential for birdwatching. For some peace and quiet, it is advisable to check the schedules with local guides to avoid large tourist crowds on the Summit Trail.

The Tapan Road spans an altitudinal range from around 300 m to 2,200 m (1,000 ft to 7,299 ft), starting from the town of Sungai Penuh. It features lower elevation species compared to the Summit Trail. These can be observed in the forests and gullies flanking the roadside. The Tapan Road is one of the most reliable sites for the Graceful Pitta. A night drive on this road cutting through dense forests may turn up nocturnal inhabitants like civets, sun bear, tapir, mouse-deer and once in a while, the Sumatran Tiger.

A less visited area is the forests around Mount Tujuh. This is also within reach from Kersik Tua with access from the village of Pelompek. Here, one can experience the beautiful 4.5 km (2.8 mi) long crater lake of Mount Tujuh sitting at an altitude close to 2,000 m (6,600 ft). The area supports birdlife similar to that of the Mount Kerinci Summit Trail.

The best months for visiting are from June to September, with the heaviest rainfall from October to January. Irrespective of season, be prepared for rain, which normally clears up quickly. Most mornings are bright and fair while mists and rain tend to come in the afternoon. Because of the park's generally high elevation, chilly conditions can be expected.

Sumatran Tiger (*Panthera tigris sondaica*) seen at Bukit Tapan on the road between Sungai Penuh and Mauro Sako in Kerinci Seblat National Park.

The rare Sumatran Tiger is the smallest of the six tiger subspecies, with a darker pelage and denser stripes. IUCN classifies it as Critically Endangered. Restricted to Sumatra, it has a population of less than 400 individuals. Kerinci Seblat National Park has some of the highest concentration of tigers on Sumatra with well over 100 individuals. The park is amongst the most important tiger conservation landscapes in the world, which is a testament to the quality of the park's forests and abundance of prey species.

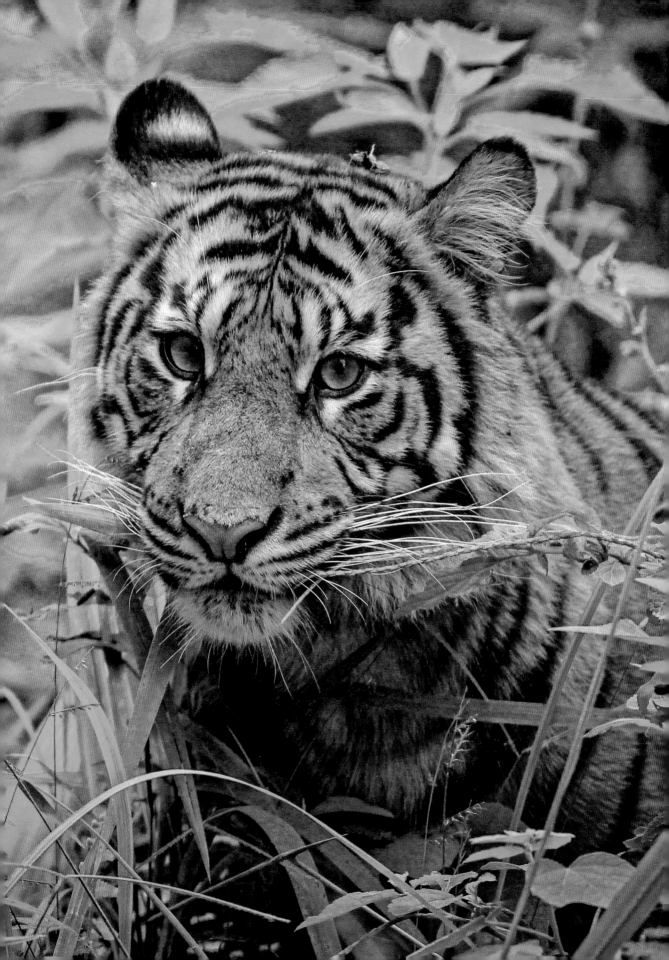

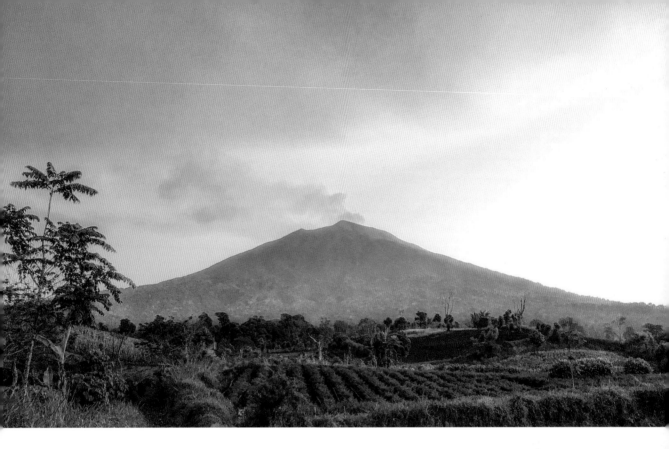

ABOVE At just over 3,800 m (12,500 ft), **Mount Kerinci** is the highest volcano in Indonesia and the iconic landmark of Kerinci Seblat National Park. This vast protected area is recognised globally as an Important Bird and Biodiversity Area and a UNESCO World Heritage Site.

RIGHT The Vulnerable **Schneider's Pitta** (*Hydrornis schneideri*) is endemic to the highlands of Sumatra. It was discovered in the Kerinci Valley well over a century ago. It went missing for much of the 20th century, only to be rediscovered at Kerinci in 1988.

This elusive pitta populates the lower and upper montane forests, between 900 m and 2,500 m (3,000 ft and 8,200 ft). The bird is easy to miss; it is mostly encountered singly or in pairs in the undergrowth of selectively-logged or primary forest areas. This handsome male was seen together with a female on the Mount Kerinci Summit Trail at around 1,900 m (6,200 ft) above sea level.

LEFT The rare **Sumatran Ground-cuckoo** (*Carpococcyx viridis*) is largely restricted to the foothills of the Barisan Range in Sumatra. Its population is estimated at below 250 mature individuals, although given its secretive habits, it may be more widespread than previously thought. The Sumatran Ground-cuckoo is amongst the most sought-after species by visiting birdwatchers. This is due in part to the ground-cuckoo having gone 'missing' for nearly 80 years until one bird was sensationally caught and photographed in 1997.

This magnificent individual was one of a pair seen at Kerinci Seblat in August 2019 – possibly the best recent photographic documentation of this elusive species.

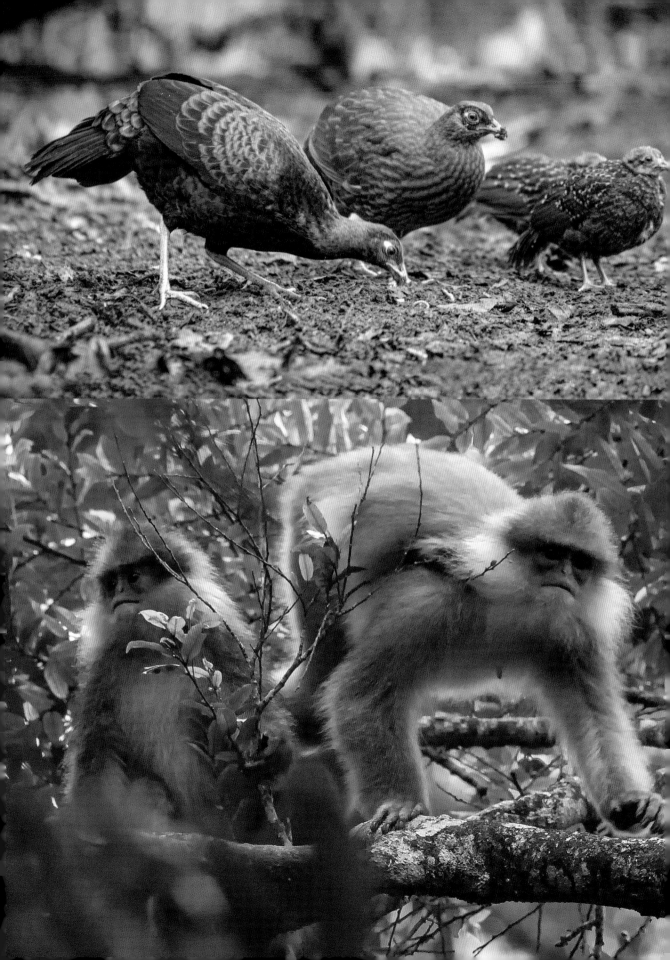

LEFT The **Salvadori's Pheasant** (*Lophura inornata*) inhabits montane forests at elevations from 700 m to 2,200 m (2,300 ft to 7,200 ft) and is endemic to the mountains of Sumatra. This rare encounter with a family took place in the month of September at Mount Kerinci near the Summit Trail.

RIGHT Male **Sumatran Whistling-thrush** (*Myophonus castaneus*). One of three species of whistling-thrush in Sumatra, this species is endemic to the Sumatran foothills and mountains of the Barisan Range at elevations of 400 m to 1,500 m (1,300 to 4,900 ft). It inhabits the forests along streams and riverbeds and is generally scarce within its limited range.

RIGHT The **Red-billed Partridge** (*Arborophila rubrirostris*) is endemic to Sumatra's montane forests between 900 m and 2,500 m (3,000 ft and 8,200 ft). Given its shy habits, this well-patterned partridge is seldom observed by birdwatchers even though it is not rare at the right elevations.

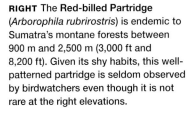

LEFT The attractive **Black-crested Sumatran Langur** (*Presbytis melalophos*) is typically found in small groups. They are fairly common throughout the park and may sometimes be encountered in the forest edge in Kerinci. As with other leaf monkeys, they are very much at home in trees. These langurs use all levels of the forest canopy when foraging, and seldom descend to the ground. Their diet consists of unripe fruits, leaves, flowers and seeds. Both young and mature leaves are eaten. These two individuals were part of a bigger group observed on the Mount Kerinci Summit Trail.

ABOVE The endemic **Sumatran Peacock Pheasant** (*Polyplectron chalcurum*) dwells in forests from submontane elevations to an altitude of 2,000 m (6,600 ft). It has been observed in logged forests and occasionally in pine forests in the Sumatran highlands, and seems to tolerate some degree of habitat disturbance. This male was seen at around 1,950 m (6,400 ft) at the Summit Trail of Mount Kerinci.

LEFT The **Sumatran Frogmouth** (*Batrachostomus poliolophus*) occurs widely in montane forests on the Barisan Range. In Kerinci Seblat, it is regularly encountered on the lower sections of the Summit Trail, including at the forest edges near the trail's entrance.

RIGHT The strikingly-coloured **Sumatran Trogon** (*Harpactes mackloti*) is easy to see in the montane forests of Sumatra. It occupies the lower canopy of the rainforest from 750 m to 2,200 m (2,500 ft to 7,200 ft). Its diet includes caterpillars, lizards, stick insects, beetles and fruits.

BELOW The ground-dwelling **Graceful Pitta** (*Erythropitta venusta*) is endemic to the hill and lower montane forests of Sumatra, occurring at elevations of 400 m to 1,400 m (1,300 ft to 4,600 ft). It often frequents steep ravines with dark undergrowth, and can be a challenge to observe. In the lowlands of Sumatra, it is replaced by the similar-looking Garnet Pitta.

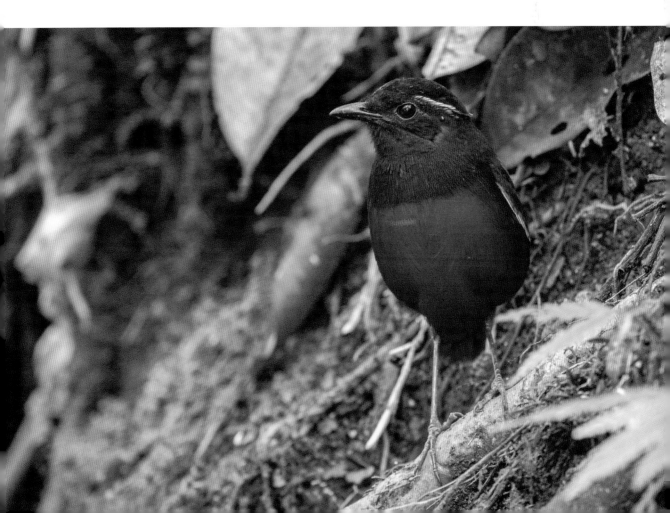

Raja Ampat Islands

The sparsely-populated Raja Ampat archipelago comprises hundreds of islands and islets off the north-west coast of New Guinea. These are scattered around the four main islands of Waigeo, Misool, Salawati and Batanta, as well as the little-visited island of Kofiau off the northwestern tip of the Bird's Head Peninsula.

The Raja Ampat Islands are home to an immense variety of plants, many of which are found nowhere else in the world. The forests on these islands vary from very wet to moderately dry, depending on their location, the aspect and sometimes, the elevation. The archipelago offers interesting jellyfish lakes, sea caves and prehistoric paintings depicting human figures, fishes and flowers, estimated by experts to be several thousand years old. Large areas of the archipelago are today protected as marine protected areas (MPAs) established by the Indonesian Government in collaboration with several NGOs such as Conservation International (CI) and The Nature Conservancy (TNC).

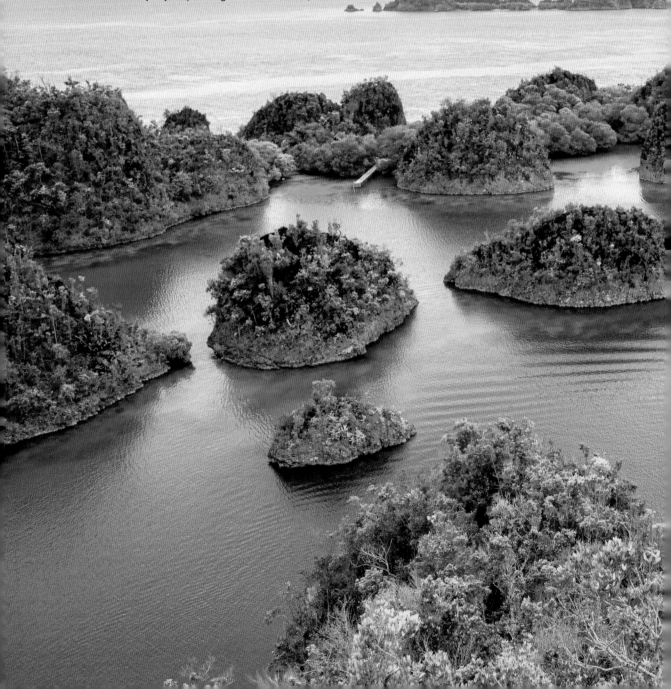

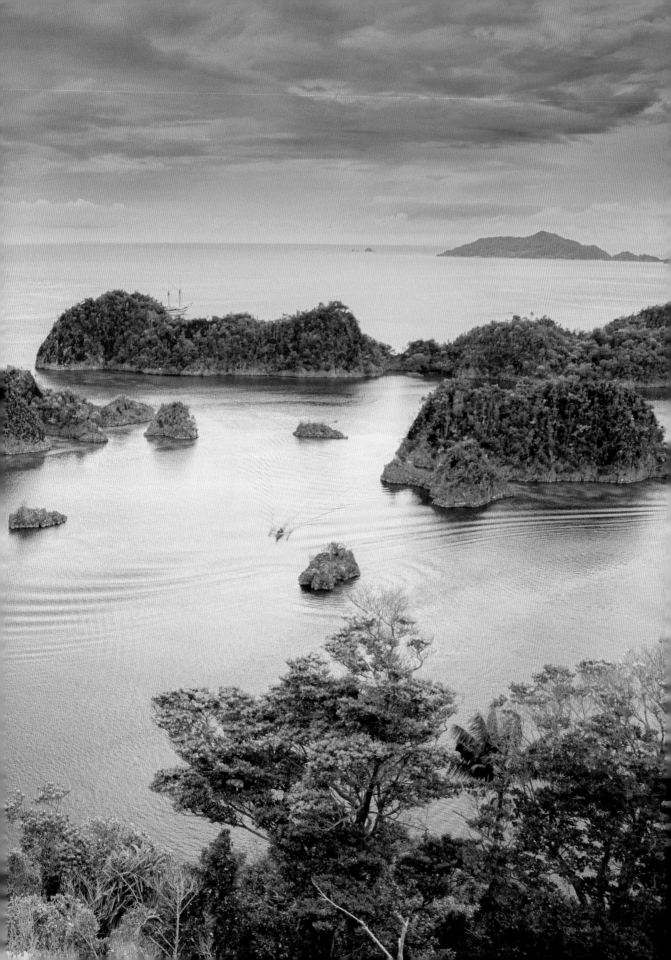

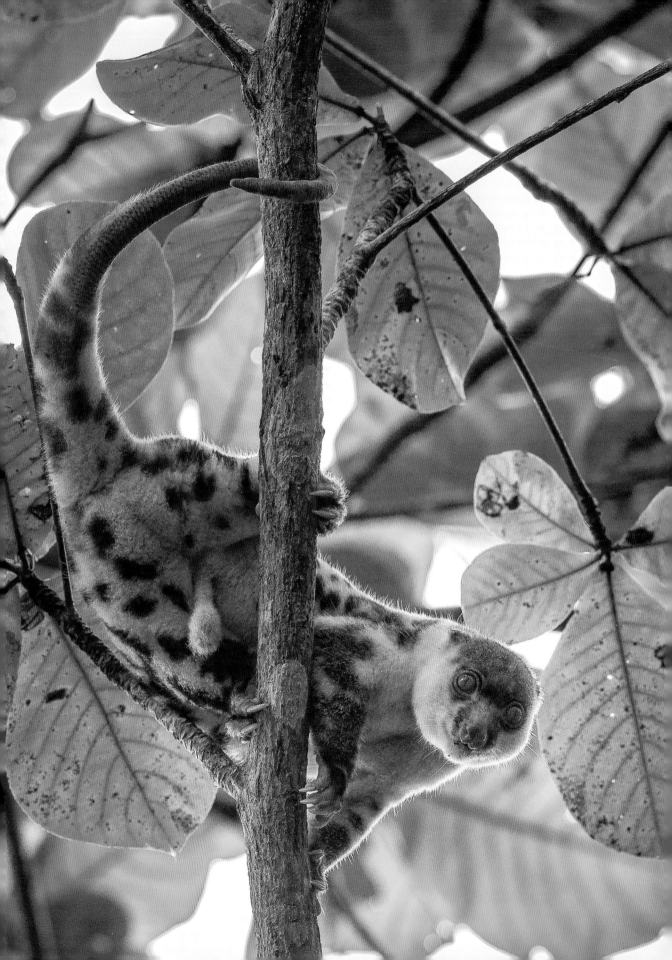

These jungle-covered islands boast more than 200 bird species. Some of the most spectacular include the Wilson's and Red Bird-of-Paradise, Western Crowned Pigeon, Blyth's Hornbill, as well as an impressive range of parrots, kingfishers and pigeons. Additionally some 50 reptiles, 40 amphibians and 30 terrestrial mammals have been recorded.

The islands are often accessed via the coastal city of Sorong, which can be reached by air from a number of Indonesian cities. Most visitors continue to the island of Waigeo by ferry from Sorong, a two-hour trip. Birdwatchers may choose to stay at Waisai, the biggest town on Waigeo or at homesteads near the village of Sapokren, where the bulk of the birds-of-paradise leks are located. The leks should be visited with a guide from the village, as they are the customary owners of the land. Many activities can be arranged through the homesteads.

The wonderful Raja Ampat Islands, together with other sites on the mainland in West Papua rank amongst the top for birdwatching in the region. Access can however be challenging. While improvements in infrastructure have made many locations easier to reach and more comfortable, trekking in the coralline-limestone hilly forests can be tough going and treacherous, especially in wet weather. The 'driest' part of the year is from September to April, while the peak month for tourists is in July. Many nature enthusiasts engage travel companies or join a group to avoid logistical issues and for access to English speaking guides and porters. If you are travelling on your own, it is preferable to have some flexibility, as flight and ferry schedules may change without notice. Taking photographs of rainforest wildlife can also be a major challenge because of poor light conditions.

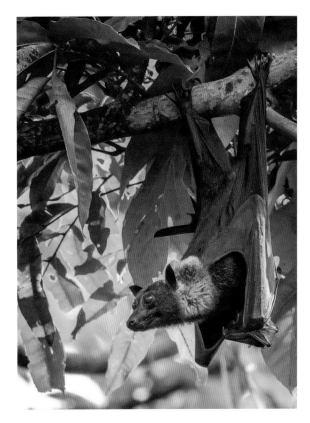

This **Spectacled Fruit-Bat** (*Pteropus conspicillatus*) was part of a big colony observed on Batanta Island.

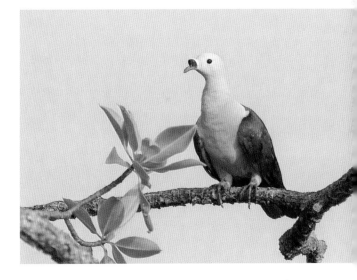

The **Spice Imperial-Pigeon** (*Ducula myristicivora*) is one of the species on Waigeo collected by Alfred Russel Wallace: *"My collection of birds, though not very rich in number of species, was yet very interesting… I was also much pleased to obtain a fine series of a large fruit-pigeon with a protuberance on the bill and to ascertain that this was not as had hitherto supposed, a sexual character, but was found equally in male and female birds."*

LEFT The **Waigeo Spotted Cuscus** (*Spilocuscus papuensis*) is an arboreal marsupial with thick fur, large eyes and a semi-prehensile tail that serves as an extra limb facilitating movement in the forest canopy. As seen here, the cuscus's tail tip is sparingly covered with fur. It is nocturnal, and spends most of the day resting. The female gives birth after only a few weeks of pregnancy. The undeveloped baby crawls into the mother's pouch where it will finish its development over the next six to seven months. The young may still return to the pouch for some time even after they are fully weaned. Only when they become too big for the mother's pouch do they start to become truly independent.

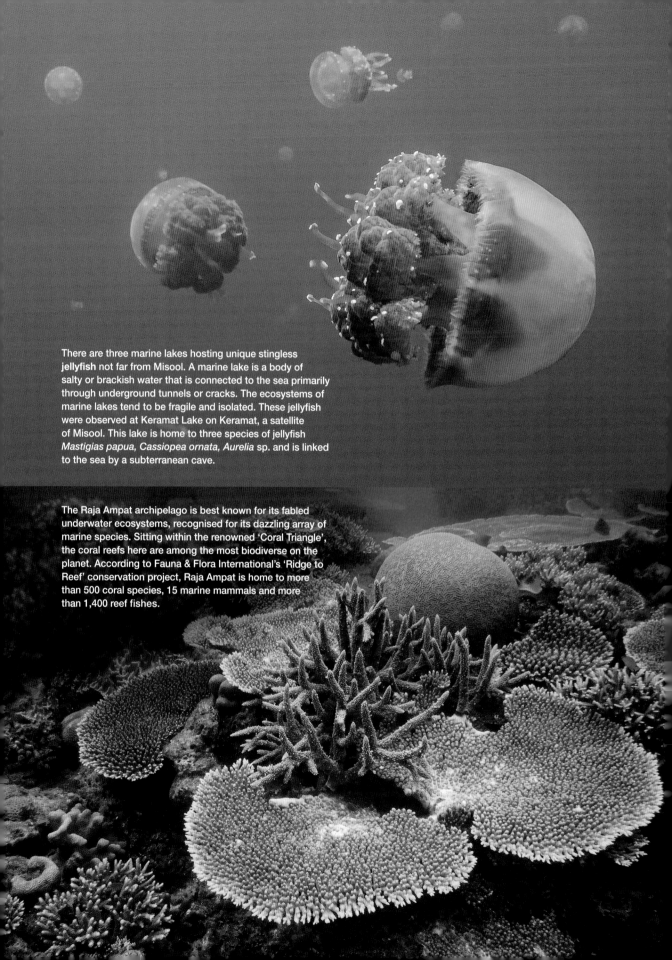

There are three marine lakes hosting unique stingless **jellyfish** not far from Misool. A marine lake is a body of salty or brackish water that is connected to the sea primarily through underground tunnels or cracks. The ecosystems of marine lakes tend to be fragile and isolated. These jellyfish were observed at Keramat Lake on Keramat, a satellite of Misool. This lake is home to three species of jellyfish *Mastigias papua, Cassiopea ornata, Aurelia* sp. and is linked to the sea by a subterranean cave.

The Raja Ampat archipelago is best known for its fabled underwater ecosystems, recognised for its dazzling array of marine species. Sitting within the renowned 'Coral Triangle', the coral reefs here are among the most biodiverse on the planet. According to Fauna & Flora International's 'Ridge to Reef' conservation project, Raja Ampat is home to more than 500 coral species, 15 marine mammals and more than 1,400 reef fishes.

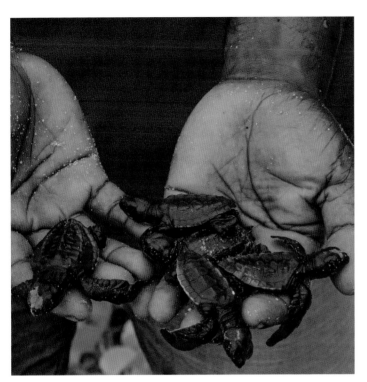

LEFT Four species of sea turtles make Raja Ampat their home. While Leatherback (*Dermochelys coriacea*) and Olive Ridley Turtles (*Lepidochelys olivacea)* are seldom seen, Hawksbill (*Eretmochelys imbricata*) and Green Turtles (*Chelonia mydas*) are common. They play an important role in marine food chains, feeding on sponges, jellyfish, and algae.

Sea turtle hatcheries can be found at several locations in Raja Ampat. These Critically Endangered **Hawksbill Turtle** hatchlings were seen on Um island not far from Malaumkarta village, where there is a turtle hatchery being managed by a local conservation group.

BELOW The **Beautiful Fruit-Dove** (*Ptilinopus pulchellus*) was collected by Alfred Russel Wallace when he stayed on Waigeo Island in 1860. Quoting Wallace: *'Several other interesting birds were obtained… but none of any remarkable beauty, except the lovely little dove,* Ptilonopus pulchellus*, which with several other pigeons I shot on the same fig-tree close to my house. It is of a beautiful green colour above, with a forehead of the richest crimson, while beneath it is ashy white and rich yellow, banded with violet red."*

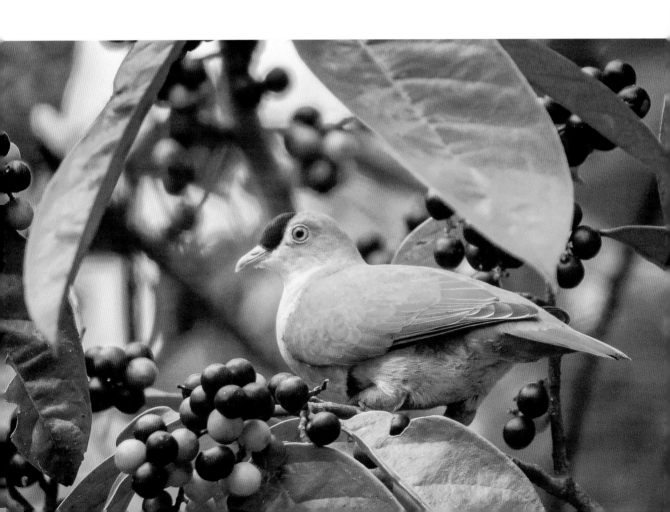

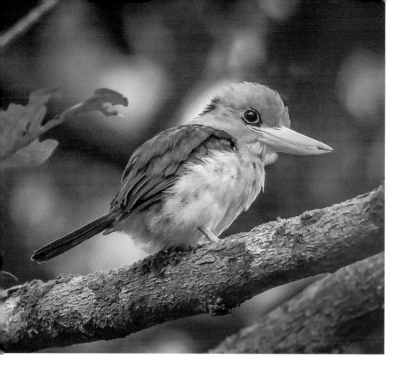

LEFT Yellow-billed Kingfisher (*Syma torotoro*) occurs on all the four main islands of Raja Ampat, and is common and widespread in lowland and hill forests throughout New Guinea. It is a vocal inhabitant of the lower canopy. This kingfisher hunts vertebrates from branches and leaves, or dives to take prey in the leaf litter on the forest floor.

RIGHT The 1.5 m (5 ft) tall **Northern Cassowary** (*Casuarius unappendiculatus*) is vaguely reminiscent of extinct giant birds from another age. This is the least known of three cassowary species. A shy and scarce species, the Northern Cassowary is known from Batanta and Salawati. Cassowaries are heavily hunted close to populated areas, as they represent a food source for indigenous communities and are also used in some traditional ceremonies.

BELOW The gorgeous **Papuan Pitta** (*Erythropitta macklotii*) is present in different lowland habitats from dense primary forest to degraded forest patches and bamboo groves.

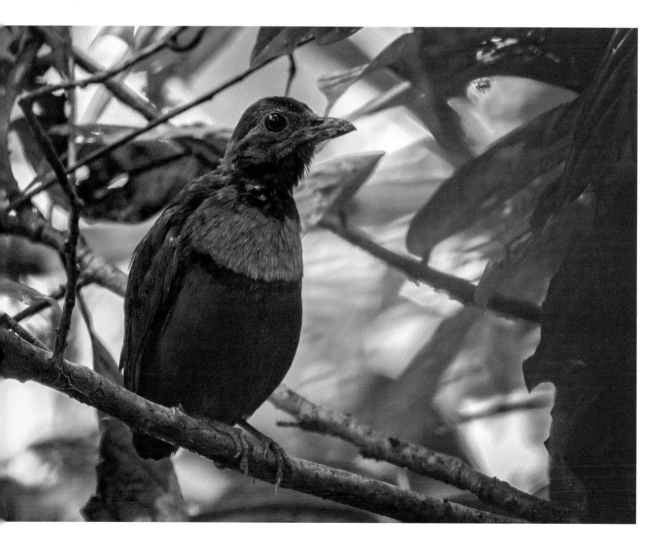

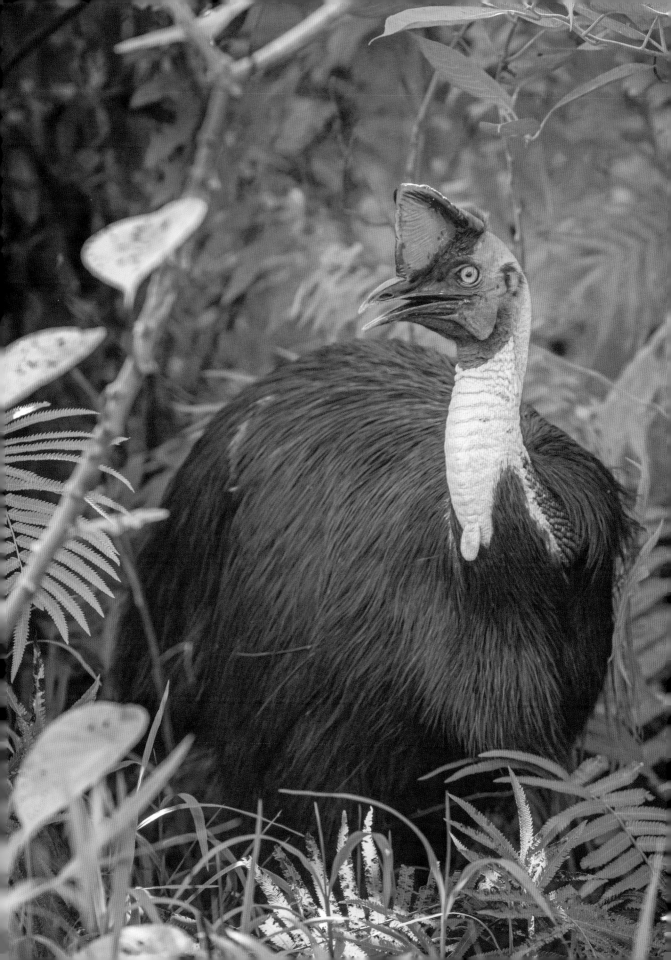

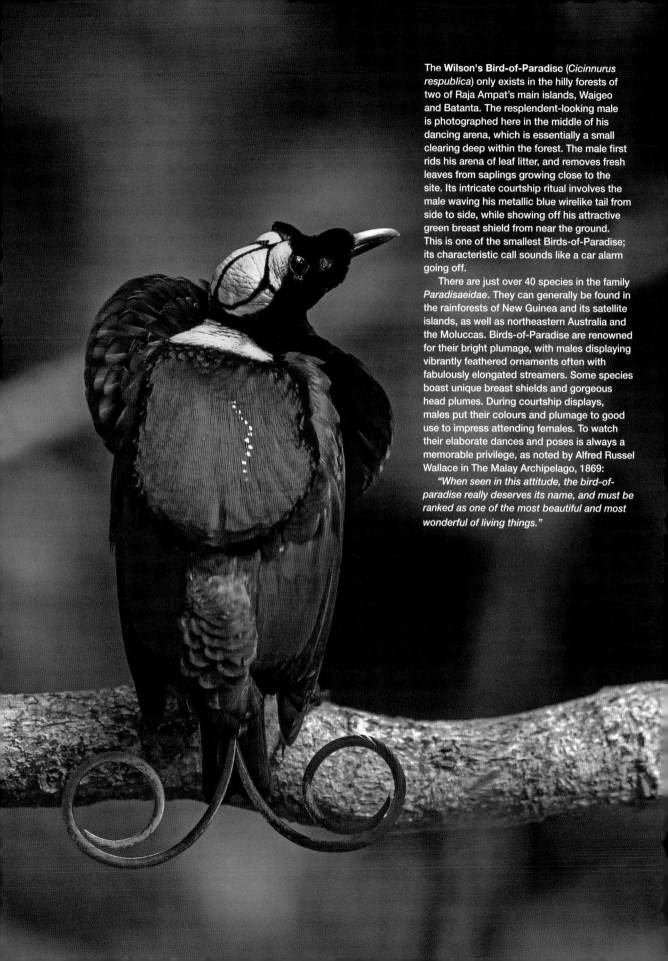

The **Wilson's Bird-of-Paradise** (*Cicinnurus respublica*) only exists in the hilly forests of two of Raja Ampat's main islands, Waigeo and Batanta. The resplendent-looking male is photographed here in the middle of his dancing arena, which is essentially a small clearing deep within the forest. The male first rids his arena of leaf litter, and removes fresh leaves from saplings growing close to the site. Its intricate courtship ritual involves the male waving his metallic blue wirelike tail from side to side, while showing off his attractive green breast shield from near the ground. This is one of the smallest Birds-of-Paradise; its characteristic call sounds like a car alarm going off.

There are just over 40 species in the family *Paradisaeidae*. They can generally be found in the rainforests of New Guinea and its satellite islands, as well as northeastern Australia and the Moluccas. Birds-of-Paradise are renowned for their bright plumage, with males displaying vibrantly feathered ornaments often with fabulously elongated streamers. Some species boast unique breast shields and gorgeous head plumes. During courtship displays, males put their colours and plumage to good use to impress attending females. To watch their elaborate dances and poses is always a memorable privilege, as noted by Alfred Russel Wallace in The Malay Archipelago, 1869:

"When seen in this attitude, the bird-of-paradise really deserves its name, and must be ranked as one of the most beautiful and most wonderful of living things."

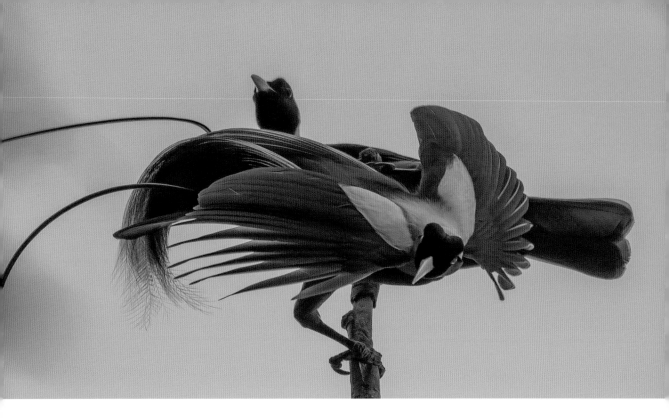

On the island of Waigeo when Wallace first observed the **Red Bird-of-Paradise**, he wrote in great detail about its beauty: *"The head, back, and shoulders are clothed with a richer yellow, the deep metallic-green colour of the throat extends further over the head, and the feathers are elongated on the forehead into two little erectile crests. The side plumes are short, but are of a rich red colour, terminating in delicate white points, and the middle tail-feathers are represented by two long rigid glossy ribands, which are black, thin, and semi-cylindrical, and droop gracefully in a spiral curve."*

The spectacular courtship ritual of the **Red Bird-of-Paradise** (*Paradisaea rubra*) is here seen at a lek (communal courtship display site) high up in a tree just after dawn. This species has a small distribution and is only found on Waigeo, Batanta and a few smaller islands in the Raja Ampat archipelago.

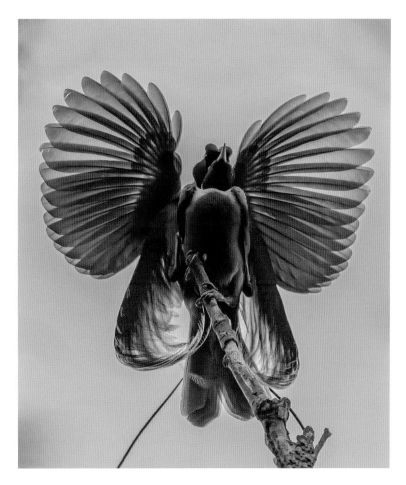

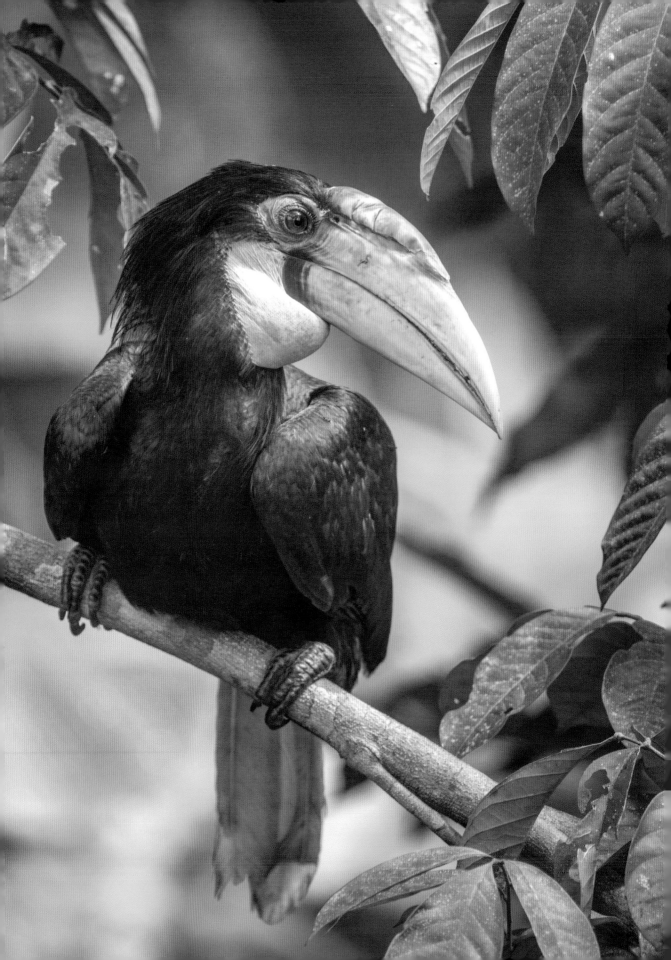

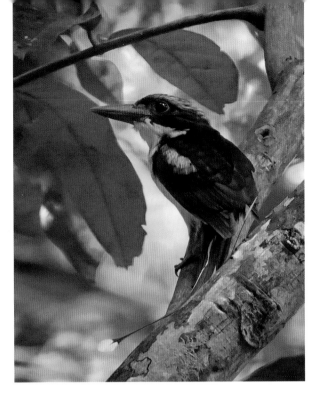

OPPOSITE Immature **Blyth's Hornbill** (*Rhyticeros plicatus*), seen close to Malagufuk village in the Klasow Valley, which can be reached in a two hours' drive from Sorong.

The Blyth's Hornbill is the only species of hornbill in New Guinea and its satellite islands. The species is an important disperser of seeds for many trees that bear large fleshy fruits, especially fruits that are not easily consumed by the smaller pigeons.

LEFT The forests of New Guinea are extremely rich in kingfisher species, including several spectacular paradise kingfishers. The **Common Paradise-Kingfisher** (*Tanysiptera galatea*) occurs across a number of different lowland habitats. It is generally sedentary and occupies the same territory throughout the year. It takes mainly It takes mainly earthworms, snails, beetles, grasshoppers and lizards. This paradise kingfisher forages in the forest understorey, diving to the ground for prey. The live food caught is carried back to the perch, and beaten before being swallowed.

BELOW The **Blue-black Kingfisher** (*Todiramphus nigrocyaneus*) is a little-studied species of the lowland rainforests of New Guinea. This kingfisher takes a variety of prey, including terrestrial and aquatic species. Its diet has been recorded to include crabs, fishes and lizards.

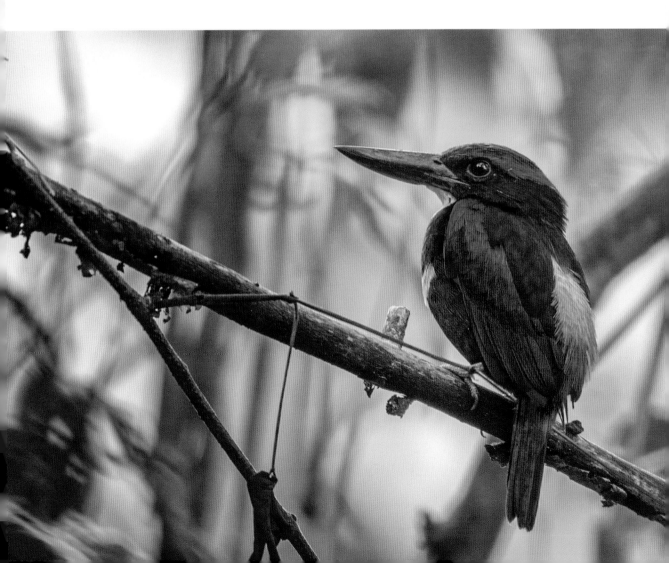

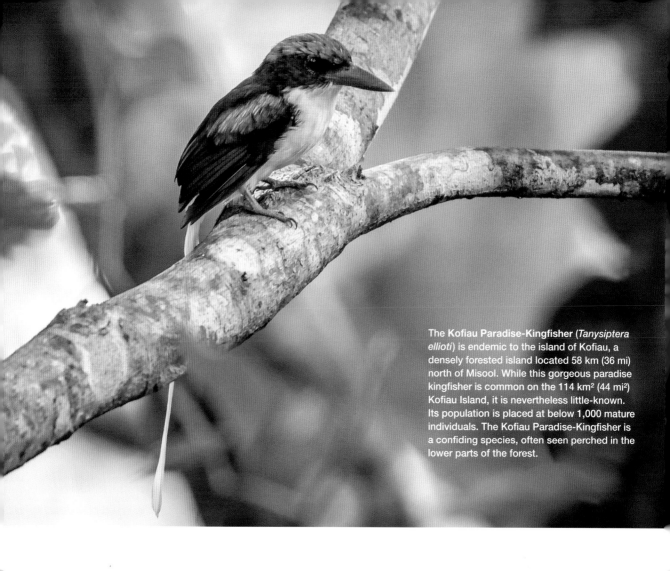

The **Kofiau Paradise-Kingfisher** (*Tanysiptera ellioti*) is endemic to the island of Kofiau, a densely forested island located 58 km (36 mi) north of Misool. While this gorgeous paradise kingfisher is common on the 114 km² (44 mi²) Kofiau Island, it is nevertheless little-known. Its population is placed at below 1,000 mature individuals. The Kofiau Paradise-Kingfisher is a confiding species, often seen perched in the lower parts of the forest.

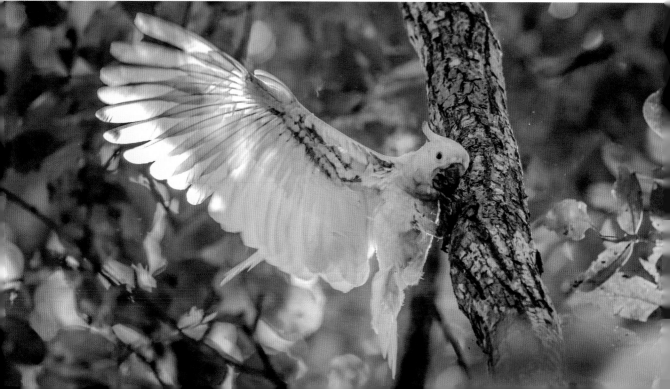

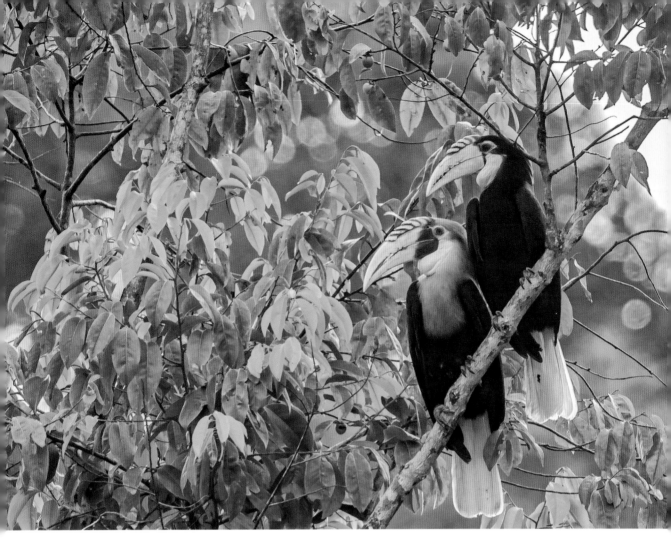

ABOVE The **Blyth's Hornbill** is a familiar sight in Raja Ampat. In flight, the terrific sound of its loud whooshing wingbeats can be heard at a great distance. It is one of the largest flying birds in the region. The Blyth's Hornbill is vocal, uttering a range of far-reaching guttural grunts and laughing calls. This species is usually recorded in pairs or small groups. Many dozens of them may congregate to roost or feed in fruiting trees.

RIGHT The red cheek patch of the **Palm Cockatoo** (*Probosciger aterrimus*) changes colour when the bird is alarmed. It is widely trapped in New Guinea for the pet trade. This individual was seen on Batanta, the smallest of the four main Raja Ampat islands.

LEFT The vocal **Sulphur-crested Cockatoo** (*Cacatua galerita*) has a wide distribution that spans New Guinea and Australia. In New Guinea, it is common in lowland and hill forests up to 1,400 m (4,600 ft) above sea level. This well-known parrot consumes a variety of seeds, fruits and buds gathered on the ground and in trees.

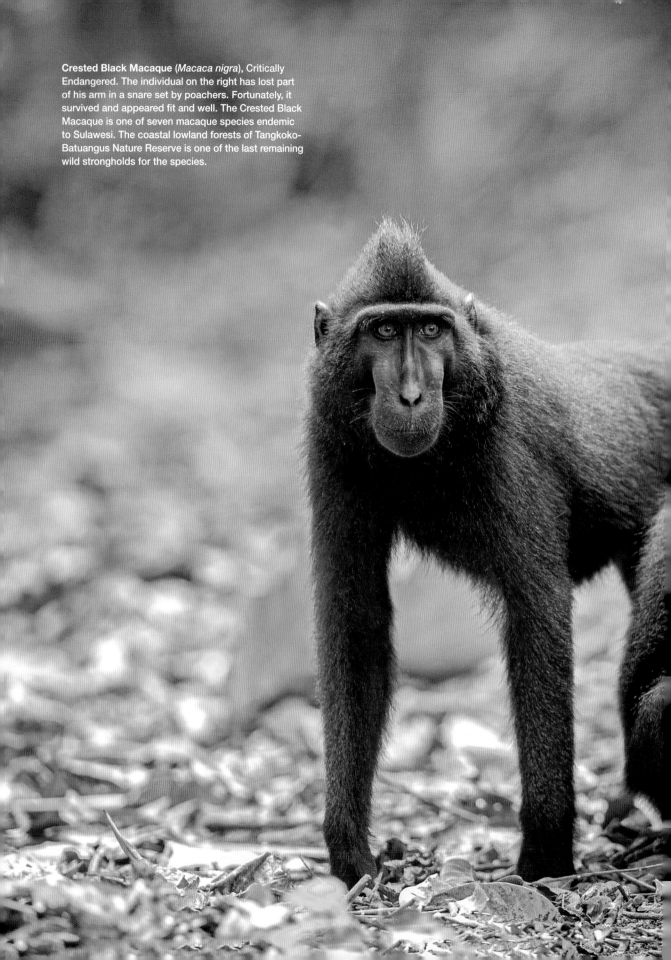

Crested Black Macaque (*Macaca nigra*), Critically Endangered. The individual on the right has lost part of his arm in a snare set by poachers. Fortunately, it survived and appeared fit and well. The Crested Black Macaque is one of seven macaque species endemic to Sulawesi. The coastal lowland forests of Tangkoko-Batuangus Nature Reserve is one of the last remaining wild strongholds for the species.

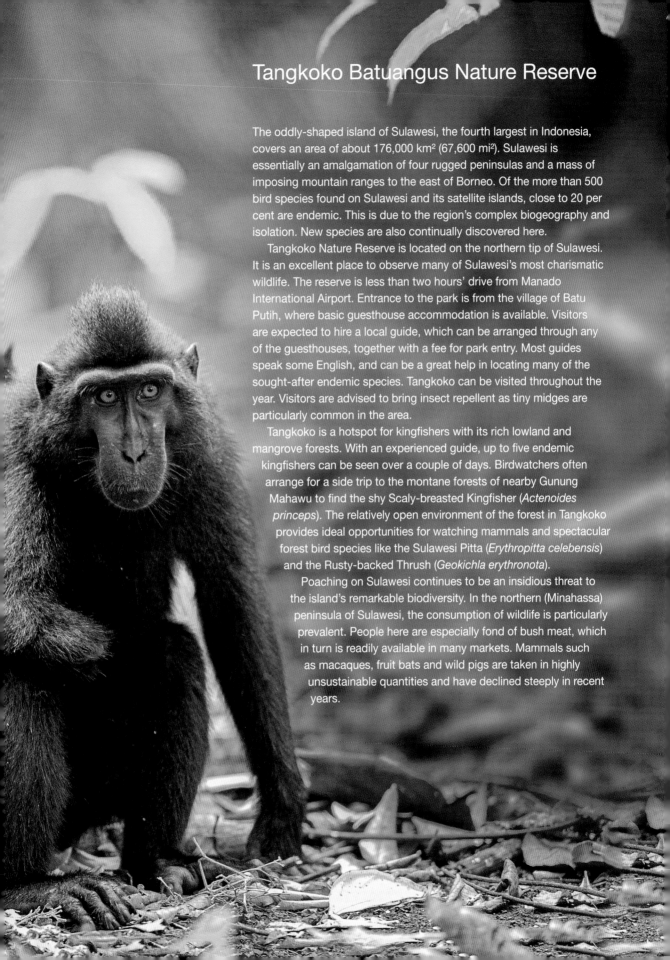

Tangkoko Batuangus Nature Reserve

The oddly-shaped island of Sulawesi, the fourth largest in Indonesia, covers an area of about 176,000 km² (67,600 mi²). Sulawesi is essentially an amalgamation of four rugged peninsulas and a mass of imposing mountain ranges to the east of Borneo. Of the more than 500 bird species found on Sulawesi and its satellite islands, close to 20 per cent are endemic. This is due to the region's complex biogeography and isolation. New species are also continually discovered here.

Tangkoko Nature Reserve is located on the northern tip of Sulawesi. It is an excellent place to observe many of Sulawesi's most charismatic wildlife. The reserve is less than two hours' drive from Manado International Airport. Entrance to the park is from the village of Batu Putih, where basic guesthouse accommodation is available. Visitors are expected to hire a local guide, which can be arranged through any of the guesthouses, together with a fee for park entry. Most guides speak some English, and can be a great help in locating many of the sought-after endemic species. Tangkoko can be visited throughout the year. Visitors are advised to bring insect repellent as tiny midges are particularly common in the area.

Tangkoko is a hotspot for kingfishers with its rich lowland and mangrove forests. With an experienced guide, up to five endemic kingfishers can be seen over a couple of days. Birdwatchers often arrange for a side trip to the montane forests of nearby Gunung Mahawu to find the shy Scaly-breasted Kingfisher (*Actenoides princeps*). The relatively open environment of the forest in Tangkoko provides ideal opportunities for watching mammals and spectacular forest bird species like the Sulawesi Pitta (*Erythropitta celebensis*) and the Rusty-backed Thrush (*Geokichla erythronota*).

Poaching on Sulawesi continues to be an insidious threat to the island's remarkable biodiversity. In the northern (Minahassa) peninsula of Sulawesi, the consumption of wildlife is particularly prevalent. People here are especially fond of bush meat, which in turn is readily available in many markets. Mammals such as macaques, fruit bats and wild pigs are taken in highly unsustainable quantities and have declined steeply in recent years.

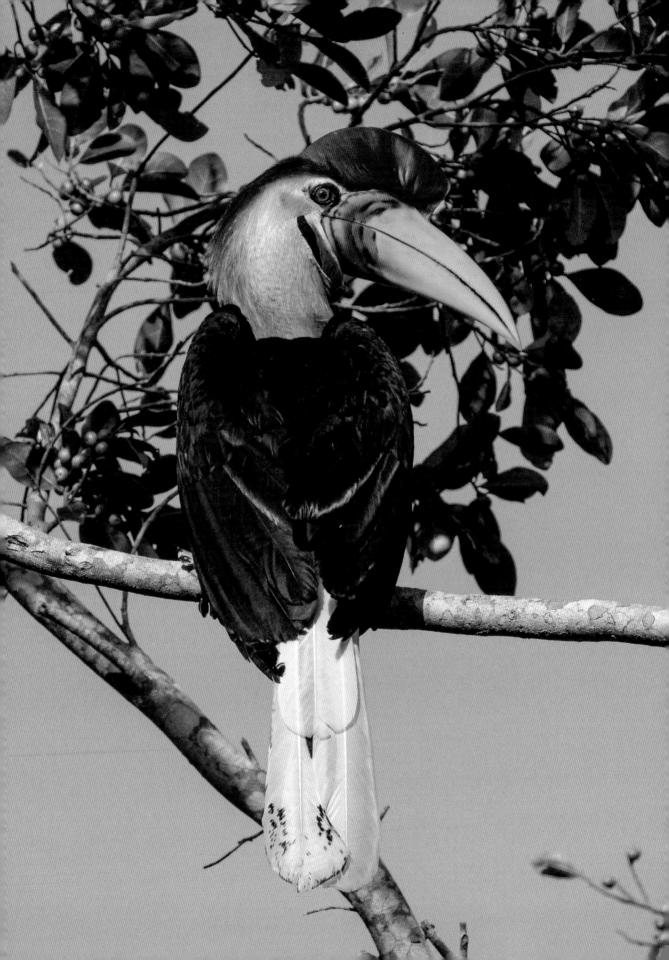

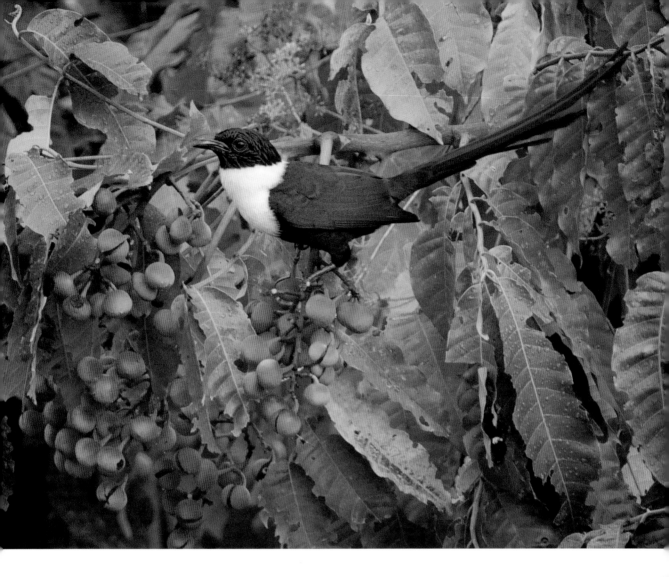

ABOVE The distribution of the **White-necked Myna** (*Streptocitta albicollis*) is restricted to Sulawesi and a few islands. This individual was part of a small family group seen at the forest edges of Tangkoko. Sulawesi is remarkably rich in starling species. The island supports a suite of bizarre and gaudily-adorned starlings and mynas, including this species.

LEFT The **Knobbed Hornbill** (*Rhyticeros cassidix*) is endemic to Indonesia where it can be found on Sulawesi and a number of its satellite islands. It is commonly seen in lowland forests, especially where there are fig trees. Together with the smaller Sulawesi Dwarf Hornbill and various Imperial Pigeons, the Knobbed Hornbill is a major disperser of seeds of many rainforest trees.

RIGHT The **Purple-bearded Bee-eater** (*Meropogon forsteni*) is a restricted-range species occurring in the montane forests of Sulawesi. Its closest relatives live in the tropical forests of western Africa. It uses a high perch as a lookout for food, which consists of a variety of flying insects.

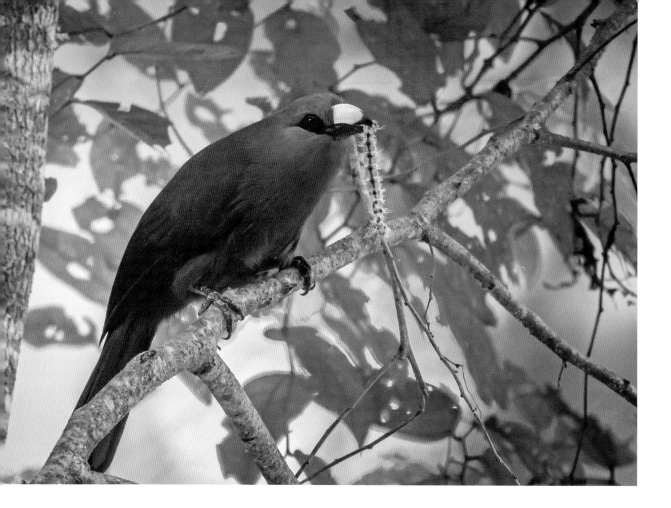

ABOVE The striking **Yellow-billed Malkoha** (*Rhamphococcyx calyorhynchus*) is a member of the cuckoo family. Unlike most other cuckoos, malkohas are not known to be brood parasites. It has been observed following groups of macaques and catching insects flushed by them.

LEFT The **Ashy Woodpecker** (*Mulleripicus fulvus*) is endemic to the Sulawesi subregion. It is a close relative of the larger and more familiar Great Slaty Woodpecker of Sundaland and mainland Southeast Asia. This male was accompanied by a female, both foraging on tree trunks for termites.

RIGHT The well-marked **Ochre-bellied Boobook** (*Ninox ochracea*) occurs primarily in Sulawesi's lowland and riverine forests up to an altitude of 1,000 m (3,300 ft). The species is able to use secondary forest habitats and may sometimes stray into cocoa plantations.

Male **Sulawesi Dwarf Hornbill** (*Rhabdotorrhinus exarhatus*) feeding on the fruits of *Dysozylum* sp. It is endemic to Sulawesi and its satellite islands off its south-eastern peninsula, where it occurs in mature and secondary lowland forests. The Sulawesi Dwarf Hornbill lives in groups. It has been documented that only the dominant pair will breed while other members of the group will act as helpers.

This species nests in natural cavities previously used by woodpeckers or other hornbills. These are usually found in mature trees high above the ground. In north Sulawesi, the egg-laying season is from February to March when two eggs are produced. As with other hornbills, the female seals herself into the nest. The male and some helpers (likely to be young from previous broods) feed her and the chicks. The nesting cycle may last up to 90 days. The Sulawesi Dwarf Hornbill is classified by IUCN as Vulnerable, due to widespread deforestation occurring across lowland Sulawesi. It is also under pressure from hunting.

ABOVE The distinctive behaviour and unique appearance of the endemic **Maleo** (*Macrocephalon maleo*) has made it one of the best known birds in Sulawesi. The majority of its population is found on the Minahassa Peninsula. The Maleo does not incubate its eggs using body heat. Instead, it lays its eggs in excavated pits on communal nesting grounds, where they are incubated by heat from the sun or volcanic soils.

After egg laying, the adults play no further role in raising the chicks. When a Maleo chick hatches after 60-90 days of incubation, it has to dig through a considerable amount of soil and sand to get to the surface. It then heads for the nearest forest. This nesting behaviour is unique to the Maleo and other members of the Megapode family.

The Wildlife Conservation Society Indonesia (WCS Indonesia) has run successful programmes protecting the Maleo's nest sites on the Minahassa Peninsula, in partnership with local conservation NGOs. By 2015, more than 10,000 Maleo chicks have been hatched and released from WCS-managed sites. At the same time, many protected nesting sites now offer eco-tours to generate additional income for local villages.

RIGHT The average weight of a **Maleo** egg is more than 200 g (7 oz), four to five times the weight of a chicken egg.

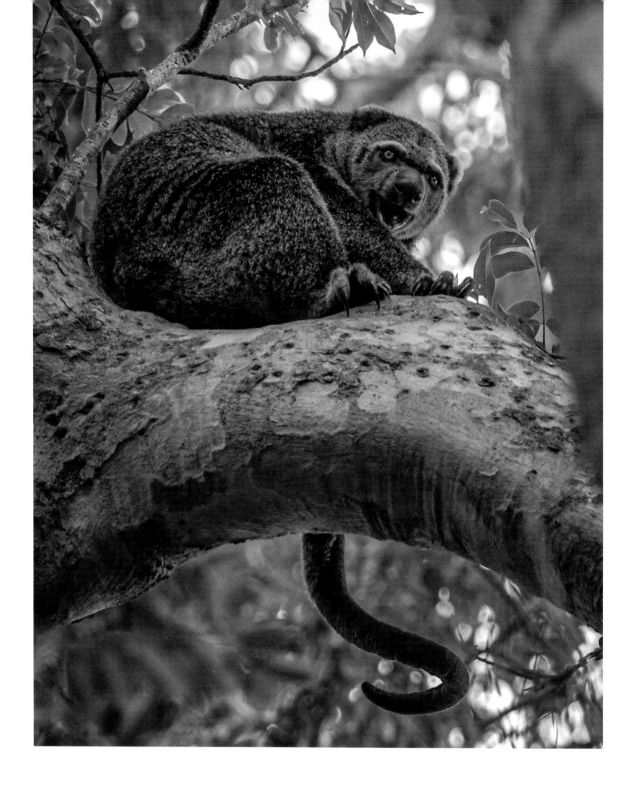

The **Sulawesi Bear Cuscus** (*Ailurops ursinus*) is a distinctive, arboreal marsupial, one of three possums found in Sulawesi. Marsupials are a group of mammals best known for their pouches, used for ferrying and caring for their young. The babies of the Sulawesi Bear Cuscus are born blind and undeveloped. They will stay in the pouch for around eight months as they develop. After this period of development, the offspring will be able to leave the pouch.

The Sulawesi Bear Cuscus prefers undisturbed lowland forests, where it spends most of its time high in the canopy. Like many marsupials, it is a herbivore with much of its diet made up of leaves supplemented with flowers and fruits. Cuscuses are ecological analogs of sloths and flying lemurs in tropical forests elsewhere. As its food is low in nutrients and calories, the cuscus moves slowly and rests often to conserve energy.

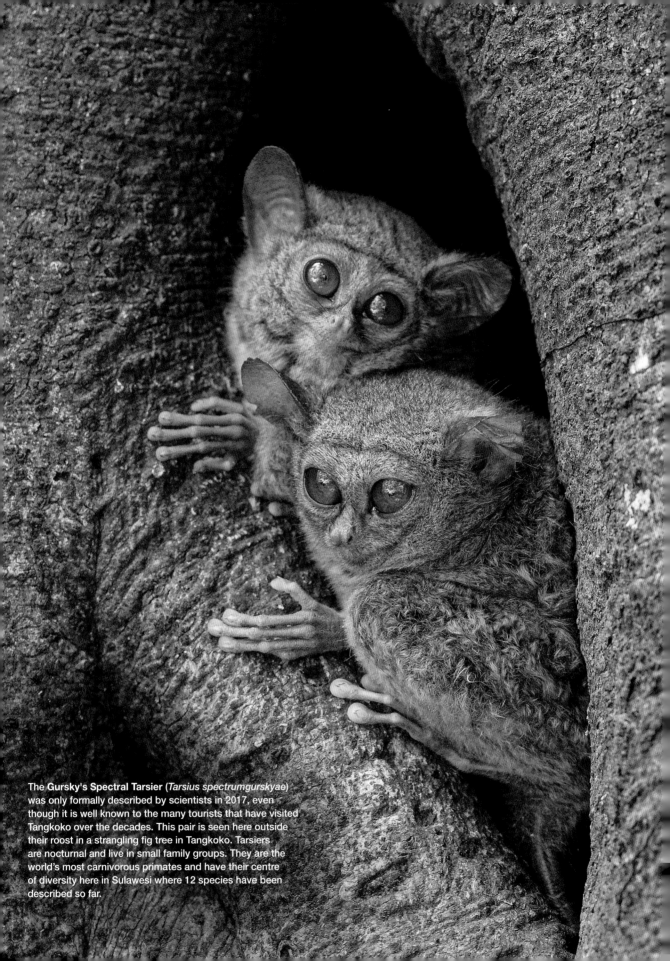

The **Gursky's Spectral Tarsier** (*Tarsius spectrumgurskyae*) was only formally described by scientists in 2017, even though it is well known to the many tourists that have visited Tangkoko over the decades. This pair is seen here outside their roost in a strangling fig tree in Tangkoko. Tarsiers are nocturnal and live in small family groups. They are the world's most carnivorous primates and have their centre of diversity here in Sulawesi where 12 species have been described so far.

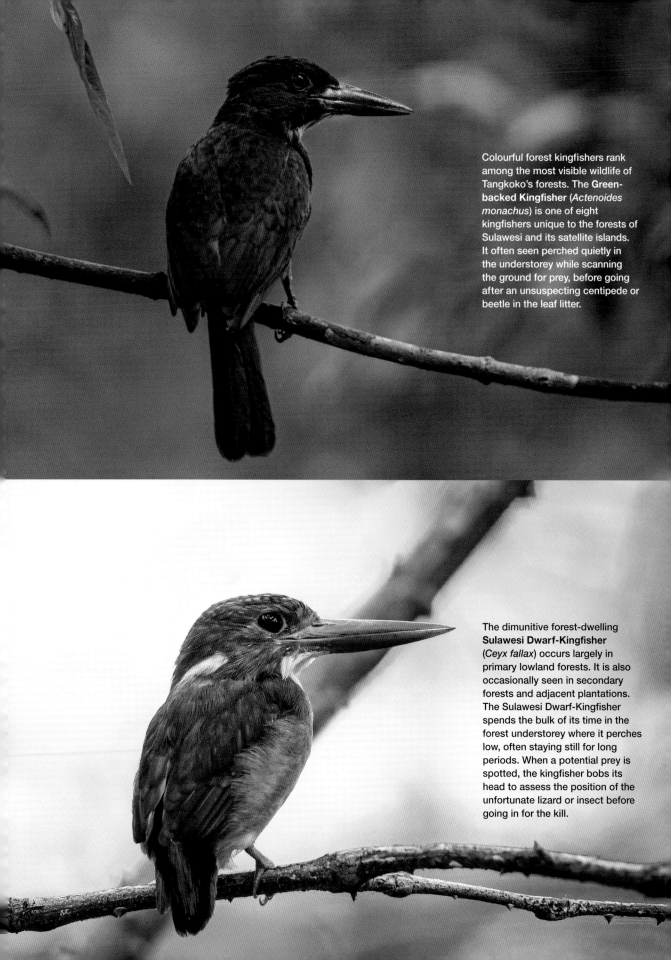

Colourful forest kingfishers rank among the most visible wildlife of Tangkoko's forests. The **Green-backed Kingfisher** (*Actenoides monachus*) is one of eight kingfishers unique to the forests of Sulawesi and its satellite islands. It often seen perched quietly in the understorey while scanning the ground for prey, before going after an unsuspecting centipede or beetle in the leaf litter.

The dimunitive forest-dwelling **Sulawesi Dwarf-Kingfisher** (*Ceyx fallax*) occurs largely in primary lowland forests. It is also occasionally seen in secondary forests and adjacent plantations. The Sulawesi Dwarf-Kingfisher spends the bulk of its time in the forest understorey where it perches low, often staying still for long periods. When a potential prey is spotted, the kingfisher bobs its head to assess the position of the unfortunate lizard or insect before going in for the kill.

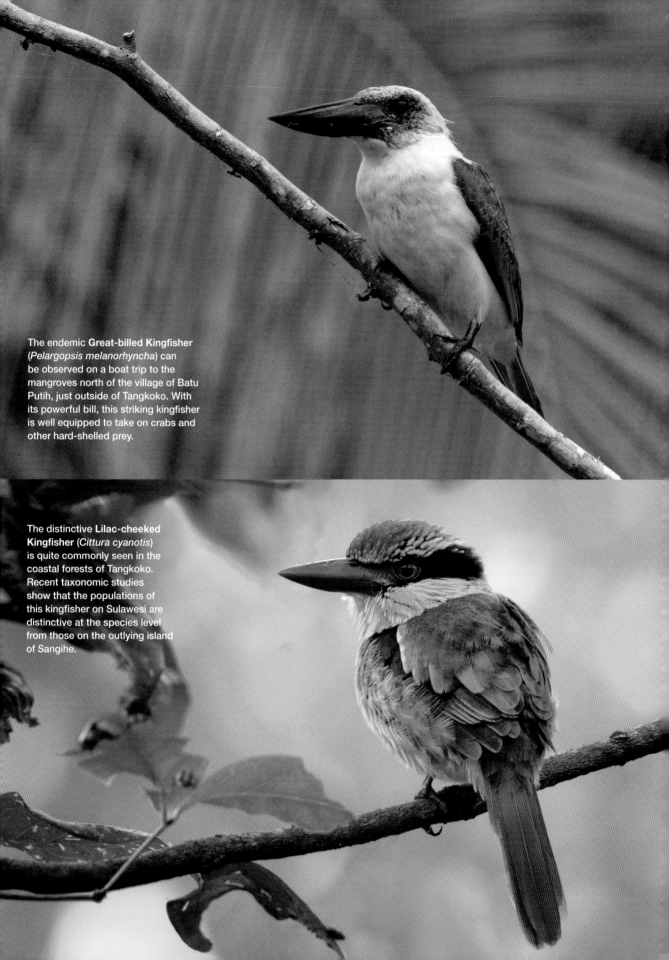

The endemic **Great-billed Kingfisher** (*Pelargopsis melanorhyncha*) can be observed on a boat trip to the mangroves north of the village of Batu Putih, just outside of Tangkoko. With its powerful bill, this striking kingfisher is well equipped to take on crabs and other hard-shelled prey.

The distinctive **Lilac-cheeked Kingfisher** (*Cittura cyanotis*) is quite commonly seen in the coastal forests of Tangkoko. Recent taxonomic studies show that the populations of this kingfisher on Sulawesi are distinctive at the species level from those on the outlying island of Sangihe.

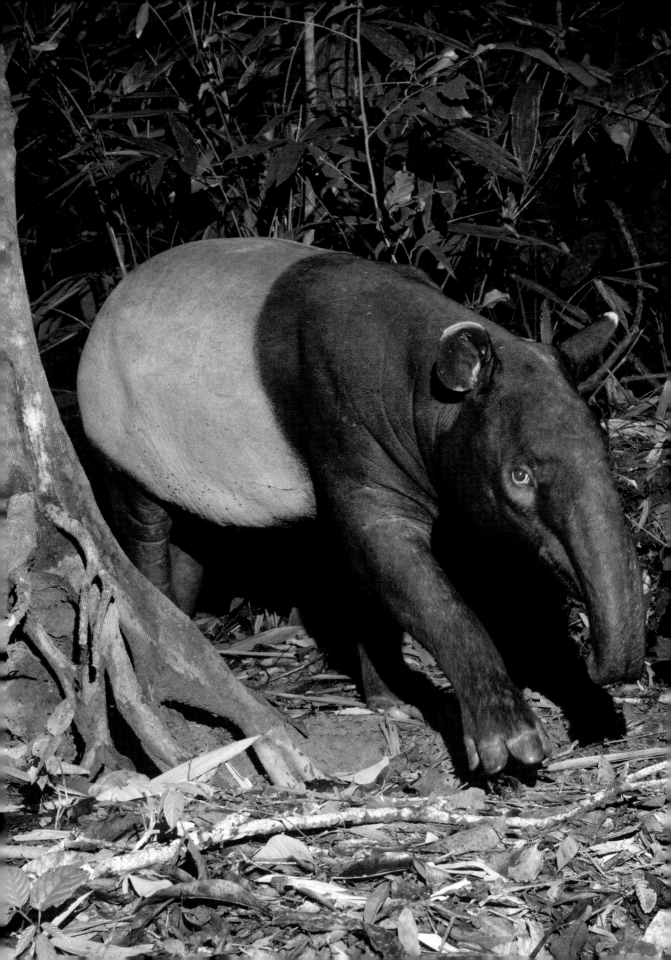

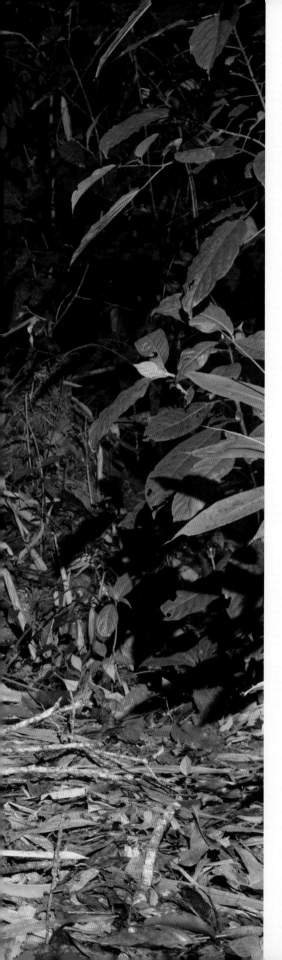

Malaysia

The Federation of Malaysia is situated in the heart of Southeast Asia just north of the equator. It comprises two geographically separate regions covering a total land area of about 330,000 km² (127,400 mi²). Peninsular Malaysia, which hosts the capital Kuala Lumpur, is separated from East Malaysia (in Borneo) by the South China Sea. To the north, Peninsular Malaysia is bordered by Thailand sharing a land boundary of some 500 km (310 mi). East Malaysia consists of the states of Sarawak and Sabah occupying around 25 per cent of the sprawling island of Borneo, and having a land boundary with Indonesia and Brunei Darussalam to the south and south-east.

Malaysia's climate is generally equatorial with uniformly high temperatures, rainfall and humidity throughout the year. Temperatures in lowland areas range from 25-34 °C (77-93 °F) during the day, and drops to 23-26 °C (73-79 °F) at night. As one ascends to Malaysia's several hill stations, the mercury drops to a comfortable 15-25 °C (59-77 °F) in the highlands, often with mist and frequent rain. Rainfall in most areas is high at around 2,500 mm (980 in).

The leading threat to Malaysia's wildlife and biodiversity is habitat loss and degradation driven by agricultural expansion and logging. The rainforests of Malaysia have been heavily exploited for their timber. For the most part, they have been replaced by large scale mono-cultures such as oil palm, rubber and acacia plantations, which now dominate the country's lowlands.

The distinctive **Malayan Tapir** (*Tapirus indicus*) is the only representative of the tapir family in Asia, with all its remaining relatives in South America. It has poor eyesight and relies greatly on its exceptional sense of smell and hearing. Malayan Tapirs are solitary animals that are largely nocturnal. They can be found in many types of lowland and sub-montane forests across Peninsular Malaysia but not on Borneo. Their diet includes a wide range of understorey plants, and they also consume a variety of fruits from the forest floor. The Malayan Tapir is Endangered with an estimated global population of less than 2,500 individuals.

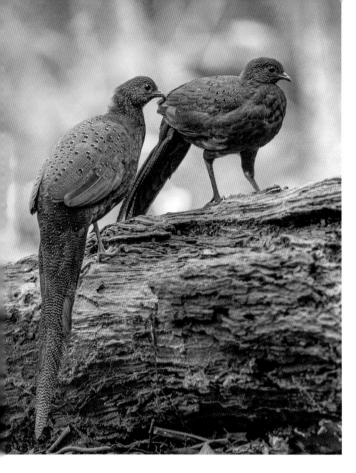

LEFT Male and female **Mountain Peacock-pheasant** (*Polyplectron inopinatum*). This pheasant is one of few endemic bird species restricted to the lower and upper montane evergreen forests on Peninsular Malaysia's Titiwangsa Range and a few outlying mountains.

BOTTOM The **Indochinese Leopard** (*Panthera pardus delacouri*) is a unique subspecies which in the past could be widely found across mainland Southeast Asia. Today, it has suffered a major range contraction. Populations have declined steeply owing to loss of habitat, declines in its prey base and illegal hunting.

Leopards have a highly varied diet, feeding on everything from insects to reptiles, birds, small mammals and large ungulates. They are able to adapt to the types of prey available in their habitat. Peninsular Malaysia, including Belum-Temengor, is a known stronghold for this large cat.

RIGHT *Rafflesia keithii* is found only in Sabah, Malaysian Borneo, and is one of several species of the *Rafflesia* found in Malaysia. The bloom of the flower shown here is three to four days old, and within days it will start to decompose. To the left of the bloom is the cabbage-like bud of the *Rafflesia*, which measures up to 25 cm (10 in) when mature.

With its gigantic blooms, the *Rafflesia* has become truly an icon of Southeast Asia's flora. The *Rafflesia* is a fully parasitic plant, entirely dependent on its host liana for water and nutrients. The *Rafflesia arnoldii*, native to Borneo and Sumatra, has the largest flower of any plant in terms of weight. It tips the scales at up to 10 kg (22 lb).

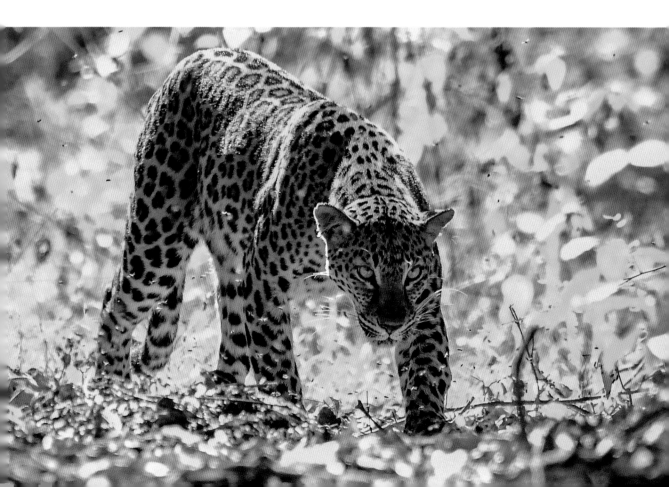

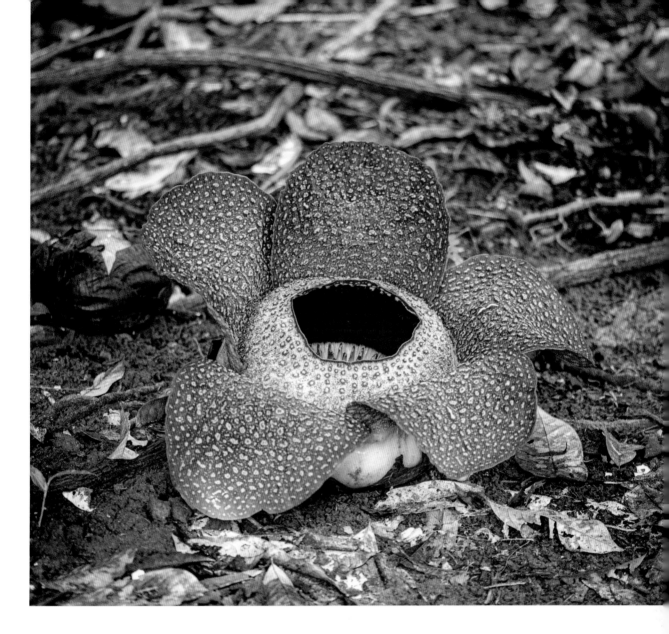

Illegal hunting and poaching continue to be major conservation issues in both the Peninsula and East Malaysia although there are increasing efforts from the Government and many NGOs to tackle hunting issues. The country's well-developed infrastructure and port network have made it a hub for the illegal wildlife trade. In spite of all the threats to wildlife, Malaysia still offers visitors one of the most hassle-free nature encounters in some of Southeast Asia's most breathtaking wildlife sanctuaries.

The high standards of Malaysia's infrastructure makes it easy for independent visitors to travel around. The capital Kuala Lumpur is the main transport hub, and many good birding sites can be reached in an hour by car. Domestic flight services are extensive and connect to many cities in East Malaysia. English is widely spoken in cities and tourist areas.

To avoid insect and leech bites in the Malaysian rainforest, trousers and long-sleeved shirts are recommended alongside insect repellent. Vaccinations for Hepatitis A and B as well as typhoid are also advised. The risk of malaria is relatively low in most areas.

Malaysia is recognised as one of 17 mega-diverse countries in the world, according to Conservation International. Its faunal diversity is very high with more than 360 species of mammals, over 800 bird species, around 500 reptiles and 240 amphibians. New species of amphibians, reptiles, many plants and insects are described from Malaysia every year.

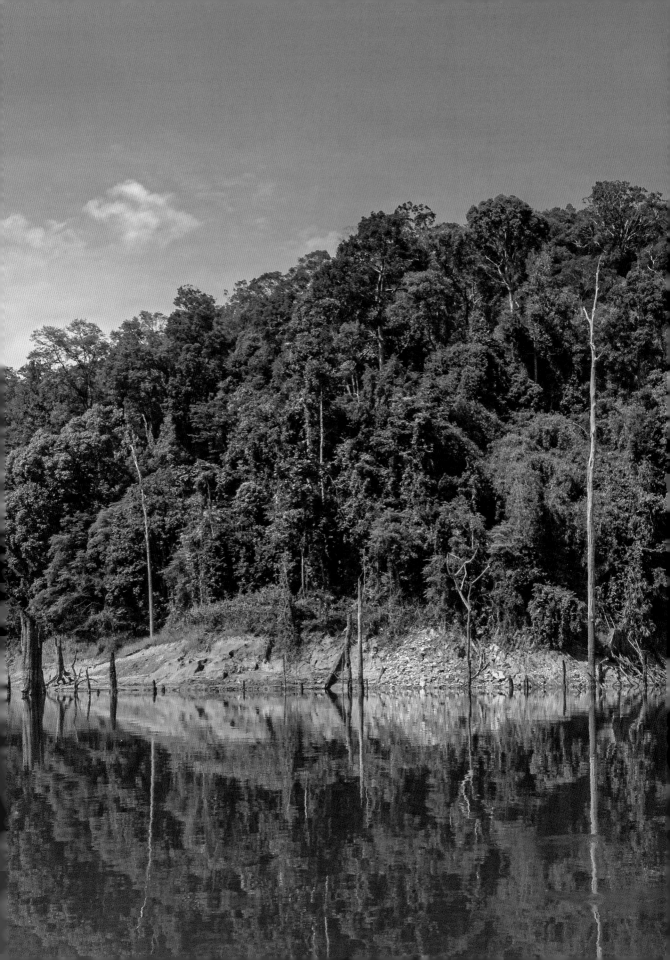

Belum-Temengor Forest Complex

The rugged landscape of the Belum-Temengor Forest Complex in the far north of Peninsular Malaysia covers a total area of 3,390 km² (1,300 mi²) of lowland and submontane tropical rainforest. The area consists of the Royal Belum State Park, Temengor, Gerik, Amanjaya and Banding Forest Reserves. This extensive forest complex spreads over mountainous terrains with altitudes ranging from 130 m (430 ft) to just over 1,500 m (4,900 ft). These landscapes support exceptionally high biodiversity, including many of Malaysia's best known large mammals.

Near the centre of Belum-Temengor lies the vast Temengor Lake. It was created from the damming of several tributaries of the Perak River to provide water for irrigation, and to meet the electricity needs of Perak. Belum-Temengor is identified as an Important Bird and Biodiversity Area (IBA) by BirdLife International and the Malaysian Nature Society. It is contiguous with Bang Lang National Park and the Hala-Bala Wildlife Sanctuary in southern Thailand covering an additional area of 1,300 km² (500 mi²).

The closest town and gateway to Belum-Temengor is the hamlet of Gerik. It is located on the East-West Highway just over 40 km (25 mi) from Banding Island, Temengor Lake. The island has a range of accommodation options and a public jetty around 5 hours' drive from Kuala Lumpur, and 3.5-4 hours from Penang. Some of the resorts can offer packages that take care of all arrangements. To enter the park, one would need a licenced guide and a State Park Entry Permit. This takes around a week to process.

Belum-Temengor's forests are of special interest as it sits in a transition zone between two botanical regions. Most species are typical of the wet Sundaic rainforests, found in Peninsula Malaysia and Sumatra. In addition, there is a higher element of deciduous species which are characteristic of the seasonal forests in peninsular Thailand further north.

The forest complex hosts an astonishing 3,500 species of seed plants, many of which are endemic to the area. Orchids are represented by more than 150 species.

The area is also notable for having three different *Rafflesia* species, one of the tropics more iconic flora with flowers that are among the largest in the plant kingdom.

The forest here is home to some 2,000 indigenous Jahai and Temiar people. They make a living from collecting non-timber forest products like wild honey, rattan and medicinal plants, as well as from fishing, planting rubber and working in the tourist industry as porters and guides.

Belum-Temengor is home to an impressive diversity of megafauna, with more than 125 mammals including the Malayan Tapir, Malayan Tiger, Asian Elephant and Sun Bear. An interesting physiographic feature of the Belum-Temengor environment is the presence of several salt licks which attracts large mammals. The forest complex also harbours numerous forest-dependent bird species such as hornbills, pittas, babblers, flycatchers, woodpeckers, diurnal raptors, bulbuls and kingfishers. More than 330 bird species have been recorded in Belum-Temengor.

The East-West Highway runs along the southern border of Royal Belum State Park, separating it from the Temengor Forest Reserve to the south. This road has enhanced accessibility and facilitated hunting and illegal activities in the forest. In spite of efforts by Government agencies and NGOs to tackle poaching, the situation has continued to deteriorate, with the tiger population experiencing further declines in recent years.

Wildlife around Temengor Lake is best observed from boats along the lakeside. Many raptor species such as the Lesser Fish-eagle (*Haliaeetus humilis*) and Grey-headed Fish-eagle (*Haliaeetus ichthyaetus*) can be spotted perched on exposed tree stumps looking for prey. Forest raptors such as the Blyth's Hawk-eagle (*Nisaetus alboniger*), Crested Goshawk (*Accipiter trivirgatus*) and Rufous-bellied Eagle (*Lophotriorchis kienerii*) can often be seen hunting above the canopy. An impressive 25 species of diurnal raptors have been recorded here.

LEFT The population of songbirds like the **White-rumped Shama** (*Copsychus malabaricus*) and the Straw-headed Bulbul (*Pycnonotus zeylanicus*) has been decimated in many of Malaysia's forests, especially in areas which have not been well patrolled for poaching enforcement. The Straw-headed Bulbul is now virtually extirpated from many parts of Peninsular Malaysia. Meanwhile, more efforts are urgently needed to safeguard populations of songbirds sought after in the cage bird trade.

RIGHT A male **Plain-pouched Hornbill** (*Rhyticeros subruficollis*) is seen returning to its nesting cavity to feed the female, while being mobbed by the much smaller **Greater Racket-tailed Drongo** (*Dicrurus paradiseus*). Drongos are very territorial and are often seen harassing larger birds especially near their own nests. These hornbills migrate south in large numbers to the forests straddling the border of Thailand and Malaysia each year from July, and leave later in the year for their breeding areas further north in western Thailand and Myanmar.

BELOW The **Red Muntjac** (*Muntiacus muntjak*) is commonly referred to as "barking deer" by naturalists due to its unusual alarm call when danger is present. It is mainly nocturnal, but is also active during the day in areas where it is not hunted. The Red Muntjac is a solitary animal except during the mating season.

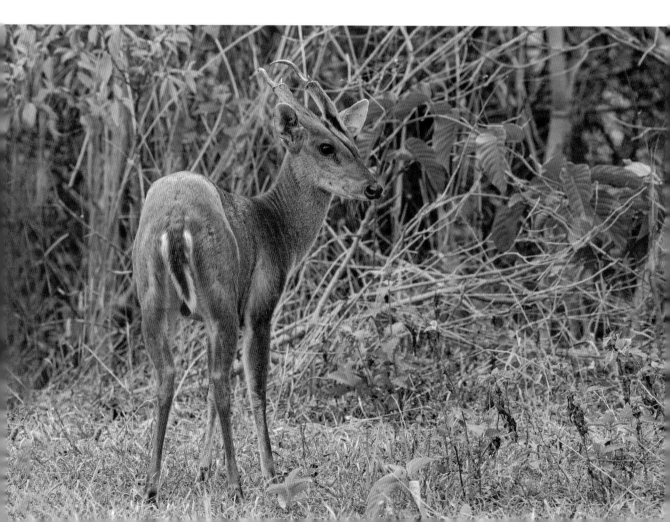

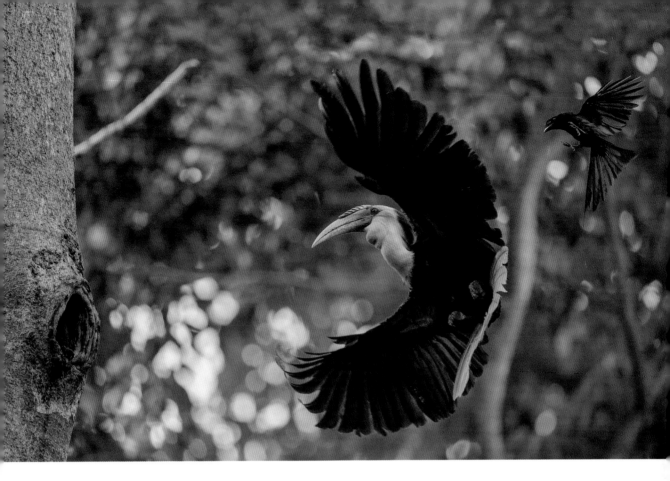

Belum-Temengor is part of a landscape described by hornbill conservationists as the "Hornbill Triangle", which includes the Greater Ulu Muda Forest Complex as well as Thailand's Bang Lang National Park and Hala-Bala Wildlife Sanctuary. More hornbill species can be found in this 'triangle' than in any other forested landscapes in the world.

In August and September, large flocks of the migratory Plain-pouched Hornbill gather in Royal Belum State Park and Temengor Forest Reserve. The highest number of Plain-pouched Hornbill ever recorded was 3,261 individuals on 14 September 2008. Subsequent records have been significantly lower. The location of the roosting sites of these hornbills far inside the Temengor Forest Reserve remains largely unknown.

Hornbills are omnivorous birds, feeding primarily on fruits and small animals. They are major seed dispersers particularly of fig trees, which are key components of tropical forests. Figs (*Ficus* spp.) are among the most important food resources for mammals and birds, given the fact that they are regularly available throughout the year, and often in large quantities.

The lake sides and river valleys of Belum can be productive when searching for hornbills during the early morning or late afternoon. The Oriental Pied Hornbill, Black Hornbill and Rhinoceros Hornbill are the most commonly encountered species. There are opportunities for forest birdwatching along the East-West Highway, and walks on short trails in one or two locations in the Royal Belum State Park are also possible. On the hill-slopes lining the lake, typical species include bulbuls, babblers, flycatchers, kingfishers, woodpeckers and spiderhunters.

Belum-Temengor can be visited throughout the year; it tends to be drier between December and April, but visitors should be prepared for rain anytime, especially in the afternoons. To see the Plain-pouched Hornbill and the other nine species of hornbills, the period between July to September is ideal.

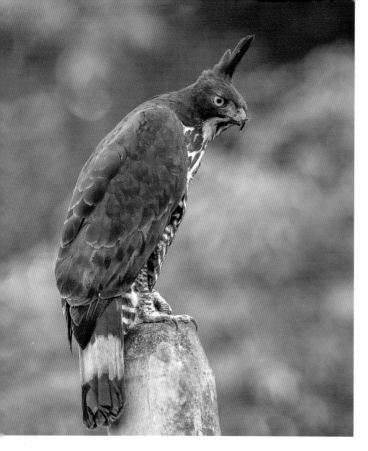

LEFT Blyth's Hawk-eagle (*Nisaetus alboniger*) is a familiar bird-of-prey in hilly and montane forest landscapes in Peninsular Malaysia.

RIGHT The male **Helmeted Hornbill** (*Rhinoplax vigil*) seen here is feeding regurgitated fruits to the female hidden inside the nesting cavity. In Belum-Temengor, Helmeted Hornbill nests are located in Tualang (*Koompassia excelsa*) and Merbau *(Intsia palembanica)* trees with protruding branch knobs. The female lays one or two eggs every year and seals herself inside the nesting cavity for as long as 160 days.

With its prehistoric looks characterised by a high red casque, short pointed bill and elongated central tail feathers, this large hornbill is one of the most impressive birds inhabiting Asia's tropical rainforests. For the past 10 years, the Helmeted Hornbill has been the target of a massive poaching drive because of its solid 'red ivory' casque sought after for ornamental carvings. It has been classified as Critically Endangered since 2015.

BELOW The **Malayan Sun Bear** (*Helarctos malayanus*) is the smallest of the world's eight bear species. Found in both East and Peninsular Malaysia in similar habitat, it mainly inhabits tropical rainforests. Signs of prominent claw marks gouged into tree trunks are seen more often than the bear itself. Sun Bears are generalists, feeding mostly on ants, termites, stingless bee larvae and honey, as well as on a variety of fruit species including figs.

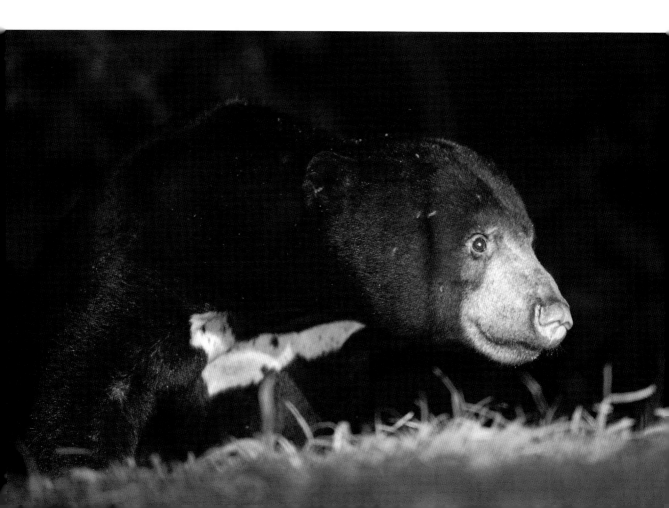

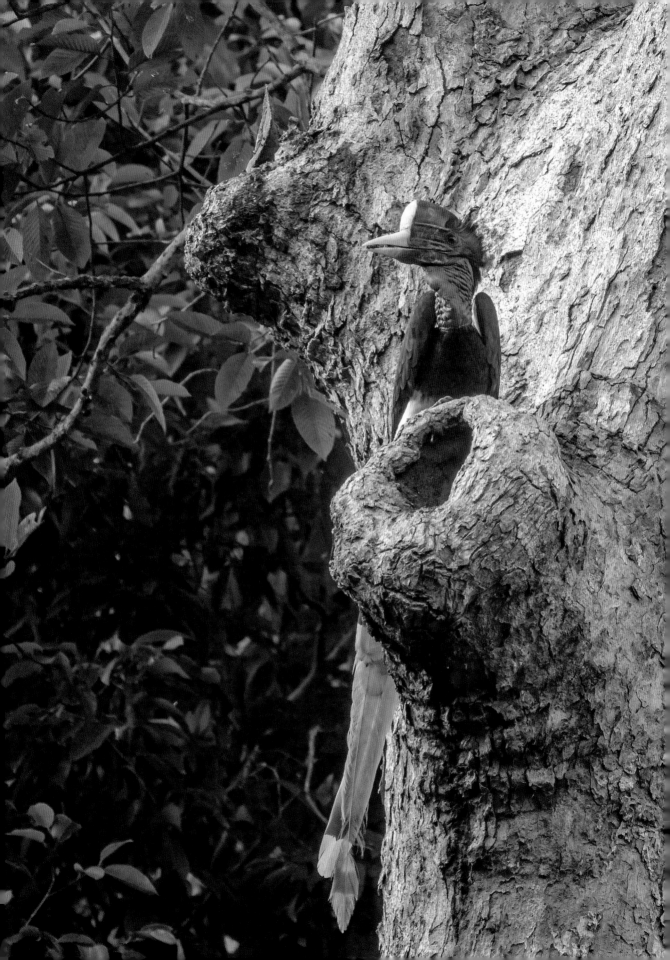

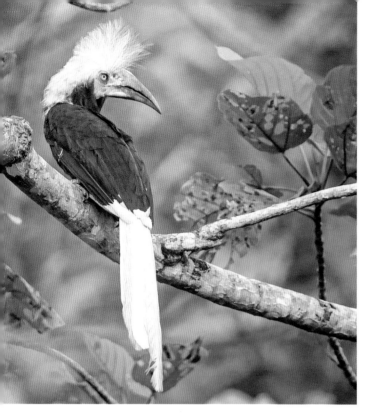

LEFT The female **White-crowned Hornbill** (*Berenicornis comatus*) is instantly recognisable with its loose, ragged crest. The diet of this funky-looking species comprises a large proportion of animals, including insects, lizards, snakes, small birds and occasionally figs. Throughout its range in Southeast Asia, it is a scarce species. This hornbill is easily overlooked as it tends to stay high up in the rainforest canopy. It has been classified as Endangered since 2018.

BELOW The female **Rhinoceros Hornbill** (*Buceros rhinoceros*) can be recognised by its white eyes and red orbital rings, whereas the male has red eyes and black orbital rings. It occurs in lowland forests at low densities, and is recently classified as Vulnerable.

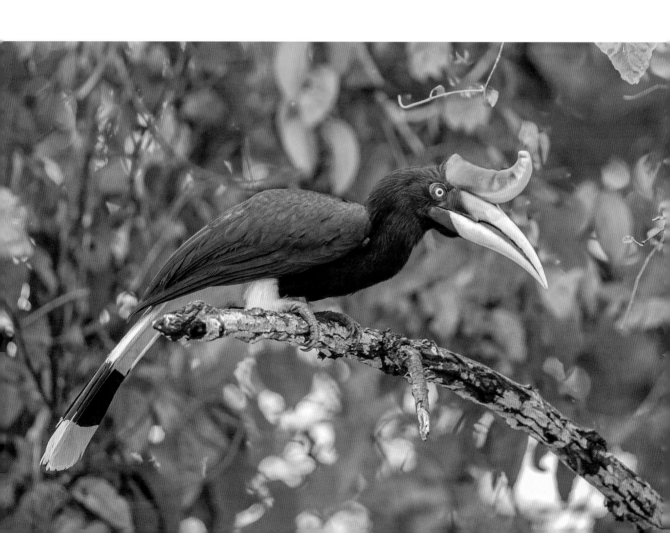

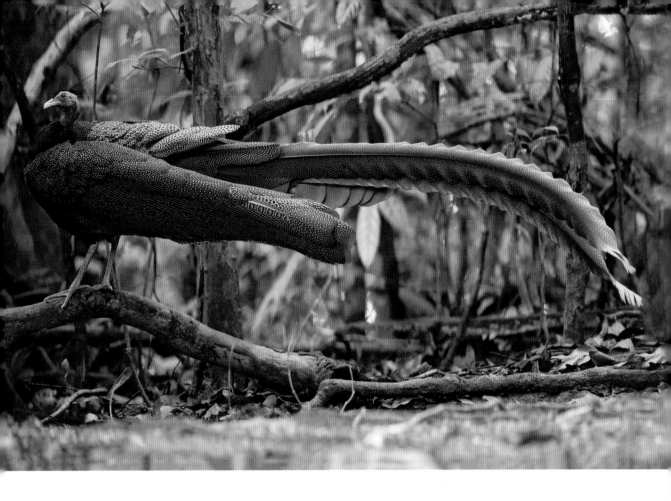

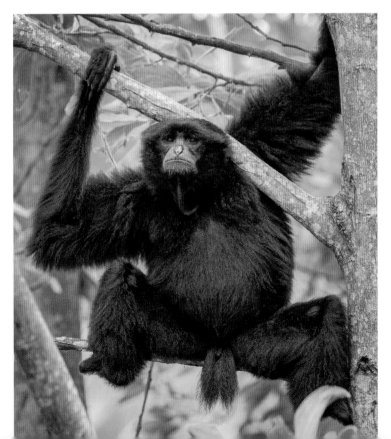

ABOVE The repeated loud "kwow-wow' calls of the **Great Argus** (*Argusianus argus*) can be heard from a great distance but the caller itself is rarely observed in the hill forests of Belum-Temengor. The male is one of Southeast Asia's most spectacular pheasants. Its total length can reach up to 2 m (6.6 ft), if the splendid tail feathers are included.

LEFT Belum-Temengor is one of the strongholds of the Endangered **Siamang** (*Symphalangus syndactylus*) in Malaysia, the world's largest gibbon. Like other gibbons, the Siamang is known for its vocal abilities. Its haunting calls can carry for several kilometres. It is a flexible forager with a diet consisting of fruits and leaves, supplemented with flowers and insects.

Danum Valley Conservation Area

Although much of Southeast Asia's lowland tropical forests have been lost to logging, palm oil and timber plantations, Malaysian Borneo still retains large tracts of lowland and montane forests. This part of Malaysia is especially rich in biodiversity, and has some of the world's highest concentrations of pitcher plants, orchids, figs and other iconic plant groups. Put together, the Malaysian states of Sabah and Sarawak boasts nearly 700 bird species including about 60 endemics, and over 200 mammal species.

Most visitors to Sabah arrive at the state capital of Kota Kinabalu or in Sandakan. Danum Valley is one of Sabah's best known wildlife watching sites. It is a two hours' drive west of the coastal town of Lahad Datu on Sabah's eastern seaboard, which can be reached via daily flights from Kota Kinabalu. From Sandakan, it is a three hour drive (175 km) (110 mi) to Lahad Datu.

One hour out of Lahad Datu on the road to Danum Valley, orangutan nests are often seen. Bornean Orangutans are fond of Laran Trees (Anthocephalus chinensis) because of their horizontal branches, which are good for nest building. Laran fruits are a favoured food item. Apart from orangutans, there is a chance to encounter the Bornean Pygmy Elephant.

Danum Valley covers 438 km² (170 mi²) of primary lowland and hill forests in the upper catchment area of the Danum and Segama rivers. It is one of Asia's top lowland birdwatching sites supporting many of Borneo's most sought after bird families. These include pittas, hornbills, partridges and pheasants. Its extraordinary animal life encompasses 121 species of mammals, 317 species of birds, 56 species of amphibians, and 73 species of reptiles according to Danum Valley: The Rain Forest by leading naturalist, Hans Hazebroek and his colleagues. It is one of the best places in Borneo to see primates such as the Bornean Orangutan, Bornean Tarsier and the Red Langur.

There are two possibilities for accommodation here: the Danum Valley Field Centre and the up-market Borneo Rainforest Lodge. The Field Centre was originally established as a base for researchers and scientists conducting fieldwork in the rainforest. Today, the basic facilities (chalets, rooms or dormitory) can be booked by independent travellers. Accommodation and transport to Danum Valley have to be arranged in advance.

Much of the forest along the access road to the Field Centre is relatively open, making it easier to spot forest birds like babblers, bulbuls and woodpeckers. Located by the Segama River, the Field Centre is surrounded by 50 km (30 mi) of extensive hiking trails which can be explored with a local guide. An early morning trek is the most productive, but make sure to also do a night walk and/or drive. The forest view before sunrise from the Field Centre's fire-observation tower is one of the most memorable experiences here. To see the morning mist clearing in the sun, and listen to the dawn chorus and whooping calls of Eastern Bornean Grey Gibbons is surely a highlight of any visit. Borneo's largest deer species, the Sambar Deer can be observed in the evenings at some of the open areas close to the Field Centre.

The 5-star Borneo Rainforest Lodge has a magnificent setting by the Danum River, located 35 km (20 mi) from the Field Centre. There is an elaborate network of trails from the lodge. With the assistance of capable local guides, it is often possible to locate some of the six species of pittas and many other key wildlife found here. Night rambles allow a good diversity of nocturnal species to be observed. These include the Bornean Tarsier, mousedeer, owls, frogmouths and amphibians.

The optimal time to visit Danum Valley is from March to September. The wettest months are from November to January due to the north-east monsoon. Annual rainfall is above 3,000 mm (1,200 in) in many locations in eastern Sabah. As such, visitors should be prepared for rain throughout the year. Bookings to the Borneo Rainforest Lodge should be made well in advance of arrival.

ABOVE The shy **Blue-banded Pitta** (*Erythropitta arquata*) is often heard but difficult to spot in the dim understorey of Danum Valley. Nine species of pittas occur in Borneo, four of which are endemic, including this species. All can be seen in Danum.

LEFT The ghostly-white, orange-backed form of the **Red Langur** (*Presbytis rubicunda chrysea*) is localised to north-eastern Borneo and is only occasionally seen in Danum Valley. Otherwise, the Red Langur is one of the more regularly encountered primates in Danum. Deforestation poses a major threat to the increasingly fragmented populations of this beautiful primate across Borneo.

RIGHT TOP The **Bornean Angle-headed Lizard** (*Gonocephalus bornensis*) is one of the more than 100 species of lizards that has been found in Borneo. It inhabits primary forests at elevations of up to 1,100 m (3,600 ft), where it can be seen foraging for ants and spiders in the forest understorey and canopy.

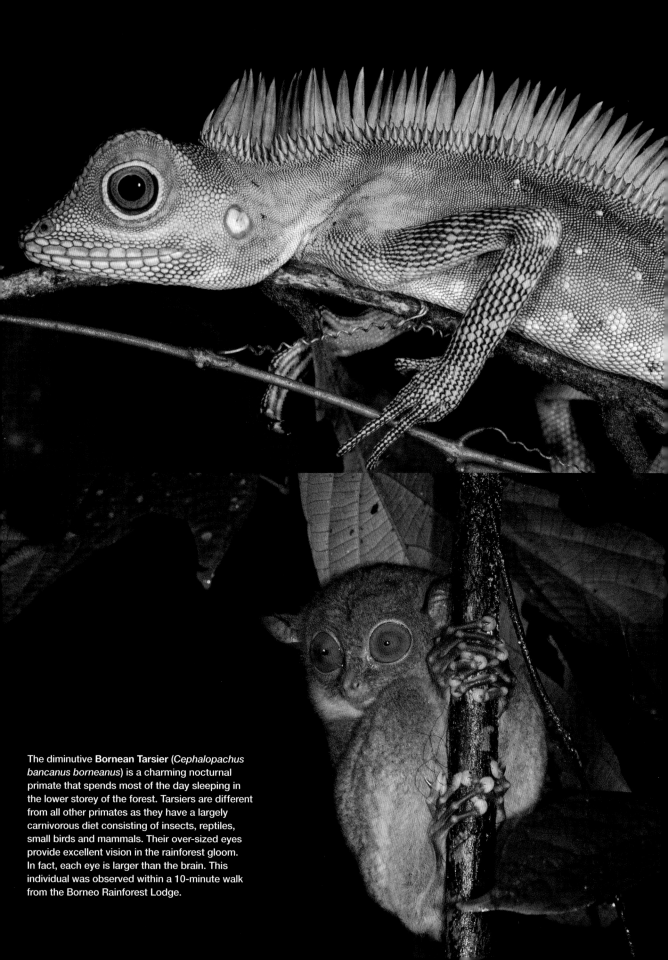

The diminutive **Bornean Tarsier** (*Cephalopachus bancanus borneanus*) is a charming nocturnal primate that spends most of the day sleeping in the lower storey of the forest. Tarsiers are different from all other primates as they have a largely carnivorous diet consisting of insects, reptiles, small birds and mammals. Their over-sized eyes provide excellent vision in the rainforest gloom. In fact, each eye is larger than the brain. This individual was observed within a 10-minute walk from the Borneo Rainforest Lodge.

ABOVE Endemic to Borneo, the striking black, red and yellow **Bornean Bristlehead** (*Pityriasis gymnocephala*) is the only member of the *Pityriaseidae* family. For this reason, it sits at the top of the wish list of most birdwatchers visiting Borneo. The Bornean Bristlehead is found in various lowland forest habitats up to 1,000 m (3,300 ft). It often moves in family groups through the upper canopy, feeding on invertebrates and small reptiles. A vocal species, it is best detected by its bizarre, cat-like mewing calls.

LEFT The canopy walk of the Borneo Rainforest Lodge spans approximately 250 m (820 ft) more than 20 m (65 ft) above the ground. It offers a different perspective of the rainforest, allowing birdwatchers great views of the mixed flocks of minivets, woodshrikes, and woodpeckers moving through the tree tops. This is an ideal perch to spot broadbills and the Bornean Bristlehead.

It was on this canopy walk that one of Borneo's major ornithological discoveries in recent times was made in 2009 when a mysterious flowerpecker was photographed for the first time. The slate-grey flowerpecker was observed in a fruiting mistletoe parasitising a large **Tualang tree** (*Koompassia excelsa*), eight metres (26 ft) above an observation platform.

Over the next few years, this elusive flowerpecker was spotted a number of times in different locations. It was not until a decade later that a specimen was collected, enabling a scientific description in 2019. The **Spectacled Flowerpecker** (*Dicaeum dayakorum*) was the first new bird species described from Borneo after more than a century. This is another reminder of the uncharted biodiversity of much of Borneo.

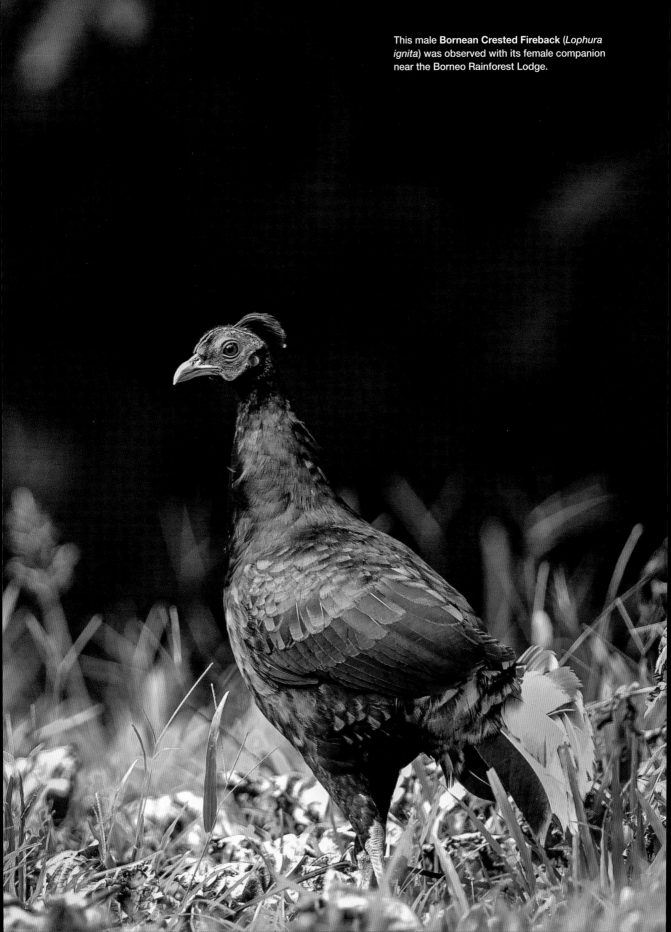

This male **Bornean Crested Fireback** (*Lophura ignita*) was observed with its female companion near the Borneo Rainforest Lodge.

Kinabatangan Wildlife Sanctuary

The Kinabatangan Wildlife Sanctuary, covering some 260 km² (100 mi²) of riparian and lowland forests, was established in 2005. It protects the last remaining riverine forest habitats along the lower reaches of the meandering Kinabatangan River, Sabah's longest. Seasonal monsoons flood the waterways, creating habitats for some of the highest concentrations of wildlife in Borneo. Prior to receiving formal protection, excessive logging and forest clearance for oil palm plantations had threatened to disrupt the migratory routes used by the Bornean Pygmy Elephants in the lower Kinabatangan floodplains.

The Kinabatangan Wildlife Sanctuary consists of a narrow corridor of riparian forests, wetlands, freshwater and swamp forests, as well as oxbow lakes. It is one of Malaysia's high priority conservation landscapes, and supports rich assemblages of large mammals and lowland forest birds. This includes the Proboscis Monkey, Bornean Orangutan, East Bornean Grey Gibbon, Bornean Pygmy Elephant, Flat-headed Cat, Estuarine Crocodile, all eight species of hornbills found in Borneo, the Storm's Stork and the Bornean Ground-cuckoo. According to a recent study, these forests host a total of 314 bird species, 129 species of mammals,

101 species of reptiles, and 33 species of amphibians.

Most visitors arrive through the coastal town of Sandakan, where it is possible to visit the Bornean Sun Bear Conservation Centre, Sepilok Orangutan Rehabilitation Centre and the Rainforest Discovery Centre (RDC) in the Kabili-Sepilok Forest Reserve.

Tourism is centred around the villages of Sukau and Bilit on the Kinabatangan River, 2-3 hours' drive from Sandakan. Alternatively, we recommend visitors to travel by boat from Sandakan to Sukau, given the opportunities to observe wildlife along the way. There are also several limestone hills in the lower Kinabatangan area, with the Gomantong Caves being the best known. These caves are used by millions of swiftlets of several species and are known for the harvests of bird nests for consumption, a delicacy in Chinese cuisine. They can be visited on a day trip from Sukau. Transport arrangements can be made through most of the local lodges and homestays. Wildlife watching is generally most productive during the early morning, late afternoon, and after dark. The late afternoons are often a good time to see hornbills on the way to their roosting sites.

RIGHT The **Cluster Fig** (*Ficus racemosa*) grows abundantly on the banks of the Kinabatangan River. This is where orangutans and other primates can be observed, often in the company of a few species of hornbills.

LEFT This juvenile **Helmeted Hornbill** was seen in a fig tree in the Kinabatangan Wildlife Sanctuary not far from its parents (below).

BELOW The **Helmeted Hornbill** (*Rhinoplax vigil*) is a particularly charismatic hornbill. Its characteristic vocalisation starts with several short "pooh" calls before shifting to an accelerating series of "poohooh" sounds, ending with a harsh maniacal laughter. One of its favourite foods is figs, but at times it is known to take rodents, reptiles and nestlings.

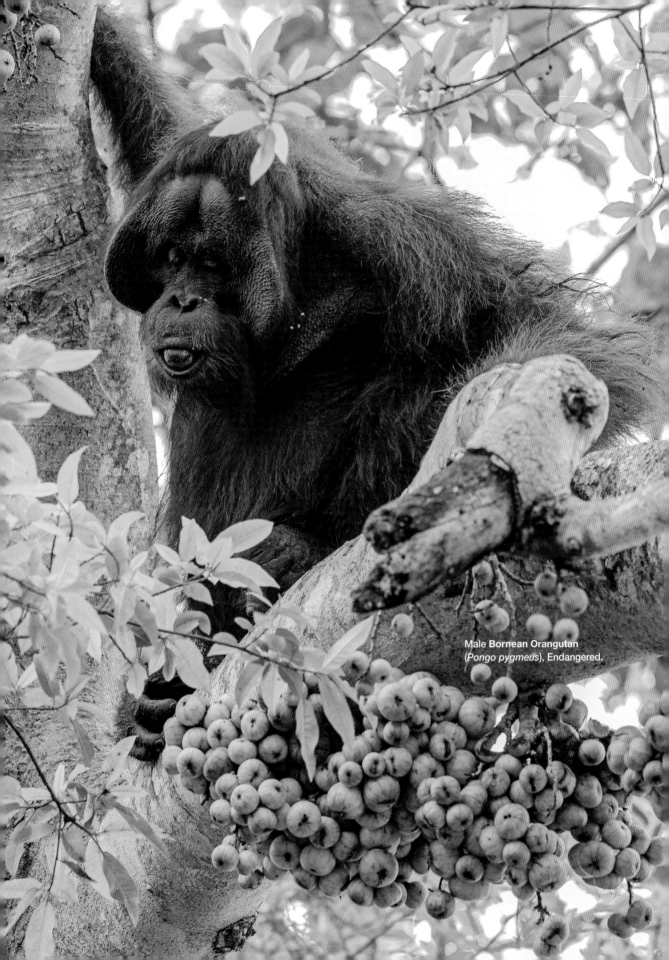

Male Bornean Orangutan
(*Pongo pygmeus*), Endangered.

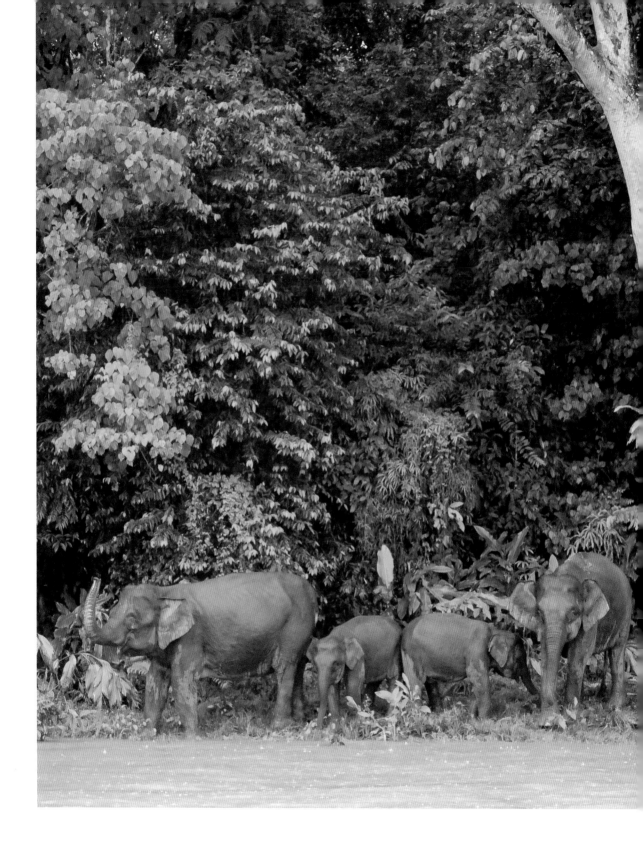

Phylogenetic studies from 2003 and 2018 suggest that the Endangered **Bornean Pygmy Elephant** (*Elephas maximus borneensis*) is genetically distinct from other Asian Elephants. It is not a feral population introduced by humans several hundred years ago as hypothesised by some researchers.

This image shows a typical family group consisting of a matriarch and seven to nine members. Regrettably, one of the reasons why these elephants are so visible is because

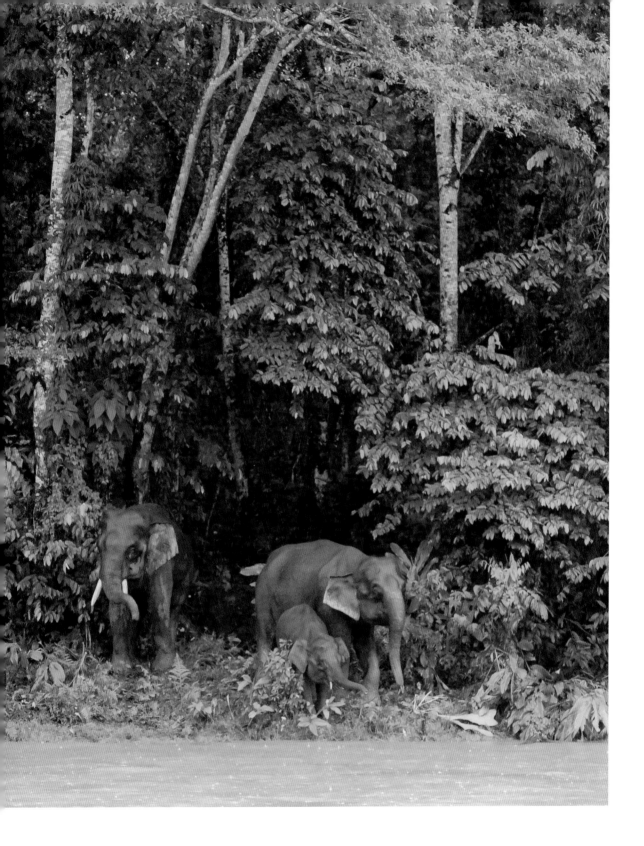

of the fragmentation of their fast declining habitat along the Kinabatangan River. Over the years, the sanctuary has suffered encroachment by oil palm plantations on its fringes. There has been an increasing number of human-elephant conflicts, making the long term future of this elephant population uncertain.

LEFT The Endangered **Storm's Stork** (*Ciconia stormi*) is perhaps the rarest of all stork species. As a flagship bird of the Kinabatangan River, it can be quite easy to observe here. The global population is estimated at around 300 adult birds with the majority occurring in Borneo.

BOTTOM The Endangered **Flat-Headed Cat** (*Prionailurus planiceps*) is strongly associated with wetlands, swampy areas and riverine forests. It hunts live fish with its head submerged, and has been observed washing food items as raccoons do. At the Kinabatangan, most sightings have been of the cats walking along riverbanks. The global population is estimated at less than 3,000 individuals.

RIGHT The **Bornean Ground-Cuckoo** (*Carpococcyx radiceus*) is a highly sought-after species by visiting birdwatchers. This endemic cuckoo is exceptionally shy and is more often heard than seen. More often than not, its presence is betrayed by its double-note call '*koo hooh*' which carries a long way. This individual was seen in the narrow Menanggol Tributary to the Kinabatangan River not far from Sukau. It feeds mainly on insects, including beetles and giant ants.

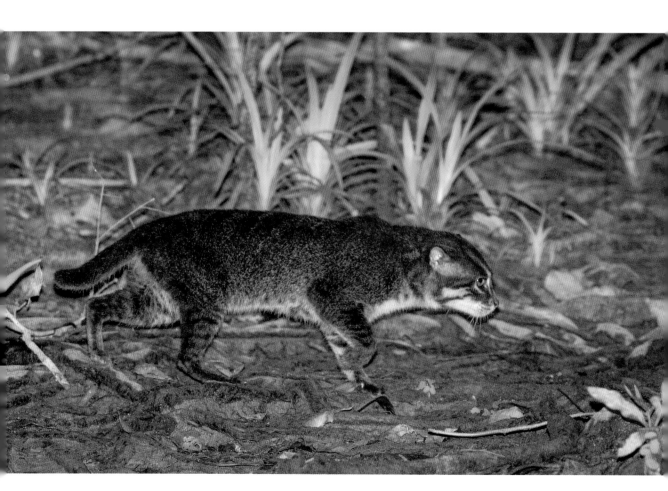

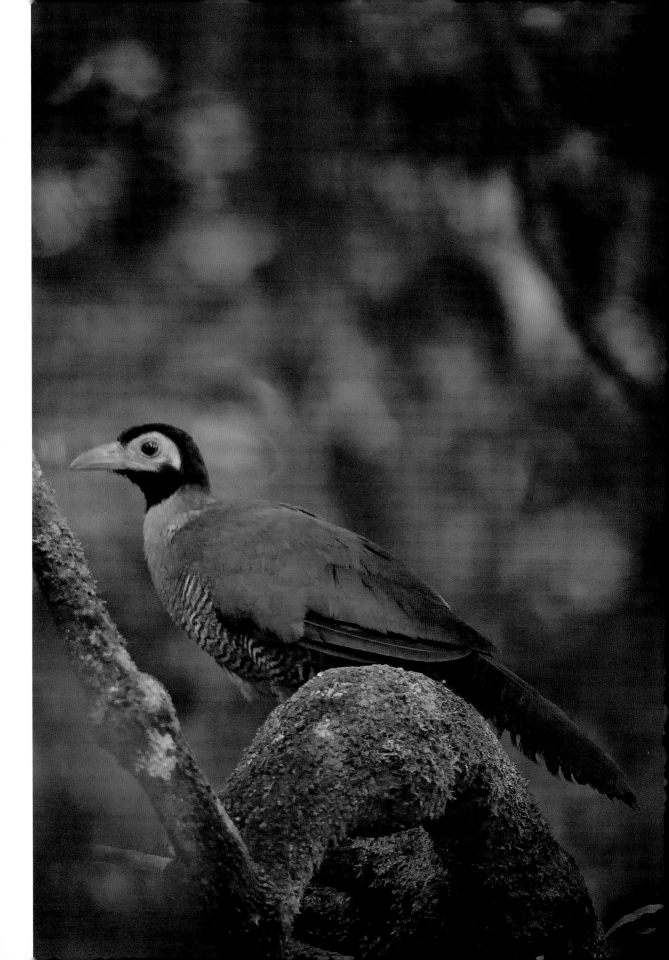

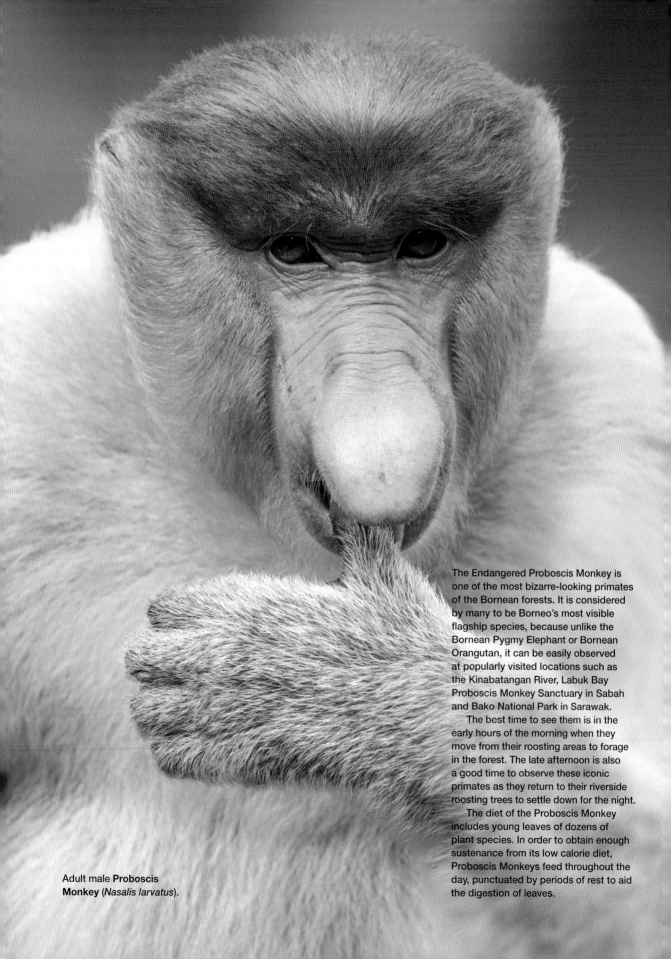

The Endangered Proboscis Monkey is one of the most bizarre-looking primates of the Bornean forests. It is considered by many to be Borneo's most visible flagship species, because unlike the Bornean Pygmy Elephant or Bornean Orangutan, it can be easily observed at popularly visited locations such as the Kinabatangan River, Labuk Bay Proboscis Monkey Sanctuary in Sabah and Bako National Park in Sarawak.

The best time to see them is in the early hours of the morning when they move from their roosting areas to forage in the forest. The late afternoon is also a good time to observe these iconic primates as they return to their riverside roosting trees to settle down for the night.

The diet of the Proboscis Monkey includes young leaves of dozens of plant species. In order to obtain enough sustenance from its low calorie diet, Proboscis Monkeys feed throughout the day, punctuated by periods of rest to aid the digestion of leaves.

Adult male **Proboscis Monkey** (*Nasalis larvatus*).

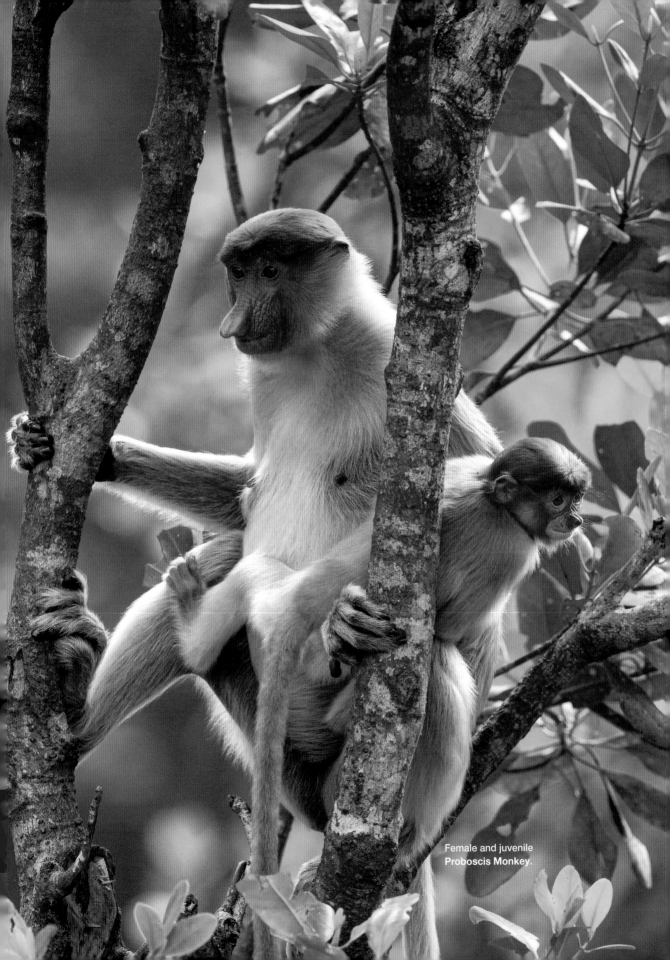

Female and juvenile
Proboscis Monkey.

Myanmar

Myanmar is a country of significant geographical diversity. It spans over 2,000 km (1240 mi), from the lofty Himalayas in the north to the steamy lowland rainforests of Tanintharyi in the south. The country occupies nearly 678,000 km² (262,000 mi²) and supports a magnificent assemblage of plants and animals. It boasts more than 1,000 bird species, around 300 mammals, 350 reptiles and 100 amphibians.

For decades, Myanmar's mountains, forests and wetlands were unexplored because of poor infrastructure, civil unrest and active insurgent groups in many parts of the country. Between 2011 to 2021, Myanmar underwent a period when biodiversity conservation and research work picked up considerable momentum. Field surveys discovered some of the largest congregations of migratory shorebirds in Asia, including the Spoon-billed Sandpiper. Surveys refound populations of the White-bellied Heron while the mysterious Jerdon's Babbler and Gurney's Pitta resurfaced after a gap of nearly a century. Even major new species were discovered for science, most notably the Myanmar Snub-nosed Monkey. Large-scale conservation projects have been launched by international and local NGOs to protect the country's forests, from Kachin in the north to Tanintharyi. From 2021, the situation has once again deteriorated due

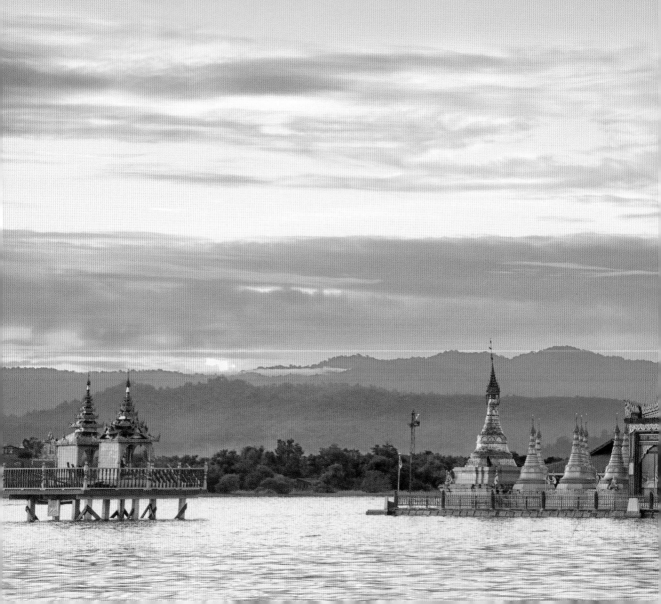

to political instability and it appears that entry into the country for tourism may come with several risks.

Despite good progress in poverty reduction, around 25 per cent of Myanmar's population lives below the poverty line. Many communities depend on natural resources for their livelihoods.

Myanmar's nature conservation record is mixed. There are multiple reasons for this, including political instability along its borderlands and overexploitation of wildlife. However, a major driver of biodiversity loss is the serious reduction of the quality and area of natural habitats. In particular, lowland forests in the biodiverse south and the hills east and west of Yangon have been heavily logged and converted into agricultural areas and plantations. The good news is that Myanmar still retains large tracts of forests and undisturbed coastal and marine ecosystems of exceptionally high conservation value, such as coral reefs and mangroves. These areas will need to be urgently conserved in the coming years.

Myanmar's opening up after decades of isolation in the early 2010s created a unique opportunity to shape the direction of nature conservation. Conservation activities have increased in momentum with the emergence of national NGOs like the Biodiversity and Nature Conservation Association (BANCA). BANCA is a leading environmental NGO in Myanmar and has

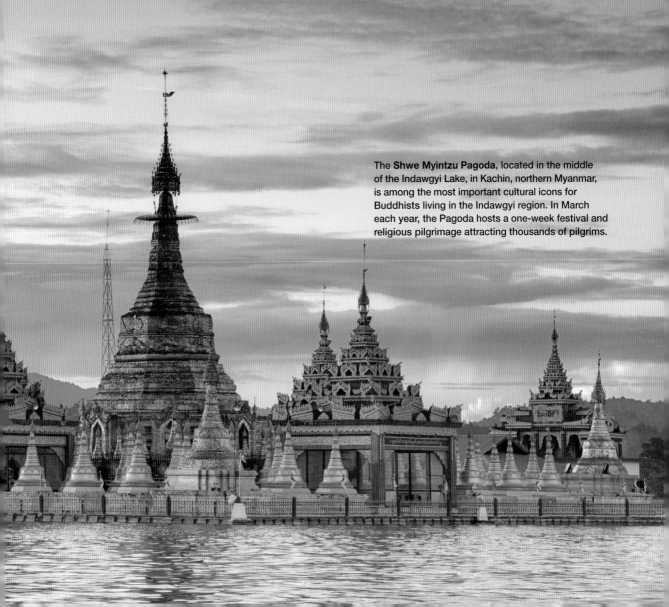

The **Shwe Myintzu Pagoda**, located in the middle of the Indawgyi Lake, in Kachin, northern Myanmar, is among the most important cultural icons for Buddhists living in the Indawgyi region. In March each year, the Pagoda hosts a one-week festival and religious pilgrimage attracting thousands of pilgrims.

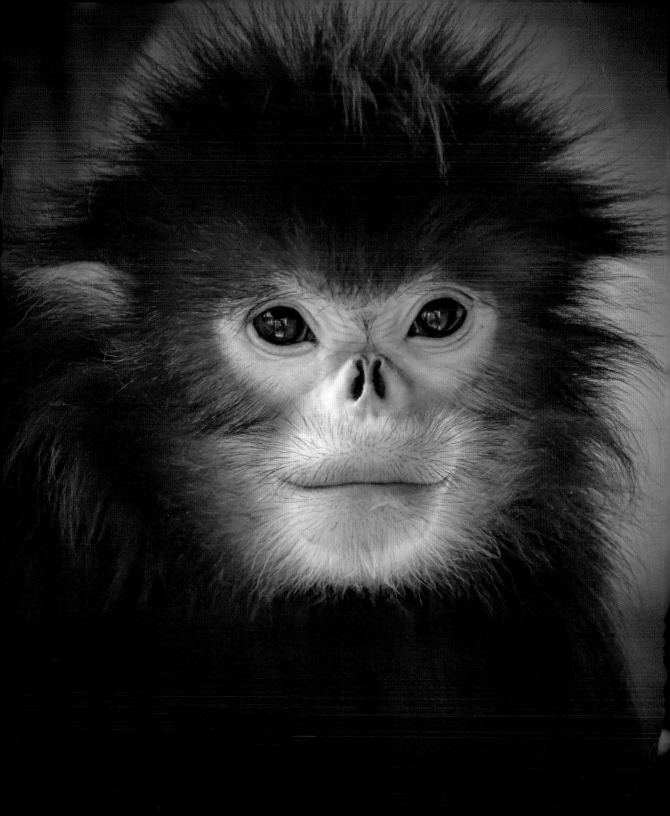

One of the most startling mammal discoveries in recent years is that of the **Myanmar** or **Black Snub-nosed Monkey**. This primate was discovered by a team from FFI and BANCA in 2010. The remarkable find was made during a biodiversity survey led by FFI Programme Manager Ngwe Lwin, who first recognised the monkey as a possible new species. It was described the year after based on a dead specimen and two adult skulls. These samples were collected from Lisu hunters in the mountains of Kachin State, bordering China. Sadly, new species are often identified from hunters' trophies in many parts of Southeast Asia where wildlife protection remains weak.

RIGHT The Critically Endangered **Gurney's Pitta** (*Hydrornis gurneyi*) was described by the eminent British ornithologist Allan O. Hume, from specimens and surveys in lower Burma (modern day Tanintharyi) in 1875. Subsequently, this lowland specialist disappeared for much of the 20th century. A very small population was rediscovered on the Thai side of the Malay Peninsula in 1986.

In 2003, the Gurney's Pitta was rediscovered in several locations in Tanintharyi, which holds some of the largest continuous lowland forests in mainland Southeast Asia. However, significant areas have since been cleared and converted into oil palm, rubber and betel nut plantations. Based on research published in 2019, it is estimated that 80% of the Gurney's Pitta habitat has been lost in less than two decades. Very little of the remaining semi-evergreen forests are legally protected. Not surprisingly, the species has declined greatly in Myanmar and is now on the brink of extinction. In Thailand, the species may already be functionally extinct.

worked closely for many years with organisations like Fauna and Flora International (FFI), BirdLife International, the Royal Society for the Protection of Birds (RSPB), as well as the Myanmese government.

In 2012, an additional population of the Myanmar Snub-nosed Monkey was found across the Chinese border, around 50 km (30 mi) southeast of the original site in Myanmar. Further localities of this enigmatic primate have been reported on the eastern slopes of the Gaoligong Mountain Range in Yunnan Province, China.

Following this epic discovery, outreach and engagement activities were undertaken in the 54 villages in the area. A non-hunting zone has been established with 23 local conservation groups. This has reduced the hunting pressure on wildlife and primates. Small grants have been given to villagers to support their livelihood activities.

Boundaries for land and forest utilisation areas have been established and agreed upon with indigenous communities. Plans are in place to organise community patrol groups to monitor and protect the Myanmar Snub-nosed Monkey population.

In 2020, the upland forest habitat of the Myanmar Snub-nosed Monkey was declared a protected area. Covering an area of over 1,500 km² (580 mi²), Imawbum may be home to nearly the entire population of the species in Myanmar, which possibly number less than 330 individuals. Teams of conservationists are working with local communities to safeguard the future of the species.

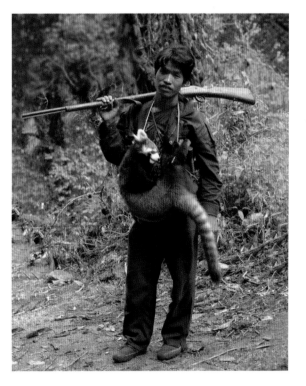

ABOVE This **Chinese Red Panda** (*Ailurus styani*) was shot by a Lisu tribesman in the Imawbum area.

Many of the indigenous peoples of northern and western Myanmar hunt wildlife for food and traditional medicine. Originally, they practiced subsistence hunting with cross bows, home-made guns and snares. Over the last 15 years, there has been a noticeable shift to commercial hunting with the use of factory-made guns and snare traps. This has unfortunately accelerated the unsustainable harvest of wildlife.

Indawgyi Lake Wildlife Sanctuary

Kachin State is the northernmost state of Myanmar. It is an area of exceptional natural beauty and extraordinary species diversity given its location in the eastern Himalayas. Kachin State is the home of Indawgyi Lake Wildlife Sanctuary, a UNESCO Biosphere Reserve since 2017. The sanctuary covers more than 800 km² (310 mi²), including its namesake 260 km² (100 mi²) Indawgyi Lake. The lake stretches 24 km (15 mi) from north to south and 10 km (six mi) from east to west. It is one of the largest natural inland lakes in Southeast Asia. The local communities living in and around the Sanctuary depend on agriculture and fishing for their livelihoods.

Indawgyi's landscape is defined by the Indawgyi lake basin, which in turn is surrounded by large tracts of freshwater wetlands. These wetlands are encircled by paddy fields and villages. Parallel to the lake on the east and west are forested mountain ranges that reach 1,200 m (3,900 ft) in elevation. The forests here consist of mixed evergreen and deciduous hardwood forest, riverine evergreen forest, and hill pine forest.

Seasonally flooded grasslands form one of the most important wildlife habitats of the Indawgyi basin. During the monsoon season, they are fully inundated and become an important aquatic habitat and breeding area for fish.

Over 400 bird species have been observed at the lake and its surrounding catchment area. Indawgyi Lake is a part of the East Asian-Australasian Flyway, used by thousands of waterbirds between November and March each year. These include large congregations of wintering ducks, most notably regular numbers of the highly threatened Baer's Pochard (*Aythya baeri*).

Myanmar has suffered from prolonged internal strife, involving a number of armed groups in its border areas. At the time of writing, it is no longer possible to visit Indawgyi due to simmering unrest and widespread political instability.

That said, Indawgyi remains one of the hidden gems of northern Myanmar. Located off the beaten track, only a few hundred international tourists visit the lake and the surrounding mountains every year. The fastest way to Indawgyi Lake is to fly from Yangon to Myitkyina, the capital of Kachin State. From there it is another four to five hours' drive (180 km) (110 mi) to the delightful lakeside village of Lonton. Here, one budget motel and one simple guest house are permitted to house foreign visitors.

One of the attractions is the Indawgyi Wetland Education Centre located just north of Lonton village. The centre features informative exhibits about the area's ecology and wildlife, as well as insights into the local culture and history. In addition, the centre provides regular environmental educational programmes for the local community.

The Wetland Educational Centre also operates as a visitors' meeting point and café. The local eco-tourist group Inn Chit Thu can arrange for activities like boat trips, kayak and bicycle tours, guided trekking and birdwatching, which are all recommended.

The Indawgyi Lake Wildlife Sanctuary has a subtropical monsoon climate, with a mild winter, warm spring and wet summer. The dry season spans November to April whilst the rainy season is from June to September. The coldest periods are in December/January when night time temperatures can plunge below 10 °C (50 °F). The hottest period is in March/April with day temperatures above 35 °C (95 °F).

Biodiversity research in Indawgyi picked up momentum from 2008, which subsequently led to the designation of the Indawgyi Lake basin as a UNESCO Biosphere Reserve some 10 years later. Co-ordinated by Fauna & Flora International, a variety of conservation programmes were undertaken with local NGOs. The activities include livelihood diversification, environmental and ecotourism education, organic farming practices, community forestry programmes, and community based waste management services.

Inn Chit Thu is a local ecotourism organisation operating from the Indawgyi Wetland Education Centre. It organises waste clean-ups around Lonton village, and supports household sanitation programmes for locals.

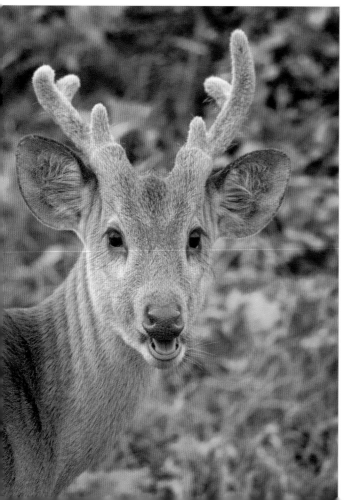

LEFT The preferred habitat of the Endangered **Hog Deer** (*Axis porcinus*) is seasonally flooded tall grasslands, once common on the riverine floodplains of tropical Asia. Today, most floodplain habitats have been converted to agriculture. The same fate has befallen the grasslands around Indawgyi Lake. The Hog Deer is hunted throughout its range which has resulted in major population declines. In Myanmar, this species is only protected at three locations: Indawgyi, Hukaung Valley and Pidaung Wildlife Sanctuaries.

RIGHT TOP Flocks of **Greylag Geese** (*Anser anser*) are among the waterfowl species that winter at Indawgyi Lake each year. To reach Indawgyi and other wetlands in northern Myanmar and eastern India, these geese migrate through the Himalayan mountains, the Tibetan Plateau and the arid deserts of central Asia from their breeding grounds further north.

RIGHT BOTTOM Some of the largest wintering congregations of the **Common Crane** (*Grus grus*) in Southeast Asia occur in the wetlands around Indawgyi Lake. The lake is also an important habitat of the Sarus Crane, the region's only resident crane.

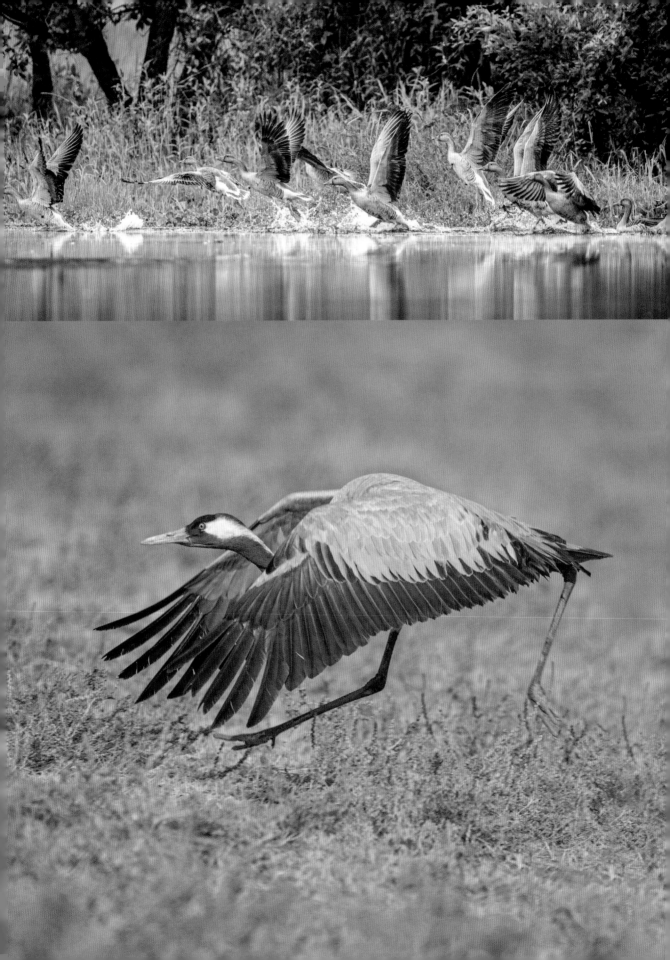

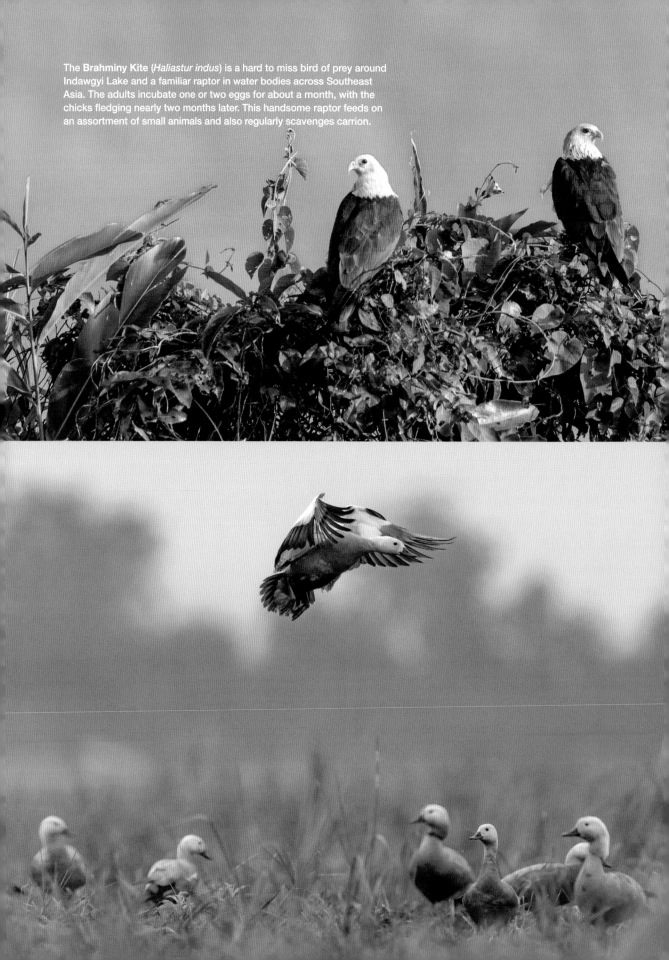

The **Brahminy Kite** (*Haliastur indus*) is a hard to miss bird of prey around Indawgyi Lake and a familiar raptor in water bodies across Southeast Asia. The adults incubate one or two eggs for about a month, with the chicks fledging nearly two months later. This handsome raptor feeds on an assortment of small animals and also regularly scavenges carrion.

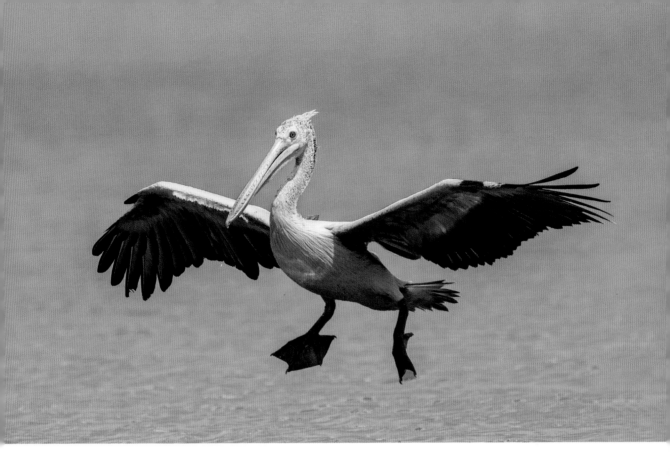

ABOVE The **Spot-billed Pelican** (*Pelecanus philippensis*) can be seen almost all year round in Indawgyi, with larger congregations between May and August. It needs large undisturbed trees for nesting and roosting. Once upon a time, it used to nest in large colonies along the Sittaung River in central Myanmar. It is unclear if there are any breeding colonies of the pelican left in Myanmar.

RIGHT Vultures have suffered some of the steepest declines among birds in the region. In Southeast Asia, most populations of the four known breeding species have collapsed. Survivors are now scattered between northern Myanmar and Cambodia. Kachin state is one of the few areas in Myanmar where the Critically Endangered **Slender-billed Vulture** (*Gyps tenuirostris*) can still be found in numbers. The historic decline of vulture populations in Myanmar is likely to have resulted from a collapse in food supply. This in turn is caused by a decrease in wild ungulates due to heavy hunting. In the case of Indawgyi and adjacent areas, this problem is further accentuated by a decline in livestock herding, which otherwise offers an important food source for vultures given the scarcity of large wild mammals.

LEFT The **Ruddy Shelduck** (*Tadorna ferruginea*) is a commonly encountered migratory duck in wetlands scattered across Myanmar, and especially on the sandy banks of major rivers. As seen here at Indawgyi Lake, it often forages in grassland where pairs or groups can be observed consuming leaves, seeds and stems, as well as invertebrates.

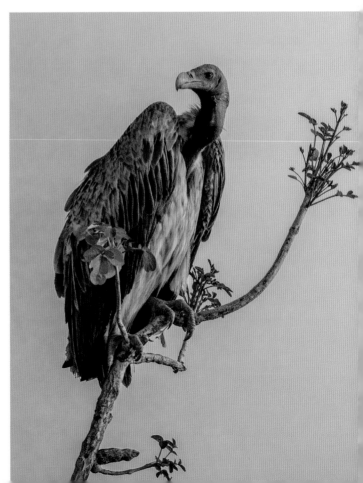

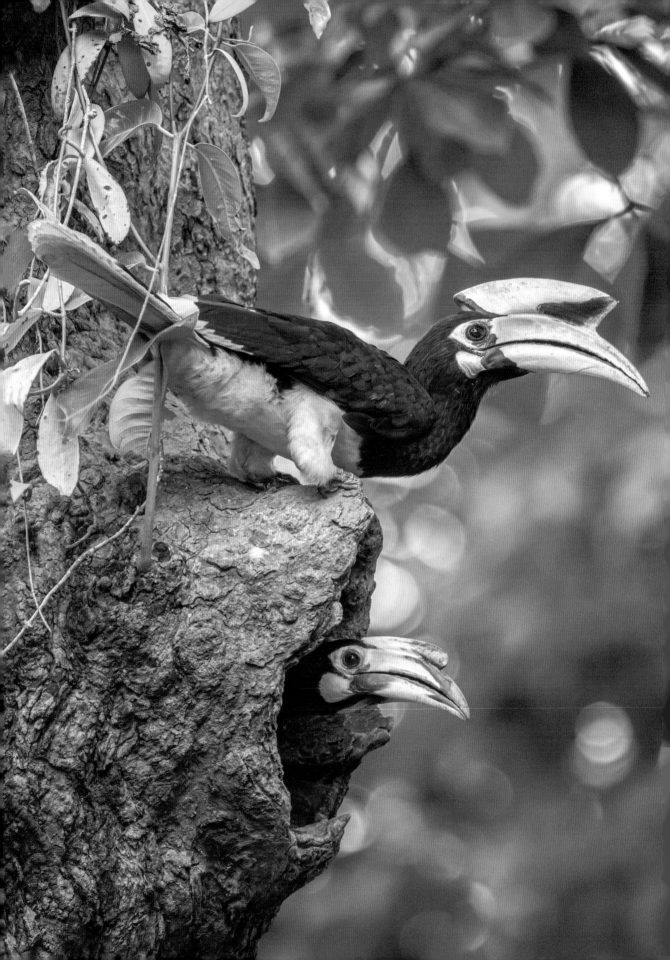

Singapore

Singapore is a gleaming city state consisting of one main island and some 60 smaller satellite islands at the southern tip of the Malay Peninsula and east of Indonesia's Sumatra. The country covers a land area of just over 700 km² (270 mi²), which is approximately half the size of metropolitan London.

Singapore is located at the centre of Southeast Asia, one of the most biodiverse regions in the world. Before the arrival of humans, Singapore's primeval vegetation was mainly lowland rainforest with mangrove forests along much of the coast and freshwater swamp forest further inland along streams and rivers. Large scale deforestation started early in the 19th century after British colonisation and by 1900, some 90 per cent of the original forest had been cleared, largely for agriculture. Despite heavy pressure from development and urbanisation, the number of wild and native species in Singapore may exceed 40,000.

The management of Singapore's forests dates back to the colonial period, when forest reserves were created by the British colonial government in the late 19th century. In 1967, the government of a newly independent Singapore introduced the 'Garden City' vision, and in subsequent years, major efforts were made to reduce pollution and clean up waterways, bringing back aquatic life into river systems.

Despite being densely populated, a 2017 study confirmed that Singapore has one of the highest "greenery density rates" of any major city in the world. Going forward, there is a need to balance increasing urbanisation with further safeguarding of areas covered with natural vegetation that are still 'unprotected'.

In the 19th century there were 3 species of hornbills in Singapore, but by sometime around the early 1900s both the Rhinoceros Hornbill and the Helmeted Hornbill had vanished, while the last recorded sighting of the **Oriental Pied Hornbill** (*Anthracoceros albirostris*) was in the 1920s. It was not until the 1990s that the Oriental Pied Hornbill was recorded in Singapore again. Since then, artificial nest boxes have been put up in several locations under a reintroduction programme, and this no doubt has helped boost the hornbill population further, which now numbers a couple of hundred individuals.

Given the scarcity of land, it is an obvious challenge to maintain a vibrant city of some six million people while at the same time protecting and preserving the country's biodiversity.

Singapore is situated just above the equator and its tropical climate is characterised by uniformly warm temperatures, abundant rainfall and high humidity all year around. There are two monsoon seasons, the northeast monsoon from December to March, and the southwest monsoon from June to September. The hottest and driest period is normally from February to May.

Singapore is centrally located and well connected by air to the rest of the world. Food and accommodation can be arranged without hassle. An extensive public transport system including trains, buses and taxis makes it easy for visitors to get around the country to enjoy its bountiful nature.

Over 400 bird species have been documented in Singapore, a figure that continues to increase. Sought-after species include the Straw-headed Bulbul, Red-legged Crake, Copper-throated Sunbird and Jambu Fruit-Dove, and in the winter months migratory species such as the Brown-chested Jungle Flycatcher, Hooded Pitta and Von Schrenck's Bittern may be observed. The country also supports a high diversity of reptiles and mammals, best headlined by the Smooth-coated Otter, a species once considered very rare. In Singapore, wildlife poaching is no longer a big issue compared to the rest of the region, and the island nation is today a safe haven for highly threatened species like the Sunda Pangolin and Straw-headed Bulbul.

Singapore offers excellent opportunities for birdwatching, during all months of the year. The time between August and April, when migratory birds from more northerly latitudes are visiting, is the most popular period for birdwatchers. Visiting naturalists can also observe a fantastic diversity of mammals and reptiles, including the stunning Paradise Tree Snake, Blue Malayan Coral Snake and King Cobra.

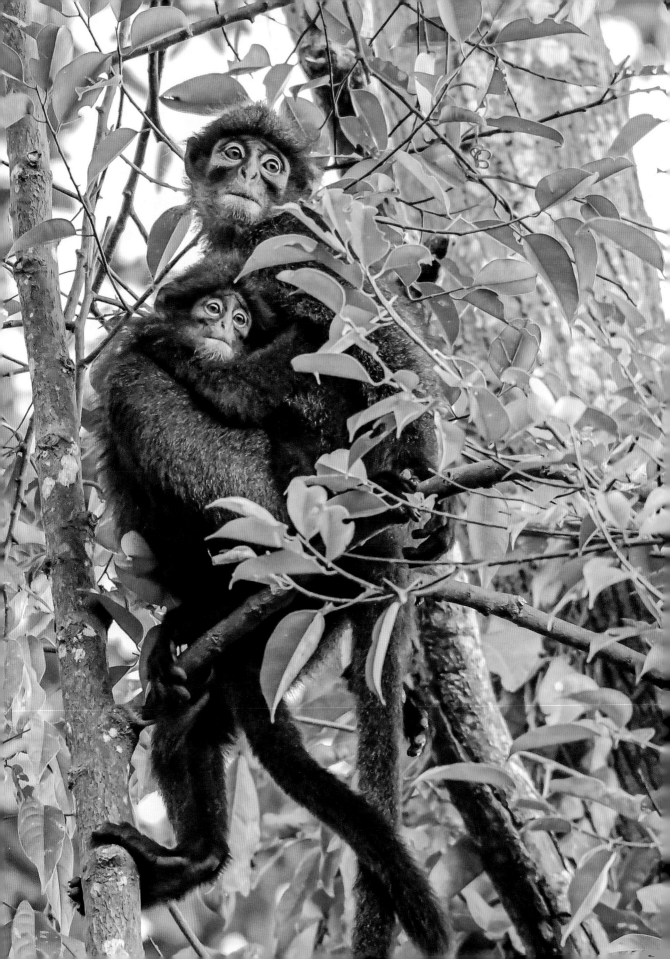

RIGHT The **Lesser Mouse-deer** (*Tragulus kanchil*) is among the world's smallest hoofed mammals with a body length of less than 50 cm (20 in) weighing only around two kg (4.4 lb). *Kanchil* is the Malay name for the mouse-deer, and is used metaphorically for a clever person. Throughout Southeast Asia, it is heavily hunted and threatened with predation by feral dogs.

LEFT The distribution of the **Raffles' Banded Langur** (*Presbytis femoralis femoralis*) is restricted to southern Peninsular Malaysia and Singapore, where it is now generally confined to the forests of the Central Catchment area. In 2021, for the first time in more than 30 years, a Raffles' Banded Langur was sighted in the Bukit Timah Nature Reserve.

 Due to loss of habitat in Singapore as well as land use change in Malaysia, the Raffles' Banded Langur is now Critically Endangered, with less than 70 individuals left in Singapore. This species is elusive and highly arboreal, making it difficult to observe as it rarely descends to the ground unless it has to travel between forest fragments.

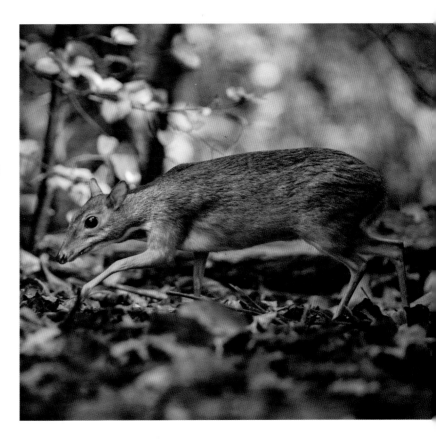

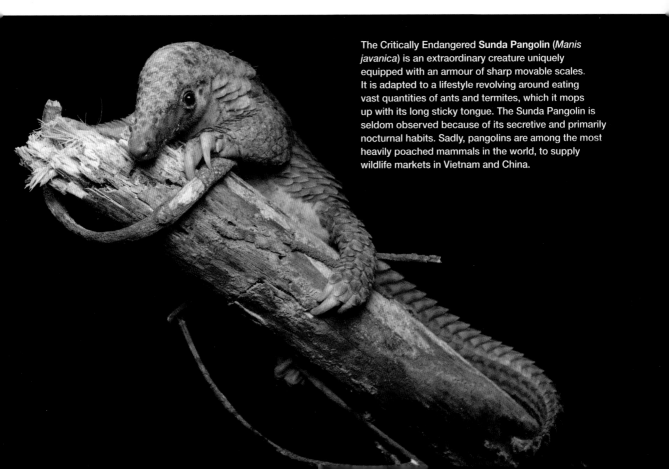

The Critically Endangered **Sunda Pangolin** (*Manis javanica*) is an extraordinary creature uniquely equipped with an armour of sharp movable scales. It is adapted to a lifestyle revolving around eating vast quantities of ants and termites, which it mops up with its long sticky tongue. The Sunda Pangolin is seldom observed because of its secretive and primarily nocturnal habits. Sadly, pangolins are among the most heavily poached mammals in the world, to supply wildlife markets in Vietnam and China.

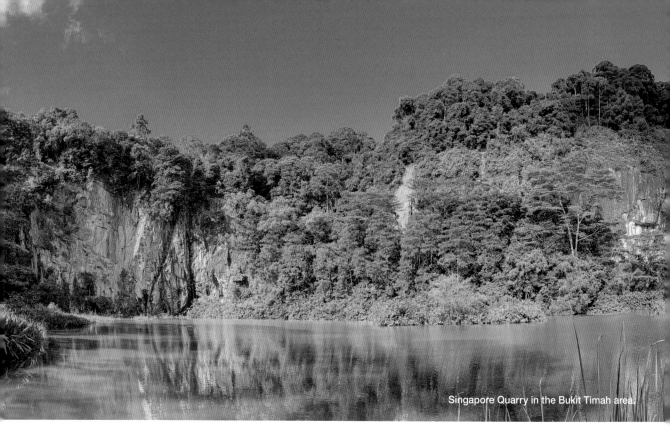

Singapore Quarry in the Bukit Timah area.

Central Catchment and Bukit Timah Nature Reserves

The Central Catchment Nature Reserve is Singapore's largest forest. It is the country's green lungs and home to some of the last remaining patches of Singapore's original rainforest. Within the Central Catchment you will also find the Nee Soon Swamp Forest, which is the only substantial patch of freshwater swamp habitat left in Singapore. Some 25 per cent of Singapore's native freshwater fish can only be found here.

In the past, the Central Catchment and the Bukit Timah Nature Reserves formed a nearly contiguous area. This changed in 1986 when the Bukit Timah Expressway was built, severing the reserves into two separate parts. Subsequently, to facilitate animal movements between the two forests, the 62 m (200 ft) Eco-Link@BKE bridge was built over the expressway in 2013, reconnecting the 20 km² (8 mi²) Central Catchment with the Bukit Timah Nature Reserve. The Eco-Link is one of the few such wildlife bridges in Southeast Asia.

The Central Catchment Nature Reserve is Singapore's main water catchment area and consists of four reservoirs: MacRitchie, Lower Peirce, Upper Peirce and Upper Seletar.

Located in the southern end of the Central Catchment, MacRitchie Reservoir Park has an extensive network of hiking trails. Starting at the entrance at Venus Drive, the 20-km (8-mi) network takes visitors through secondary forests at various stages of regeneration, and is a good way to study the structure of tropical rainforests. Another highlight is the TreeTop Walk, a suspension bridge hanging some 25 m (80 ft) above the forest floor. The TreeTop Walk offers a spectacular vantage of the forest canopy with more than 100 bird species recorded. The seven deck Jelutong Tower is popular with birdwatchers and photographers observing canopy-dwelling species such as leafbirds, swiftlets, raptors, barbets and pigeons.

A little to the north of MacRitchie is the Upper Peirce Forest. This part of the Central Catchment is less visited but one may readily encounter several forest birds such as the Red-crowned Barbet and Chestnut-bellied Malkoha, and if one is lucky, the Raffles' Banded Langur.

Bukit Timah Nature Reserve, an ASEAN Heritage Park, protects some of Singapore's last remaining bits of old-growth forest. Once upon a time, old-growth rainforests formed the island's main vegetation cover, and also its richest ecosystem. The reserve has Singapore's highest point, the Bukit Timah Hill which stands at 164 m (538 ft).

Bukit Timah Nature Reserve can be reached via Hindhede Drive. The main track up Bukit Timah Hill is often crowded, so trying some of the side paths may be worthwhile for observing animal life. When in fruit, fig trees at the summit of Bukit Timah Hill can be very productive when various leafbirds, fruit doves and flowerpeckers congregate.

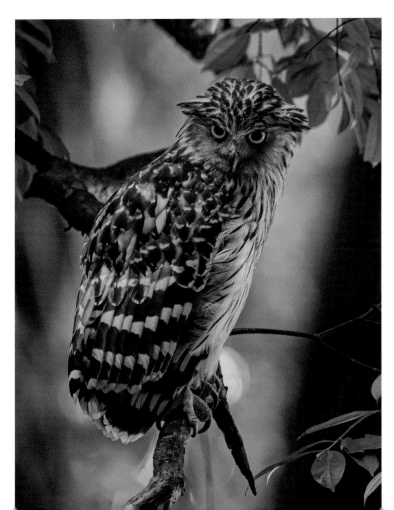

The **Buffy Fish-Owl** (*Ketupa ketupu*) appears to have adapted well to Singapore's urban greenery and occupies a wide range of wooded habitats. It forages at night, and at times can be observed emerging from its roosting site late in the afternoon. This bulky owl hunts from a perch, swooping down to catch fish and frogs from the shallow edges of reservoirs, ponds, streams and canals.

RIGHT Long-horned Orb Weaver (*Macracantha arcuata*) documented here from Bukit Timah Nature Reserve must certainly be one of Southeast Asia's most recognisable spiders. This species is associated with old-growth, little disturbed dipterocarp forests.

BELOW Jumping Spider (*Hyllus* sp.) from Venus Drive at Central Catchment Nature Reserve. Jumping spiders are among the most species-rich groups of spiders in Singapore with well over 70 species documented to date.

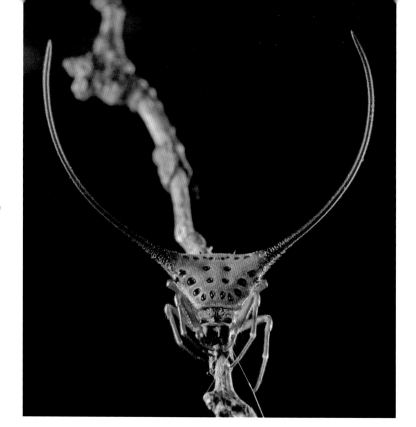

RIGHT The tender embrace of a mating pair of **Sunda Colugos** (*Galeopterus variegatus*). Colugos are peculiar mammals of the Southeast Asian rainforests, often inaccurately referred to as 'flying lemurs' even though they are neither lemurs nor can they achieve powered flight. It is now widely accepted that colugos are distant relatives of the primates. The extensive patagium stretches out across the limbs and tail, and enables colugos to glide from tree to tree covering over 100 m (330 ft).

BELOW The colourful **Red-crowned Barbet** (*Psilopogon rafflesii*) is the only forest barbet left in Singapore, the others having gone extinct. Although extremely vocal and can be heard in many parts of the Central Catchment, observing one well is a different story.

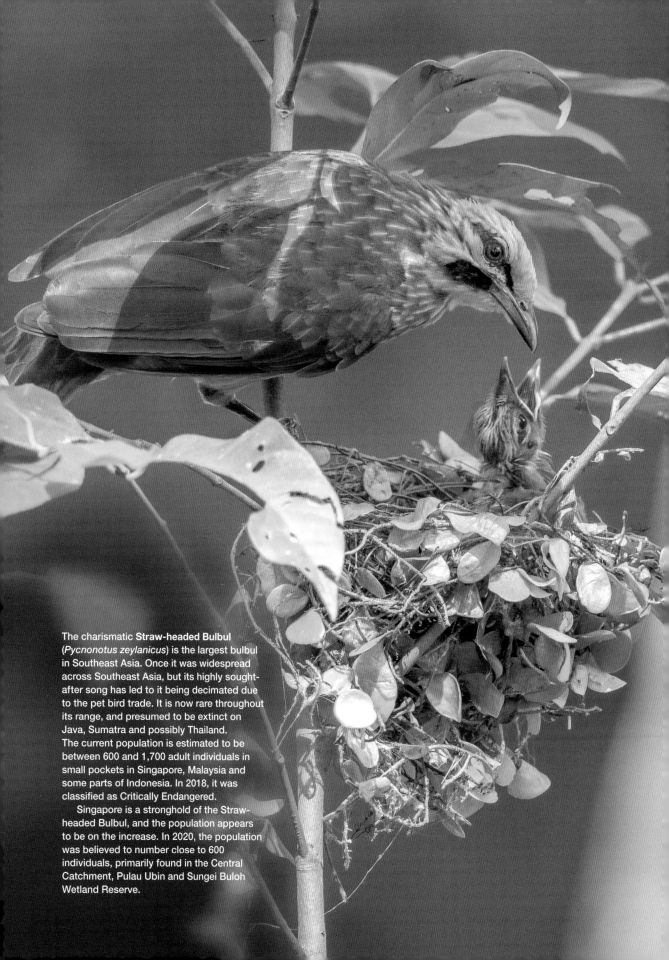

The charismatic **Straw-headed Bulbul** (*Pycnonotus zeylanicus*) is the largest bulbul in Southeast Asia. Once it was widespread across Southeast Asia, but its highly sought-after song has led to it being decimated due to the pet bird trade. It is now rare throughout its range, and presumed to be extinct on Java, Sumatra and possibly Thailand. The current population is estimated to be between 600 and 1,700 adult individuals in small pockets in Singapore, Malaysia and some parts of Indonesia. In 2018, it was classified as Critically Endangered.

Singapore is a stronghold of the Straw-headed Bulbul, and the population appears to be on the increase. In 2020, the population was believed to number close to 600 individuals, primarily found in the Central Catchment, Pulau Ubin and Sungei Buloh Wetland Reserve.

Sungei Buloh Wetland Reserve

The Sungei Buloh Wetland Reserve is situated on the northwestern tip of Singapore and represents the once extensive mangrove forests that lined the northern coast of the island. Sungei Buloh protects riverine estuaries, mudflats, creeks and mangrove islands, the largest of which is Buloh Island. Mangroves and mudflats are surprisingly rich in biodiversity, many little known and recent studies of mangroves in Singapore have led to the discovery of several invertebrate species new to science.

It was not until the mid 1980s that the diversity of the area's birdlife was fully realised by local conservationists. The importance of these wetlands to migratory shorebirds in the East Asian-Australasian Flyway formed the basis for its conservation. A team from the Singapore branch of the Malayan Nature Society then (today the Nature Society [Singapore]), led by the prominent naturalist Richard Hale, convinced top government officials that the area should be preserved for posterity.

Sungei Buloh was gazetted as Singapore's first nature reserve post-independence and renamed Sungei Buloh Wetland Reserve. It subsequently became recognised as an Asean Heritage Park. In 2015, a 0.31 km² (0.12 mi²) extension extended the wetland reserve area to over 2 km² (0.8 mi²) of mangroves, freshwater marshland and secondary forest. Sungei Buloh is an important part of the Kranji-Mandai Important Bird and Biodiversity Area.

It is open from 7 am to 7 pm and no entrance fee is payable. From September to March, thousands of migratory birds arrive from their northern breeding grounds to rest and refuel before travelling to their wintering grounds in Indonesia and Australia. Several thousand shorebirds also spend their winters here.

At the time of writing, work has commenced at the new Sungei Buloh Nature Park Network, which aims to extend protection to other important areas like the Mandai mangroves, the Kranji marshes, as well as the nature areas of Jalan Gemala. The new network will cover more than four km² (1.5 mi²) offering 15 km (9 mi) of trails.

Some of the star species in Sungei Buloh include the Smooth-coated Otter, Saltwater Crocodile, Great-billed Heron, Buffy Fish Owl, Grey-headed Fish Eagle, Oriental Pied Hornbill, Lesser Adjutant and Copper-throated Sunbird. Regularly seen shorebirds here include the Whimbrel, Pacific Golden Plover and Common Redshank.

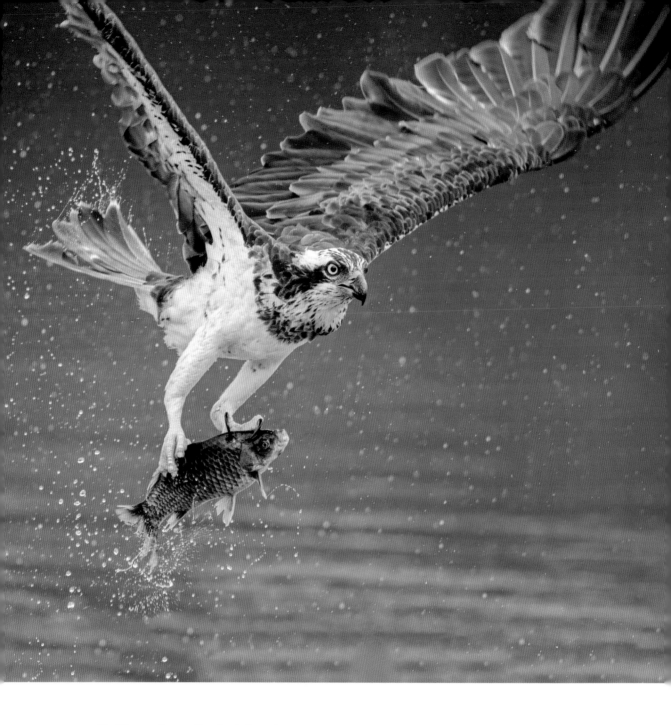

ABOVE The **Western Osprey** (*Pandion haliaetus*) is an uncommon raptor regularly seen along the Sungei Buloh coast, where it is most often encountered in the winter months between September and March. The osprey's vision is well adapted to spot underwater prey. When diving, they often plunge their entire bodies into the water.

RIGHT Black-capped Kingfisher (*Halcyon pileata*) with an unfortunate mudskipper along the main estuarine channel of Sungei Buloh Besar. This migratory kingfisher is a regular visitor to the park's mangroves but appear to have declined in recent years, as is the case with the population of this species across many parts of East Asia.

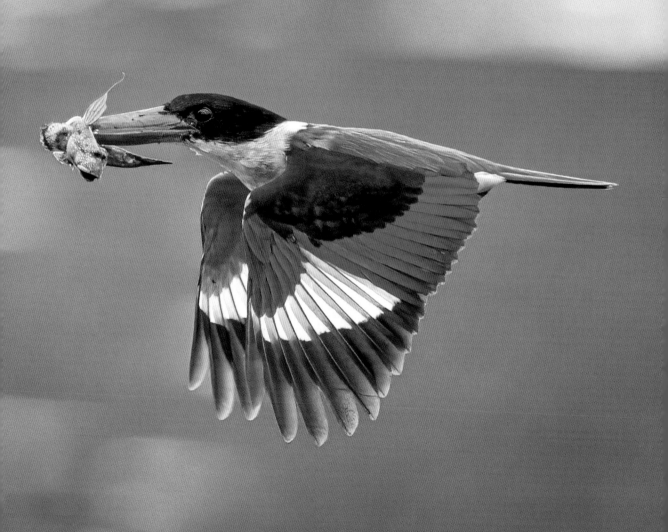

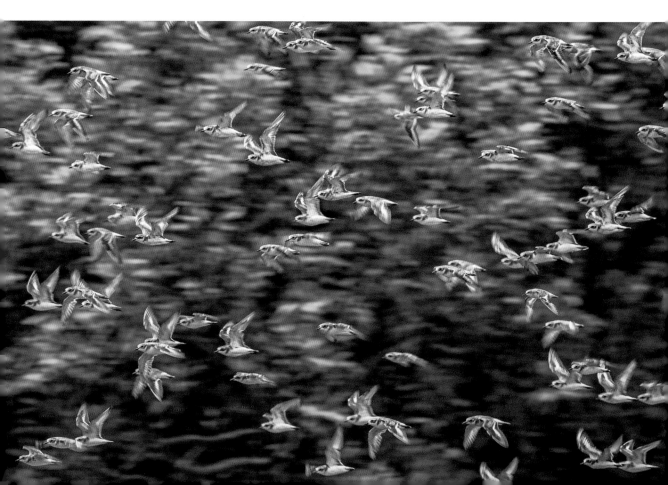

ABOVE Lesser Dog-faced Fruit Bats (*Cynopterus brachyotis*) form small roosting groups, shown here at the entrance of Sungei Buloh Wetland Reserve. This petit fruit bat is the most commonly seen of the fruit bats known from Singapore. The Lesser Dog-faced Fruit Bat is an important seed disperser and pollinator. Because of its small mouth, larger fruits are chewed whereas smaller fruits are swallowed. At times, it will consume the juices after chewing the fruit, while spitting out the remaining pulpy mess.

RIGHT Large **Saltwater Crocodiles** (*Crocodylus porosus*) are regularly seen at Sungei Buloh.

LEFT ABOVE One of the longest surviving **Common Redshank** (*Tringa totanus*) on record lived to be at least 20 years old. It was first tagged in 1990 at Sungei Buloh and re-captured in 2011.

LEFT Lesser Sandplover (*Charadrius mongolus*).

WATCH OUT
FOR CROCODILES
STAY CLEAR OF THE WATER'S EDGE

LEFT The heavy bill of the **Mangrove Pitta** (*Pitta megarhyncha*) sets it apart from other pittas. This mangrove specialist is one of four pitta species known to occur in Singapore and lives primarily in mangroves. It frequents the understorey, where it finds its invertebrate prey consisting chiefly of crabs. It is, however, no longer found in Sungei Buloh.

BELOW The **Whimbrel** (*Numenius phaeopus*) is one of the most common shorebirds in Sungei Buloh. It is both a passage migrant and winter visitor, often staying up to six months before returning to its breeding grounds in Siberia. Recent studies by the National Parks Board show that some of the Whimbrel here have migrated across the Himalayas from their breeding areas in central Russia.

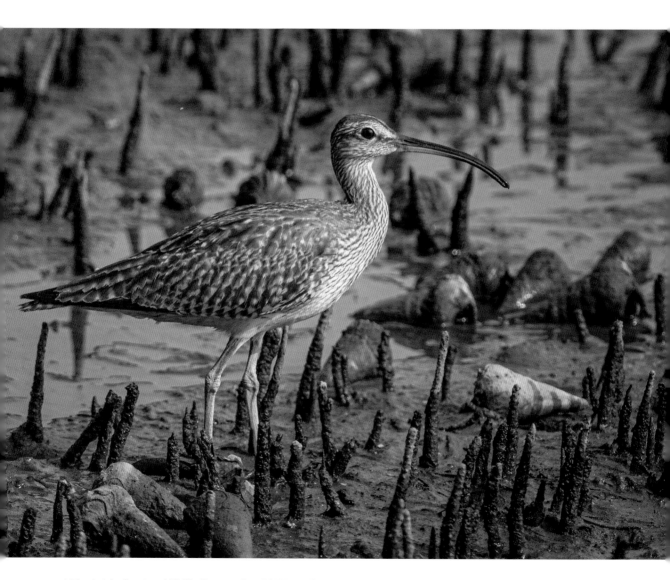

RIGHT The **Malayan Water Monitor** (*Varanus salvator*) is a common sight at Sungei Buloh. It can grow up to a length of three m (10 ft) and is the world's second largest lizard. Monitor lizards are mostly carnivorous and feed on a huge variety of food types; they also play an important ecological role as scavengers.

BELOW Frolicking **Smooth-coated Otters** (*Lutrogale perspicillata*) at Sungei Buloh Wetland Reserve. This species is the largest otter in Asia. Smooth-coated Otters have returned to Singapore after an absence of some 30 years, and are now commonly seen in many locations. Their return has been attributed to a number of reasons, including the clean-up of waterways, abundance of invasive fish prey in urban ecosystems as well good wildlife protection laws. These Smooth-coated Otters provide an encouraging example of how species can thrive in a heavily urbanised environment provided their ecological needs are met and protected.

Thailand

Situated in the heart of continental Southeast Asia, Thailand consistently wins the popularity stakes as a favoured wildlife and birdwatching destination for visitors to Asia. The country is highly regarded for its tourism infrastructure and astounding levels of biodiversity, protected by perhaps the finest networks of national parks in Southeast Asia. Thailand covers around the same land area as France. It encompasses many distinct ecosystems, including large tracts of hilly and mountainous forests on the frontier with Myanmar and Cambodia. The highly fertile central plains are drained by the Ping and Chao Phraya River Systems and heavily cultivated. To the northeast, the extensive Khorat Plateau stretches out to the borders of Laos and Cambodia. South of Bangkok, the country narrows into a long hilly strip stretching nearly a thousand kilometres towards Malaysia. The coast is complex and diverse, very muddy in parts and heavily utilised by people.

Thailand's climate is tropical, but strongly seasonal. Three seasons are normally recognised. The cool season is from November to February, the hot months from March to June, and the monsoon rains from June until October. These seasons are less pronounced in the peninsula and the southeast, where downpours may occur anytime during the year.

Thailand's temperatures are fairly stable throughout the year, averaging between 24 °C and 29 °C (75 °F and 84 °F). The greatest variations are in the northern mountain range of Thanon Thong Chai. Here, frost occasionally occurs in December at higher elevations, and fog can be frequent in the early mornings. In contrast, maritime influences from the Andaman Sea and Gulf of Thailand moderate the climate in the south. Humidity is particularly high during the rainy season. In the dry months, ticks are common in forested areas. When the monsoon season rolls in, leeches can be a nuisance. Detailed and useful information about Thailand's national parks is available at www.thainationalparks.com.

The magnificent biodiversity of Thailand is represented by close to 150 species of amphibians, more than 400 reptiles, and nearly 300 mammals. Thailand also boasts a national bird list numbering over 1,000 species. Many remarkable birds are more easily seen here than elsewhere. Amongst them are the Green Peafowl, Grey Peacock-pheasant, Coral-billed Ground-cuckoo, Spoon-billed Sandpiper and a good serving of spectacular broadbills, hornbills and pittas.

Thailand is a country of great contrast, and home to varied forests, grasslands and wetlands. It has one of the most extensive networks of protected areas in Southeast Asia with greater than 15 per cent of land area conserved as national parks, wildlife sanctuaries and non-hunting areas. However, rapid economic growth in Thailand has resulted in numerous environmental issues. Assessments vary, but for the past 70 years or so, forest cover has declined from more than 60 per cent of the total land area to less than one third today.

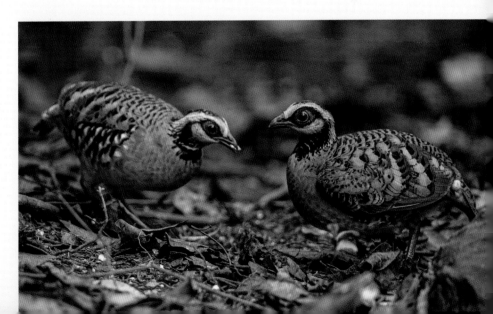

LEFT The ground dwelling **Siamese Fireback** (*Lophura diardi*) is regarded as Thailand's national bird. This striking male was photographed at Khao Yai National Park, the best known of a series of protected areas in the vast Dong Phayayen Forest Complex in south-east Thailand.

RIGHT A shy species, the **Bar-backed Partridge** (*Arborophila brunneopectus*) occurs widely in the mountains of western Thailand and can be regularly encountered at Kaeng Krachan and Mae Wong national parks.

These two Indochinese Tiger Cubs in the Dong Phayayen-Khao Yai Forest Complex are among the first ever photographed in eastern Thailand.

In 2017, Thailand's Department of National Parks announced the discovery of a second breeding population of Indochinese Tiger in the Dong Phayayen-Khao Yai Forest Complex. The field surveys were conducted together with conservation groups Freeland and Panthera. The photographic evidence of breeding tigers is the first in more than 15 years. Indeed, it is a long-awaited conservation milestone going towards ensuring the survival of this majestic cat in the wild. The survey collected data using 120 camera traps over a period of eight months, providing an estimate of 18 tigers in the park complex.

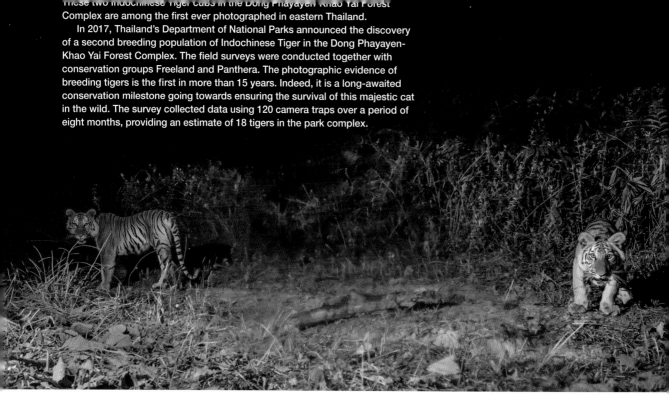

Thailand was among the first countries in the region to deplete large areas of its forests. Fortunately in the late 1980s, its government took the drastic step to ban logging. It was also among the first to create an extensive network of national parks. In the 1990s, Myanmar, Cambodia, Laos and Vietnam still had significant areas of pristine rainforests left with populations of Indochinese Tigers. In Thailand, up to the early 2000s, tiger numbers were in decline and seriously fragmented.

Meanwhile, in the other Southeast Asian countries, high levels of encroachment and illegal hunting have further depleted tiger populations to the point that the Indochinese Tiger is now considered extinct in Cambodia and functionally extinct in Vietnam and Laos. For Myanmar, population assessments vary between 50 and 100 individuals living in the far north and far south of the country, where extensive forest cover still remains.

In Thailand, strengthened conservation efforts and law enforcement have gradually allowed the population of Indochinese Tigers to recover in some places.

The protected areas of the Western Forest Complex bordering Myanmar, in particular the Huai Kha Khaeng Wildlife Sanctuary, are now the stronghold of the species. The Indochinese Tiger population in Thailand is estimated at 200 individuals, roughly half of the global population. With some of the best managed parks in Southeast Asia, Thailand now finds itself as the most important sanctuary of the Indochinese Tiger.

Logging and the growth of monoculture plantations such as rubber and oil palm are the main forces driving deforestation and other forms of encroachment. With a government ban on logging in place for the past three decades, deforestation rates have dropped. But illegal harvesting of the Siamese Rosewood (*Dalbergia cochinchinensis*) poses a serious problem. With its dark hues, density and fine grain, rosewood has long been a sought-after medium for elaborately carved furniture and religious statues. Equally serious is the illegal harvesting of agarwood (*Aquilaria* sp.) Encroachment of forested land for agricultural purposes is likewise a significant issue. Corruption often affects land tenure, making law enforcement more challenging.

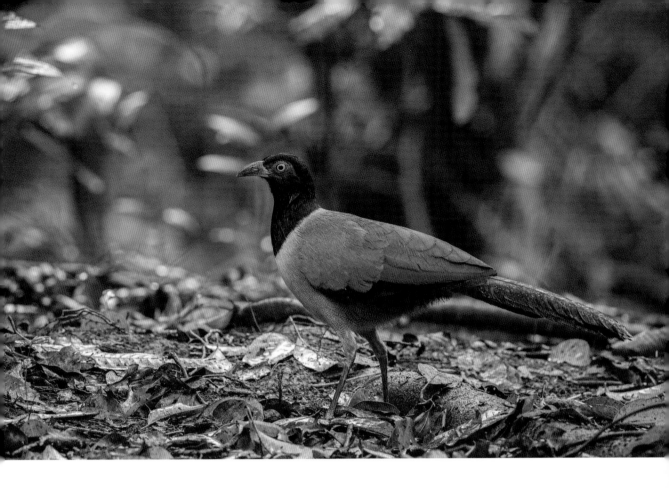

ABOVE Three species of ground cuckoos can be found in Asia. One of the best places on the planet to encounter the **Coral-billed Ground-cuckoo** (*Carpococcyx renauldi*) is on the forested trails of Khao Yai.

It is largely terrestrial, but nests and roosts in trees, and is quick and agile when running away from potential dangers. The ground-cuckoo is also capable of strong and sustained flight. Its preferred diet includes insects, reptiles, small birds and other tiny animals picked up from the ground.

When visiting Khao Yai, it is advisable to avoid weekends and school holidays as the park will be bustling with locals and tourists. The best period is from November to April.

It takes around three hours to drive from Bangkok to the main entrance in the north of the park. The nearest town is Pak Chong. There is a good choice of hotels and resorts near the north gate. The visitors' centre is located 14 km (9 mi) from the entry point. Here, a variety of forest trails radiate outwards for your exploration. Guided tours are a good option if you have limited time. They can be booked through hotels or tour operators. The park is open from 6 am to 6 pm all year round.

ABOVE The endemic **Rufous Limestone-babbler** (*Turdinus calcicola*) is very localised and believed to be restricted to the limestone hill country of Saraburi Province.

Dong Phayayen-Khao Yai Forest Complex

This UNESCO World Heritage Site covers five protected areas from Khao Yai National Park in the west stretching some 230 km (140 mi) to the east to the Ta Phraya National Park not far from the Cambodian border.

The rugged and mountainous Khao Yai is Thailand's oldest and best known national park. Around 80 per cent of Khao Yai consists of moist and dry evergreen or semi-evergreen forests. There are substantial areas of well-preserved old growth forests in the park. The complex represents a mosaic of different vegetation and habitat types remaining in southeast Thailand, including important forest ecosystems. With significant annual precipitation and an elevated topography, this landscape forms a critically important watershed for Thailand, feeding five major rivers.

As the last sizeable block of forest in eastern Thailand, Dong Phayayen-Khao Yai is hugely important for the conservation of many threatened and endangered mammal, bird and reptile species. Khao Yai alone is home to an estimated 800 species of vertebrates, including more than 60 species of mammals, close to 400 bird species and around 200 reptile and amphibian species.

The Dong Phayayen-Khao Yai forest complex faces various threats. This is accentuated by the lack of a buffer zone around the protected complex, increasing the impacts of encroachment. Much of the land surrounding the protected areas is now cultivated and a number of major roads skirt the margins.

Poaching is a known threat to large mammal and bird populations, as well as the precious Siamese Rosewood. Commercial trapping of birds for the pet trade servicing urban centres, especially Bangkok, is an issue. The trade does not benefit local villagers but rather urban-based middlemen in control.

Public roads crisscross the forest complex and internally fragment its wildlife habitats. At the same time, they provide access for poachers and illegal loggers. The growing traffic increases the frequency of animal roadkills. Moreover, the continued construction of visitor facilities may disturb mammal and bird life. Tourism, particularly during peak visitation periods, places pressure on the facilities and management. This is especially so for Khao Yai, which by far is the most popular site within the forest complex. Despite these problems, the construction of a wildlife corridor across highway 304 has improved ecological connectivity. By rebuilding the highway as a tunnel, the corridor has helped to re-establish the connections between Khao Yai and Thap Lan National Park, allowing the exchange of animal populations.

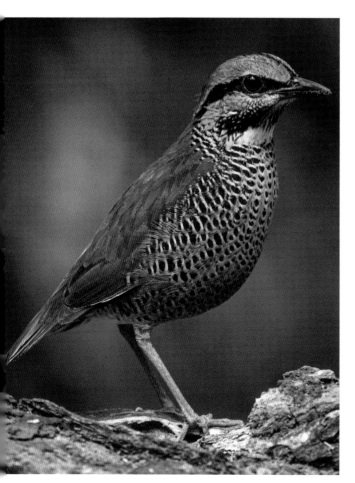

The gorgeous **Blue Pitta** (*Hydrornis cyaneus*) is not rare in Khao Yai. However, given its shy habits, it can easily be overlooked. The pitta forages by tossing the leaf litter with its bill for worms, grubs, snails and insects.

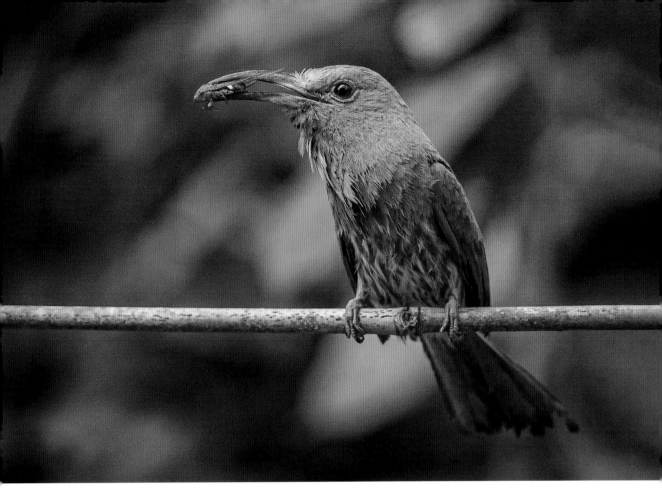

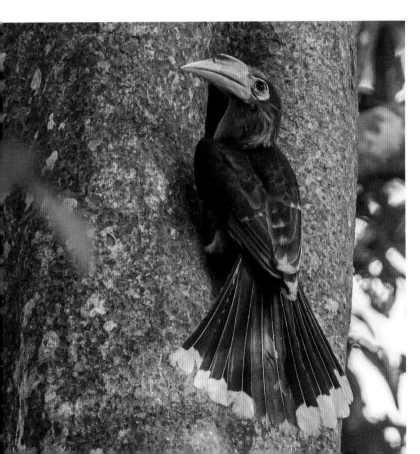

ABOVE Blue-bearded Bee-eater (*Nyctyornis athertoni*) seen here tending to nestlings in Khao Yai during the month of May. This bee-eater had excavated a burrow in a sandy bank by the road side. Both adults were busy feeding the chicks with bees and beetles.

LEFT Austen's Brown Hornbill (*Anorrhinus austeni*) in front of its nesting cavity. Like a number of other Asian hornbills, it is a cooperative breeder, with a dominant pair assisted by both female and male helpers.

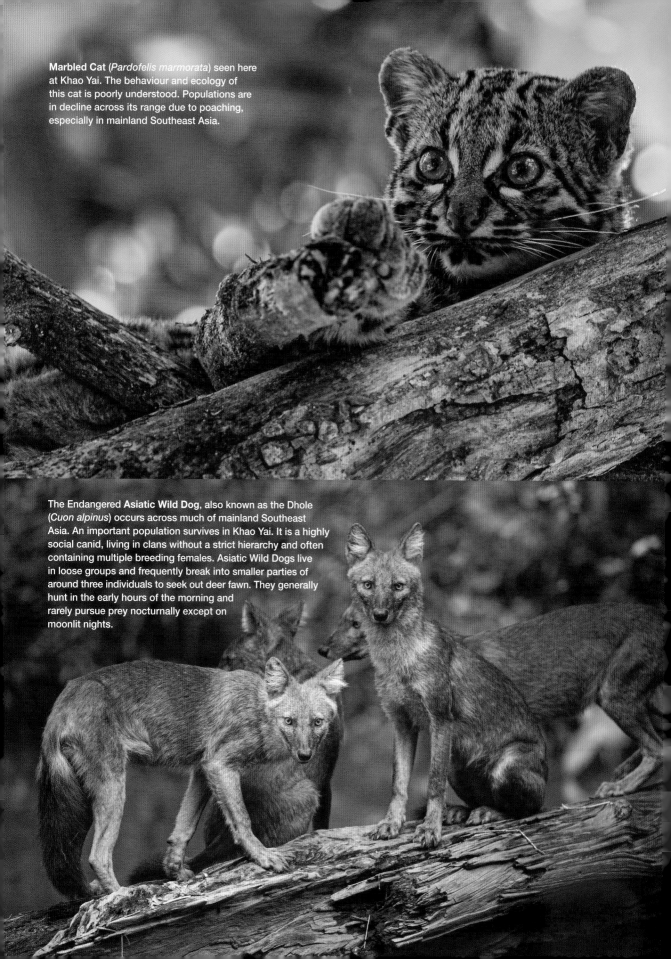

Marbled Cat (*Pardofelis marmorata*) seen here at Khao Yai. The behaviour and ecology of this cat is poorly understood. Populations are in decline across its range due to poaching, especially in mainland Southeast Asia.

The Endangered **Asiatic Wild Dog**, also known as the Dhole (*Cuon alpinus*) occurs across much of mainland Southeast Asia. An important population survives in Khao Yai. It is a highly social canid, living in clans without a strict hierarchy and often containing multiple breeding females. Asiatic Wild Dogs live in loose groups and frequently break into smaller parties of around three individuals to seek out deer fawn. They generally hunt in the early hours of the morning and rarely pursue prey nocturnally except on moonlit nights.

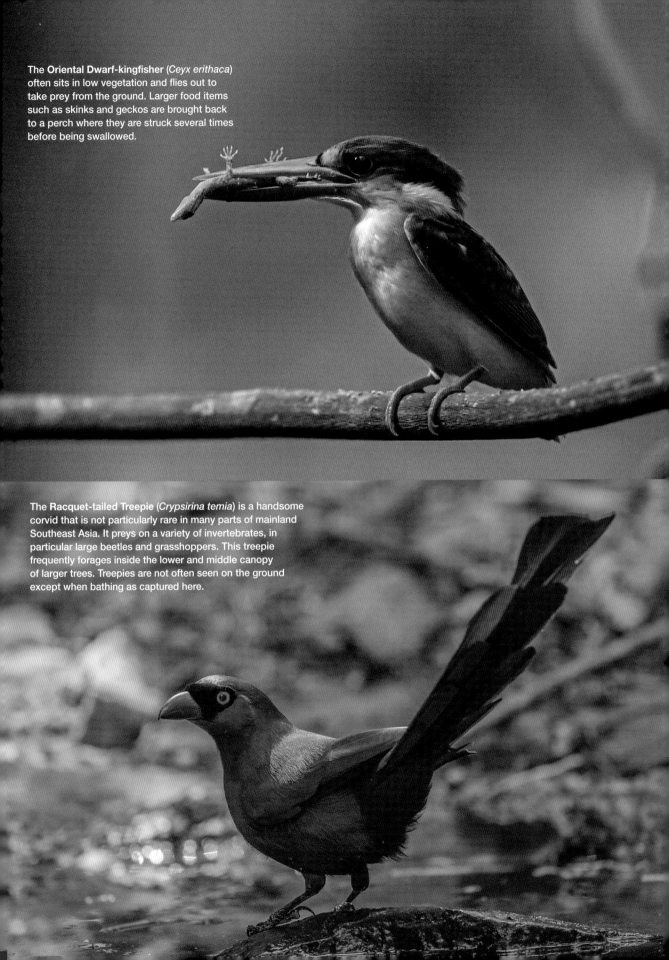

The **Oriental Dwarf-kingfisher** (*Ceyx erithaca*) often sits in low vegetation and flies out to take prey from the ground. Larger food items such as skinks and geckos are brought back to a perch where they are struck several times before being swallowed.

The **Racquet-tailed Treepie** (*Crypsirina temia*) is a handsome corvid that is not particularly rare in many parts of mainland Southeast Asia. It preys on a variety of invertebrates, in particular large beetles and grasshoppers. This treepie frequently forages inside the lower and middle canopy of larger trees. Treepies are not often seen on the ground except when bathing as captured here.

Kaeng Krachan National Park

Kaeng Krachan National Park occupies close to 3,000 km² (1,200 mi²) of forested country in western Thailand, and is the largest national park in the country. It is also recognised as an Important Bird and Biodiversity Area, perhaps the most speciose one in the country, and a UNESCO World Heritage Site. The Park is surprisingly close to Bangkok and can be reached in a three-hour drive.

For birdwatchers, this is Thailand's premier forest birding destination, due to high numbers and diversity of species found here. Kaeng Krachan is contiguous to extensive forests in southern Myanmar and the Western Forest Complex. These collectively form one of the largest stretches of undisturbed forests in Southeast Asia.

Most of Kaeng Krachan's sub-montane evergreen and deciduous forests are in good condition, providing a sanctuary to some of Asia's rarest birds and mammals. The mixture of bird species from the Sundaic region (Malaysia and Indonesia) and mainland Southeast Asia is one of the defining features of this terrific reserve. More than 400 bird species have been documented, together with close to 60 species of mammals as well as some 300 butterfly species.

There are quite a few resorts found outside the national park and in Kaeng Krachan Town, where day trips into the park can be arranged. The Sam Yot checkpoint is the main entrance and is open from 5 am to 5 pm. Visitors are allowed to linger until 7 pm.

Basic camping is possible inside the park. The Ban Krang and Phanoen Thung campsites are the best. At night, Malayan Porcupines, civets, and occasionally the Malayan Sun Bear can be seen at the Ban Krang campsite, which is located more than 10 km (6 mi) from the park's entrance. Mobile telephone coverage here can be spotty.

Male **Wreathed Hornbill** (*Rhyticeros undulatus*) leaving its nesting cavity after having fed fruits to the female inside.

Visitors to Kaeng Krachan should check the watering holes along the park's main road, which can be rewarding especially in the dry season. Look out for fruiting trees that attract many different species. Hiking the forest trails can be very productive. However, visitors must be accompanied by a local guide or ranger, who can be hired at any of the campsites.

The best time to visit Kaeng Krachan is from November to July, with the period between November to February being cooler with less rain. Weekends and public holidays should be avoided, as the park becomes crowded. Most areas are closed to visitors during the rainy season from August to October.

ABOVE The Vulnerable **White-fronted Scops-owl** (*Otus sagittatus*) is rare throughout its limited range on the Thai-Malay Peninsula. It is a lowland specialist occurring in primary evergreen forests. Kaeng Krachan is probably the single best location to observe this poorly documented scops-owl. The remarkable voice of this owl is a long-drawn tremolo, reminiscent of the screech owls in the New World rather than typical scops-owls in Asia.

RIGHT TOP A good place to see the **Ferruginous Partridge** (*Caloperdix oculeus*) in Thailand is in the forest around the Bang Krang campsite at Kaeng Krachan.

RIGHT BOTTOM Female and male **Kalij Pheasant** (*Lophura leucomelanos*). The large range of this intricately marked pheasant spans Pakistan, through much of northern India and east to the forested hills on Thailand's border with Myanmar. This species is omnivorous with a diverse diet that includes bamboo seeds, small snakes, termites, figs and forest yams. As depicted here, it is often seen in the morning foraging in small family groups by scratching the ground and digging for tubers and roots.

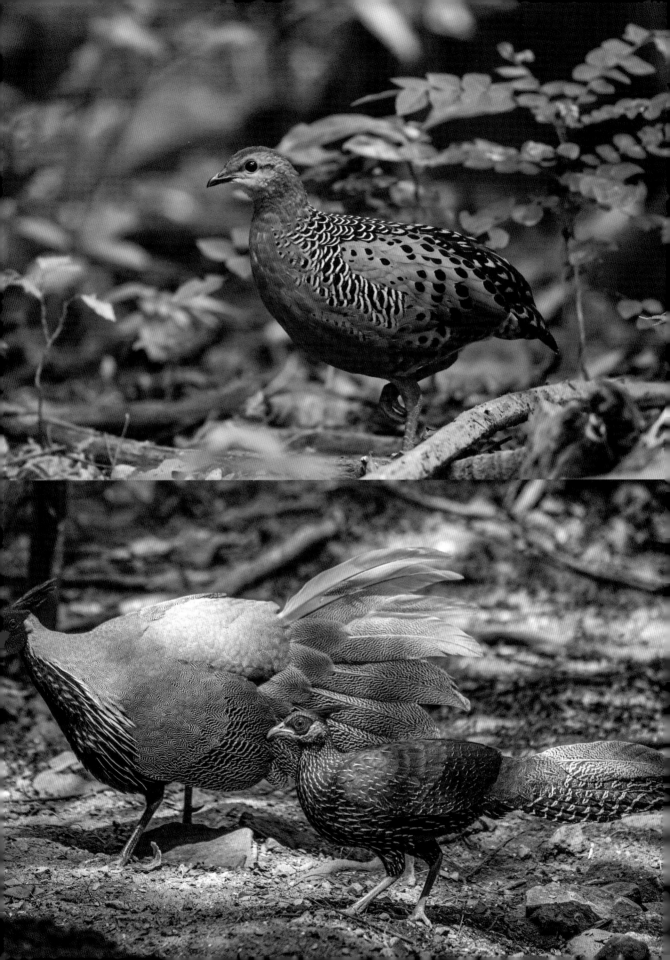

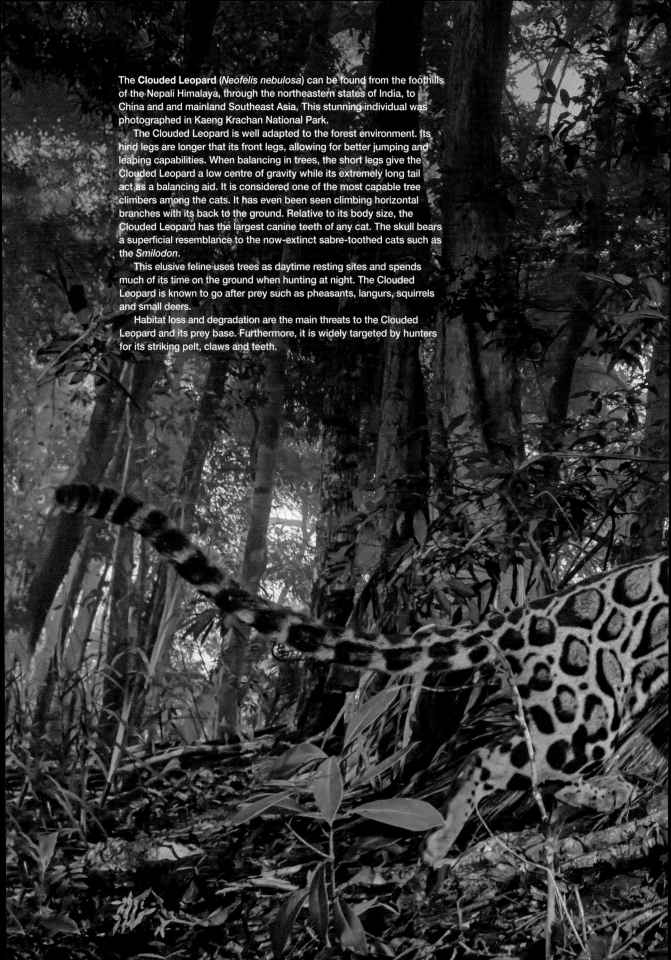

The **Clouded Leopard** (*Neofelis nebulosa*) can be found from the foothills of the Nepali Himalaya, through the northeastern states of India, to China and and mainland Southeast Asia, This stunning individual was photographed in Kaeng Krachan National Park.

The Clouded Leopard is well adapted to the forest environment. Its hind legs are longer that its front legs, allowing for better jumping and leaping capabilities. When balancing in trees, the short legs give the Clouded Leopard a low centre of gravity while its extremely long tail act as a balancing aid. It is considered one of the most capable tree climbers among the cats. It has even been seen climbing horizontal branches with its back to the ground. Relative to its body size, the Clouded Leopard has the largest canine teeth of any cat. The skull bears a superficial resemblance to the now-extinct sabre-toothed cats such as the *Smilodon*.

This elusive feline uses trees as daytime resting sites and spends much of its time on the ground when hunting at night. The Clouded Leopard is known to go after prey such as pheasants, langurs, squirrels and small deers.

Habitat loss and degradation are the main threats to the Clouded Leopard and its prey base. Furthermore, it is widely targeted by hunters for its striking pelt, claws and teeth.

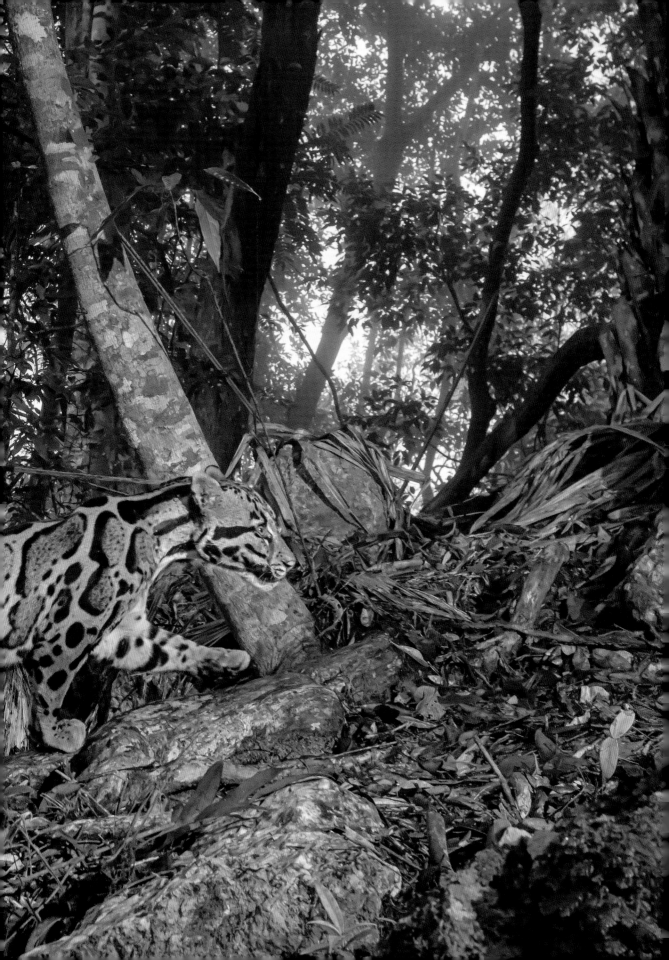

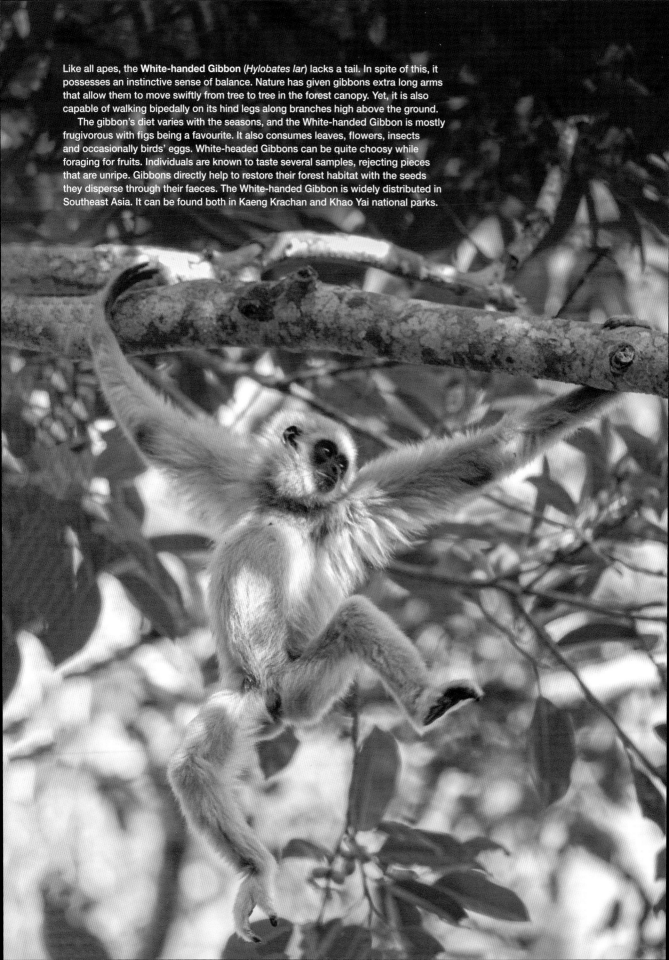

Like all apes, the **White-handed Gibbon** (*Hylobates lar*) lacks a tail. In spite of this, it possesses an instinctive sense of balance. Nature has given gibbons extra long arms that allow them to move swiftly from tree to tree in the forest canopy. Yet, it is also capable of walking bipedally on its hind legs along branches high above the ground.

The gibbon's diet varies with the seasons, and the White-handed Gibbon is mostly frugivorous with figs being a favourite. It also consumes leaves, flowers, insects and occasionally birds' eggs. White-headed Gibbons can be quite choosy while foraging for fruits. Individuals are known to taste several samples, rejecting pieces that are unripe. Gibbons directly help to restore their forest habitat with the seeds they disperse through their faeces. The White-handed Gibbon is widely distributed in Southeast Asia. It can be found both in Kaeng Krachan and Khao Yai national parks.

RIGHT The **Malayan Porcupine** (*Hystrix brachyura*) is at home in a wide array of habitats including primary and secondary forests as well as plantations. It is one of two species of porcupines found in Thailand and can be regularly encountered in Kaeng Krachan. Porcupines are generally nocturnal, foraging at night and resting in its large den during the day. As with most species in the region, the Malayan Porcupine has a diverse diet of roots, tubers, fallen fruits, insects and carrion.

BELOW The **Greater Hog Badger** (*Arctonyx collaris*) occurs in hill and montane forests across much of mainland Southeast Asia. It is a unique looking creature with an elongated pig-like snout. The diet of hog badgers consists of roots, fallen fruits and tubers. This is often supplemented by invertebrates found on the forest floor. Studies on the ecology of the Hog Badger suggests that it is active both in the day and at night.

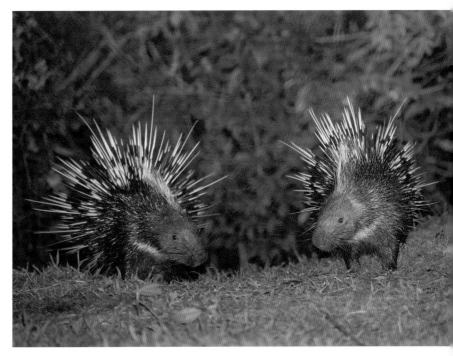

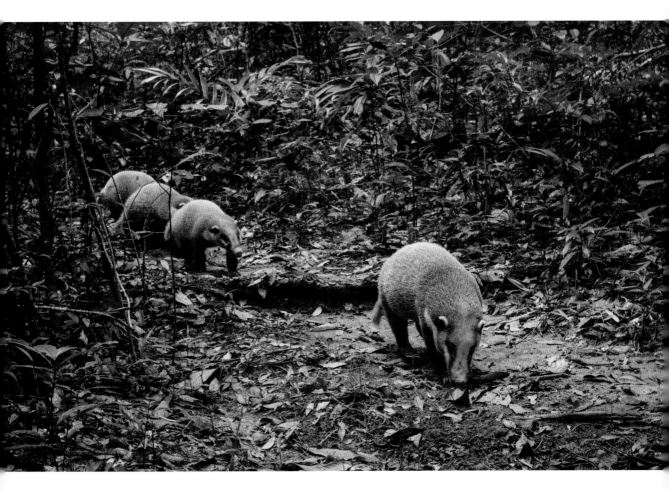

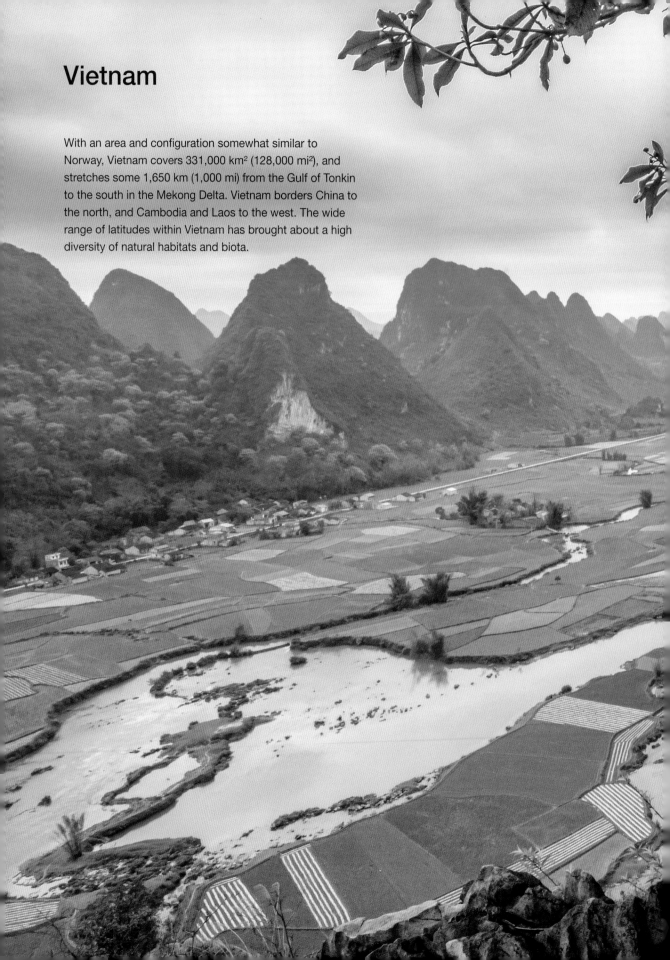

Vietnam

With an area and configuration somewhat similar to
Norway, Vietnam covers 331,000 km² (128,000 mi²), and
stretches some 1,650 km (1,000 mi) from the Gulf of Tonkin
to the south in the Mekong Delta. Vietnam borders China to
the north, and Cambodia and Laos to the west. The wide
range of latitudes within Vietnam has brought about a high
diversity of natural habitats and biota.

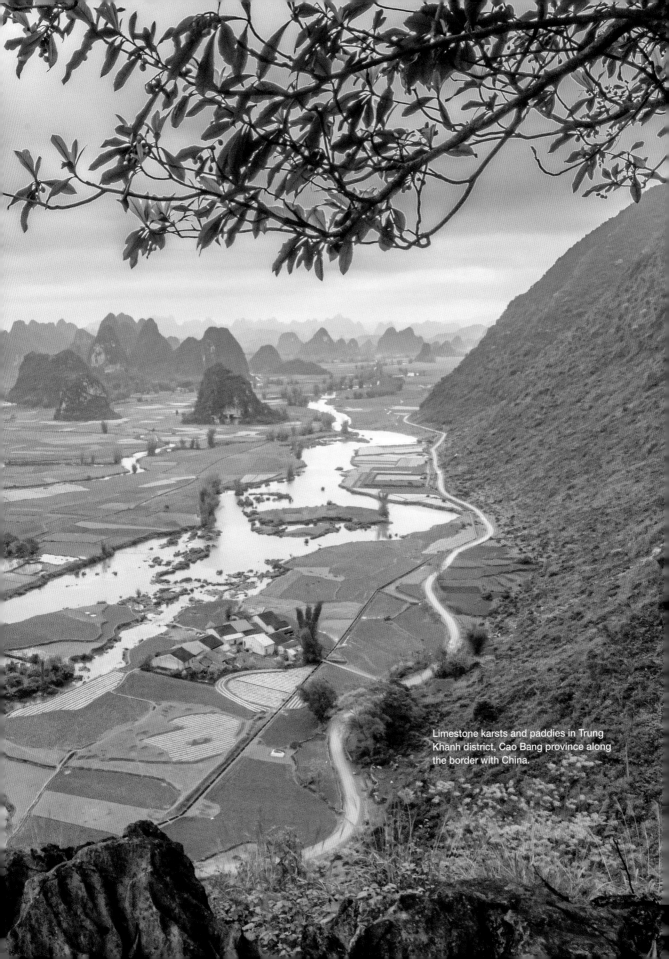

Limestone karsts and paddies in Trung Khanh district, Cao Bang province along the border with China.

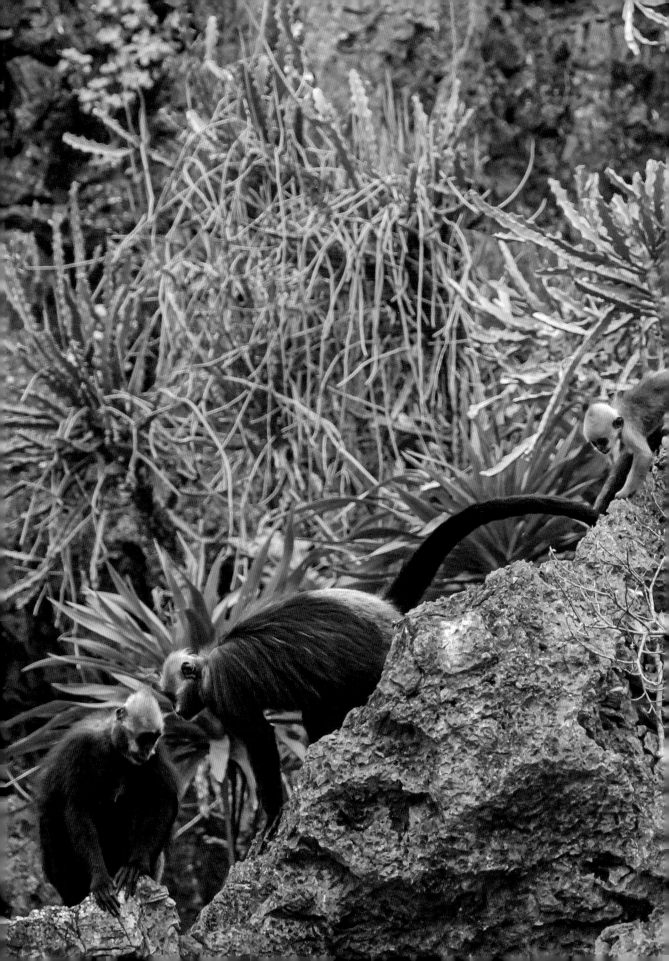

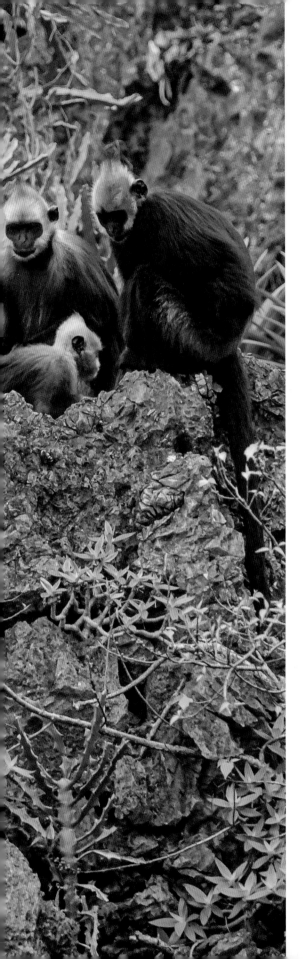

Vietnam's fertile lowlands support rich broad-leaved evergreen forests, with some of the finest examples in Cat Tien National Park. The Annamite mountains or 'Truong Son' as it is known in Vietnamese, defines much of the Vietnam-Laos border. It holds extensive montane forests, as do the easternmost spurs of the Himalayas in northern Vietnam. There are also large areas of limestone karsts across the country, characterised by unique karst forests.

From about 1,200 m (3,900 ft) elevation, the montane forest takes over. At even higher altitudes, rhododendrons become increasingly common. Vietnam's montane forests are of particular interest to naturalists, as they are where many of the endemic and near-endemic babblers, laughingthrushes, and amphibians are found.

Three quarters of Vietnam is hilly and mountainous, with the long Annamite mountain range dominating more than half the length of the country, alongside various plateaus and highlands in the south and central. Vietnam's remaining land mass lies at moderate to low elevations. This includes the low-lying plains surrounding the Red River Delta and the Mekong Delta region, which hold a large proportion of the country's population.

Wildlife watching in Vietnam is often in dense forested environments, where many species are located by sound rather than by sight. Due to hunting pressure, birds and mammals tend to be shy and less approachable compared to other parts of Asia. However, patience and perseverance usually pay off.

Vietnam's climate is diverse with different weather conditions across the north, central and south. Most of the country experiences a mild, tropical climate except for the subtropical north which undergoes cool winters. For visiting birdwatchers wanting to see a high number of species, the time from November through March is often the most productive.

With less than 100 individuals, the **Cat Ba Langur** (*Trachypithecus poliocephalus*) is amongst the top 25 most threatened primates in the world. The distribution of this striking species is restricted to Cat Ba Island in north-eastern Vietnam. Like a few other langurs in Indochina, the Cat Ba Langur inhabits the steep limestone outcrops on the island. Social groups use the limestone caves as sleeping sites. In recent years, the population has stabilised and increased thanks to sustained work by conservation NGOs and projects such as the Cat Ba Langur Conservation Project (CBLCP). The species is classified as Critically Endangered.

Vietnam is very rich in vertebrate diversity, harbouring more than 300 mammals including 25 primates, of which five are found nowhere else in the world. Its sprawling avifauna spans more than 900 species and this continues to increase gradually as birdwatchers and ornithologists discover new records and species.

For the past three decades, an extraordinary amount of new zoological discoveries has been made in Vietnam. In 1992, one of the foremost mammal discoveries in recent memory occured in Vietnam. A pair of peculiar skulls and a pair of unusual tapered horns were uncovered in a hunter's hut in the Annamite mountains close to the Laos border in north-central Vietnam. These remains were found to belong to the Saola, an antelope-like wild ox with a shoulder height of up to 90 cm (35 in) and a body length of around 150 cm (60 in). For many zoologists, it was astounding that such a large mammal could escape detection and discovery for so long. Indeed, the Saola is widely regarded by researchers as amongst the greatest discoveries in mammalogy since the Okapi from Africa in 1900.

Other remarkable mammalian discoveries from Vietnam in the past three decades include three ungulate species: Silver-backed Chevrotain (*Tragulus versicolor*), Large-antlered Muntjac (*Muntiacus vuquangensis*) and the Annamite Muntjac (*Muntiacus truongsonensis*). Also of considerable interest to conservationists are the Annamite Striped Rabbit (*Nesolagus timminsi*), Van Sung's Shrew (*Chodsigoa caovansunga*) and Annamite Myotis Bat (*Myotis annamiticus*), all fairly recent discoveries.

In the same period, several new bird species were described by Jonathan Eames, Le Trong Trai and their colleagues. These include the Golden-winged Laughingthrush (*Trochalopteron ngoclinhensis*), Black-crowned Barwing (*Actinodura sodangorum*) and Chestnut-eared Laughing-thrush (*Lanthocincla konkakinhensis*), all of which occur in the mountains of central Vietnam.

The **Cao-vit Gibbon** (*Nomascus nasutus*) was thought to be extinct until 2002, when scientists from Fauna & Flora International found a small surviving population in remote Trung Khanh district, Cao Bang province on Vietnam's border with China. In 2006, more gibbons were discovered on the Chinese side of the border. Successful conservation initiatives with local stakeholders on both sides of the border have resulted in a doubling of the population to around 135 individuals in 2019. The Cao-vit Gibbon is classified as Critically Endangered and is the second rarest ape in the world after the Hainan Gibbon (*Nomascus hainanus*).

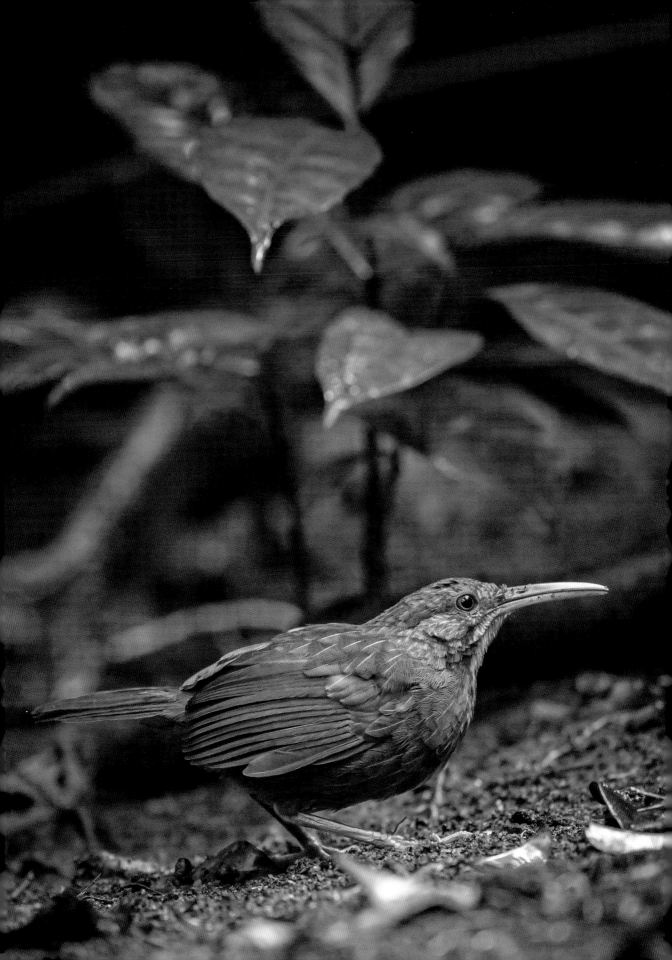

From 1997 through 2004, 58 new species of amphibians and reptiles were described. This brings the total number of herptile species to 500, according to *Vietnam: A Natural History*. The country is certain to hold many more zoological surprises.

Land use conversion from forests is considered the single biggest threat to Vietnam's biodiversity. From 1950 to 2020, Vietnam's population jumped from 25 million to 97 million people. The country's rapidly opening market economy and the resulting economic development have put its rich biodiversity under immense pressure. The remaining natural areas are threatened by slash-and-burn agriculture, aquaculture, logging, industrial development and infrastructure projects.

The use of wild animals for food, traditional medicine and keeping them as pets is widespread in Vietnamese society, including in many indigenous communities. While an extensive number of species is today protected under Vietnamese law, enforcement is inherently weak. Trading and poaching of animals are commonly treated as minor offences rather than serious criminal acts.

Although Vietnam continues to face major hurdles in protecting its rich biodiversity, the possibility of seeing some of Southeast Asia's most threatened and spectacular species means that nature-based tourism is growing rapidly. Vietnam is fast becoming one of the favourite destinations in Southeast Asia for visiting naturalists and birdwatchers. Today, there are many nature and birdwatching guides in the country who have intimate knowledge of its biodiversity. Engaging local guides not only gives one the best chance of observing many sought-after species, but also builds local ownership and creates livelihoods for local people to motivate them to protect their biodiversity.

LEFT The **Short-tailed Scimitar-Babbler** (*Napothera danjoui*) thrives in montane evergreen forests at elevations between 1,200 m and 2,100 m (3,900 ft and 6,900 ft) across the mountains of Vietnam. This species hangs around the lower storey and is regularly seen feeding on the ground where it quietly probes the soil or flips leaf litter for invertebrates.

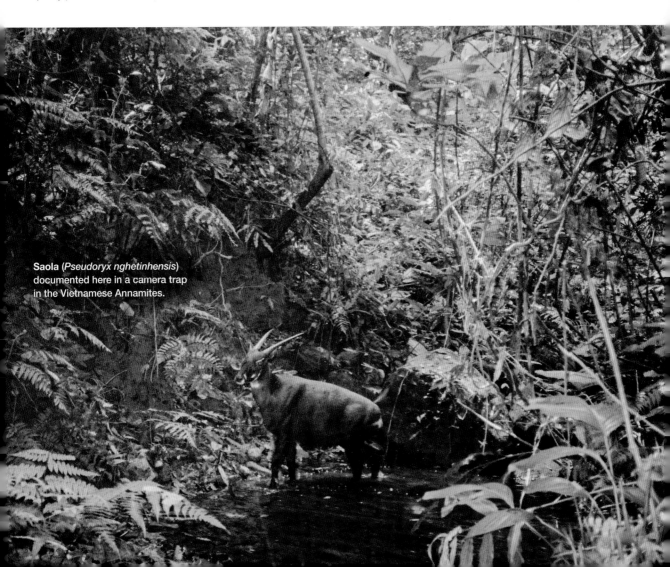

Saola (*Pseudoryx nghetinhensis*) documented here in a camera trap in the Vietnamese Annamites.

The beautiful **Bar-bellied Pitta** (*Hydrornis elliotii*) is a near-endemic species, and one of Vietnam's nine pittas. It is a shy ground-dweller that prefers dense forest understories close to water, and is most regularly encountered in the forests of Cat Tien National Park.

Pittas build well-camouflaged nests near the ground consisting of a flattened dome made from small twigs, dried leaves and other plant matter. The dome contains a cup lined with fine fibre.

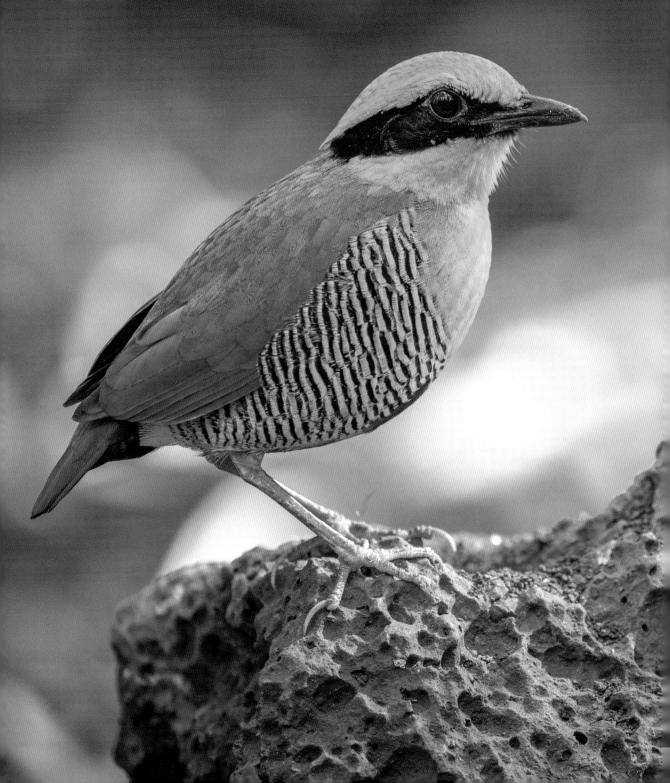

Cat Tien National Park

Cat Tien counts itself amongst the largest protected areas of lowland rainforest in Vietnam. It occupies 720 km² (280 mi²). Many parts of Cat Tien are covered by bamboo thickets and grassland, a result of defoliation with 'Agent Orange' during the Second Indochina War. Despite this, the park continues to support high biodiversity and is one of the few remaining examples of intact lowland forests in southern Vietnam. Of particular significance are the rich primate and ungulate communities within the park, as other unprotected lowland populations come under increasing human pressures. Around 70 mammal species have been recorded in the park, including until recently, the only mainland Asian population of the Javan Rhinoceros.

Close to 350 species of birds are on the park's checklist. There are excellent opportunities to see the Siamese Fireback, Green Peafowl, Germain's Peacock Pheasant, Orange-necked Partridge, Blue-rumped and Bar-bellied Pittas, as well as various broadbills and woodpeckers. In the open areas of wetland around Bau Sau or the 'Crocodile' lake, waterbirds including Lesser Adjutant and Asian Woollyneck may be seen.

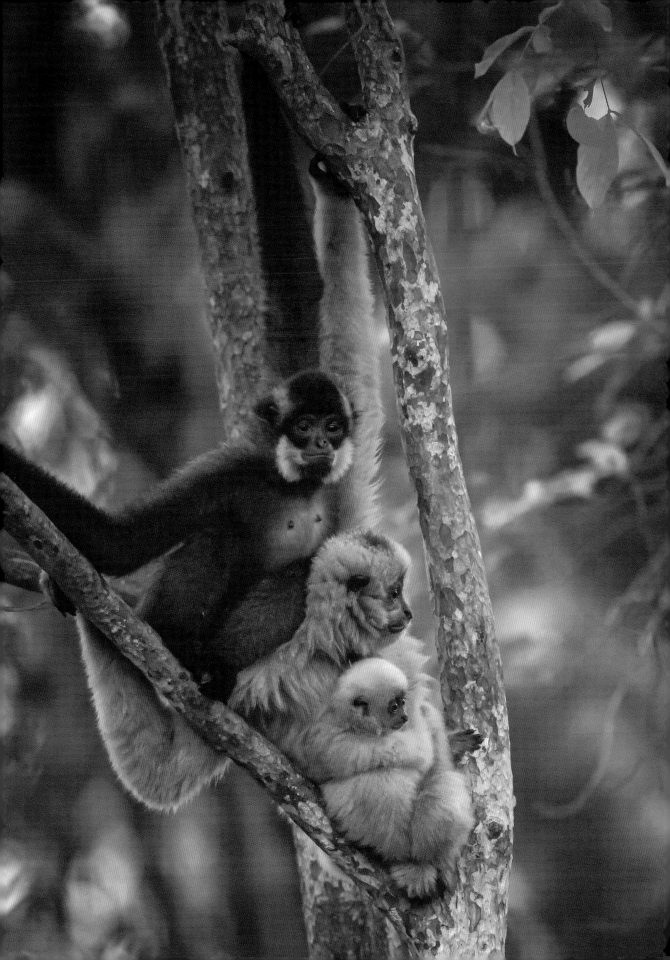

Cat Tien is a comparatively well protected park, but poaching and encroachment remain as threats to its rich biodiversity.

The park is situated around 160 km (100 mi) north of Ho Chi Minh City and can be accessed via a barge shuttle service across the Dong Nai River. Accommodation is available at the park's headquarters, as well as right outside the grounds. Cat Tien is a popular destination with visiting naturalists and possesses a good network of trails.

The monsoons in south Vietnam generally start during the second half of May and last till the end of October with the heaviest downpours in September. Low-lying areas are often flooded during this period, which is also hot and steamy. The best time to visit Cat Tien is from December to April when rainfall is less frequent and temperatures drop to a more comfortable range. The park tends to get crowded over weekends and public holidays.

A number of mammals may be encountered during guided morning and evening drives/walks, including the Annamese Silvered Langur, Red-cheeked Gibbon, Black-shanked Douc Langur, Pygmy Slow Loris, Gaur, Sambar and Lesser Mousedeer.

ABOVE The **Annamese Silvered Langur** (*Trachypithecus margarita*) is primarily a lowland species occurring in evergreen, semi-evergreen and coastal forests. This handsome primate typically gathers in groups ranging from five to 15 individuals. The main diet consists of young leaves, fruits and flowers. The Annamese Silvered Langur is known to descend to the ground to ingest soil as part of its nutrient needs that cannot be fulfilled by its leaf-based diet alone.

LEFT Cat Tien National Park is possibly the best place to observe the Endangered **Red-cheeked Gibbon** (*Nomascus gabriellae*), which is generally found in tall evergreen and semi-evergreen forests in Indochina east of the Mekong. Like most gibbons, this species takes mainly fruits, leaves and flowers. Red-cheeked Gibbons live in small family groups consisting of an adult pair and three to five offspring.

During the early morning hours, mated pairs often 'defend' their territory by producing coordinated song bouts (duets). The female emits notes of increasing frequency and decreasing duration, whereas the male's contribution is a series of modulated notes; sometimes the male also issues booms and disjointed notes during these duets. Gibbons are known to vocalise less frequently in rainy weather, and more often when food is abundant. Apart from habitat loss, the major threat to gibbons is poaching for food and the pet trade.

RIGHT The **Sambar** (*Rusa unicolor*) is classified as Vulnerable because of substantial population declines across its range. A **Vinous-breasted Starling** (*Acridotheres burmannicus*) is here seen cleaning the ear of a female Sambar at Cat Tien National Park.

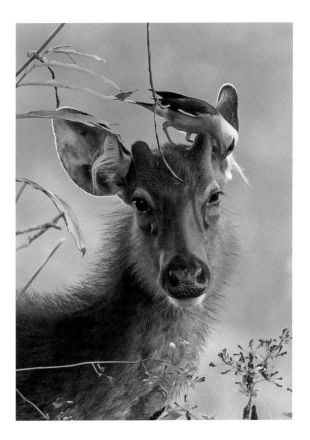

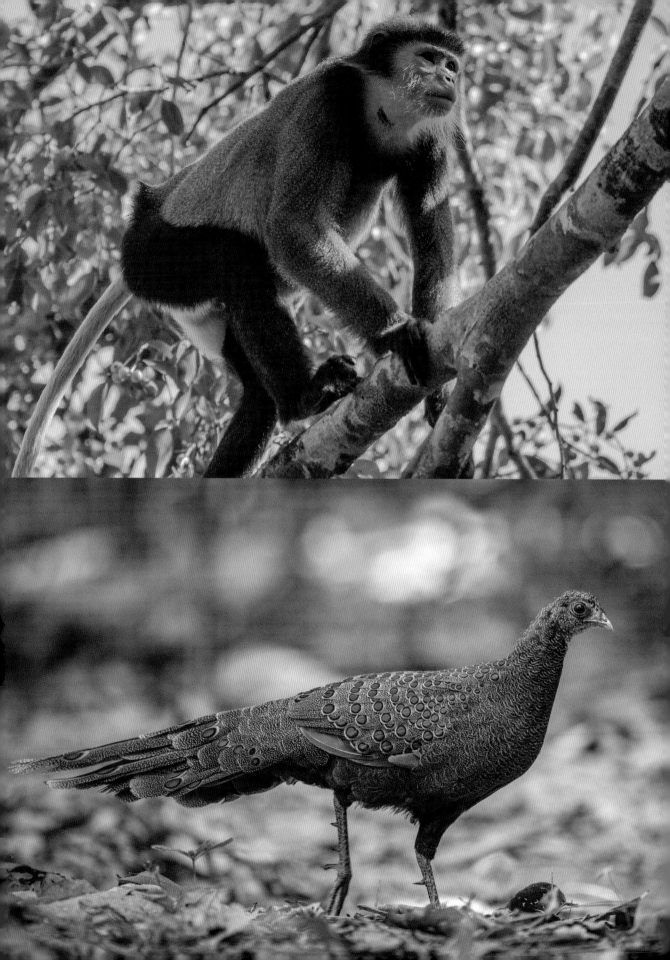

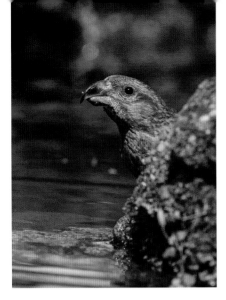

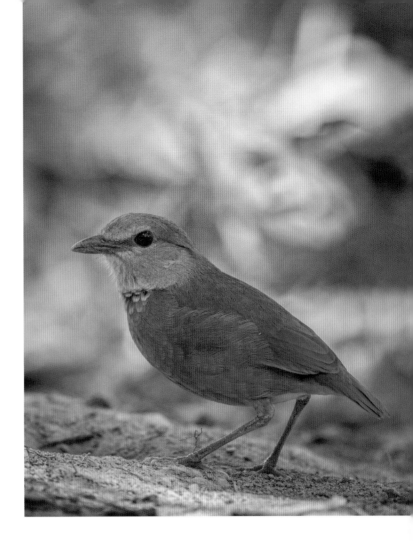

ABOVE This **Red Crossbill** (*Loxia curvirostra meridionalis*) was observed in mature pine forest at Bidoup Nui Ba National Park. Crossbills are specialist birds that feed largely on seeds in conifer cones. Their unique bill with pointed mandibles crossed at the tip allows them to open the cones and extract the seeds. The local subspecies of Red Crossbill is found only in the Da Lat Plateau, and may one day be split as a separate species.

RIGHT TOP The **Blue-rumped Pitta** (*Hydrornis soror*) is known to use stones as anvils for smashing snail shells to access the soft parts. This pitta occurs in a variety of lowland habitats including riverine forests and mixed forests with bamboo, from Vietnam to southern China.

RIGHT BOTTOM The stunning **Vietnamese Blue Crested Lizard** (*Calotes bachae*) was only described in 2013 based on research in Cat Tien National Park. This species was originally confused with a similar-looking agamid found in Thailand and Myanmar.

LEFT TOP The Critically Endangered **Black-shanked Douc Langur** (*Pygathrix nigripes*) is predominantly arboreal but can sometimes be seen on the ground. This ornately-patterned monkey occurs in a number of forest habitats, and seems to be able to adapt to disturbed areas. The main population is in eastern Cambodia, although it is also known to persist at several forested sites in southern Vietnam, including Cat Tien.

LEFT BOTTOM The **Germain's Peacock-Pheasant** (*Polyplectron germaini*) lives in lowland and sub-montane forests in central and south Indochina, where it appears to tolerate some level of habitat disturbance. The Germain's Peacock-Pheasant can be regularly encountered in the forests around Cat Tien's headquarters.

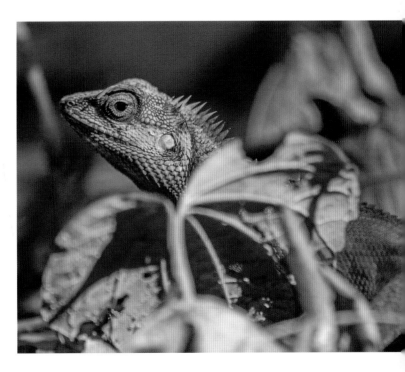

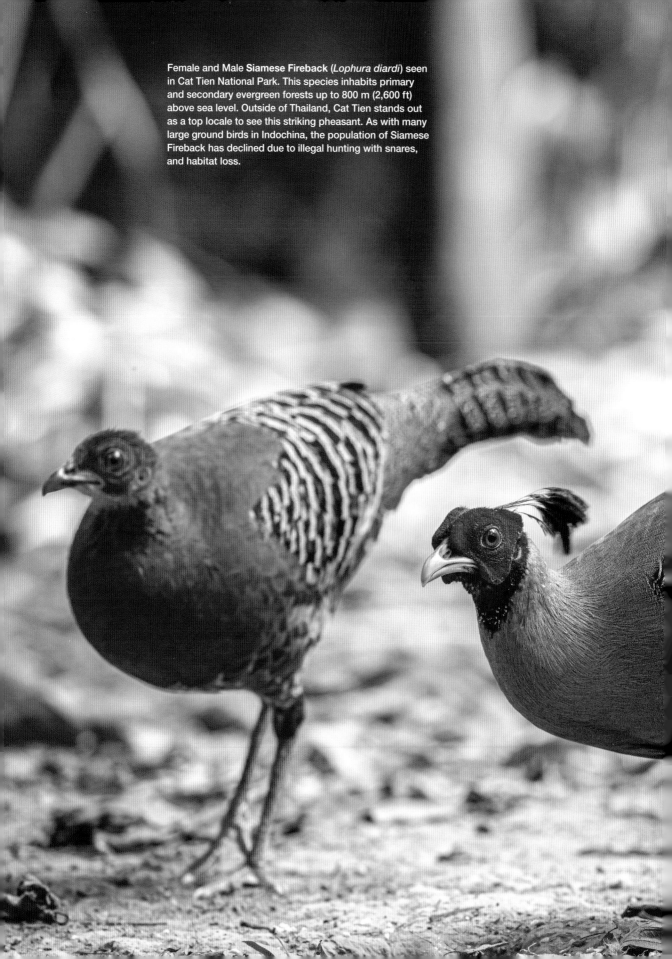

Female and Male **Siamese Fireback** (*Lophura diardi*) seen in Cat Tien National Park. This species inhabits primary and secondary evergreen forests up to 800 m (2,600 ft) above sea level. Outside of Thailand, Cat Tien stands out as a top locale to see this striking pheasant. As with many large ground birds in Indochina, the population of Siamese Fireback has declined due to illegal hunting with snares, and habitat loss.

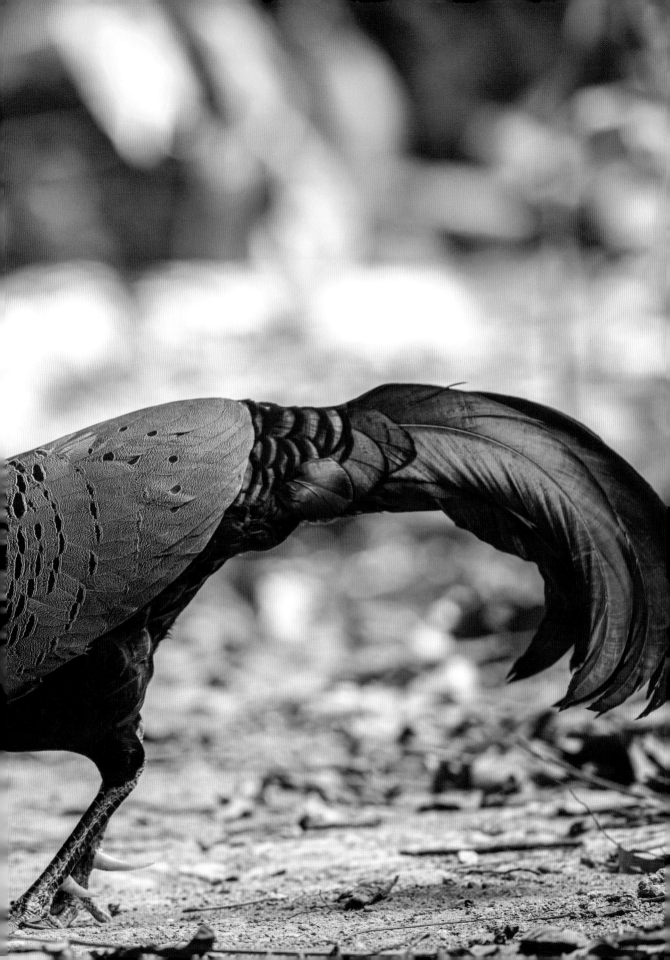

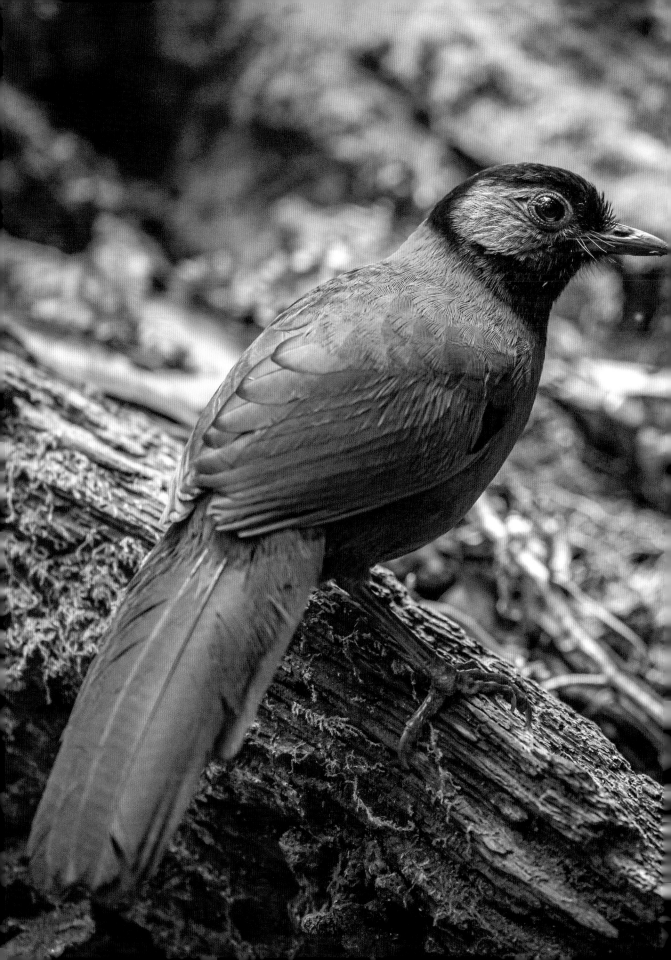

Da Lat Plateau

The Da Lat Plateau is one of the seven Endemic Bird Areas (EBA) in Vietnam identified by BirdLife International. It is situated at an elevation between 800 m and 2,400 m (2,600 ft and 7,900 ft). The plateau holds extensive stands of coniferous forests dominated by the Khasi Pine (*Pinus kesiya*). At higher elevations, the Dalat Pine (*Pinus dalatensis*) and the endemic Krempf's Pine (*Pinus krempfii*) are mixed with broadleaved evergreen forest.

Da Lat is Vietnam's most important hotspot for bird endemism. Several narrowly distributed species associated with montane forests can be found here, including the Black-hooded, Collared and Orange-breasted Laughingthrushes, Black-crowned Fulvetta, Grey-crowned Crocias, Vietnamese Greenfinch and Langbian Sunbird. Da Lat City is a popular tourist destination with a selection of accommodation options, making it a great base to explore the surrounding forests during day trips. Da Lat is best reached by a short flight from Ho Chi Minh City, or a four-hour drive from Cat Tien National Park.

Da Lat offers some of the finest birdwatching opportunities in south Vietnam, and is a must-visit spot on Vietnam's birding circuit. Several good birding locations can be found within a short drive from Da Lat, including the man-made Tuyén Lam Lake and Mount Langbian with its mix of coniferous forest at lower elevations and broadleaved evergreen forest higher up. Other areas to explore are the Bidoup Núi Bà National Park, and a well-forested valley near the village of Ta Nung around 15 km (nine mi) from Da Lat.

Some 80 km (50 mi) from Da Lat, en route to Cat Tien National Park, the road winds through the Di Linh Highlands. The town of Di Linh forms a convenient base to look for bird specialties that are easier to see here. One such site is Deo Suoi Lanh often referred to be 'Deo Nui San', a forested mountain pass at an elevation of 1,100 m (3,600 ft) half an hour's drive from Di Linh town. Desired birds that can be ticked off here include the Orange-breasted and Black-hooded Laughingthrushes, Blue and Rusty-naped Pitta, Black-headed Parrotbill and Green Cochoa.

The narrowly-distributed **Collared Laughingthrush** (*Trochalopteron yersini*) is restricted to the Da Lat Plateau and surrounding highlands where it survives in the dense understorey of primary and secondary evergreen forests between 1,500 m to 2,200 m (4,900 ft to 7,200 ft). The Collared Laughingthrush can be challenging to see, given its shy and skulking nature. This individual was photographed in Bidoup Nui Ba National Park.

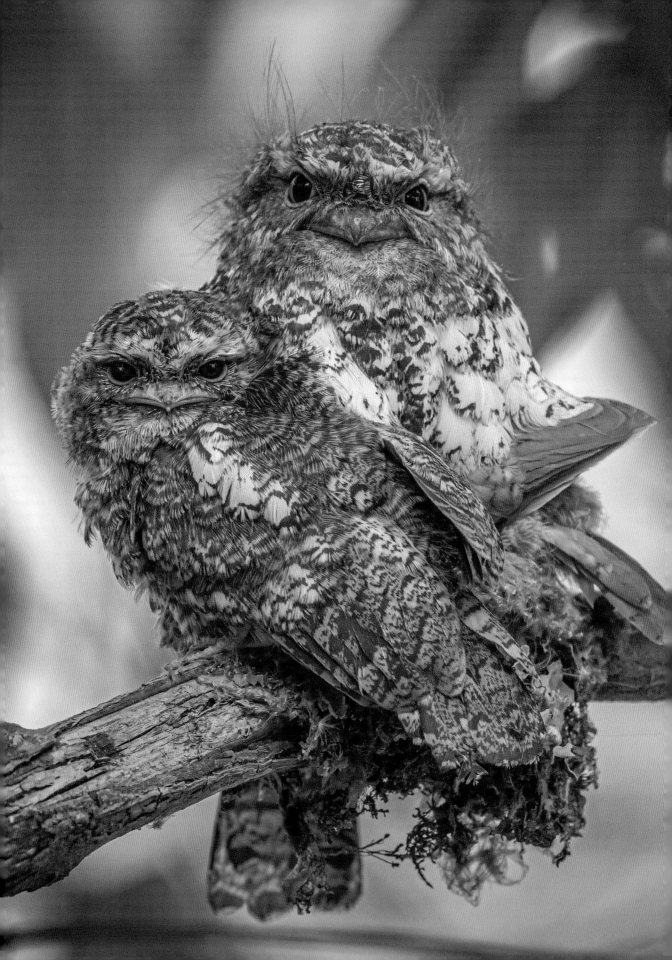

LEFT Hodgson's Frogmouth (*Batrachostomus hodgsoni*), an adult with two chicks seen at Ta Nung Valley area of Da Lat. The typical frogmouth diet consists of large insects which are hawked in the air or taken from the ground. In Vietnam, the Hodgson's Frogmouth occurs in disjunct populations from Da Lat to the Kon Tum Plateau and the Annamite mountains.

RIGHT The **White-cheeked Laughingthrush** (*Garrulax vassali*) has a fairly small distribution, but is not considered globally threatened as it can persist in an array of habitats including broadleaved evergreen forests, secondary growth as well as scrubland. Often seen in mixed feeding flocks, particularly with other laughingthrushes, it forages mostly on or close to the ground.

BELOW The **Cambodian Striped Squirrel** (*Tamiops rodophii*) ranges across the forests of eastern Thailand and Indochina. It is amongst the more commonly encountered squirrels in Da Lat and Cat Tien. This dainty mammal is known to consume large quantities of tree bark in its diet.

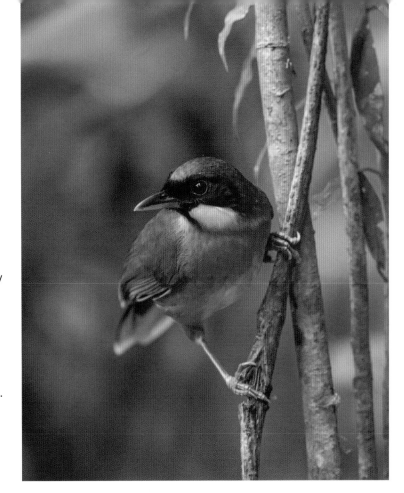

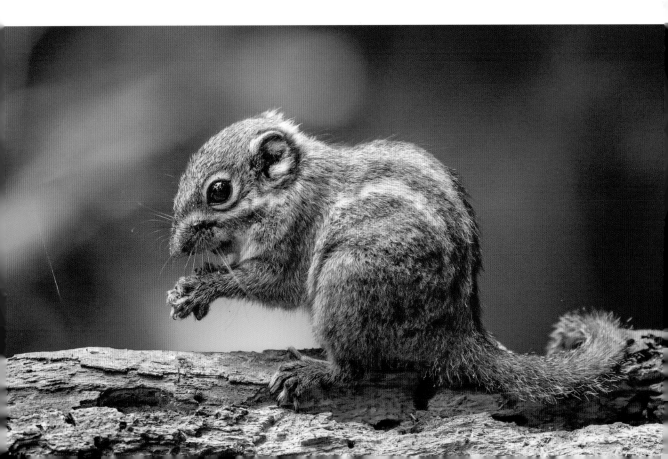

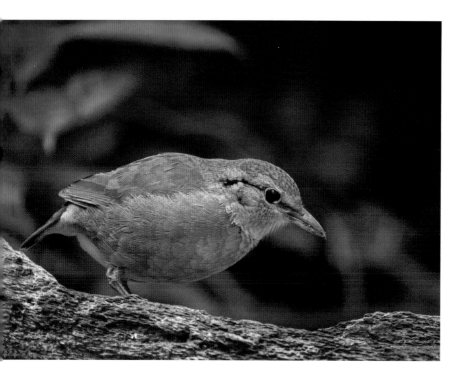

LEFT Rusty-naped Pitta (*Hydrornis oatesi bolovenensis*) seen in the forests at Di Linh. It is an elusive and secretive species of montane forests, often found in deep ravines. As shown here, the Rusty-naped Pitta is usually encountered foraging on the forest floor, turning over leaves to look for insects and invertebrates.

BELOW The **Dalat Shrike-Babbler** (*Pteruthius annamensis*) occurs from 700 m to 2,500 m (2,300 ft to 8,200 ft) in the Da Lat Plateau and adjoining areas of mountains. Apart from insects, the diet of this striking bird includes berries, fruits and seeds. The Dalat Shrike-Babbler feeds mostly in the higher canopy, working slowly upwards by inspecting moss and lichen on branches for insects. In the forests of the Da Lat Plateau, this species is a regular participant of mixed foraging flocks, associating with babblers, warblers and woodpeckers as they travel together through the forest canopy.

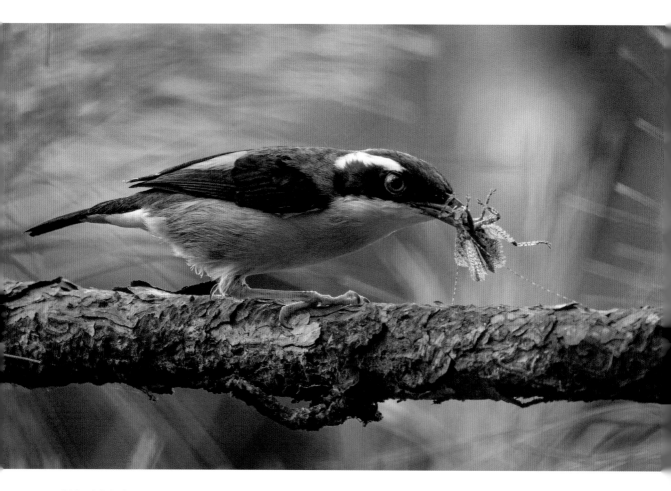

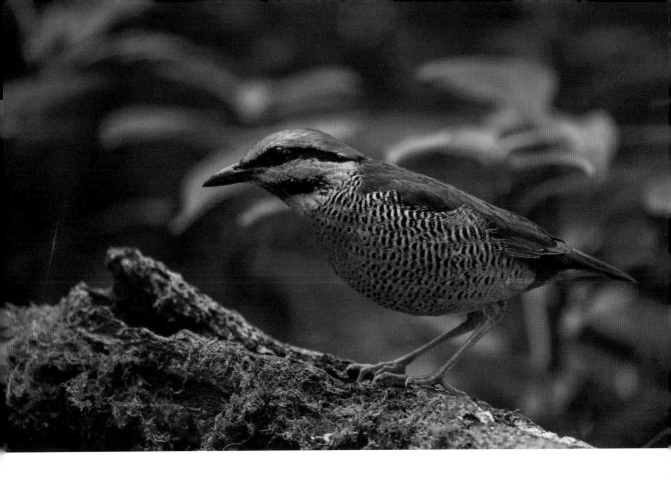

ABOVE The colourful **Blue Pitta** (*Hydrornis cyaneus willoughbyi*) can be surprisingly difficult to see as it forages on the forest floor. Its skulking habit makes it easy to overlook. Therefore, it may be more common than observations indicate. This pitta lives in evergreen forests and dense bamboo groves with thick ground vegetation, often in hills and lower mountains. In the forests around Di Linh, the bird is more often heard than seen, calling from dense ravines.

RIGHT The **Orange-breasted Laughingthrush** (*Garrulax annamensis*) is endemic to the highland forests in and around Da Lat Plateau. It occurs in dense secondary growth and scrub at the edges and gaps of broadleaved evergreen forests. A retiring species, the Orange-breasted Laughingthrush is usually heard rather than seen, with its varied calls typically emanating from thick vegetation.

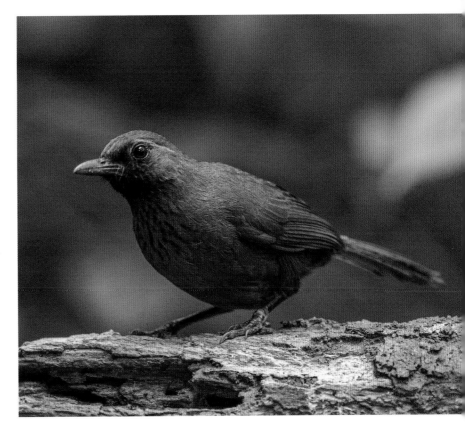

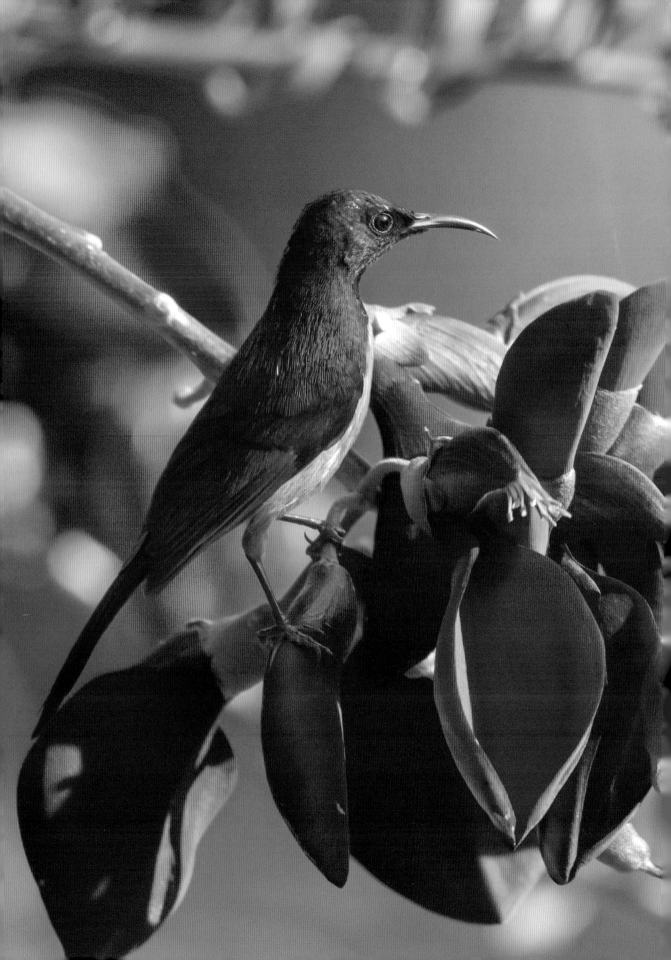

RIGHT The petit **Grey-bellied Tesia** (*Tesia cyaniventer*) can be found primarily between 1,000 m to 2,500 m (3,300 ft to 8,200 ft) in broadleaved forests with dense undergrowth in and around Da Lat. It feeds in low vegetation and fallen trees, sometimes descending to the forest floor. Tesias form a peculiar group of bush warblers that are confined largely to montane forests in Southeast Asia and the Himalayas.

LEFT The **Langbian Sunbird** (*Aethopyga johnsi*) frequents broadleaved and evergreen forests as well as secondary growth at elevations from 1,000 m to 2,000 m (3,300 ft to 6,600 ft) in Da Lat. This handsome sunbird is often observed foraging alone or in pairs. One of the prime spots to see it is at the forest edges along the Ta Nung Valley, and on the slopes of Mount Langbian, which it is named after. The Langbian Sunbird was once considered a subspecies of the more widely distributed Black-throated Sunbird.

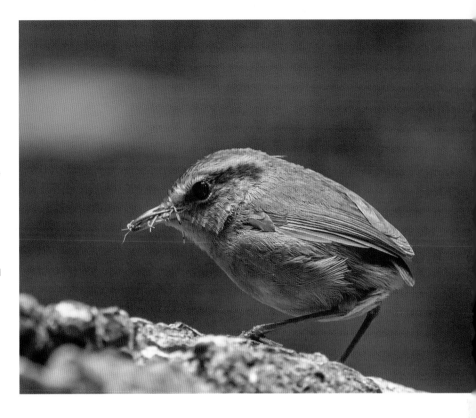

The **Northern Treeshrew** (*Tupaia belangeri*) makes its living in a range of habitats, including evergreen and deciduous forests. It is never seen too far away from streams and rivers. The Northern Treeshrew occurs widely across the forests of Indochina and is the most northerly distributed species of treeshrew. The bulk of the world's treeshrews are found on Borneo and Sumatra, while only a handful of species extends to mainland Southeast Asia and parts of India.

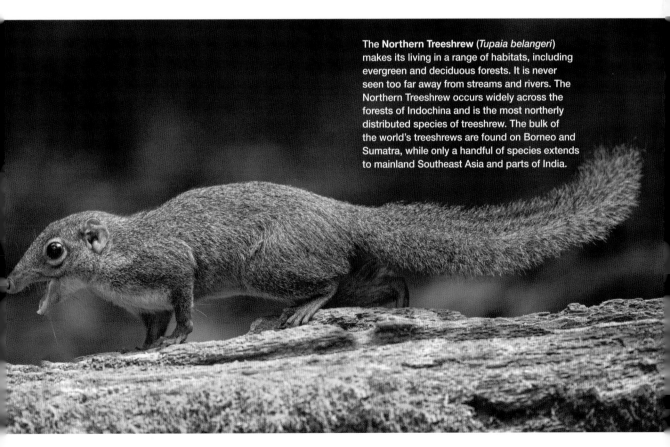

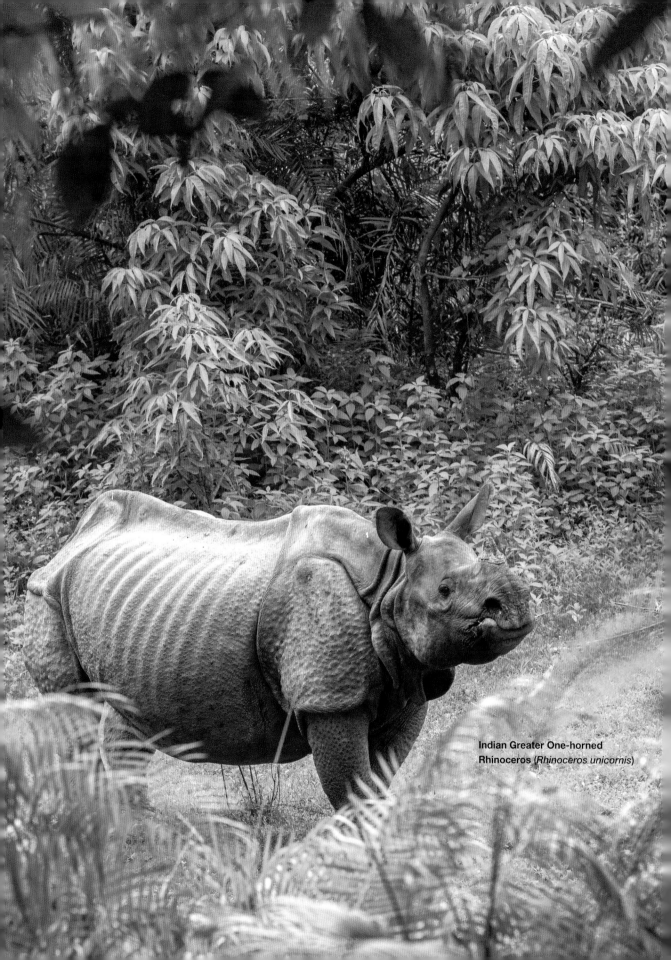

Indian Greater One-horned
Rhinoceros (*Rhinoceros unicornis*)

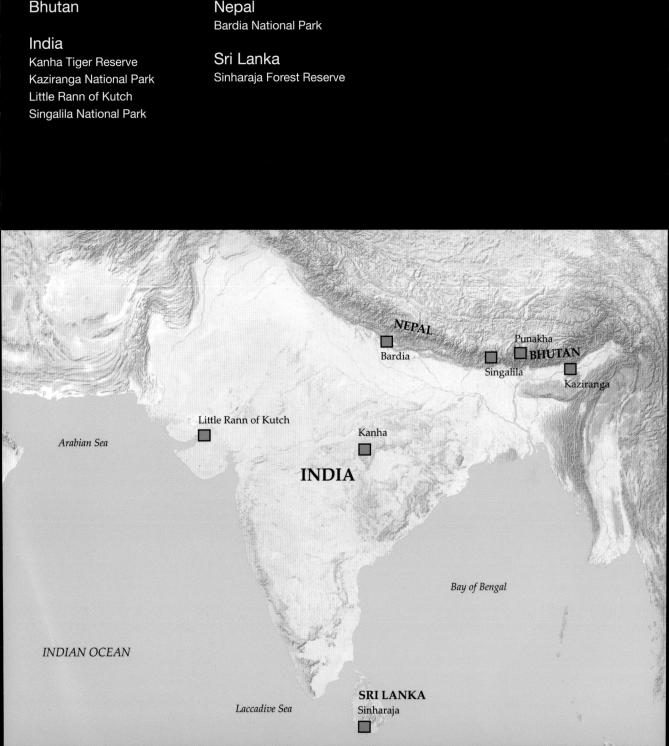

Bhutan

India
Kanha Tiger Reserve
Kaziranga National Park
Little Rann of Kutch
Singalila National Park

Nepal
Bardia National Park

Sri Lanka
Sinharaja Forest Reserve

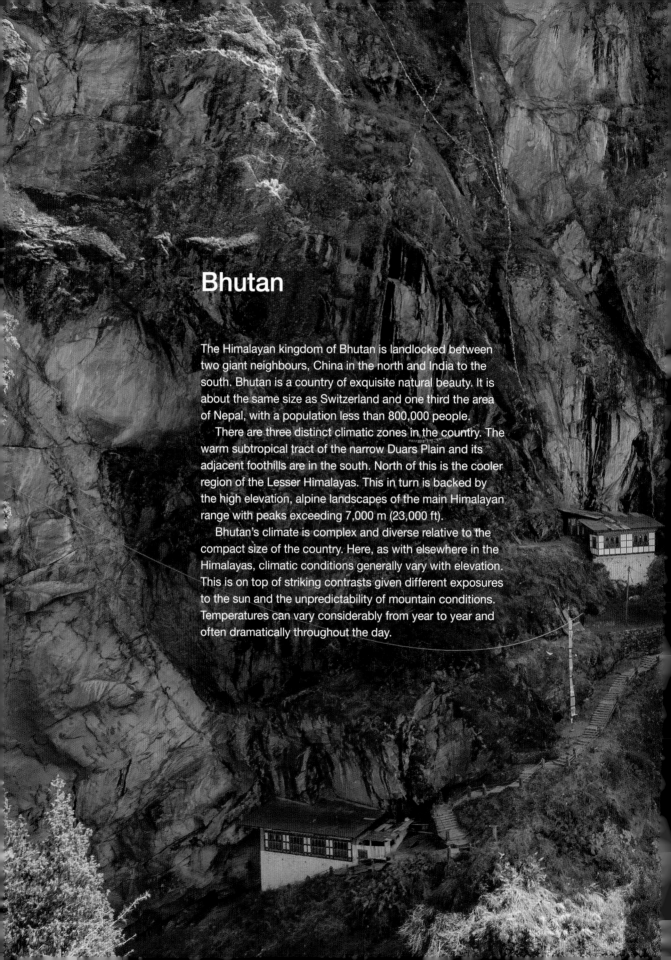

Bhutan

The Himalayan kingdom of Bhutan is landlocked between two giant neighbours, China in the north and India to the south. Bhutan is a country of exquisite natural beauty. It is about the same size as Switzerland and one third the area of Nepal, with a population less than 800,000 people.

There are three distinct climatic zones in the country. The warm subtropical tract of the narrow Duars Plain and its adjacent foothills are in the south. North of this is the cooler region of the Lesser Himalayas. This in turn is backed by the high elevation, alpine landscapes of the main Himalayan range with peaks exceeding 7,000 m (23,000 ft).

Bhutan's climate is complex and diverse relative to the compact size of the country. Here, as with elsewhere in the Himalayas, climatic conditions generally vary with elevation. This is on top of striking contrasts given different exposures to the sun and the unpredictability of mountain conditions. Temperatures can vary considerably from year to year and often dramatically throughout the day.

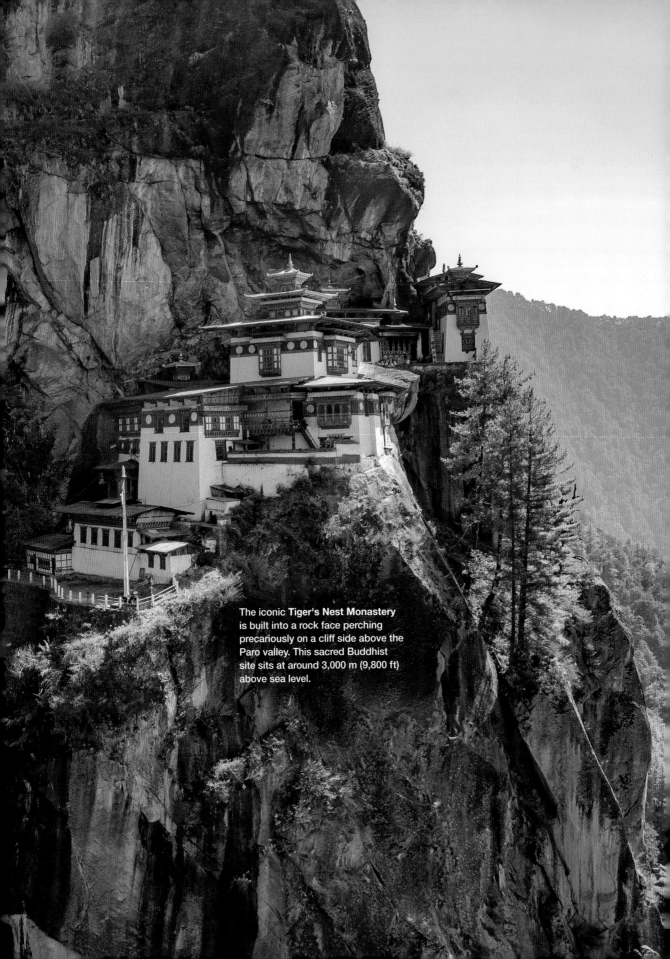

The iconic **Tiger's Nest Monastery** is built into a rock face perching precariously on a cliff side above the Paro valley. This sacred Buddhist site sits at around 3,000 m (9,800 ft) above sea level.

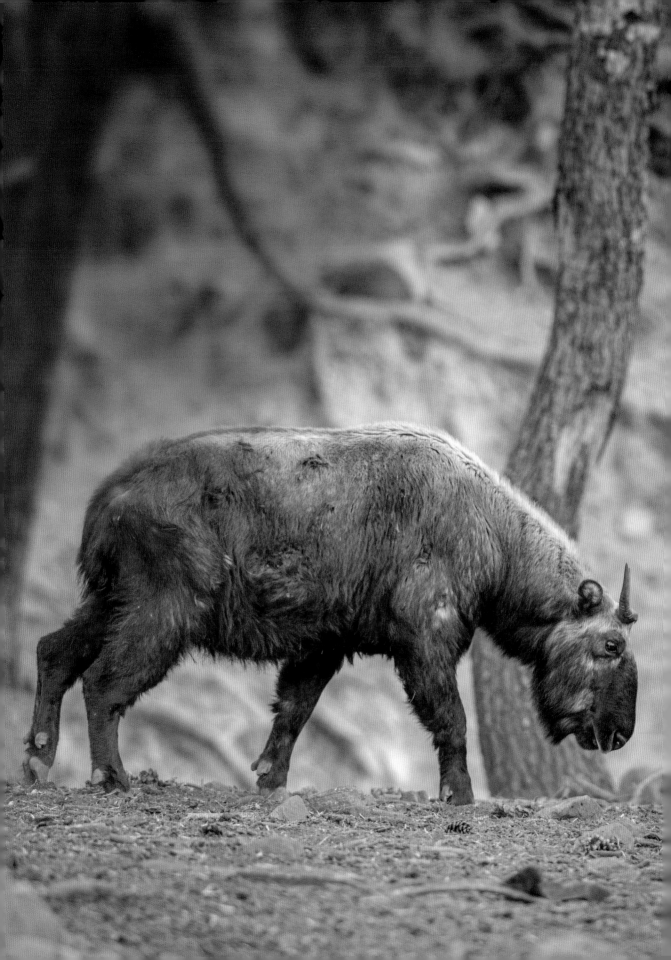

One of the best periods for naturalists and birdwatchers to visit Bhutan is springtime, from March to May. This is when most resident species are breeding while some migrant species are still present before heading for their high altitude breeding grounds. This is also the time when many migratory birds pass through Bhutan on their journeys back to their breeding grounds further north in China, Mongolia and Russia. Bhutan's flora is notable for its enormous diversity, with both tropical and temperate alpine plant families being well represented. From late March to early May, the timeless beauty of Bhutan's flora can be seen when many rhododendrons and magnolias are flowering.

The period from June to early September is the rainy season here. During this time, the monsoon deluge may obscure views of the valleys and mountains with heavy cloud cover. This is also the time of the year when floods and landslides are likely to occur. The autumn months from September to November are normally the best for trekking and photography with clear skies and beautiful mountain panoramas. Daytime conditions during winter from December to February can be warm and sunny with superb light. However, nights are predictably cold, and many passes leading to central and eastern Bhutan may be closed due to snow.

Bulwarked by some of the highest mountain peaks on earth, Bhutan has gradually emerged from its self-imposed isolation with a reputation for being one of the most alluring countries in Asia. At the same time, Bhutan has managed to retain much of its culture, old rituals, and fascinating heritage.

Unlike its neighbours, Bhutan has kept much of its forest cover intact. Thankfully, it has preserved some of the best remaining forest landscapes in the Himalayas. Much of Bhutan's foreign exchange earnings come from the export of hydroelectric power to India, making it less dependent on other forms of revenue including mass tourism. This has allowed the kingdom to focus on attracting affluent foreign tourists able to afford its high daily expenses. Bhutan may thus avoid the types of unsustainable mass tourism seen in other Asian countries. Tourist numbers are controlled and all visitors must be on an organised tour. Although much of the birdwatching is in forested country and alpine habitats, most of it is done along the roads because of the rugged terrain and dense forests.

Many tours arrive at Bhutan's western airport in Paro, not far from the capital city of Thimphu. From there, visitors usually traverse two thirds of Bhutan's length before heading southeast, entering Assam in India for outbound flights from the city of Guwahati.

Considering its limited size, Bhutan harbours an inordinate diversity of vertebrates. More than 700 species of birds can be found here, including rarities like the White-rumped Vulture and Red-headed Vulture, Pallas's Fish-eagle, Rufous-necked Hornbill, Ward's Trogon and Yellow-rumped Honeyguide. Among the most sought-after bird species in Bhutan is the majestic White-bellied Heron. This bird is one of the largest herons in the world, and much of the world population resides in Bhutan.

Around 200 species of mammals find sanctuary in the kingdom's protected areas, including the Bengal Tiger, Greater One-horned Rhinoceros, Snow Leopard, Takin, Pygmy Hog, Sloth Bear and Gee's Golden Langur. As hunting is forbidden, mammals and birds are generally less wary of humans than in other parts of Asia. One of the sterling places to see mammals, including the Asian Elephant, Gaur, Greater One-horned Rhinoceros and Golden Langur, is in the Royal Manas National Park. It is located in the south of Bhutan, immediately north of Manas National Park in India.

The **Takin** (*Budorcas taxicolor whitei*) is the national animal of Bhutan. Native to Bhutan, China, Myanmar and India, there is no estimate of its population size in Bhutan, and it is rarely seen in the wild. It is found in scattered populations along Bhutan's northern regions, mainly between 2,000 m and 3,500 m (6,600 ft and 11,500 ft) above sea level.

The Takin is known to undertake seasonal migrations to habitats at different elevations. In summer, herds gather to feed in alpine meadows often up to 4,000 m (13,100 ft) above sea level. In winter when food is less plentiful, they split into smaller groups, and move into forested valleys at lower altitudes. Mating takes place in August and September. A single young is typically born in March and April with a weaning period of nine months. This individual was seen in the Motithang Takin Preserve, an enclosed, forested habitat at the edge of Thimphu.

Bhutan is renowned for pioneering the concept of **Gross National Happiness (GNH)**. This forms a holistic and sustainable framework to development, balancing material growth and non-material values. Instead of being guided by strict economic measures, the concept of GNH takes into account a mix of 'quality of life' factors. Fittingly, one of its main pillars is the conservation and protection of Bhutan's natural environment. The current forest cover is estimated at 71 per cent of Bhutan's total area. Just over 50 per cent of its total land area is legally protected. Bhutan's Constitution states that at least 60 per cent forest cover must be maintained in perpetuity.

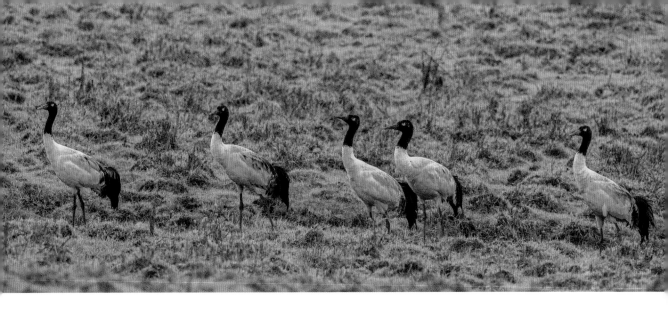

ABOVE Bhutan is home to the largest wintering population of the **Black-necked Crane** (*Grus nigricollis*) outside China. The majority of these cranes can be found in the scenic highland valley of Phobjikha on the edge of the Jigme Singye Wangchuck National Park (formerly Black Mountains National Park) in central Bhutan. Each year, the cranes arrive between mid-October and early December. The birds stay until around March when they migrate north towards their breeding grounds on the Tibetan Plateau. In their wintering habitat, they forage on harvest leftovers in agricultural fields of barley, winter wheat and rice, on top of their usual diet of tubers and invertebrates.

BELOW The striking **Himalayan Cutia** (*Cutia nipalensis*) is a montane species occurring at elevations above 1,200 m (3,900 ft) in the Eastern Himalayas and Southeast Asia. Cutias, which belong to the laughingthrush family, are often seen creeping up and down branches where it glean for insects hidden in foliage, moss and bark. The Himalayan Cutia is known to be a regular participant of mixed feeding flocks. Here, it is seen in a flowering Coral Tree.

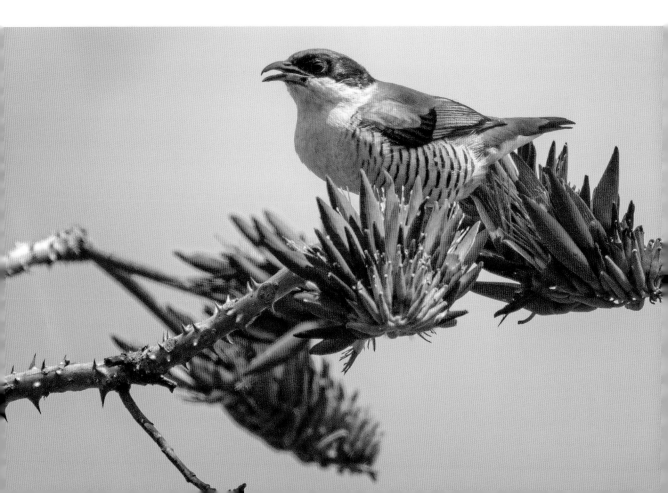

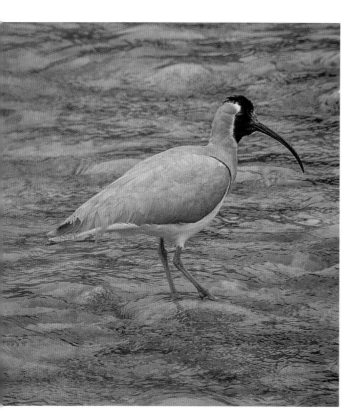

LEFT The distinctive **Ibisbill** (*Ibidorhyncha struthersii*) is the the sole member of the family Ibidorhynchidae. It has an extensive distribution that spans the high plateaux of Central Asia, Tibet and the Himalayas, east to northern China. The main diet of the Ibisbill includes aquatic invertebrates and fish. This individual was seen at Punakha, around three hours' drive from the capital Thimphu. Punakha, is also one of the sites where the Critically Endangered White-bellied Heron can be spotted.

RIGHT The coat colour of the Endangered **Gee's Golden Langur** (*Trachypithecus geei*) varies from very pale in Bhutan to bright orange in India at the south of its range. This species eats mostly leaves but will resort to raiding crops if natural food sources are in short supply. Territorial behaviour between different langur groups is not evident, and the territories of various troops may overlap. This species is common around Tingitibi and Royal Manas National Park in the southern part of Bhutan. The global population consists of less than 6,500 individuals. It is found across widely scattered sites in Bhutan as well as adjacent areas in the state of Assam in northeastern India.

BELOW A **Rufous Sibia** (*Heterophasia capistrata*) with a face full of rhododendron pollen. From spring to summer, this species can be found at altitudes ranging from 1,600 m to 3,000 m (5,200 ft to 9,800 ft), visiting rhododendron flowers in search of insects and nectar. In areas with good forest, the Rufous Sibia is amongst the most common birds, often forming large flocks of some 20 individuals.

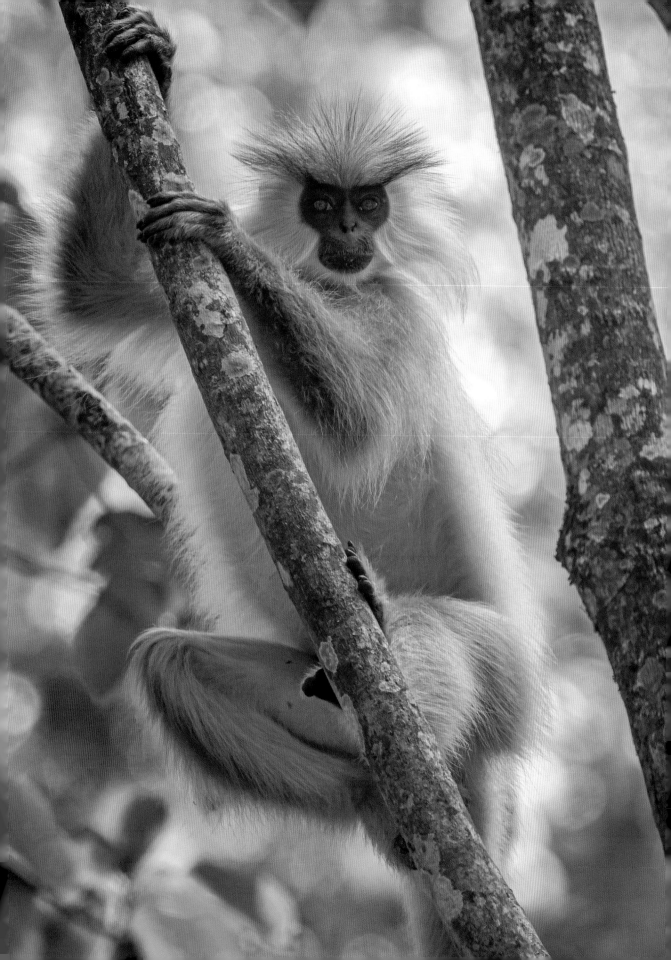

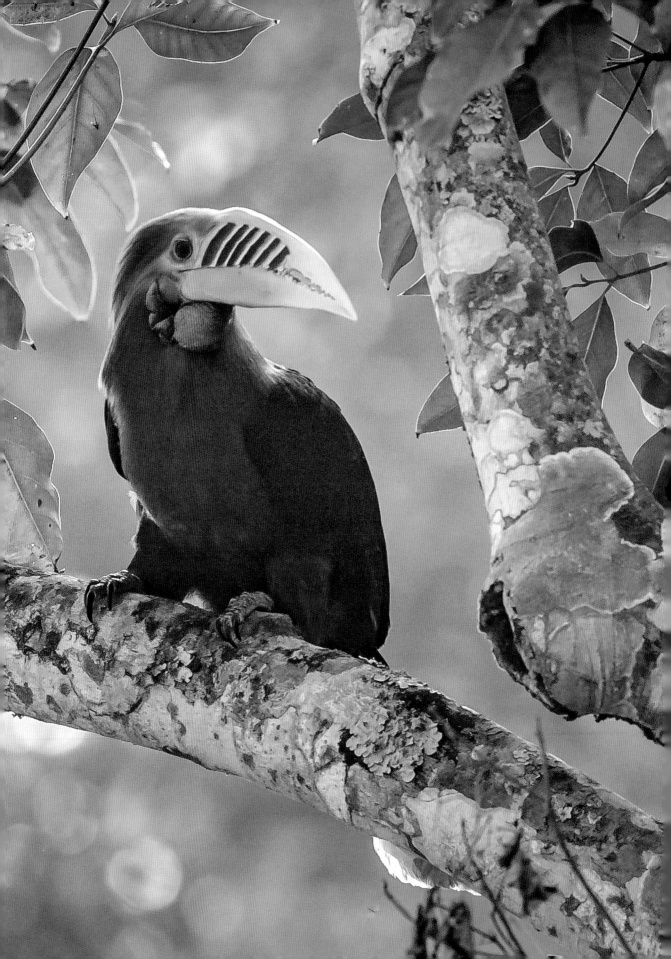

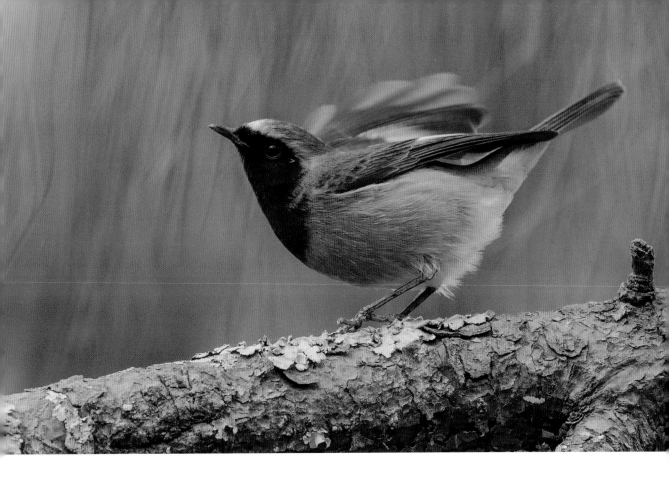

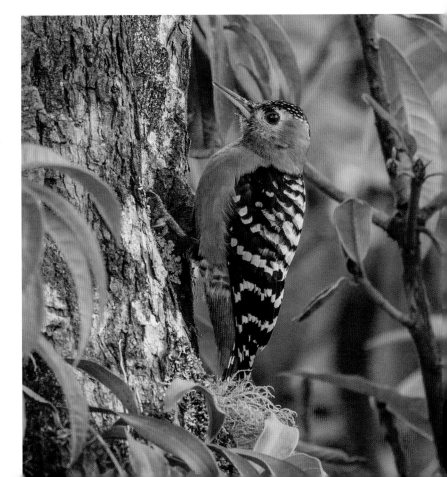

ABOVE This male **Hodgson's Redstart** (*Phoenicurus hodgsoni*) was seen close to Punakha, making sallies for flying insects. This species occurs in different montane landscapes and upland valleys at altitudes from 2,400 m to 3,600 m (7,900 ft to 11,800 ft). It is frequently observed near streams and rivers and is one of between five to six species of redstarts regularly encountered in Bhutan.

RIGHT In Bhutan, the smart-looking **Rufous-bellied Woodpecker** (*Dendrocopos hyperythrus*) occurs between 2,100 m to 4,100 m (6,900 ft to 13,400 ft) above sea level. Its diet consists largely of insects. During spring it also feeds on tree sap. This individual was seen at the Royal Botanical Park, Lampelri, a recommended locale to easily find a number of common montane bird species.

LEFT The majestic **Rufous-necked Hornbill** (*Aceros nipalensis*) can be encountered in subtropical broadleaved forest along the foothills up to 1,200 m (3,900 ft) high. It is common in Bhutan, but is rare and declining elsewhere in its range which includes northeast India and Southeast Asia.

India

India is the third largest country in Asia. It hosts an incredible array of landscapes spanning the arid Thar desert to the towering snow peaks of the Himalayas. It covers a huge range of habitats such as rainforests, montane forests, grasslands, deserts and mangrove swamps. This diversity is also reflected in the number of animal species found in India, with more than 420 mammals and above 1,300 bird species.

As of 2019, India has more than 100 national parks and 550 wildlife sanctuaries. If various community reserves are included, its total protected area exceeds 165,000 km^2 (63,700 mi^2).

In ancient India, forests and wildlife were already greatly valued. Post independence, India's Government was not the first to establish protected areas. Sanctuaries were also created by indigenous and tribal communities, who set aside land for religious purposes. Other forested areas were designated for hunting by India's royalty. The abundant depiction of wildlife in Indian art, especially during the Mughal period, reflects an important affinity with nature that harks back to the past.

Today, wildlife conservation in India faces many challenges. Over the years, economic development has largely been made at the expense of nature conservation. Permits for development projects, mining, as well as dams and roads inside and outside protected areas have been granted without appropriate checks and balances. Undoubtedly, this has caused further degradation of already fragile ecosystems.

India is home to more indigenous people than any other country. As of 2011, estimates reach 104 million or some nine per cent of India's population. The Indian Forests Rights Act gives indigenous people in 16 states land access to those who can prove their ancestral links to the land. However, there have been incidents involving evictions of indigenous people. Worried about the fate of these forests, leading environmental groups have filed the initial petition seeking evictions in cases where state governments had disputed the families' claims made under the Forest Rights law.

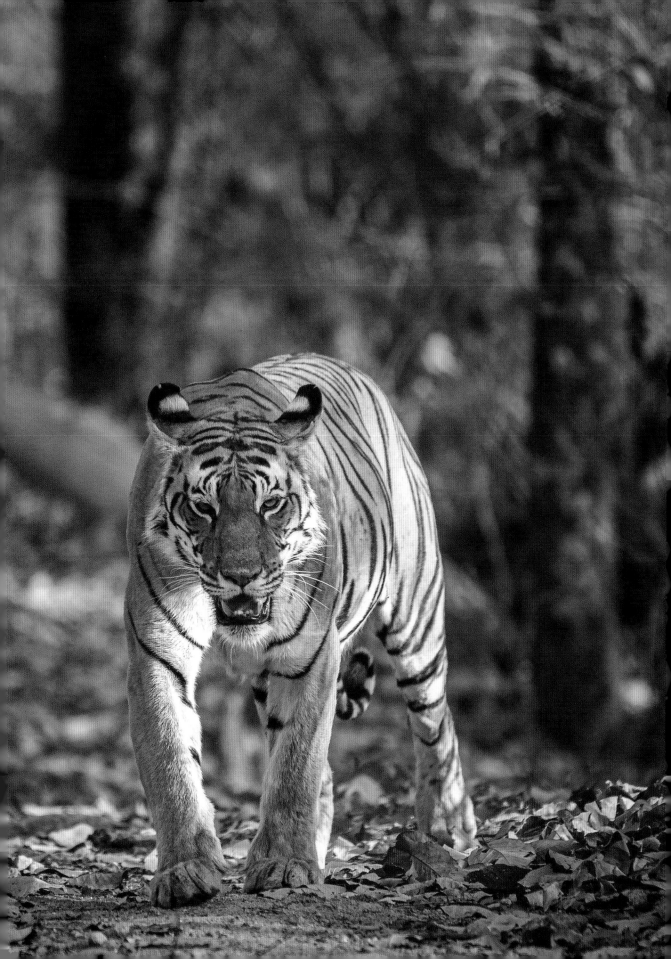

Some wildlife conservation groups argue that local communities degrade the forest environment and should be evicted if they cannot prove their ancestral land rights. For them, human encroachment on areas meant exclusively for wildlife is relentlessly eroding India's natural habitats. Other groups disagree, asserting that indigenous people are well placed to protect the forests and keep industrial development at bay. In their view, the rights of local communities form a fundamental part of any sustainable model of nature conservation.

This presents a serious dilemma: the needs of people versus the needs of wildlife, with no easy solution in sight. Increasing population pressures have contributed to habitat degradation and fragmentation for many species over the years. This is the main threat for iconic species like the Asian Elephant. It has resulted in a growing number of human-elephant conflicts, as these pachyderms are now forced to forage outside the protected areas. In India alone, more that 300 people are killed every year by crop-raiding elephants, which often leads to lethal retaliation by local people. Some reports suggest that more than 50 per cent of India's elephants are now found outside protected areas.

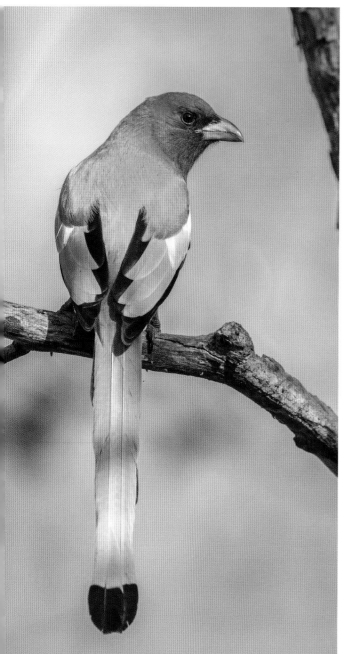

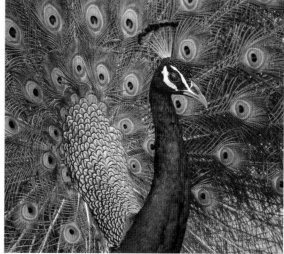

ABOVE The **Indian Peafowl** (*Pavo cristatus*) is the national bird of India. It is considered sacred by both Hindus and Buddhists and thus protected in many parts of the country.

The breeding period of the peafowl varies across the Indian subcontinent, but appears to be linked to the monsoons when small harems can be seen foraging together. Outside the breeding season, segregated groups of females with young and males are typically observed.

LEFT The omnivorous **Rufous Treepie** (*Dendrocitta vagabunda*) occurs in many parts of India and mainland Southeast Asia. This handsome crow can be found across lowland and hilly habitats, from dry forests to moist broadleaved woodlands, as well as in open agricultural areas with scattered trees.

RIGHT The **Asian Elephant** (*Elephas maximus*) is revered in India, and prominently features in the country's religion, culture and history. Classified by the International Union for the Conservation of Nature as Endangered, it is estimated that more than half of the global population of 41–52,000 individuals is found in India.

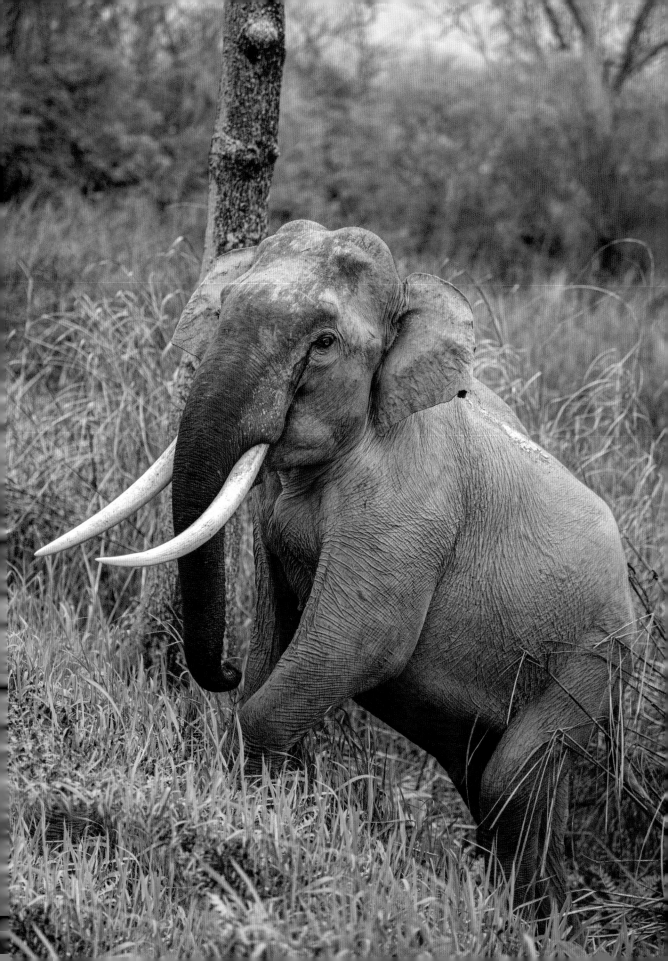

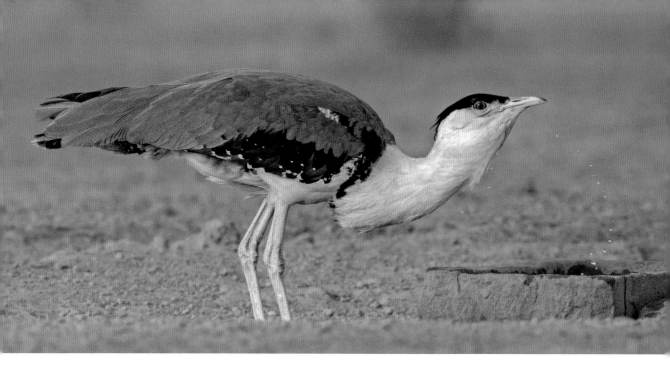

ABOVE The **Great Indian Bustard** (*Ardeotis nigriceps*) is Critically Endangered and one of Asia's most imperilled birds. These magnificent bustards are hunted in parts of their distribution. Sadly, many are killed annually by collisions with newly-constructed energy infrastructure such as power lines thoughtlessly built across their home range. Great Indian Bustards are slow breeders, rarely raising more than one chick a season. The species has been extirpated in over 90 per cent of its former range. The remaining population, estimated at less than 200 individuals, survives mainly in the states of Rajasthan and Gujarat. Significant conservation efforts have been made to protect this iconic species, but so far with mixed success. In the next few years, it is critical to ensure that the remaining landscapes used by the bustards are well protected, and shielded from new energy infrastructural developments.

The Great Indian Bustard occupies a mosaic of open habitat, which includes rolling grasslands and sub-desert. Areas with denser cover are used for nesting while sparse, elevated patches are used for courtship display. It is an opportunistic feeder, exploiting the local and seasonal abundance of grains, shoots and berries. In addition, it feeds on locusts, beetles, lizards and small mammals. The Great Indian Bustard forms small groups in winter, when it sometimes associates with antelopes.

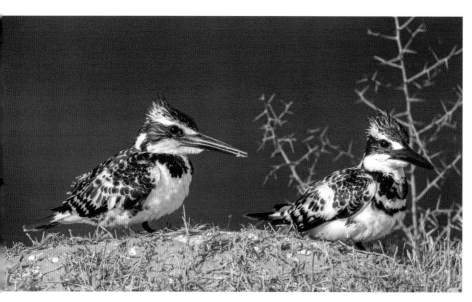

LEFT The **Pied Kingfisher** (*Ceryle rudis*) is widely distributed across Asia and Africa. In India, it is found chiefly on the plains near lakes, rivers and estuaries, often on waterside perches. Unlike other kingfishers, this species regularly hovers before diving to take prey in the water. This behaviour occurs more often in windy conditions, or if suitable perches cannot be located.

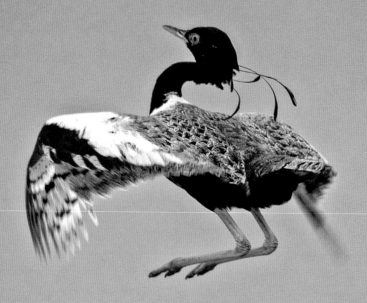

India is home to four species of bustards including the
Critically Endangered **Lesser Florican** (*Sypheotides indicus*).
This is the smallest, and perhaps the most threatened of its
bustards. As seen here, the male jumps vertically into the
air using shallow wing beats with its neck inflated and head
thrown back during its courtship display. At the top of its leap,
the wings are held so as to show off the white wing patch.
The bird then drops to the ground to repeat the act over and
over again. The Lesser Florican is very much at home in the
grasslands of north-west India but large areas of its habitat
have been cleared or encroached into in recent years.

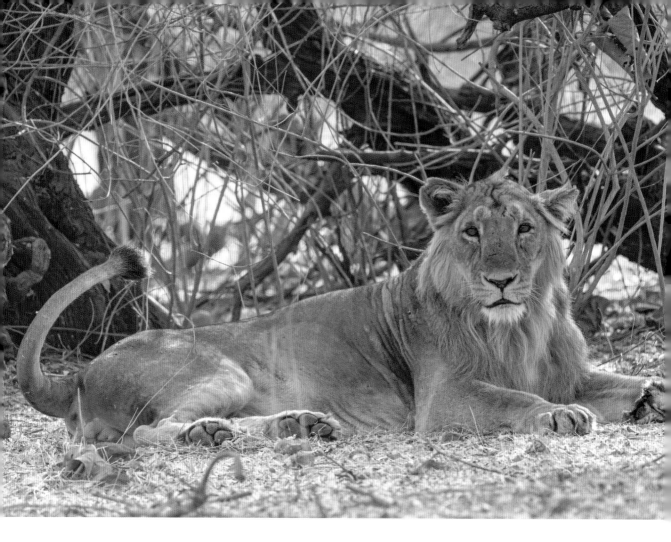

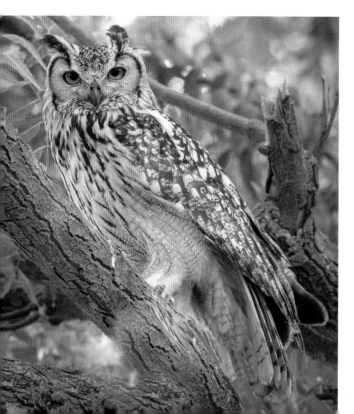

ABOVE Male **Asiatic Lion** (*Panthera leo leo*), Endangered, seen here at the famed Gir National Park in the state of Gujarat. This locale now hosts the only population of this once widespread lion subspecies. Indeed, India's notable fauna extends well beyond its tigers.

LEFT The **Rock Eagle-owl** (*Bubo bengalensis*) is one of four species of Eagle-owls in India. It is largely nocturnal, but can often be seen perching in trees well before sunset and after sunrise. Dietary studies confirm that the Rock Eagle-owl is a generalist feeder. Its diet is dominated by rodents and many small mammals. This eagle-owl is widespread across the Indian subcontinent but seemingly absent from Sri Lanka. The presence of large predators such as eagle-owls can be a good indicator of habitat quality.

Kanha Tiger Reserve

Picturesque Kanha Tiger Reserve, located in the central Indian state of Madhya Pradesh, was established in June 1955. It is one of India's oldest wildlife sanctuaries and has a reputation for being among the country's best managed national parks. With its lush sal and bamboo forests in addition to grassy meadows, Kanha is superbly suited as a key site to observe the Bengal Tiger.

One of the reserve's claim to fame is that it served as the inspiration for Rudyard Kipling's 1894 children's classic *The Jungle Book*, a story about a boy raised by wolves.

At the turn of the 20th century, the forests of the Banjar Valley and Halon Valley forming Kanha's western and eastern sectors had long been famous for their deer and tiger populations. At that point, Kanha was the exclusive hunting grounds for the British.

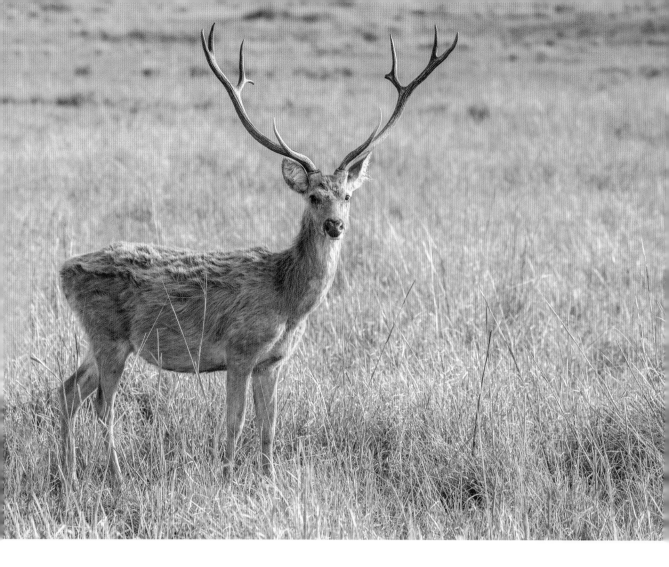

At the invitation of the Indian Government, the renowned wildlife biologist and conservationist George B. Schaller spent 20 months at Kanha National Park between 1963-65 to study its wildlife. Schaller's book, *The Deer and the Tiger,* is a detailed account of the ecology and behaviour of Bengal Tigers in relation to four species of hoofed mammals on which they prey on.

Despite the success stories associated with the conservation of large mammals in Kanha, the park faces several management challenges. This includes its relationship with local communities. The Baiga are indigenous people living in central India. Since 1968, they have been relocated from their homes inside Kanha National Park. Several human rights organisations have highlighted that thousands of Baiga have been evicted without proper compensation. The Madhya Pradesh Government maintains that the relocation of these forest dwellers from the core area of Kanha National Park was not forced but voluntary.

One of the deer species studied by George Schaller was the **Southern Swamp Deer** or Barasingha (*Rucervus duvaucelii branderi*), which has robust hooves and is adapted to the hard ground in open sal forests. Today, this subspecies of the Swamp Deer is largely confined to Kanha Tiger Reserve. It was brought back from the brink of extinction in 1970, when the total population numbered less than 100 individuals versus around 750 individuals in 2016. This sustained conservation push has turned out to be one of India's most lauded wildlife conservation programmes. The Southern Swamp Deer is now classified as Vulnerable.

It was done to protect tiger habitat and to reduce human-tiger conflicts.

Kanha Tiger Reserve is shaped like a figure of eight, with a length from west to east of approximately 80 km and a width ranging from eight km to 35 km (five mi to 22 mi). The Park's total area is about 1,940 km² (750 mi²) consisting of a core area of 940 km² (360 mi²) surrounded by a buffer zone of close to 1,000 km²

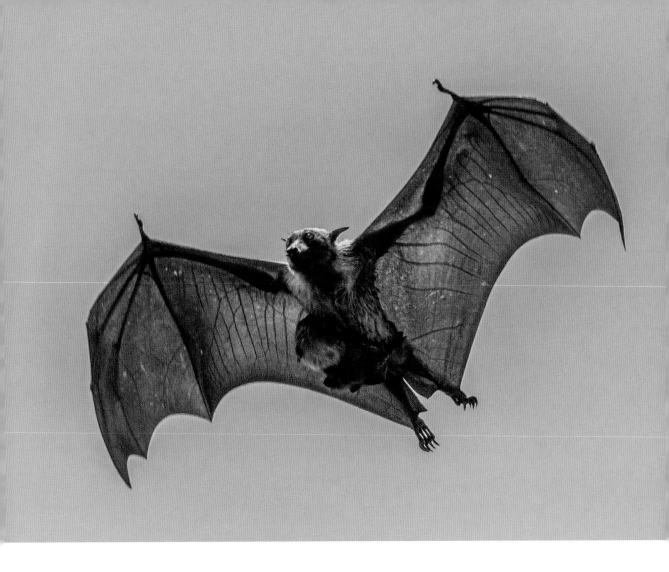

(390 mi²). Kanha's birdlife is rich with a tally reaching nearly 300 species.

The central highlands of Kanha is situated in the Maikal Hills. The park lies 165 km (100 mi) southeast of Jabalpur, and around 260 km (160 mi) northeast of the city of Nagpur, with convenient connecting flights to many parts of India.

As is generally the case in India, jeep safaris are only permitted during the day. The best times are early morning and late afternoon. Vehicles are not allowed to leave the established tracks, and walking is prohibited outside designated areas.

Kanha has a remarkable variation in its climate, with summer temperatures exceeding 40 °C (104 °F). The monsoons normally span the month of June to September, when 90 per cent of the annual precipitation occurs. The winters are truly scenic during the months of November to end March, when frost may cloak the meadows.

Indian Flying Fox (*Pteropus medius*) with its pup. The young bat is carried by its mother for the initial weeks. Males do not take part in parental care. Young bats start to fly two to three months after birth.

The Indian Flying Fox is India's largest bat, and one of the biggest in the world with a wingspan of up to 1.5 m (4.6 ft). It takes largely fruits and nectar. Fruit eating bats are critical to the health of the forest as they are efficient seed dispersers. The Indian Flying Fox roosts in large colonies on tall trees, often in close proximity to bodies of water.

Every year, the reserve is open to visitors from the middle of October to the end of June. The peak season for visitors is from November to March. The winter period between November and February is excellent for birdwatching as migratory birds call at the park in substantial numbers. From March to May, most of the vegetation is desiccated, and wildlife consequently becomes easier to see and photograph.

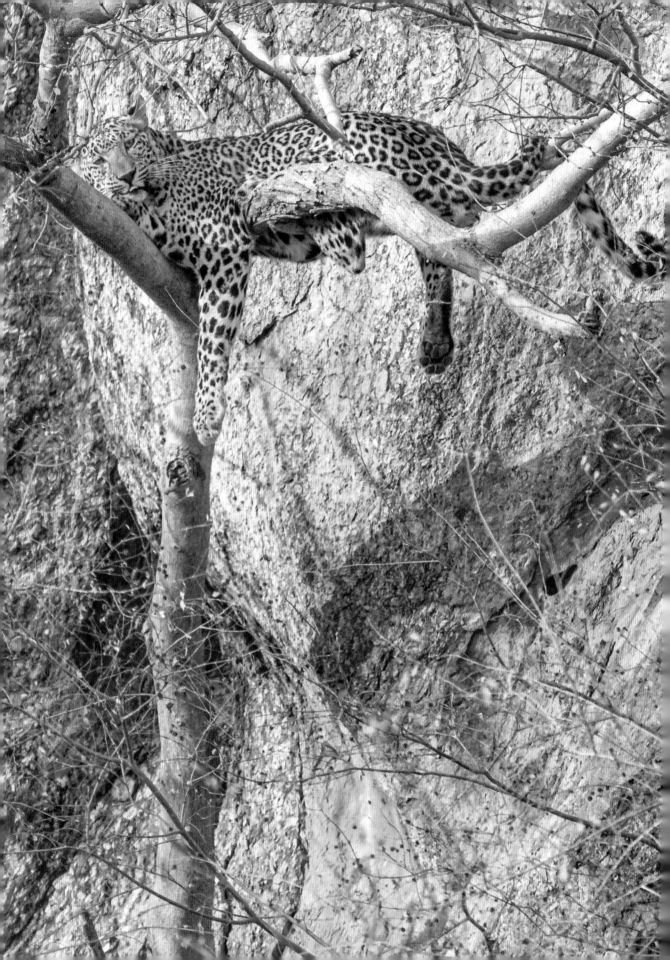

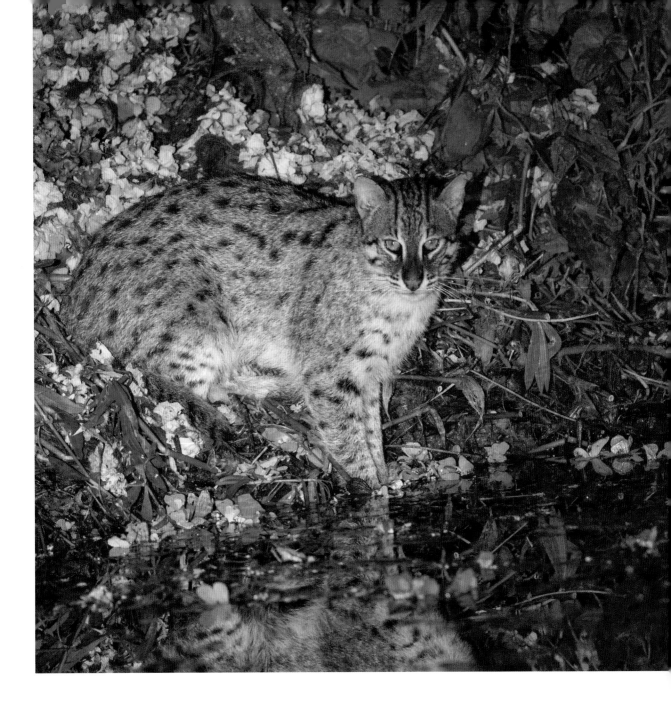

LEFT The **Indian Leopard** (*Panthera pardus fusca*) may, like tigers and elephants, have some of the best protection among species under India's wildlife laws. Unfortunately, poaching, habitat loss and human-wildlife conflicts continue to pose challenges to conserving this magnificent predator.

ABOVE The **Fishing Cat** (*Prionailurus viverrinus*) is about twice the size of a house cat, and is known for its adept fishing skills. Although its diet is largely dominated by fish and rodents, this adaptable feline has also been observed eating shellfish, lizards and frogs.

The Fishing Cat is nocturnal and perhaps one of the least understood cats. Until recently, little is known about its ecology but studies in Sri Lanka, India and Bangladesh have all improved knowledge of its habits and behaviour. It can be found in wetlands, such as swamps and marshes. It also dwells in agricultural areas with standing water, likely a result of encroachment of humans into its traditional wetland habitat. This handsome predator is threatened by habitat loss, and to some extent, by poaching for its pelt.

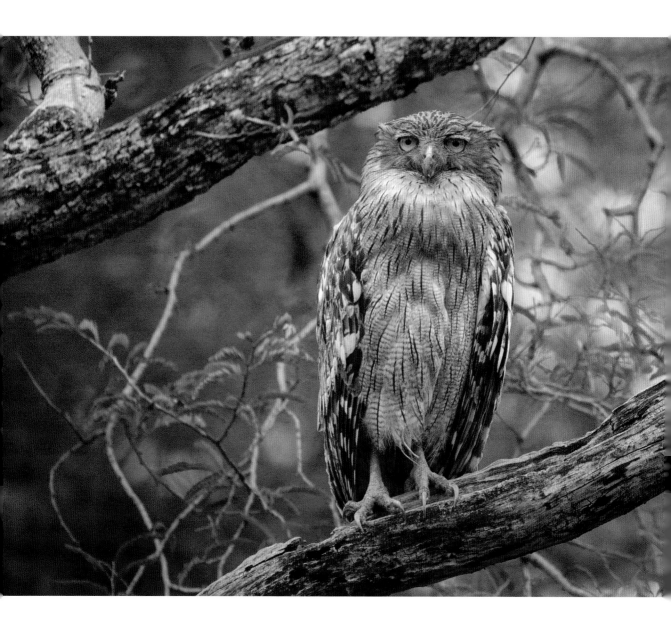

ABOVE The **Brown Fish-owl** (*Ketupa zeylonensis*) can be found across Asia from Türkiye to the Malay Peninsula in deciduous and open evergreen woodlands. It is almost always spotted near water. It prefers to feed on fish and frogs, but may also consume snakes and lizards. This neat-looking individual was seen on a perch overlooking a pond before it dropped in to seize a prey item.

RIGHT The **Northern Plains Gray Langur** (*Semnopithecus entellus*) is sometimes referred to as deer herders by local people. Very often, deer can be seen under a tree where Gray Langurs are foraging. Wild Boars (*Sus scrofa*) are also commonly observed following the feeding langurs, and greedily eating the fruits and leaves thrown to the ground by the langurs. This association is advantageous to both the deers and the boars as the langurs, from their higher vantage point, also serve as early detection for predators with their warning cries.

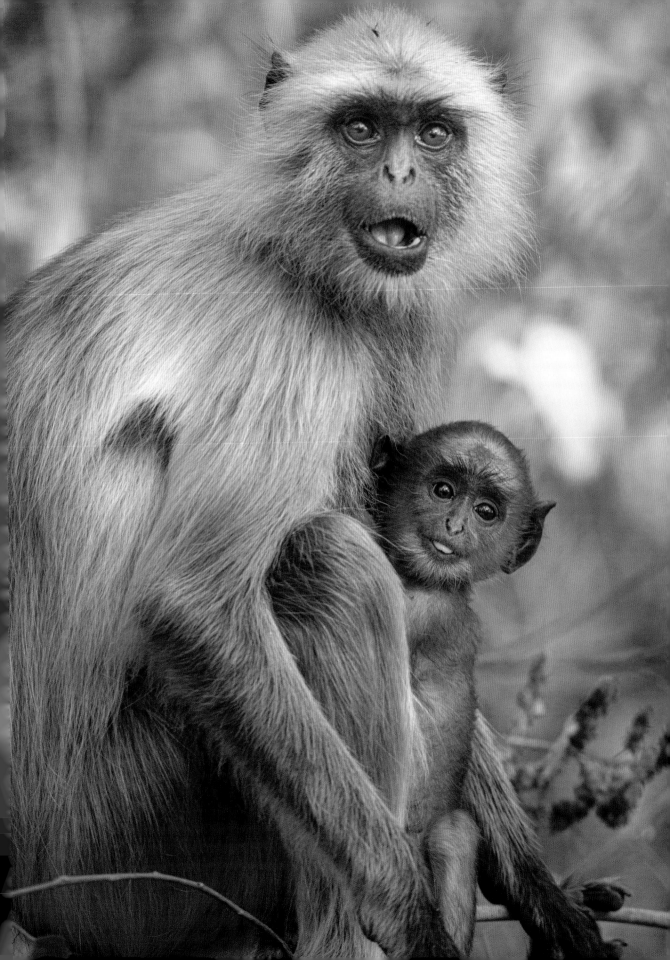

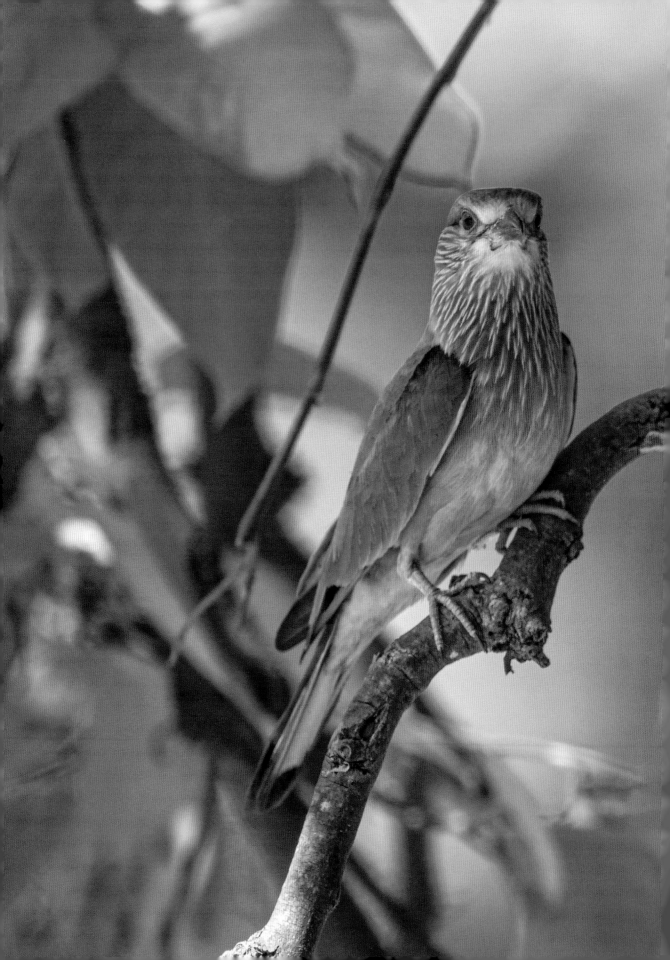

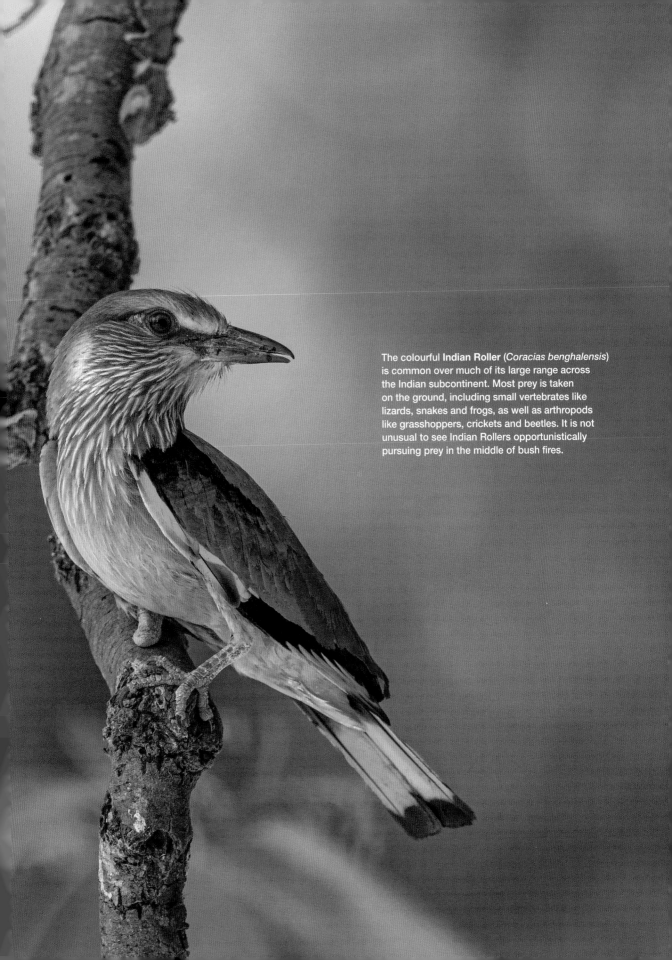

The colourful **Indian Roller** (*Coracias benghalensis*) is common over much of its large range across the Indian subcontinent. Most prey is taken on the ground, including small vertebrates like lizards, snakes and frogs, as well as arthropods like grasshoppers, crickets and beetles. It is not unusual to see Indian Rollers opportunistically pursuing prey in the middle of bush fires.

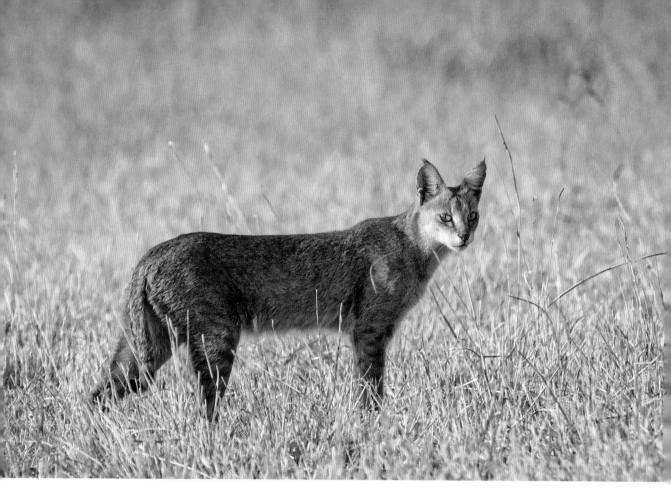

ABOVE The **Jungle Cat** (*Felis chaus*) is the most ubiquitous of the smaller wild cats in India. It is a habitat generalist and is highly adaptable, occurring in grasslands as well as dry deciduous and evergreen forests. The Jungle Cat often hunts animals much larger than itself, tackling prey such as Spotted Deer fawns. However, it can also subsist on small kills such as lizards, snakes, rodents and amphibians.

LEFT The beautiful **Orchid Tree** (*Bauhinia variegata*) is native to Asia and is distributed across the sub-Himalayan foothills and outer Himalayas. It is also planted in gardens and along roadsides as an ornamental. Various parts of the plant have been used by different ethnic groups to treat a wide range of ailments since ancient times.

RIGHT Changeable Hawk-eagle (*Nisaetus cirrhatus*) with the remains of a **Red Spurfowl** (*Galloperdix spadicea*), a ground bird endemic to India. This powerful raptor is common on the Indian subcontinent. It eats birds, mammals, and reptiles. Changeable Hawk-eagles are often seen in high canopy perches waiting for prey to venture into the open. The raptor then swoops, strikes, and carries its meal away.

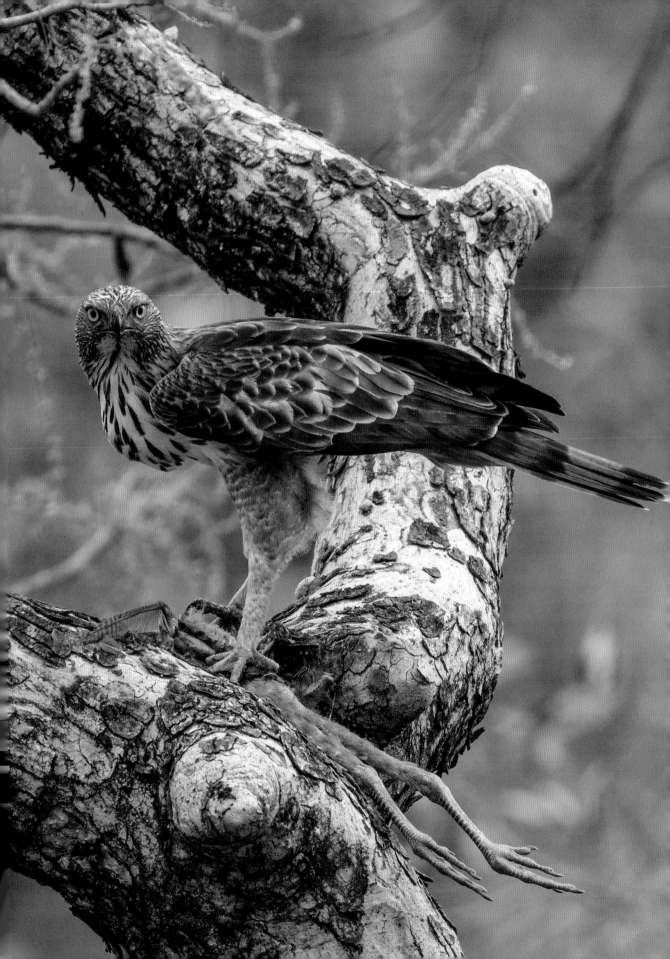

Tiger watching is a huge draw for tourists to India. There is no better place than India to see a wild tiger. The country is home to 50 tiger reserves where these majestic cats can be readily spotted. Core zones are defined in these reserves and a limited number of tourists are allowed access at any one time to observe tigers. Even with these controls in place, several tiger reserves remain over-crowded during peak visiting periods.

The role of tigers as an apex predator is vital in regulating ecological processes in the ecosystems they occupy. In India, tigers inhabit a wide variety of habitats ranging from mountains, to mangrove swamps, tall grasslands and deciduous forest. Tigers, as an umbrella species, require large tracts of land with sufficient prey to sustain viable populations.

India's record of tiger conservation so far has been very encouraging, with a doubling of the population over the past 10 years. There was close to an estimated 3,000 individuals in 2018, compared to just over 1,400 individuals in 2006.

Of the 50 tiger reserves in India, around 10-12 of them have optimal numbers. What is needed now is to enhance the 'secondary' tiger reserves. While there is enough habitat to accommodate increasing tiger numbers, the main issues with the remaining protected areas are a low prey base and grazing pressure. However, with good management, this can be overcome. It is critical that the local population and indigenous people actively participate tiger conservation efforts. They should be adequately compensated when tigers kill their livestock. The burden of tiger conservation should not be borne by India's poorest.

When people visit India to watch wildlife, they may also encounter Asiatic Lions, Leopards, Dholes, Sloth Bears, Asian Elephants, and Greater One-horned Rhinos. This diversity of easily observed large, charismatic mammals inhabiting the different ecosystems of India is truly remarkable. It makes India stand out from much of Asia. Perhaps it may be a good thing to move beyond 'tiger tourism' towards appreciating nature as a whole.

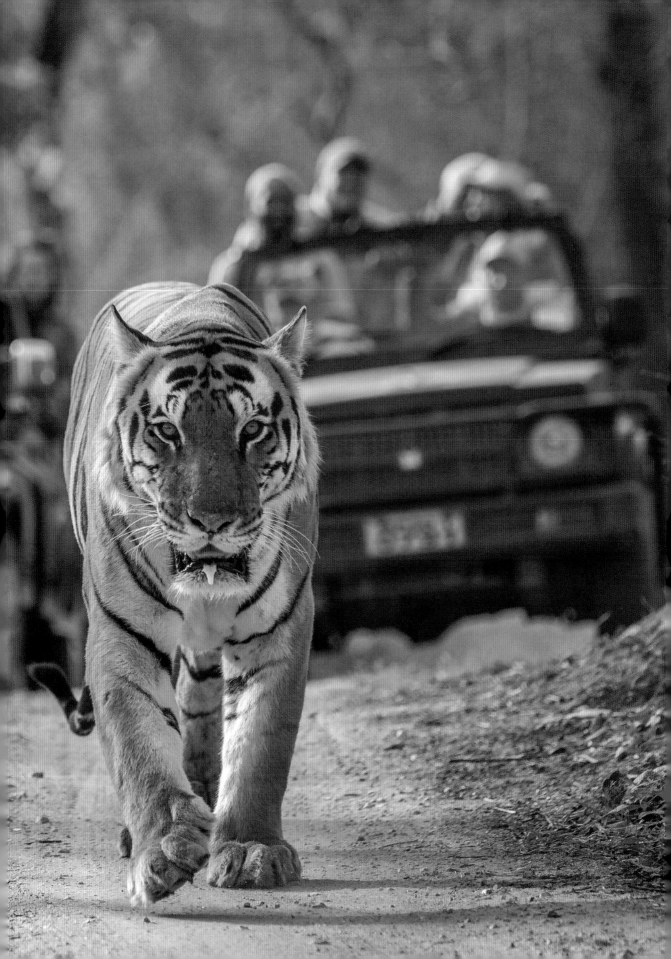

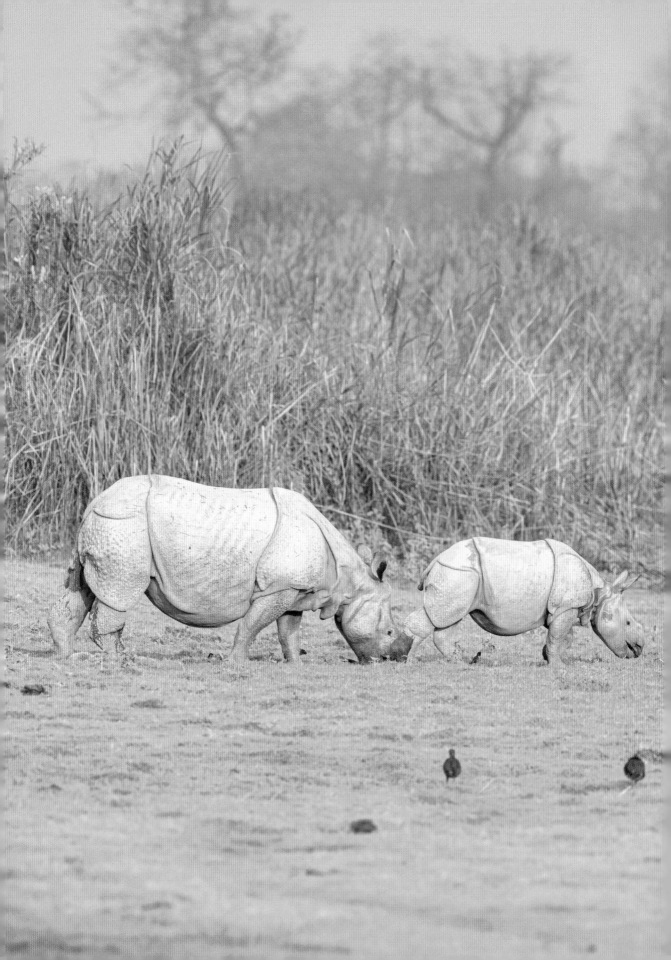

Kaziranga National Park

Kaziranga National Park is amongst the last unspoilt wilderness on the Brahmaputra floodplains of north-east India. This stunning park is located on the southern bank of the Brahmaputra River in the State of Assam. It was declared a UNESCO World Heritage Site in 1985. In 2007, the park was designated a Tiger Reserve, having one of the highest densities of tigers in India. Since then, there has been six new extensions to the park, a welcome addition of critical habitat for wildlife.

Kaziranga is considered by many to be one of the finest wildlife sanctuaries in Asia. Apart from harbouring the single largest population of the Indian Greater One-horned Rhinoceros *(Rhinoceros unicornis)* in the world, Kaziranga is also home to significant populations of threatened species such as the Asian Elephant, Swamp Deer and Asian Buffalo. It also has an impressive array of primates, including the Western Hoolock Gibbon.

Kaziranga is a key area for migratory birds. Birdlife International has classified it as an Important Bird and Biodiversity Area. Its location at the confluence of the East Asian-Australasian and Central Asian flyways makes the park's marshlands crucially important for the protection of migratory waterbirds.

Kaziranga offers expansive tall grassland, wetlands, and dense broadleaved forests intertwined with four rivers. The park includes numerous smaller bodies of water and swampy lagoons. Its diverse flora contributes to the breathtaking beauty of the area. The Indian Greater One-Horned Rhinoceros, Bengal Tiger, Asian Elephant, Asian Buffalo and Swamp Deer are collectively known as the 'Big Five' of Kaziranga.

Despite its size, Kaziranga is bordered on three sides by human settlements and tea plantations. This has led to challenges in its management, especially keeping the park from illegal incursions by poachers and livestock.

Recurrent heavy rains and flooding during the monsoon season have resulted in the death of many of the park's iconic wildlife and damage to its infrastructure. To escape the flood-affected zones, many animals migrate to elevated areas outside the park's boundaries. Here, they are exposed to poaching, and often subjected to reprisals by villagers for causing crop damage. Massive floods in July 2019 resulted in a toll of more than 200 animals including 19 rhinoceros. This happened in spite of extensive efforts by the park management and conservation organisations to save stranded wildlife. This problem is magnified by Kaziranga's location and proximity to numerous human settlements.

Poaching in and around Kaziranga has been significantly reduced through establishment of new anti-poaching camps, increased patrolling, and better firearms control around the park. The current conservation situation is considered one of the best in the country. However, poaching, invasive species, tourism pressure, highway traffic, and livestock grazing in buffer zones remain as key threats to wildlife.

Kaziranga is normally open from November to April, and is closed for the remaining part of the year because of monsoon rains.

The two nearest cities with airports are Guwahati and Jorhat, located 217 km (135 mi) and 97 km (60 mi) respectively from the park. There are well maintained roads from both cities to Kaziranga.

From Jorhat, it is only an hour's drive to visit the Hollongapar Gibbon Sanctuary. This is a recommended site to see the Western Hoolock Gibbon *(Hoolock hoolock)* and the Stump-tailed Macaque *(Macaca arctoides)*, both globally threatened species.

Jeep safaris in Kaziranga can be arranged through any of the numerous hotels outside the park. Authorised guides by the Forest Department will accompany all park visitors. A number of observation towers are strategically placed inside the park.

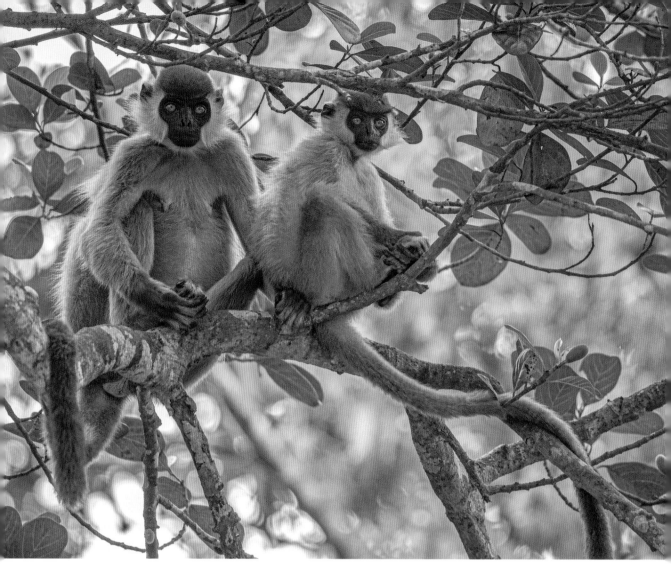

ABOVE Capped Langur (*Trachypithecus pileatus*), Vulnerable. The Capped Langur is probably the most widely distributed of the langurs associated with northeastern India. In spite of habitat degradation, this adaptable primate has managed to persist at numerous sites in the region, often using disturbed landscapes. Poaching poses a serious threat in many parts of its range.

RIGHT Nesting pair of **Great Hornbills** (*Buceros bicornis*) in Kaziranga National Park.

The male, with its black-rimmed red eyes, is here seen feeding the female inside the nesting cavity. The diet consists mainly of fruits, and occasionally large insects, small reptiles, birds and mammals.

Great Hornbills favour many species of figs, which comprise some 70 per cent of food delivered to nest sites in India. As with many other hornbill species, it is threatened by the loss and degradation of its forest habitat, and to some extent by hunting. The Great Hornbill was recently uplisted by the IUCN to globally Vulnerable due to its declining population.

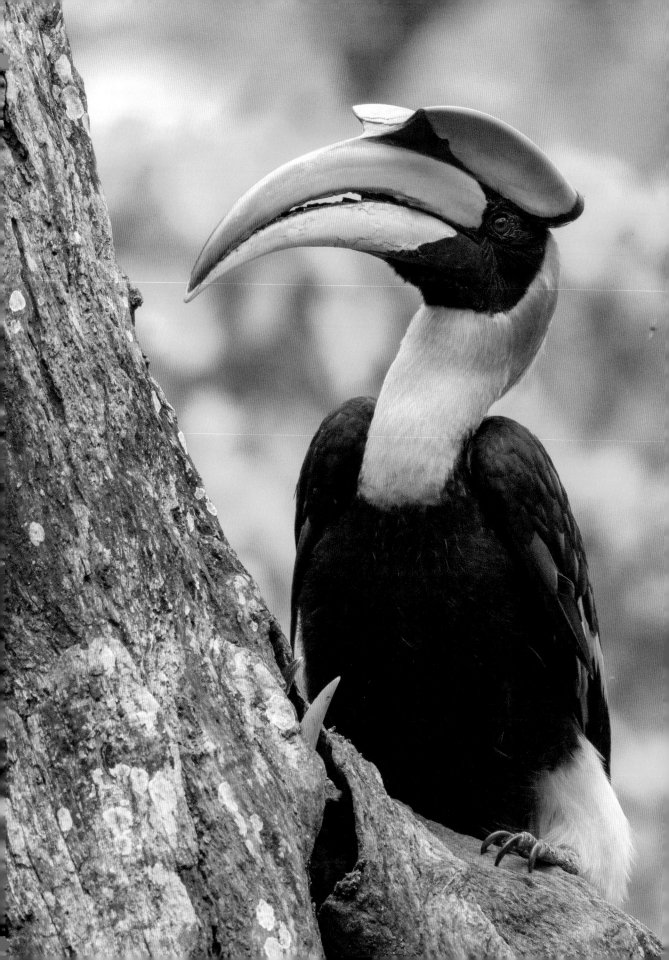

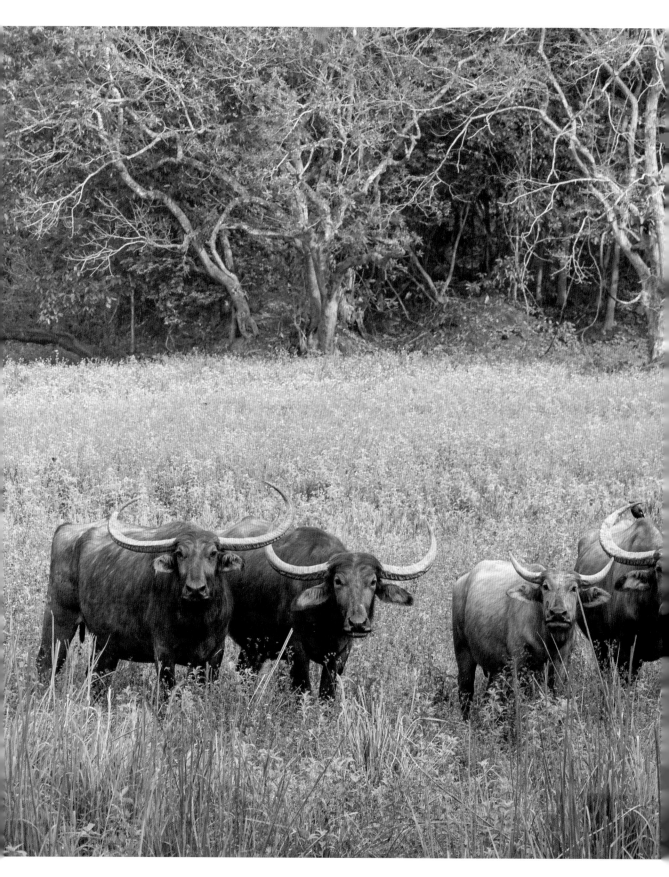

ABOVE The **Yellow-throated Marten** (*Martes flavigula*) is a widely-distributed member of the mustelid family in Asia. This nimble predator takes anything it can catch, including small vertebrate prey like squirrels, hares and birds. The marten is adaptable and has been spotted in many habitat types from the lowlands to montane coniferous forests. Most sightings of this attractive mammal involve singles or small family groups.

LEFT The Endangered **Asian Buffalo** (*Bubalus arnee*) sits as one of the most familiar large mammals of Kaziranga. In the past, it ranged extensively across the northern and central parts of India and east towards Southeast Asia. Today, scattered herds only remain in protected areas. Kaziranga is regarded as India's foremost site for the Asian Buffalo, with an estimated population of 2,600 individuals. The Asian Buffalo is the ancestor of the familiar water buffalo, having been domesticated some 5,000 years ago. Today, hybridisation with the domestic buffalo is a serious threat to the Asian Buffalo's populations in India.

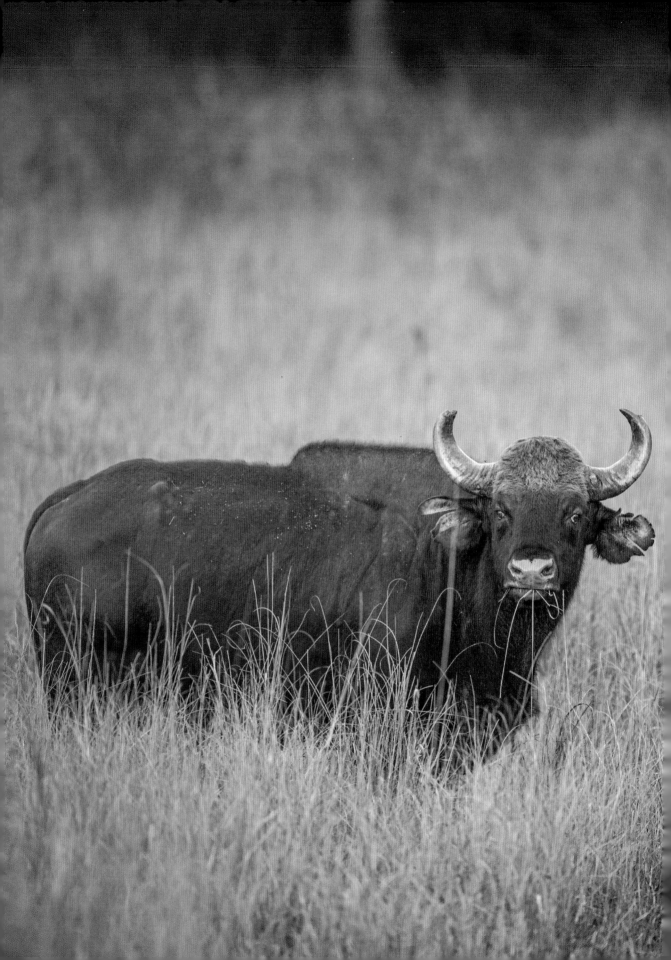

ABOVE Assam Macaque (*Macaca assamensis*) foraging in an Orchid Tree. In India, this primate occurs largely in the hills and montane forests of the north-eastern states. It feeds on fruits, young leaves, small vertebrates and insects mostly in trees. It has cheek pouches for storing food while foraging.

RIGHT Globally, the largest subpopulation of the Endangered **Hog Deer** (*Axis porcinus*) lives in Kaziranga. The species prefers a habitat of moist tall grasslands connected to water bodies. The Hog Deer is primarily a grazer of young grasses. In areas with low hunting pressure such as Kaziranga, large herds can be seen during the daytime. Heavily threatened by poaching across much of its distribution, the Hog Deer is typically shy, but not so in Kaziranga where they are easily observed.

LEFT The **Indian Gaur** (*Bos gaurus gaurus*) can be found in mixed herds of 2-30 individuals led by a single female. Adult males tend to be solitary. The Gaur is typically diurnal, but in places where there are regular human disturbances, these cattle become more nocturnal. They are rarely observed in the open apart from early mornings. While Gaurs use water bodies to drink, they are hardly seen bathing or wallowing.

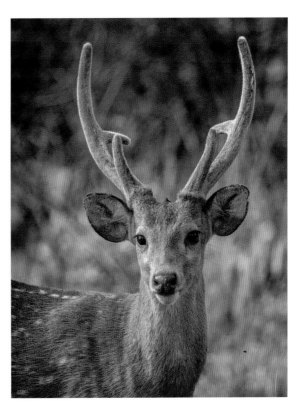

Western Hoolock Gibbon (*Hoolock hoolock*), Endangered. With their exceptionally long arms, almost double the length of their legs, gibbons are ideally adapted to life in the forest canopy and rarely descend to the ground. Hoolocks are the second largest gibbons after the Siamang of Southeast Asia. As shown here, males are black with distinctive white brows, while females and juveniles are buffy brown. The population of the Western Hoolock Gibbons has dropped by almost 90 per cent over the last few decades.

 Western Hoolock Gibbons form monogamous pairs. Hoolocks and other gibbons are extraordinarily vocal creatures. They are well known for their haunting calls that can travel great distances in the forest. Their songs and calls are highly complex, enabling individuals to locate family members, ward off intruders, or announce the presence of predators.

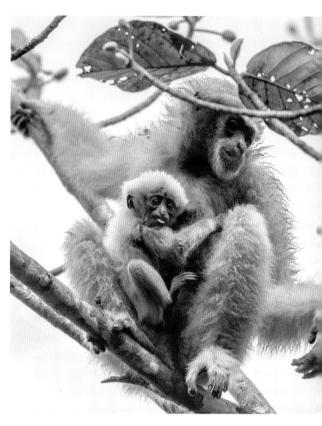

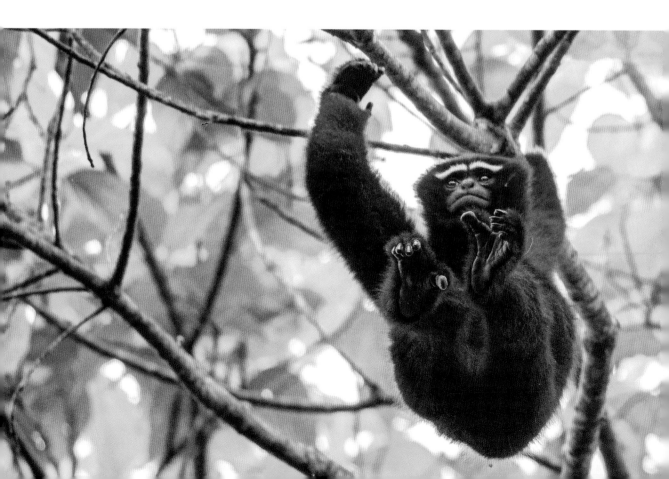

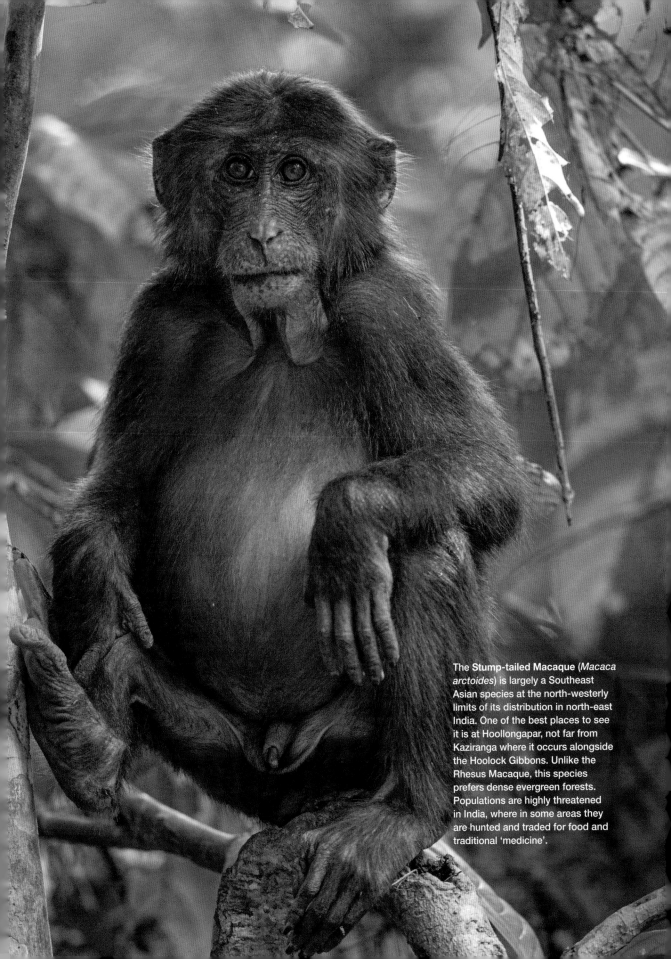

The **Stump-tailed Macaque** (*Macaca arctoides*) is largely a Southeast Asian species at the north-westerly limits of its distribution in north-east India. One of the best places to see it is at Hoollongapar, not far from Kaziranga where it occurs alongside the Hoolock Gibbons. Unlike the Rhesus Macaque, this species prefers dense evergreen forests. Populations are highly threatened in India, where in some areas they are hunted and traded for food and traditional 'medicine'.

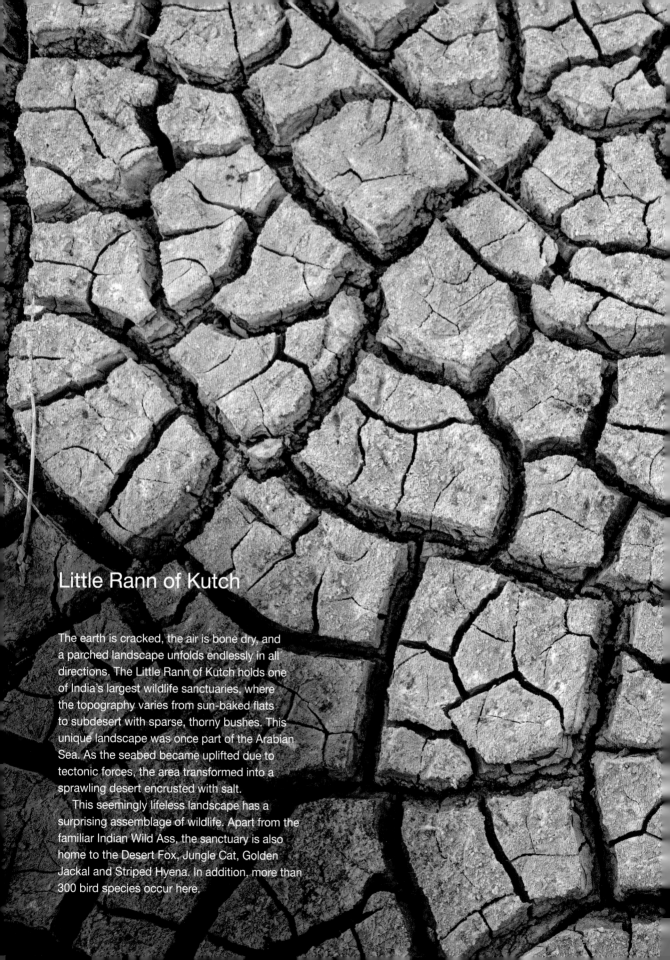

Little Rann of Kutch

The earth is cracked, the air is bone dry, and a parched landscape unfolds endlessly in all directions. The Little Rann of Kutch holds one of India's largest wildlife sanctuaries, where the topography varies from sun-baked flats to subdesert with sparse, thorny bushes. This unique landscape was once part of the Arabian Sea. As the seabed became uplifted due to tectonic forces, the area transformed into a sprawling desert encrusted with salt.

This seemingly lifeless landscape has a surprising assemblage of wildlife. Apart from the familiar Indian Wild Ass, the sanctuary is also home to the Desert Fox, Jungle Cat, Golden Jackal and Striped Hyena. In addition, more than 300 bird species occur here.

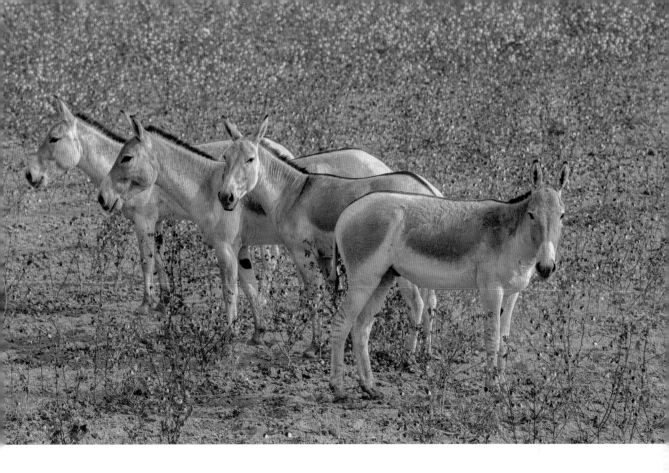

ABOVE The Wild Ass Sanctuary, located in the Little Rann of Kutch in the state of Gujarat, was established in 1972. It covers an area of around 5,000 km² (3,100 mi²). This unique terrain provides the last home of the **Indian Wild Ass** (*Equus hemionus khur*). In the past, this iconic equine was much more widespread. It could then be found in Pakistan and several areas of the Thar Desert in the state of Rajasthan. Now, it is largely confined to Gujarat where the population has recovered to around 4,500 individuals.

The Indian Wild Ass feeds on grasses, leaves and fruits of plant and saline vegetation in the daytime. It is one of the fastest Indian animals, running at speeds of up to 70 km (45 mi) per hour. Stallions live solitarily or in small groups, while family herds are much larger. When a mare comes into heat, she separates from the family herd. She then pairs off with a stallion which has to battle with rivals to win mating rights with her. The mare gives birth to one foal.

RIGHT The **Indian Fox** (*Vulpes bengalensis*) favours thinly vegetated areas such as grasslands, thorn scrub and semi-deserts, and thus are very much at home in the deserts of the Rann of Kutch. These foxes occupy burrows that are typically one metre below ground. Such burrows may have several openings leading towards a central breeding space. Indian Foxes are thought to form monogamous pairs. During the breeding season, male foxes vocalise loudly at dusk and dawn, and occasionally in the middle of the night.

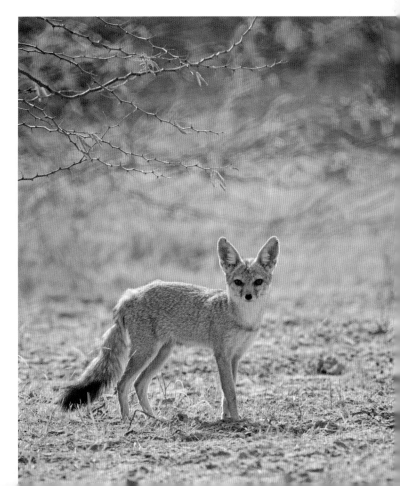

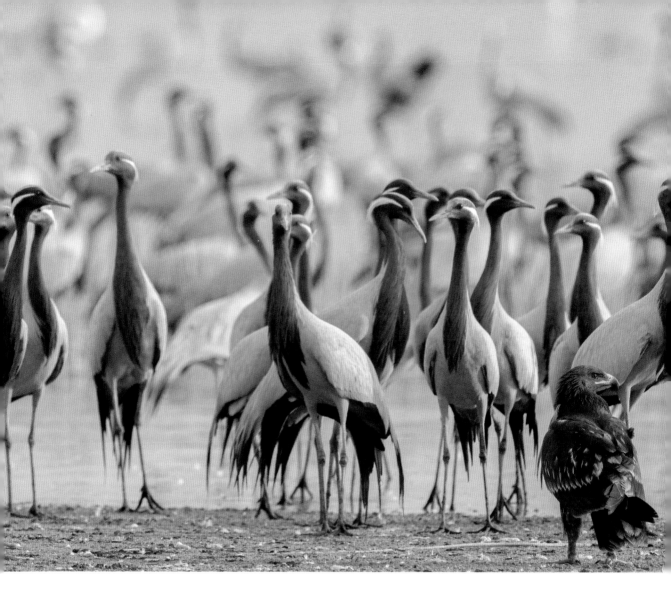

During the monsoon, some portions of the sanctuary are transformed into a spectacular wetland, which forms part of a larger Ramsar site also covering the Greater Rann of Kutch. In years with high rainfall, many low-lying areas remain flooded during the winter months from October to March. This is the best time for birdwatching at the lakes and marshes, where vast flocks of feathered beauties like the Demoiselle Cranes and Great White Pelicans gather. The wetlands also attract flamingos, storks, ibises, and a variety of ducks and other waterfowl.

The Little Rann of Kutch is an important feeding and breeding habitat for a huge number of birds. This is due to its strategic location on the Central Asian Flyway and its connections to the Gulf of Kutch, providing food availability in an otherwise resource-sparse ecosystem.

Demoiselle Cranes (*Grus virgo*) being watched by a **Greater Spotted Eagle** (*Clanga clanga*).

Local communities around the Little Rann of Kutch have voiced their concern over crop raiding by the Wild Ass, Nilgai and Wild Pigs. They are seeking compensation from the government for crop losses and/or subsidies for fencing material to protect their crops. Thus far, the locals have not pushed strongly or retaliated. However, the situation could change if there is no response from local authorities. There is a need for conservationists to find a better way to reconcile wildlife protection with the livelihoods of local people, to avert future human-wildlife conflicts.

The Little Rann of Kutch is around 130 km (80 mi)

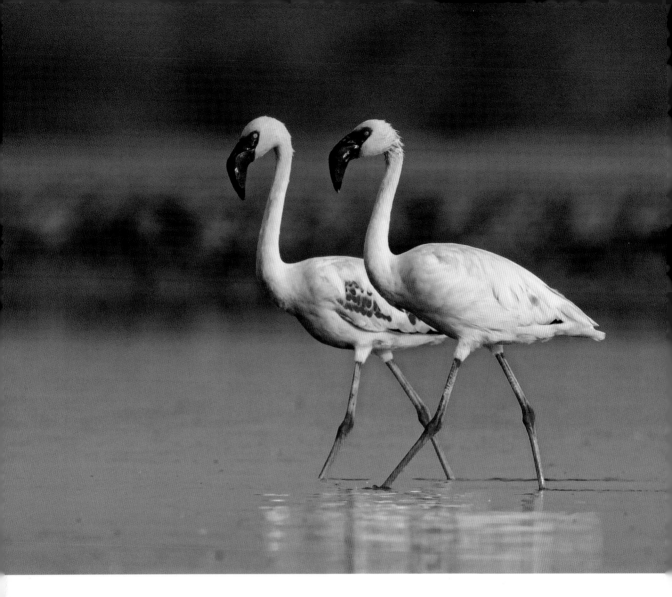

or three hours' drive northwest of Gujarat's capital at Ahmedabad. From here, direct flights are available to most major Indian cities.

Visitors are allowed to drive their own vehicles into the sanctuary. However, this is not recommended, as it is easy to get lost in a habitat with few landmarks or roads. The best option is to join desert safaris with local guides, which can be organised by many hotels. Since there are few places for wildlife to hide in this open wilderness, animals are comparatively easy to spot. Birdwatchers prefer the marshlands where large numbers of waterbirds congregate. If one wants to see mammals, the arid desert areas hold more species. The summer in Kutch lasts from February till June and is extremely hot. The landscapes here becomes flooded and inaccessible during the monsoon from June to September.

The **Lesser Flamingo** (*Phoeniconaias minor*) is a highly specialised feeder. It is almost totally dependent on microscopic blue green algae, and to a smaller extent on tiny invertebrates. The Flamingo filter feeds with its beak upside down whilst tipping its head into the water and using its upper mandible to sieve aquatic organisms. The Rann of Kutch is the best place to see this species, which also breeds here in large congregations, perhaps the largest in Asia.

The pleasant winter months stretch from October to January. The temperatures during this time vary from 10 °C to 25 °C (50 °F to 77 °F), but may drop to 0 °C (32 °F) during the early mornings, so multiple layers of warm clothes are advised. Generally the best time to visit Kutch is from October to March, before the start of summer.

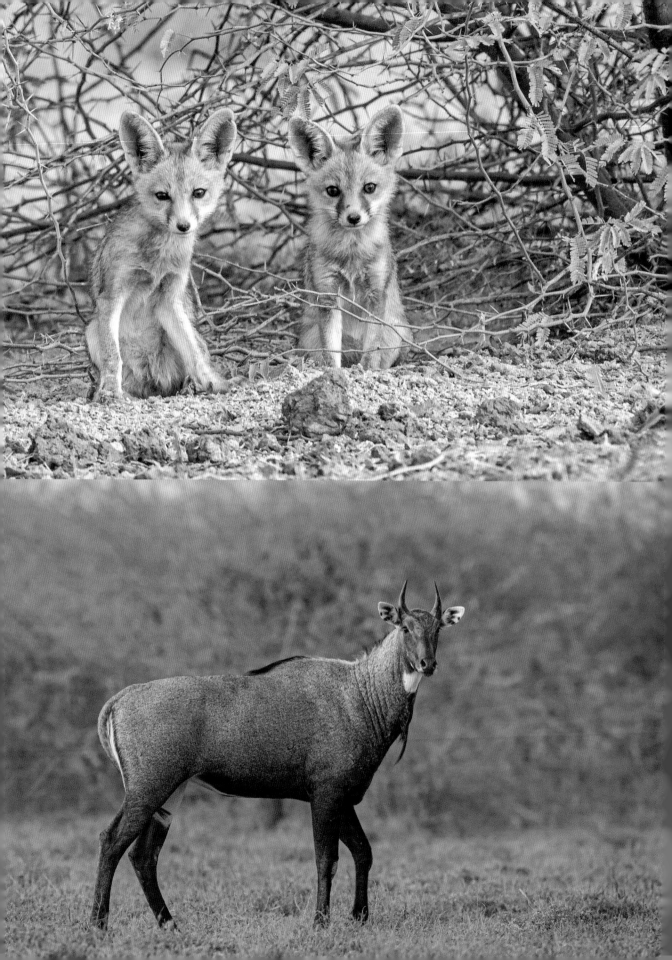

LEFT TOP **Desert Red Fox** (*Vulpes vulpes pusilla*) pups in front of their den in the Little Rann of Kutch. The cubs are born inside the den and are looked after by both parents. At around one month old, they start to venture out and play.

The Desert Red Fox is a small subspecies of the widely-distributed Red Fox, which occurs throughout tracts of arid north-west India. Its sandy pelt provides first-rate camouflage. The Desert Red Fox is perfectly adapted to the harsh climatic conditions where temperatures may reach up to 50 °C (122 °F). Its favourite food is gerbils, but this wily predator eats anything that it can get hold of including birds, large insects, reptiles, fruits and eggs.

LEFT BOTTOM The **Nilgai** or 'Blue Bull' (*Boselaphus tragocamelus*) is the largest Asian antelope and is endemic to the Indian subcontinent. The male measures up to 1.5 m (4.6 ft) tall at the shoulder, and can weigh up to 300 kg (660 lb). It is most active during the day and can survive for long periods without water. In the rainy season, its diet is mainly grasses and herbs. During summer and winter, it switches to an intake of foliage, flowers, pods and fruits. In some of India's northern states, the Nilgai is considered a pest that can cause considerable crop damage.

ABOVE The **Sarus Crane** (*Antigone antigone*) is the tallest flying bird in the world. This handsome crane stands at up to 1.7 m (5.2 ft) tall and boasts a wingspan of around 2.5 m (7.6 ft). In India, this species is habituated to human activity, foraging in and around canals, irrigation ditches, shallow marshes and cultivated fields, and can be easily observed in agricultural areas in Gujarat. The diet varies from the corms of wetland grasses, rice and other grains to snails, crustaceans, insects and small vertebrates.

The Sarus Crane is known to pair for life and is sexually mature at two-three years old. Generally, the breeding season coincides with the monsoons. Nests are built in natural wetlands or in flooded paddy fields. Most nests hold a clutch of two eggs, which are incubated by both parents for 30 to 35 days. The parents accompany their young from the day of birth.

Unlike most other crane species that make long-distance migrations, Sarus Cranes are generally non-migratory. The species is venerated in India, and the state of Uttar Pradesh has declared it as its official state bird.

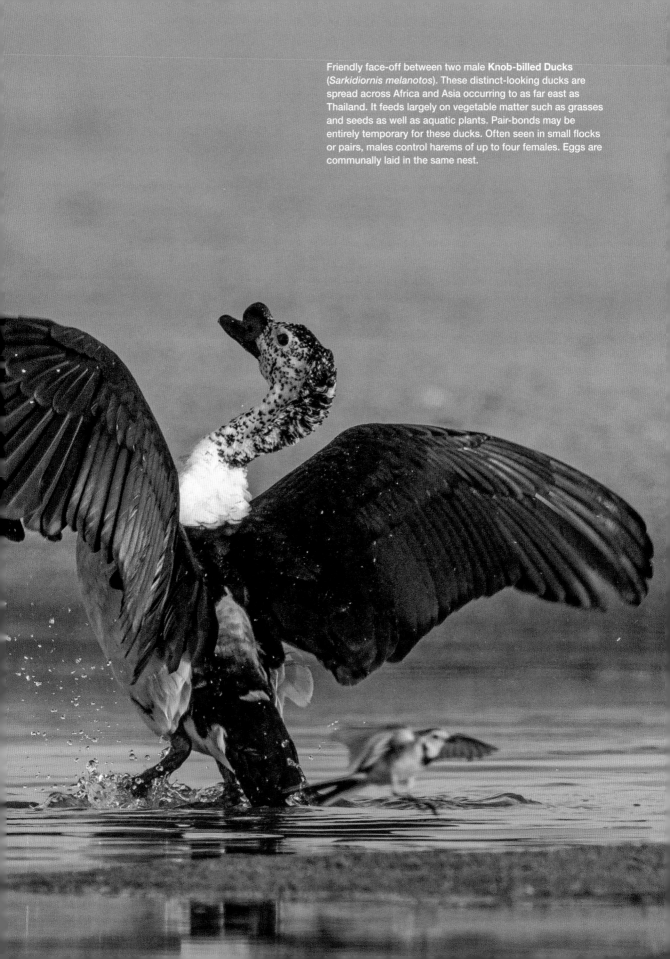

Friendly face-off between two male **Knob-billed Ducks** (*Sarkidiornis melanotos*). These distinct-looking ducks are spread across Africa and Asia occurring to as far east as Thailand. It feeds largely on vegetable matter such as grasses and seeds as well as aquatic plants. Pair-bonds may be entirely temporary for these ducks. Often seen in small flocks or pairs, males control harems of up to four females. Eggs are communally laid in the same nest.

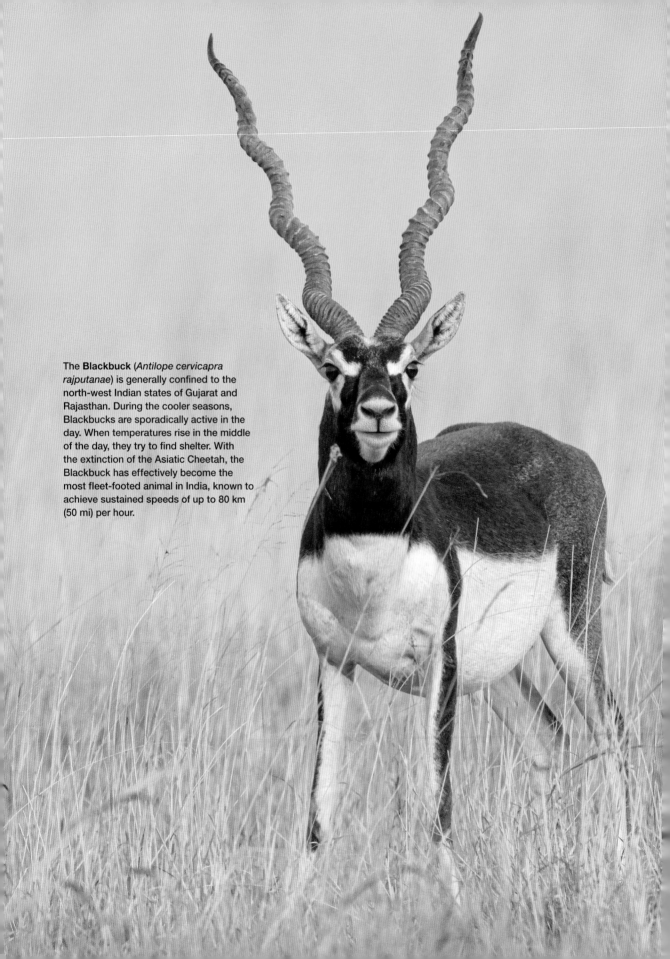

The **Blackbuck** (*Antilope cervicapra rajputanae*) is generally confined to the north-west Indian states of Gujarat and Rajasthan. During the cooler seasons, Blackbucks are sporadically active in the day. When temperatures rise in the middle of the day, they try to find shelter. With the extinction of the Asiatic Cheetah, the Blackbuck has effectively become the most fleet-footed animal in India, known to achieve sustained speeds of up to 80 km (50 mi) per hour.

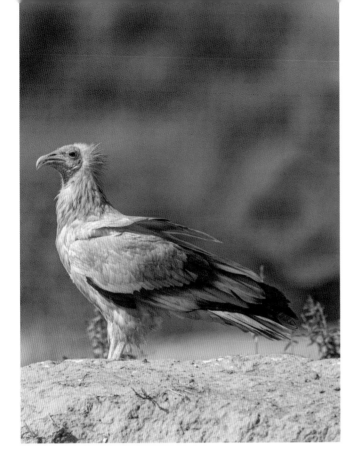

LEFT The Endangered **Egyptian Vulture** (*Neophron percnopterus*) is one of many vultures in decline across Asia. It is amongst the few birds known to use tools. These vultures reportedly drop stones on eggs until the shells crack. In recent years, its population has been decimated by poisoning and illegal hunting in much of its range. Many of its larger relatives have been impacted by the use of the veterinary drug, diclofenac, which is highly toxic to vultures.

BELOW The **Grey Francolin** (*Francolinus pondicerianus*) is widespread over much of northern India. It is the most frequently encountered of the nation's ground birds, partly because of its adaptability to different habitat types, and its tolerance of human disturbance.

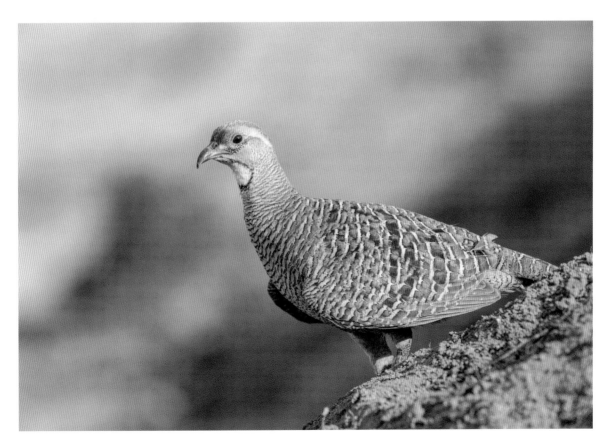

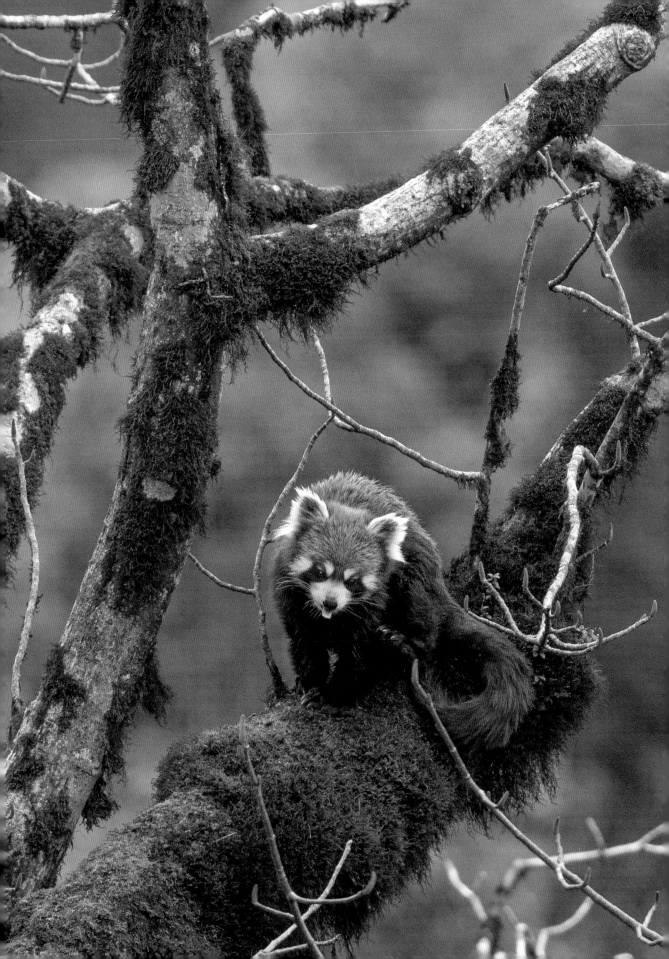

Singalila National Park

Singalila National Park is a choice destination for naturalists in the Eastern Himalayas, boasting more than 350 recorded bird species. Without a doubt, it is an excellent site to see a representation of Himalayan wildlife. The park is part of an Important Bird and Biodiversity Area (IBA) located in north-eastern India in West Bengal's Darjeeling district. To the north, Singalila is bordered by Sikkim, and to the west by Nepal. Singalila was made a wildlife sanctuary in 1986, and declared a national park in 1992.

Singalila occupies an area of close to 80 km² (30 mi²) on the Singalila Ridge. The ridge line spans an altitude of 2,400 m to around 3,600 m (7,900 ft to around 11,800 ft), running north to south. Its stunning rhododendron forests are perhaps one of the park's most recognisable features. The high elevation and rugged topography, together with lush rainfall during the monsoons, have carved out a varied alpine ecosystem populated by a diversity of wildlife and sceneries not easily observed elsewhere in India's Eastern Himalayas. As one hikes into Singalila, one is immersed in verdant broadleaved forests dominated by oaks, ferns, and conifers. The park also supports a fantastic spectrum of flowering plants such as rhododendrons, orchids, magnolias and primroses.

The threats faced by the forests of the Singalila Ridge have intensified over the last few decades. With human encroachment comes agriculture, livestock grazing, poaching and feral dogs, all of which result in different pressures to Singalila's wildlife. At these elevations, firewood is a major source of fuel for the locals, in the form of junipers and rhododendrons. In turn, this has resulted in forest degradation. Forest fires, aggravated by the dry season, have caused further damage in recent years.

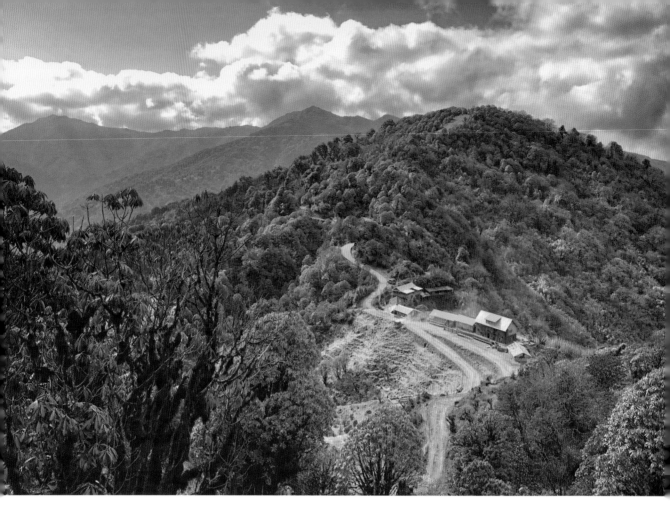

Livestock herders also inflict harm on these fragile alpine ecosystems by collecting firewood and medicinal plants, hunting, as well as harvesting of trees for fodder. In addition, free-roaming herding dogs are known to attack wildlife such as pheasants and mammals, including the Red Panda. This has led to wildlife becoming shyer and more difficult to observe. While grazing may not be that damaging, it is the associated human activities that impact the park's fragile ecosystem negatively. That being said, carefully managed eco-tourism and livestock husbandry need to be balanced. This will ensure that Singalila's biodiversity is adequately protected while sustaining local livelihoods.

Singalila National Park was the location of the first successful reintroduction of Red Pandas in 2004, as documented in the film 'Cherub of the Mist' by Naresh Bedi. This was also the first time these beautiful mammals and their ecology were captured in a documentary.

The nearest airport to Singalila is Bagdogra International Airport. From here, it is a three-four hour

The homestay 'Habre's Nest' in the tiny village of Kaiakata on the Singalila Ridge sits at around 2,900 m (9,500 ft) above sea level. The road seen here demarcates the border between Nepal (on the right) and India. 'Habre's Nest' has made consistent efforts to support the villagers with medical services, skills development, and employment while undertaking work to restore the forest habitat. Their Red Panda tracking programme is 'best-in-class' where patrons stand a good chance of observing this elusive species.

drive to Manebhanjan, a small mountain hamlet close to Singalila National Park. All visitors need a permit to enter the park, obtainable from the forest department in Manebhanjan. Here, one can transfer to a classic four-wheel drive vehicle, which is the preferred mode of transport in the park. The scenic drive brings one to the homestead of 'Habre's Nest' in the village of Kaiakata, where birdwatching and Red Panda trekking can be arranged. Ideally, one should make bookings in advance. As the homestead is technically across the border in Nepal, visitors are advised to get a visa for Nepal.

There are two main seasons to visit Singalila. The spring and summer period from March to May is popular, when rhododendrons of different colours bloom all across the park. In May, occasional showers and unpredictable weather can occur. As such, warm clothes and comfortable trekking footwear are essential. Singalila is closed during the monsoon months from mid June to mid September. Another favourable time to visit is from October to early December when many species of orchids are in bloom.

ABOVE The **Buff-barred Warbler** (*Phylloscopus pulcher*) is one of several species of leaf warblers that can be seen in Singalila. This bird breeds in oak and rhododendron forests ranging from 2,100 m to 4,300 m (6,900 ft to 14,100 ft) above sea level. In the non-breeding season, it is often encountered in mixed-species flocks with tits and other small insectivorous birds.

RIGHT Rubbish accumulated along the trekking routes in Singalila National Park has become a problem due to ballooning numbers of visitors.

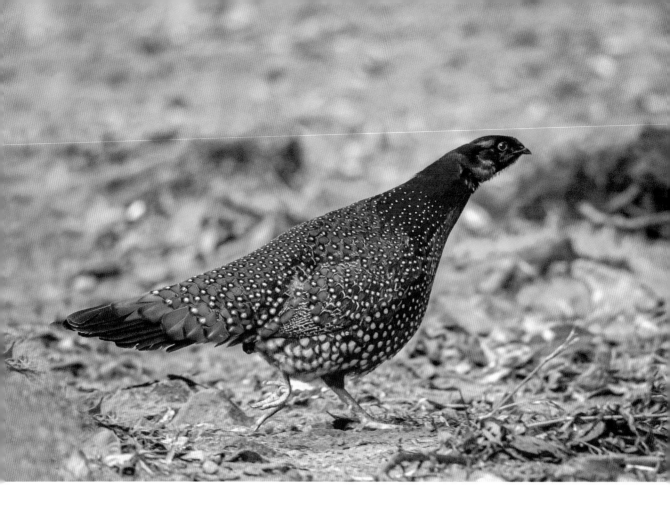

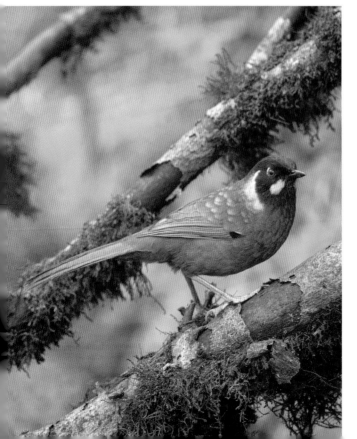

ABOVE The **Satyr Tragopan** (*Tragopan satyra*) is one of the flagship species that draws birdwatchers to Singalila National Park. It is commonly heard early in the morning, but can be rather difficult to see. The Satyr Tragopan lives in pairs or small family groups. However, little is known about its courtship behaviour in the wild. In the Indian Himalayas, the tragopan resides in moist broadleaved forests between 2,400 m and 4,300 m (7,900 ft and 14,100 ft). Such forests are characterised by oak, magnolia and rhododendron, often with a well-developed undergrowth of bamboo.

LEFT The **Black-faced Laughingthrush** (*Trochalopteron affine*) can be easily seen in Singalila, inhabiting broadleaved evergreen, coniferous and mixed forests. It is one of the commoner laughingthrushes at higher elevations and occur to well over 4,000 m (13,100 ft) above sea level.

RIGHT TOP Spotted Laughingthrush (*Ianthocincla ocellatus*). This very large laughingthrush feeds on fruits, seeds and insects. It is one of nearly 10 species of laughingthrushes found here. Despite its size, it is quite inconspicuous and tends to keep in pairs and small family parties inside the undergrowth of high elevation forests between 2,100 m to 3,700 m (6,900 ft to 12,100 ft).

RIGHT BOTTOM Male **Chestnut-bellied Rock-thrush** (*Monticola rufiventris*) seen in Singalila at 2,800 m (9,180 ft) above sea level. This species breeds from March to June in coniferous and rhododendron forests. The nest is a cup of moss, leaves and twigs, lined with fine grass and fibres. This is often constructed in a rock crevice in an inaccessible area. The three to six eggs laid are creamy white with brownish speckles.

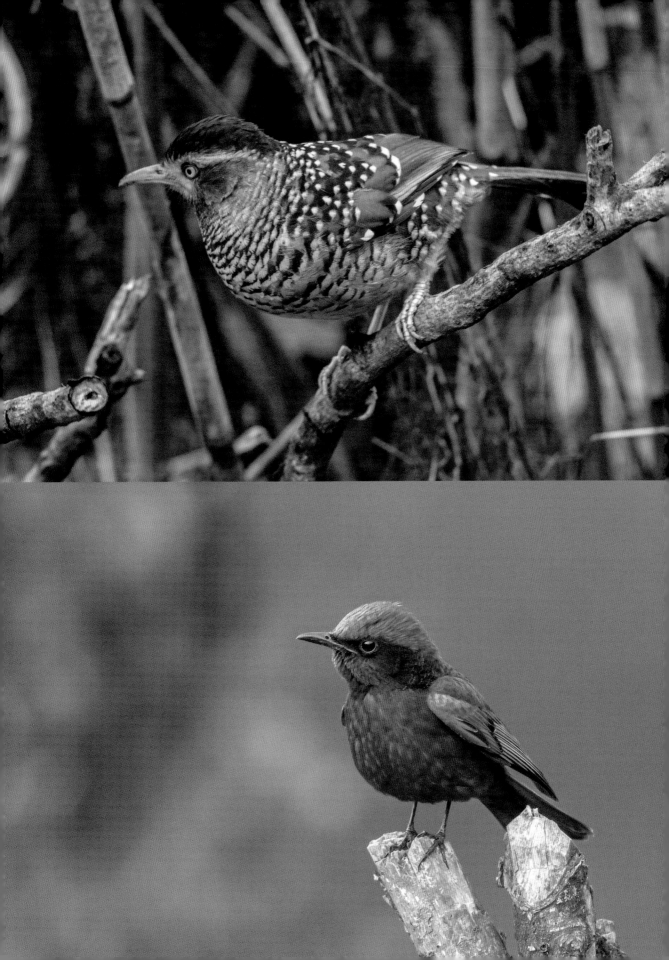

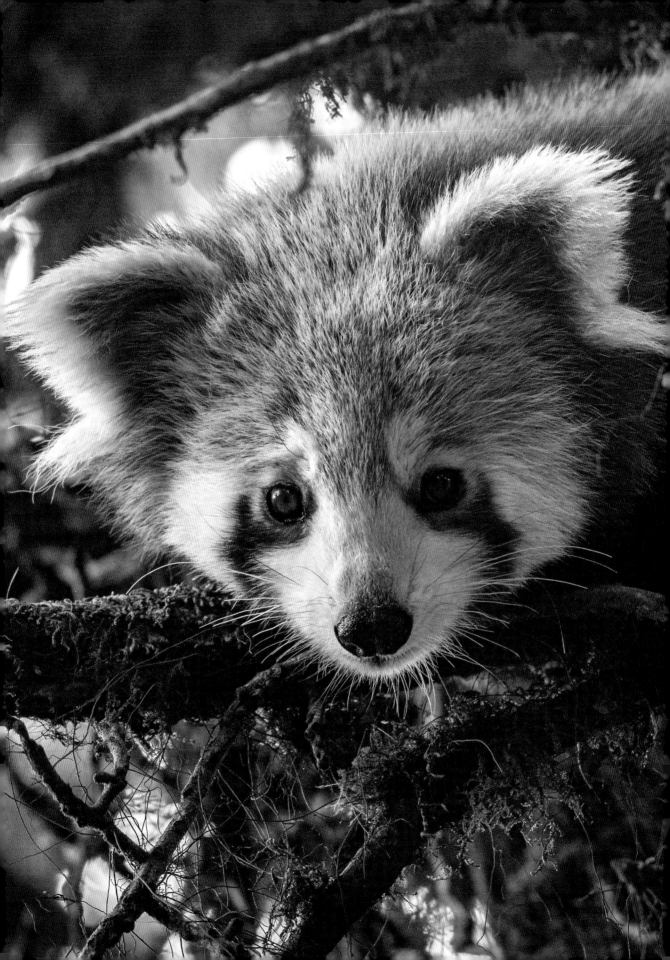

Singalila National Park is one of the best places to see the **Red Panda** (*Ailurus f. fulgens*), a flagship species of the Himalayas and central China. The Red Panda is highly sought-after amongst naturalists. It is closely associated with montane forests with dense bamboo thickets. A recent study of Red Panda genetics suggests that the populations in central China are distinct at the species level from those in the Himalayas, with a major geographical barrier for dispersal in the mountains of Arunachal Pradesh.

The Red Panda is mostly seen in big trees where it curls up and rests during the day. It is most active at night, and at dusk and dawn. Red Pandas generally forage for bamboo sprouts, shoots, and tubers. During the monsoon, its diet is supplemented by acorns, fruits and occasionally bird eggs and small animals. Like Giant Pandas, the Red Panda has an extended wrist bone that functions as a pseudo thumb, greatly improving its grip.

Part of the challenge in protecting Red Pandas has to do with their habitat requirements and sensitivity to human disturbance. These animals need proximity to water, and most importantly, stands of bamboo microhabitat. As human intrusion continues, ideal habitat becomes increasingly scarce. To make matters worse, bamboo can be particularly sensitive to environmental degradation from overgrazing. This can lead to a reduction in canopy cover and greater fire risk, hastening forest degradation as a result.

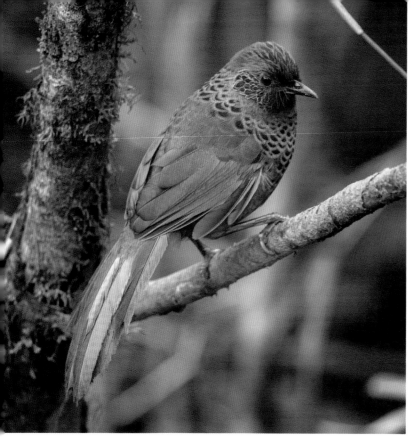

LEFT The **Chestnut-crowned Laughingthrush** (*Trochalopteron erythrocephalum*) is typically observed in parties of five to 10 individuals, at times in the company of other laughingthrushes. The nest is a neat deep cup made of dead leaves, often lined with moss. It is placed above the ground in a fork of sapling. It lays a clutch of two to four eggs.

BELOW The **Green-tailed Sunbird** (*Aethopyga nipalensis*) is a common sight around flowering rhododendron trees in Singalila National Park. Its diet consists largely of small insects and nectar. This gaudy sunbird forages singly or in small groups, often up in the canopy and only occasionally descending to lower levels.

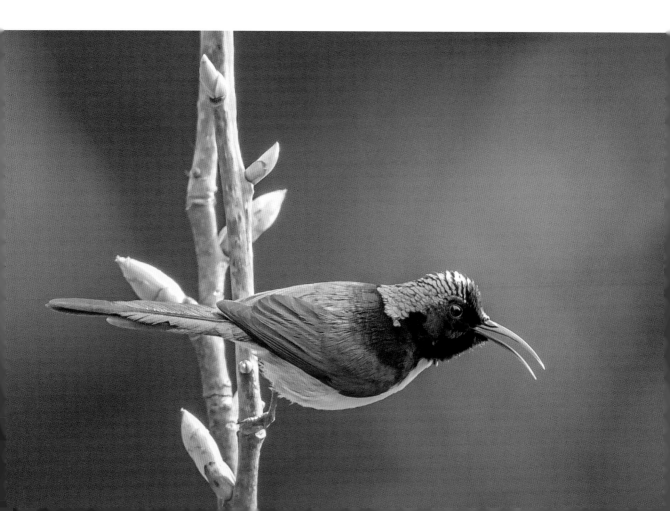

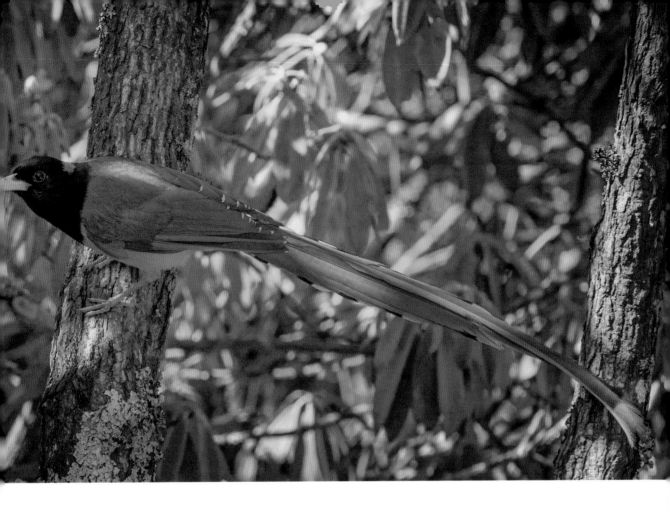

ABOVE The **Yellow-billed Blue Magpie** (*Urocissa flavirostris*) is a stunning corvid associated with moist deciduous forests characterised by oaks and rhododendrons in the Himalayas. It can also be found at clearings near to terraced agriculture or the fringes of tea plantations in the mountains. This species typically breeds above 2,000 m (6,600 ft) in altitude.

RIGHT The **Hoary-throated Barwing** (*Sibia nipalensis*) is a restricted-range laughingthrush confined largely to the Eastern Himalayas and its adjoining mountain ranges. It is found in mixed forests of oaks, conifers and rhododendrons as well as dense undergrowth including bamboo. Depending on the time of the year, this barwing eats mostly beetles, caterpillars, berries and flowers. Outside the breeding season from April to June, it is frequently encountered in small parties of up to 10 birds, often in mixed flocks in association with minlas, sibias and yuhinas.

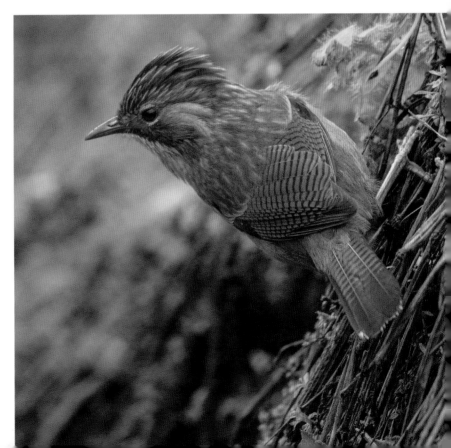

Nepal

Landlocked Nepal is located on the slopes of the central Himalayas. It is surrounded by the world's two most populous countries, India to the south and China in the north. Nepal covers an area of around 147,000 km² (57,700 mi²) harbouring an extraordinary array of environments. Perhaps, the nation has greater landscape diversity than many other countries several times larger. This ranges from a strip of subtropical lowlands in the south known as the Terai that continues eastwards to the Duars of Bhutan, to the foothills and high mountains of the Himalayas that dominate much of the interior, as well as the arid landscapes of the Himalayas' northern slopes and the Tibetan Plateau in Mustang. Towering above them all is Sagarmatha (or Mount Everest), the highest point on the planet. Around 25 per cent of Nepal falls within protected areas, including 12 National Parks.

More than 850 species of birds and 200 species of mammals can be found in Nepal. This includes the second largest terrestrial mammal, the Asian Elephant, and some of the best protected populations of the Bengal Tiger.

Over the past 20 years, Nepal has been successful in advancing the conservation of its biodiversity. This is remarkable for a small nation that directly borders China and India—both with disconcertingly large markets for animal products.

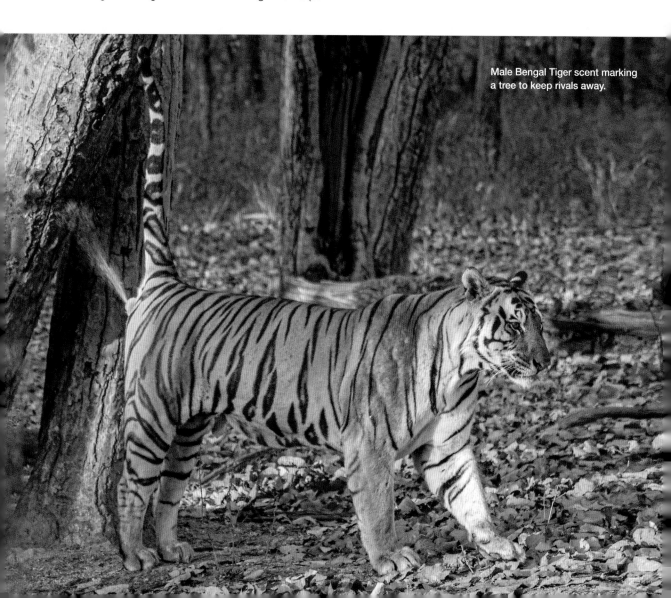

Male Bengal Tiger scent marking a tree to keep rivals away.

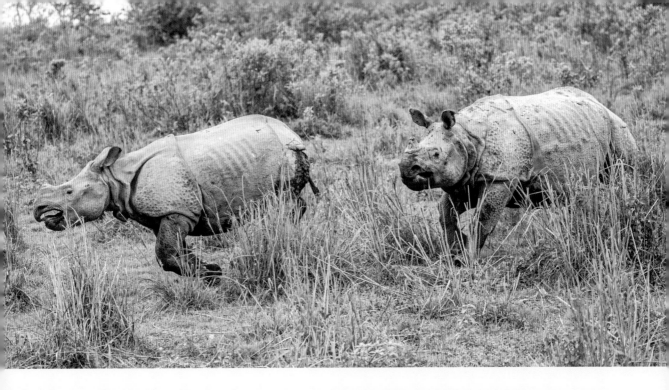

ABOVE Male **Greater One-horned Rhinoceros** (*Rhinoceros unicornis*) chasing the smaller female, which has a bleeding injury.

RIGHT The **Spotted Deer** or **Chital** (*Axis axis*) is the main prey for Bengal Tigers in Bardia National Park, where large herds of this elegant species can be seen.

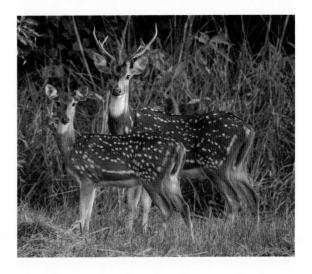

Nepal's track record for tiger conservation is one of the most admirable in the world. In April 2018, the country concluded a comprehensive transboundary tiger survey in the Terai Arc Landscape, a vast area of ecosystems shared with India. There are now an estimated 235 tigers in the wild, which is double the recorded population of 121 in 2009. If this trajectory continues, Nepal is on track to achieve its goal of doubling its tiger population by 2022.

Subsequent to the Maoist Insurgency which ended in 2006, Nepal has virtually brought the poaching of the Greater One-horned Rhinoceros to very low levels. This has resulted in a net population growth for the species. In the latest rhinoceros census in 2015, a population of 645 individuals was recorded, a significant increase from the 534 rhinoceros counted in 2011. In 2018, Nepal celebrated five years of zero rhinoceros poached since 2011.

These are excellent examples of conservation change that is possible when a country mobilises the efforts of the government, conservation NGOs, and not least, the local communities. Rural poverty is one of the key drivers of unsustainable use of forest resources.

To this end, training programmes for various cottage industries like the production of weaved craft items, vegetable growing and the making of food plates using sal leaves have been viable livelihood alternatives.

Despite these successes, fundamental issues remain. Poaching of wildlife and smuggling of herbs and timber products continue to be threats. Demand from neighbouring countries is unlikely to go away. Indigenous people often depend on natural resources for their livelihood and cultural needs. As such, finding a balance between sustainable harvesting, human rights, rural development and habitat protection will continue to pose a challenge.

Bardia National Park

Bardia National Park is the largest and perhaps the most undisturbed protected area in the Nepalese Terai. It used to be a hunting reserve for Nepal's royalty. As one of the country's hidden gems, it was declared a national park in 1988. Bardia's northern limits are demarcated by the Sivalik Hills of the southern Himalayas, while the Nepalgunj-Shurkhet highway partly forms its southern boundary.

Bardia is a beautiful wilderness largely covered by deciduous forests of Sal (*Shorea robusta*), with a mosaic of grasslands, savannah and riverine forests. These provide an outstanding home for a multitude of fauna and flora. The park extends over an area of 968 km² (375 mi²) with a wide buffer zone of 507 km² (195 mi²).

This national park is an Important Bird and Biodiversity Area with more than 500 recorded bird species or well over half of Nepal's avifauna, including threatened flagships such as the White-rumped Vulture, Slender-billed Vulture, Bengal Florican, Sarus Crane, and the Pallas's Fish Eagle.

Bardia is also home to critical populations of four globally threatened bird species: the Asian Woollyneck, Steppe Eagle, Great Slaty Woodpecker, and Lesser Adjutant.

The Karnali-Babai river system and its tributaries harbour a small population of the Critically Endangered Gharial as well as Mugger Crocodile and a rich diversity of reptiles and amphibians.

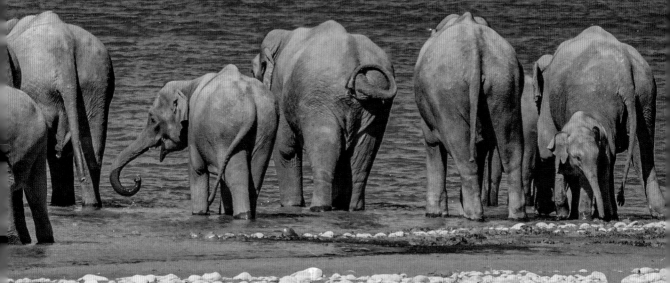

Asian Elephants *(Elephas maximus)* in Bardia National Park.

Bardia National Park is well off the beaten track, located some 400 km (250 mi) west of Kathmandu. The most convenient means of access is to fly from Kathmandu to Nepalgunj, which takes around one hour. From Nepalgunj, it is another 2-3 hour's drive to Thakurdwara where most of Bardia's resorts and the park headquarters are located.

The monsoon season is roughly from July to September, when rising river levels make it difficult to get around. The most popular time to visit Bardia is from September to December, and from February till the end of May.

In Bardia, the rhinoceros population has increased from 24 individuals in 2011 to 29 in the last census done in 2015. For some time, it has been the plan to translocate 25 rhinoceroses from Chitwan National Park to Bardia. In 2016/17, the first eight rhinoceroses (six females and two males) were moved to the Babai Valley in Bardia. Only six survive today, one individual died from liver failure, while a female was killed by a male during mating.

Tiger conservation efforts have been particularly successful in Bardia National Park. The population has jumped from 50 individuals in 2013 to an impressive 87 individuals in the last tiger census in 2018. If this trend continues, Bardia may soon hold the largest population of tigers in Nepal, as the numbers in Chitwan National Park are stabilising, possibly because of limited carrying capacity.

The extraordinary increase in Bardia's tiger population can be attributed to several factors. These include enhanced transboundary habitat management, protection measures and increased support from local communities in the buffer zone. Bardia National Park also benefits from the adjoining Khata corridor that provides direct habitat connections to Katarniaghat Wildlife Sanctuary in India. This facilitates the dispersal of tigers, elephants, rhinoceroses and other species between the two protected areas.

Before 1994, there were only two resident elephants in addition to a seasonally occurring herd. Elephant numbers started to go up due to immigration from India through the Khata-Katarniaghat corridor. The first systematic census of elephant numbers in Bardia was carried out in 2007. It revealed a population of around 50 individuals in the Karnali floodplain, and over 30 elephants spread over two herds in the Babai Valley.

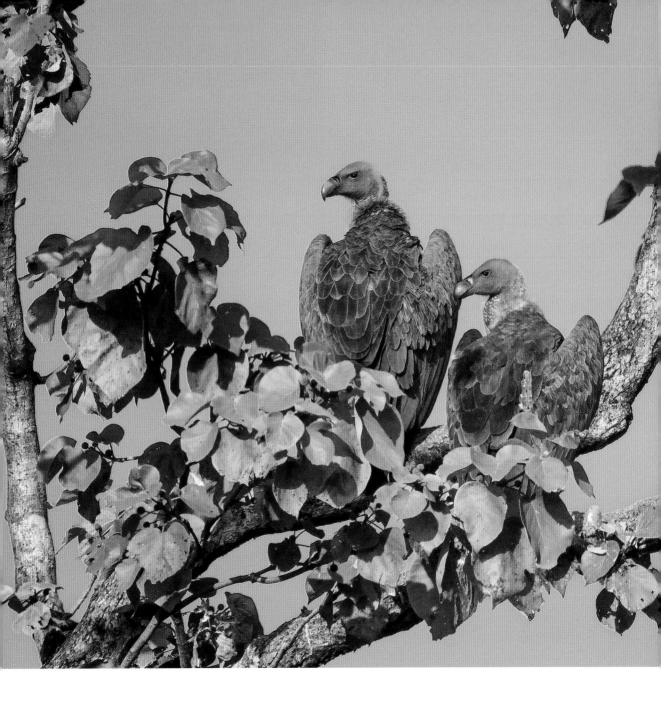

White-rumped Vulture (*Gyps bengalensis*). Critically Endangered.

Vultures are keystone species that provide an important ecosystem service by recycling nutrients from animal carcasses. In the 1990s, vultures were a common sight in South Asia. However, within a decade, numbers have crashed and several species are now on the brink of extinction.

The main cause of this catastrophic collapse is the use of diclofenac, an anti-inflammatory drug deployed to treat livestock. Vultures feeding on carcasses with this drug suffer renal failure and eventually die. In Nepal, numbers of White-rumped Vultures have dropped by more than 90 per cent. In 2006, a ban was introduced on the importation of diclofenac for veterinary use.

Local NGOs including Bird Conservation Nepal (BirdLife International's Partner in Nepal) have initiated a number of activities to protect the remaining vulture populations. These include nest guarding schemes and the establishment of Vulture Safe Zones free from diclofenac.

Vulture safe feeding sites, also called "vulture restaurants", have been created. These come with viewing areas for visitors to generate eco-tourism income for the local community. An increasing number of vultures are now recorded at the feeding stations, and flocks of over 150 birds are not uncommon. A Vulture Conservation Action Plan for Nepal was successfully launched in 2015. The plan is calling for urgent work to captive breed and release White-rumped Vultures, among several other priorities.

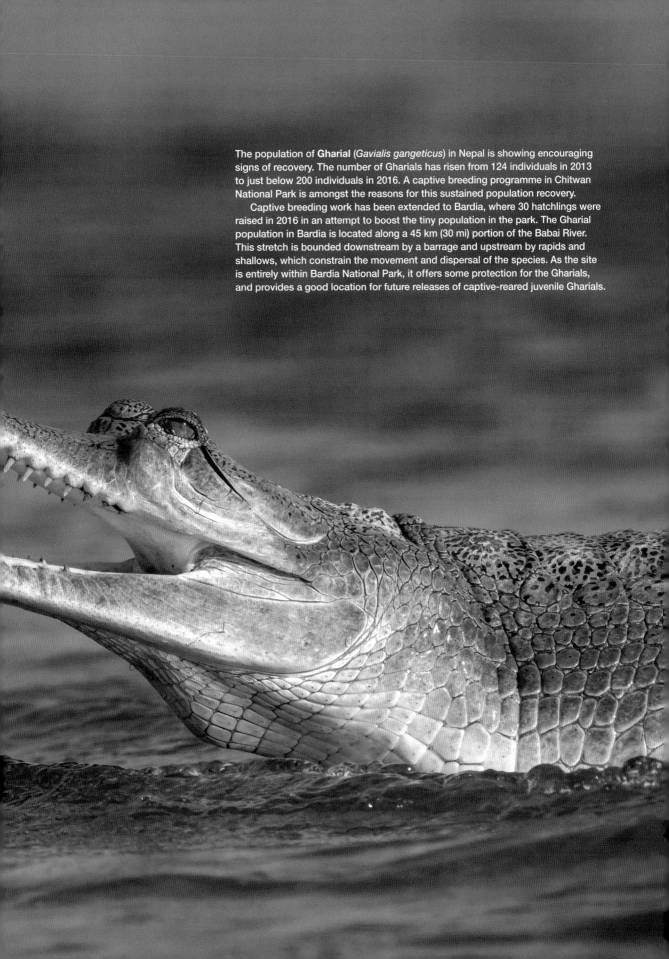

The population of **Gharial** (*Gavialis gangeticus*) in Nepal is showing encouraging signs of recovery. The number of Gharials has risen from 124 individuals in 2013 to just below 200 individuals in 2016. A captive breeding programme in Chitwan National Park is amongst the reasons for this sustained population recovery.

Captive breeding work has been extended to Bardia, where 30 hatchlings were raised in 2016 in an attempt to boost the tiny population in the park. The Gharial population in Bardia is located along a 45 km (30 mi) portion of the Babai River. This stretch is bounded downstream by a barrage and upstream by rapids and shallows, which constrain the movement and dispersal of the species. As the site is entirely within Bardia National Park, it offers some protection for the Gharials, and provides a good location for future releases of captive-reared juvenile Gharials.

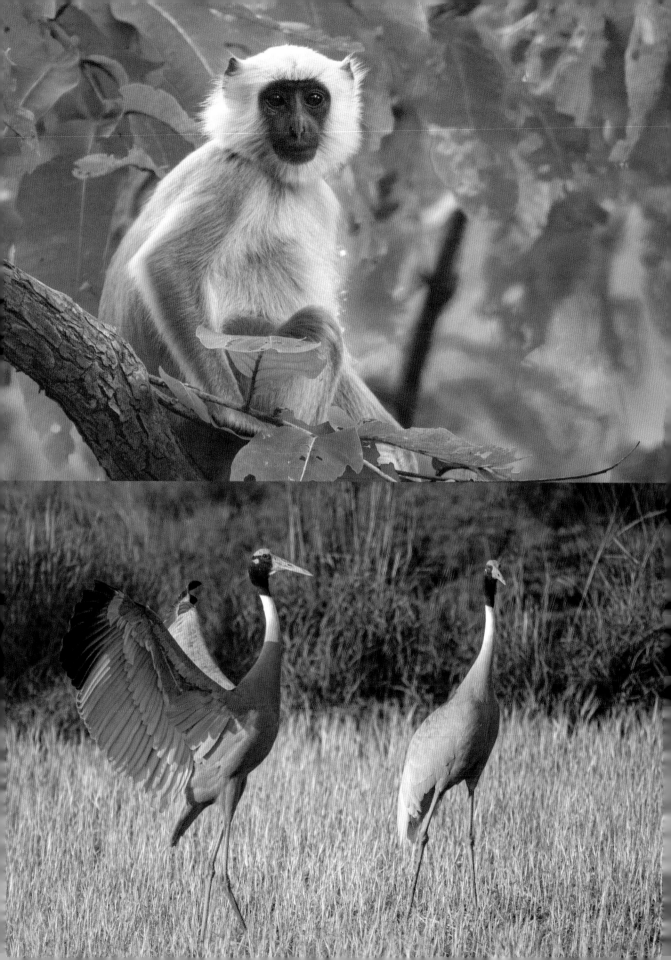

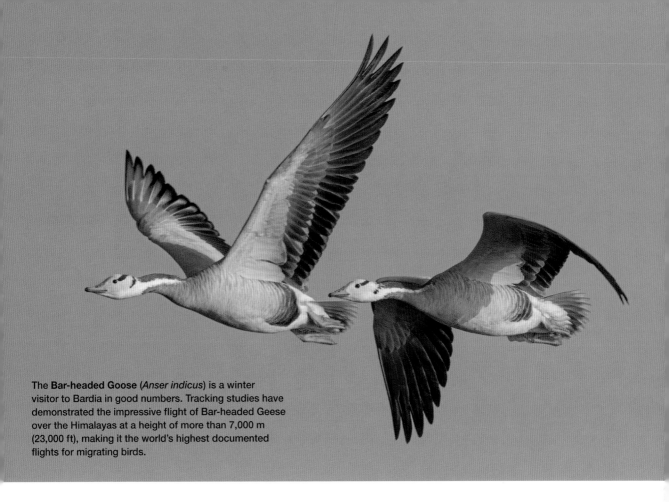

The **Bar-headed Goose** (*Anser indicus*) is a winter visitor to Bardia in good numbers. Tracking studies have demonstrated the impressive flight of Bar-headed Geese over the Himalayas at a height of more than 7,000 m (23,000 ft), making it the world's highest documented flights for migrating birds.

LEFT TOP The **Nepal Gray Langur** (*Semnopithecus schistaceus*) is one of the biggest and heaviest langurs alive. It is equally at home on the ground or eating leaves up in the trees. Formerly considered a subspecies of the widespread Hanuman or Gray Langur, genetic studies show that many of these subspecies are distinctive. Today, eight species of Gray Langur are recognised.

LEFT BOTTOM The **Sarus Crane** (*Antigone antigone*) is the only breeding crane species in Nepal but an uncommon visitor to Bardia. It is somewhat protected by religious beliefs and local traditions in Nepal, where the population has shown signs of recovery. The Sarus Crane is, however, increasingly threatened. It has now become more dependent on farmlands for roosting and nesting, while its wetland habitats are being degraded. Over time, shifting monsoonal patterns due to climate change may disrupt traditional rice paddy cultivation and consequently alter the fates of Sarus Cranes.

RIGHT Bardia National Park is one of only a handful of locations where the **Great Thick-knee** (*Esacus recurvirostris*) has been recorded in Nepal. This peculiar-looking shorebird is dependent on pebbly and rocky banks of major rivers. It is particularly sensitive to human disturbance. The presence of the thick-knee is thus a good indicator of the health of riverine ecosystems.

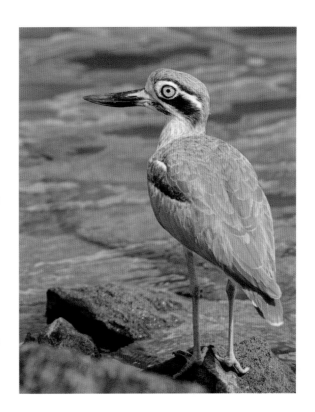

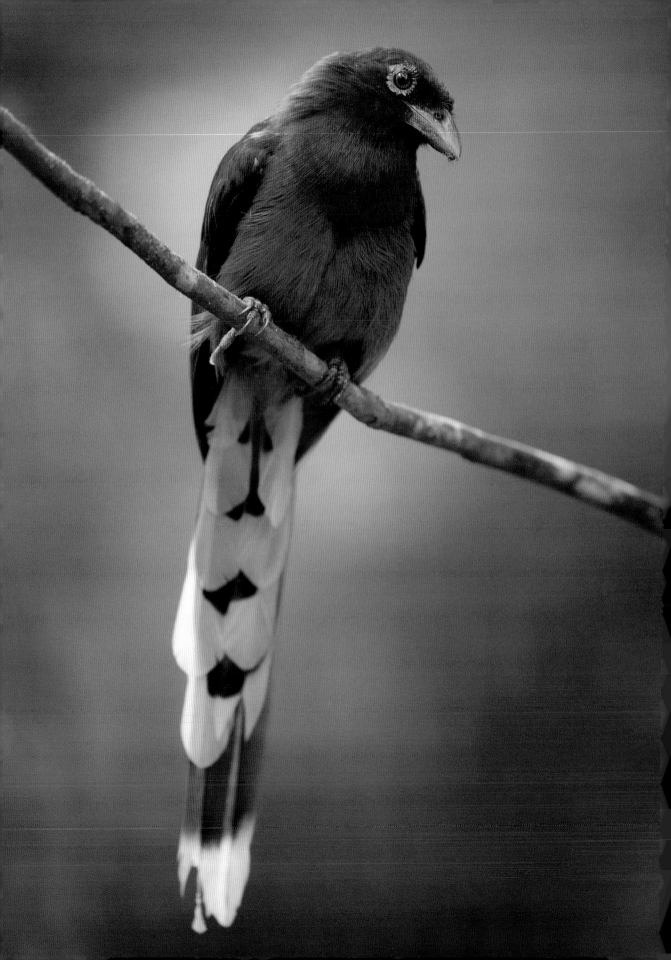

Sri Lanka

The island nation of Sri Lanka is located off the south-east coast of southern India, and well within the tropics. Despite its small size, Sri Lanka packs an array of natural ecosystems into an area of approximately 65,000 km² (25,000 km²). This diversity of habitats and its isolation from the Indian Subcontinent have led to the emergence of a bewildering variety of endemic species. Sri Lanka forms one of the planet's 36 biodiversity hot spots. Including migratory species, the island is home to around 450 bird species. Its mammalian diversity is equally outstanding at around 120 species, as is its amphibian fauna.

Sri Lanka's topography can be broadly characterised to include a coastal belt, the plains and a mountainous interior in the central highlands. Much of the country is low-lying with highly seasonal rainfall and is referred to as the 'Dry Zone'. The rugged south-west and central highlands experience very high precipitation. They fall within what is described as the 'Wet Zone'.

Lowland rainforests can be found in the southwest of the island within the Wet Zone. Here, warm tropical conditions with high annual rainfall promote the growth of lush vegetation, especially species-rich rainforest. However, topsoils in rainforests tend to be relatively nutrient poor as the climate and efficient microflora in the ground quickly break down organic matter. This is then absorbed by the trees in the rainforest. It is also the reason why land formerly occupied by rainforests, when cleared to grow agricultural crops, becomes impoverished after a few harvest seasons.

Two hundred years ago, Sri Lanka was practically covered by forests and woodlands. Over the colonial and post-Independence period, the growth and expansion of tea and rubber plantations, as well as rice paddies have resulted in the destruction of native forests. They now cloak less that 30 per cent of the island.

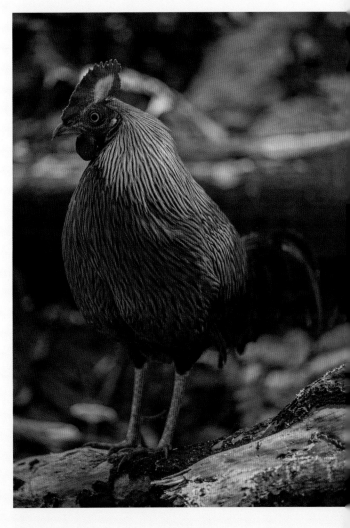

LEFT The **Sri Lanka Blue Magpie** (*Urocissa ornata*) is a striking forest crow and perhaps one of the nation's most recognisable birds. The species is known to breed from mid January to late March with a clutch of three to five eggs laid. The nest is sometimes parasitised by the Western Koel (*Eudynamys scolopaceus*). The Sri Lanka Blue Magpie is a restricted range species with a healthy population in Sinharaja Forest Reserve, where this individual was spotted. Due to its narrow distribution, it is considered a threatened species, and is currently listed as Vulnerable.

RIGHT In Sinharaja, it is easy to see the endemic **Sri Lanka Junglefowl** (*Gallus lafayettii*), which is the national bird of Sri Lanka and a close relative of the Red Junglefowl, the ancestor of domestic chickens.

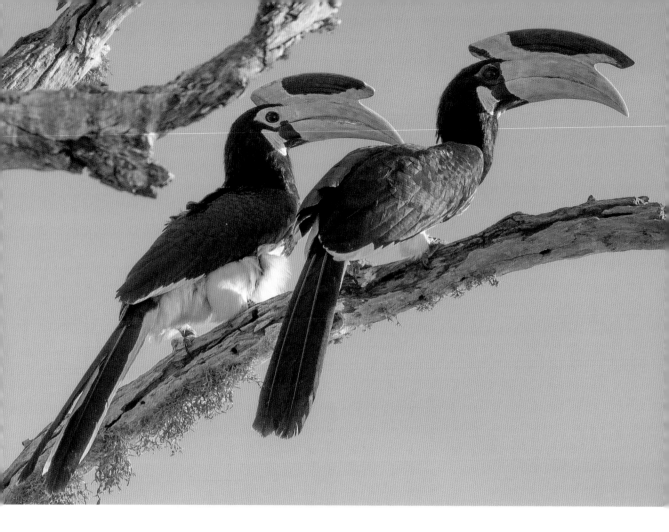

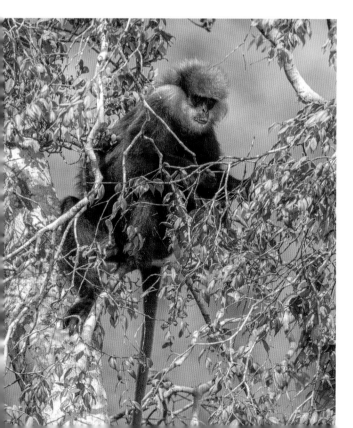

ABOVE Male and female **Malabar Pied Hornbill** (*Anthracoceros coronatus*). The species occurs at the margins of evergreen forests and open forests in both India and Sri Lanka. It takes mainly fruits and whatever small animals it can catch. This hornbill is generally common in areas with low human density.

LEFT The Endangered **Purple-faced Langur** (*Trachypithecus vetulus*) is one of five primates found in Sri Lanka. Four subspecies are recognised by scientists, with the Western Purple-faced Langur at greatest risk of extinction. While this species ingests mostly leaves, it also opportunistically eats fruits, seeds and flowers. A troop normally consists of one alpha male with up to seven adult females, as well as a number of juveniles and infants. All-male groups also occur with between two to 14 individuals. Occasionally, the home ranges of all-male troops overlap.

RIGHT TOP The **Tufted Gray Langur** (*Semnopithecus priam*) is endemic to southeastern India and Sri Lanka. It is generally shy and only descends to the ground when there is no visible danger. Families rest in the highest branches of trees. They are able to adapt to human settlements and often live comfortably close to villages and towns. The Tufted Gray Langur takes a range of food including evergreen leaves, leaf buds and fruits. In general, this langur is not a fussy eater and will opportunistically eat what is available.

RIGHT BOTTOM The Endangered **Toque Macaque** (*Macaca sinica*) with its crew cut hairdo, is highly recognisable and not uncommon at all. It is endemic to Sri Lanka and like many other macaque species, lives in troops of up to 40 individuals. These groups have a highly structured social hierarchy across females and males. When troops become very large, aggression and tension often result in individuals leaving to form their own clans.

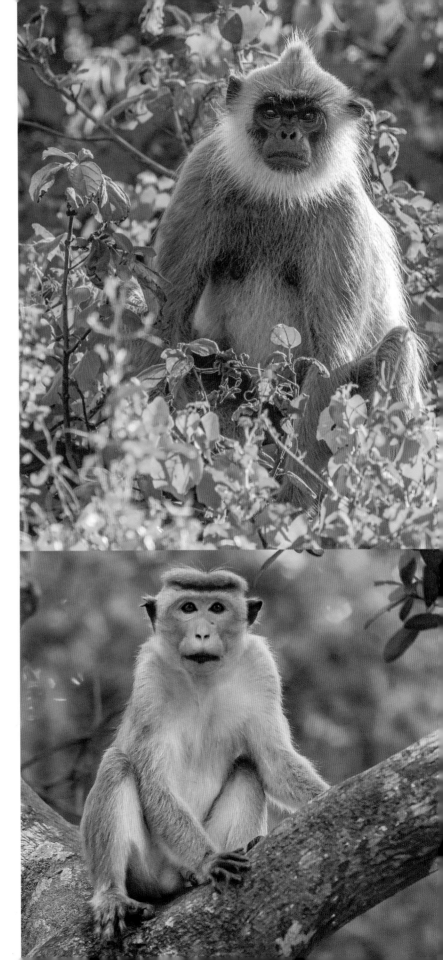

Sinharaja Forest Reserve

In 1988, Sinharaja was declared a UNESCO World Heritage site covering an area of around 90 km² (35 mi²), and ranging in altitude from 300 m to 1,170 m (1,000 ft to 3,800 ft) above sea level. The reserve is situated in the humid Wet Zone of southwest Sri Lanka. It is one of 70 Important Bird and Biodiversity Areas in the country.

The importance of Sinharaja as a World Heritage property is continuously being strengthened by the discovery of new species of plants and animals. This includes several species of amphibians described from the eastern part of the reserve. In 2007, the Endangered Sinharaja White-toothed Shrew (*Crocidura hikmiya*) was discovered.

Species endemism in Sri Lanka's Wet Zone is exceptionally high. Sinharaja is a key site to see wild orchids in their natural habitat. Around 80 orchid species have been documented, of which 40 per cent are endemic. The reserve is home to more than 50 per cent of the country's endemic mammals and butterflies. In addition, it boasts many insects, reptiles and narrowly-distributed species of amphibians. As Sri Lanka's most valuable refuge for biodiversity, Sinharaja is probably the best place to encounter the island's unique amphibians and reptiles.

Sinharaja is a prime locale for birdwatching. Except for a few montane species, most of Sri Lanka's 30-odd endemic species can be relatively easily seen here. This includes the Serendib Scops Owl, Red-faced Malkoha, Sri Lanka Spurfowl, Ashy-headed Laughingthrush and White-faced Starling, all of which can be difficult to observe at other sites in the Wet Zone.

From Colombo, it is about a five hour drive to Kudawa in Sinharaja, where the Forestry Department has its office. Visitors can register and obtain a permit/ticket to enter the reserve here. A local guide is compulsory, and greatly increases your chances of seeing wildlife. Be aware of an abundance of leeches when trekking, even in the dry season. Leech socks can be bought locally. There are a number of basic lodges close to the reserve's boundary. The driest months from December to April are the preferred time to visit, but do note that it generally rains throughout the year.

Serendib Scops Owl (*Otus thilohoffmanni*)

It was in 2001 at the Sinharaja Forest Reserve that the first new bird species was discovered in Sri Lanka in nearly 150 years. This richly-coloured owl is so secretive that it was never recorded in any of the avifaunal surveys over the previous 200 years.

In February 1995, noted ornithologist Deepal Warakagoda heard it for the first time. It was only a month later that he was able to make an audio recording. There was general agreement among the experts that his recording could represent a completely new owl species. In spite of two close encounters, it took nearly six years before the first satisfactory sighting was made in January 2001. Three weeks later, the mystery owl was photographed and subsequently described as a species new to science in June 2004, astonishing ornithologists around the world. The owl was named *Otus thilohoffmanni* in honour of Thilo W. Hoffmann, one of the leading conservationists in Sri Lanka. It has been classified as Endangered.

RIGHT One of three species of malkohas in Sri Lanka, the Vulnerable **Red-faced Malkoha** (*Phaenicophaeus pyrrhocephalus*) is endemic to the island. It is best seen in the Wet Zone although it is known to live in riparian forests in the Dry Zone. The Red-faced Malkoha regularly participates in mixed foraging flocks, and has been documented eating a good mix of large insects, as well as the occasional lizard.

BELOW The **Green-billed Coucal** (*Centropus chlororhynchos*) is endemic to Sri Lanka, and occurs in the wet zone forests where it is often associated with dense thickets of bamboos and palms. This coucal feeds on a diverse variety of invertebrates, frogs, lizards and very occasionally, on fruits. It is considered by birdwatchers to be amongst the most difficult endemics to observe well.

The Sinharaja Forest Reserve consists of a core zone and a buffer area around it. Some parts subjected to selective logging in the 1970s are gradually recovering with maturing trees. The reserve is surrounded by 13 patches of forests, which confer an extra layer of protection. However, some locations need to be better defined and protected.

The integrity of Sinharaja is threatened by encroaching cultivation, in particular along its southern boundary. Illegal logging and hunting have been reported by conservation groups. The buffer zone is particularly vulnerable to disturbance as some human communities reside within it. Fortunately, overall forest dependency of local communities is low. The poorly managed use of agrochemicals in the adjacent tea plantations can lead to the pollution of freshwater streams and impact aquatic life. Other developments outside Sinharaja indirectly impact the reserve and may open up new entry points into the forest and facilitate illegal hunting, logging and mining.

Over the years, pioneering ornithological studies have been conducted on the behaviour of mixed foraging bird flocks in Sinharaja. Many universities and conservation NGOs, particularly the Field

The Endangered **Long-snouted Tree-frog** (*Taruga longinasus*) is endemic to the south-western and central parts of Sri Lanka in the Wet Zone. It is an arboreal species found close to water, at elevations from 150 m (500 ft) to some 1,300 m (4,300 ft) above sea level.

Sri Lanka is a hotspot for amphibian diversity, harbouring around 120 species, of which 85 per cent are endemic. Sinharaja has the distinction of having the greatest number of amphibian species in the country.

Ornithologists Group of Sri Lanka (FOGSL), have run workshops and awareness programmes on the reserve's biological treasures. This has resulted in a better understanding and appreciation of the significance of the reserve. This work needs to be sustained, in partnership with local communities.

Meanwhile, it is critical that the laws and regulations set up to protect Sinharaja are enforced and monitored, so as to safeguard the integrity of the reserve for future generations.

ABOVE Breeding in the forests of India and Nepal, the **Indian Pitta** (*Pitta brachyura*) is regarded only as a migrant to Sri Lanka during the northern winter. It largely inhabits secondary lowland and foothill forests with dense undergrowth and may sometime stray into parks. Like most pittas, the Indian Pitta forages largely on the ground where it often tosses leaf litter in its quest for tasty invertebrate morsels.

RIGHT As one of two species of white-eyes on the island, the **Sri Lanka White-eye** (*Zosterops ceylonensis*) is mostly seen at forest edges, tea plantations and gardens above an altitude of 1,000 m (3,300 ft). Occasionally, it descends to as low as 450 m (1,500 ft) in the hilly parts of Sinharaja. Its main food sources include nectar, berries and small insects.

LEFT The **Sri Lanka Grey Hornbill** (*Ocyceros gingalensis*) is found in many forested parts of the country, including much of the Dry Zone where it is commoner. It forages mainly in the lower canopy and consumes a lot of figs and other fruits, but also eats insects, frogs and lizards.

BELOW The **Sri Lanka Spurfowl** (*Galloperdix bicalcarata*) is extremely shy and difficult to observe, even in Sinharaja. Territorial calls often betray their presence, but more often than not, they remain out of sight. When alarmed, the spurfowl scurries away into thick cover, flying only when hard pressed.

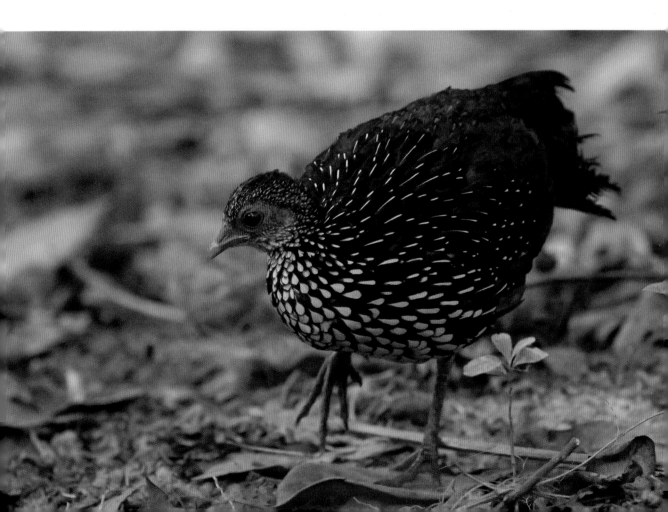

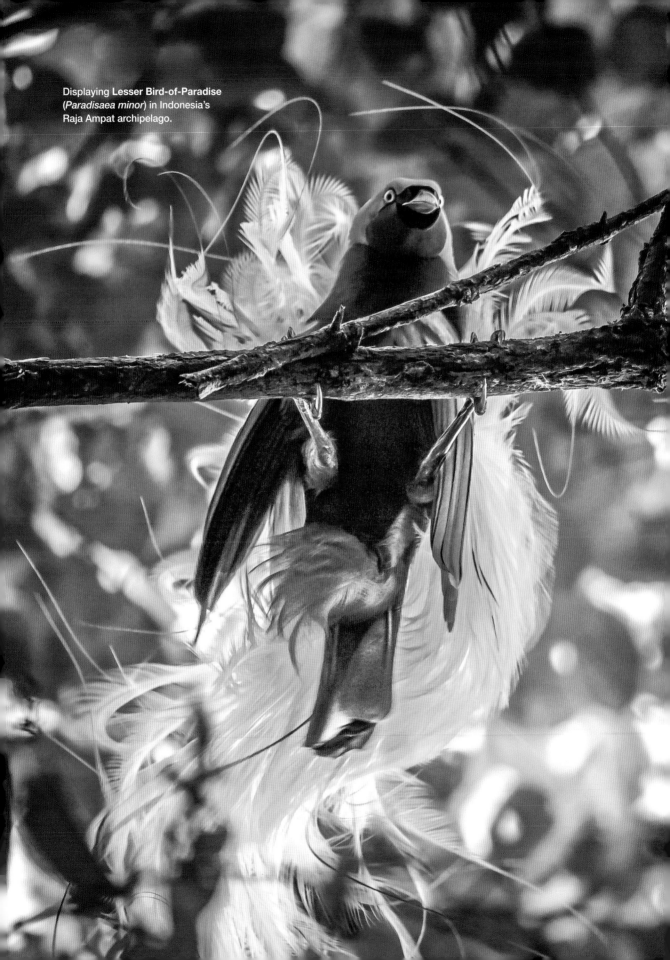

Displaying **Lesser Bird-of-Paradise** (*Paradisaea minor*) in Indonesia's Raja Ampat archipelago.

Acknowledgements

The support and encouragement that we have received for *Asia's Greatest Wildlife Sanctuaries* have been overwhelming.

It is a distinguished honour for us to have **Her Imperial Highness Princess Takamado** of Japan write the inspiring foreword for this publication.

We would like to thank **Yong Ding Li** for taking on the job as editor of *Asia's Greatest Wildlife Sanctuaries*, like he did with our two previous publications. He has done another terrific job in contributing to and editing the manuscript. Ding Li is the Regional Flyway Coordinator for BirdLife International's migratory bird conservation projects and one of Asia's leading field ornithologists. He has written extensively on biodiversity and species conservation in Asia, including publishing six books and more than 50 peer-reviewed papers. Without his network and broad knowledge of the fauna and flora in Asia, this publication as we see it would not have been possible.

This exciting undertaking would not have seen the light of day without the solid backing and hands-on contribution of our publisher **Eric Oey**, **June Chong** and **Chan Sow Yun**.

Also a warm thank you to the CEO of BirdLife International **Patricia Zurita** and **Vinayagan Dharmarajah** who is the Regional Director in Asia supporting this project from the very beginning.

As was the case with our previous three publications, our consultant **Zinnira Bani** has contributed her valuable advice for *Asia's Greatest Wildlife Sanctuaries*. The (too) many revisions were expertly managed on time, while coordinating all the technical aspects regarding the production of the publication.

Gloria Seow has done a marvellous job as copy editor, also proof-reading the manuscript and improving text and style where necessary.

This publication showcases close to 400 unique images. This includes works from leading international and local wildlife photographers. They have generously contributed some of their finest images to promote nature conservation in Asia. Their names and details appear on page 307.

Many thanks to BirdLife International's partners, including Nature Society (Singapore) (NSS), Malaysian Nature Society (MNS), Bird Conservation Nepal (BCN) and Burung Indonesia that have supported this project. A special thanks goes to **Henry Goh** and **Yeap Chin Aik** of the Malaysian Nature Society.

Warm thanks go to: -

Dhritiman Mukherjee who contributed a number of his award-winning images to this publication. He is, in our view, India's most accomplished nature and wildlife photographer.

Moushumi Ghosh of Wandervogel Adventures who over the past few years has managed our complex and ever changing India itineraries without a hitch.

William Robichaud for sharing his amazing story and unrivalled knowledge of Indochina's mysterious Saola.

Mogens Trolle for his contribution of the expressive primate portraits from China. In 2020, he won the "Animal Portraits" category of the Wildlife Photographer of the Year competition.

Frank Momberg & **Ngwe Lwin** of Fauna & Flora International for co-ordinating our visits to Indawgyi Lake Wildlife Sanctuary, Myanmar and for letting us use their unique images. Their support to the local community and the Indawgyi Wetland Education Centre has been inspirational.

Frank Momberg who assisted with the draft manuscript as well as the co-ordination and planning of the logistics of our trips to the Raja Ampat Islands.

Jonathan Charles Eames OBE for his assistance with the manuscript and contribution of images from Western Siem Pang in Cambodia.

Harprit Singh for his support over the years during dozens of trips in Southeast Asia.

Paul Thompson for contributing his amazing images of Thai wildlife.

Yann Muzika who has gone out of his way to share his unique images of threatened and rare species from China and Japan.

Terry Townshend for his images and help with Sanjiangyuan National Park in the China chapter.

Andie Ang, President of Jane Goodall Institute (Singapore), for her support and the use of her images. We have known Andie for more than a decade since the time she did her inspirational studies on the Raffles' Banded Langur in Singapore.

Con Foley who has contributed some of his excellent images of endangered bird species.

Nial Moores for a superbly well-arranged trip to South Korea and help with the manuscript.

K David Bishop for his advice and help with the manuscript covering the Raja Ampat Islands.

Heru Cahyono for a very productive week in East Java and Bali, Indonesia.

Dwi Wahyudi who knows Kerinci Seblat National Park, Sumatra better than most people.

Our friend the late **Dr. Tony Whitten** of Fauna & Flora International with whom we spent 10 days during our first trip to the Raja Ampat Islands, West Papua, Indonesia when we captured most of the bird-of-paradise images in this publication.

Arjin Sookkaseam (Guide A) for his tireless efforts over the years to find rare birds in Thailand as well as contributing some of his own exceptional images.

Our numerous trips would not have been successful without expert support in the field, and we would like to extend our heartfelt thanks to:

Thinh Dinh, Rits Kafiar, Sonam Dorji, Soven Singh, Siddhartha Goswami, Kusum Kumar Fernando, Chea Sophea, Mai Men, Samarn Khunkwamdee and Menxiu Tong.

Our appreciation is also due to the many unnamed contributors who have supported or helped us with this comprehensive project.

Fanny & Bjorn

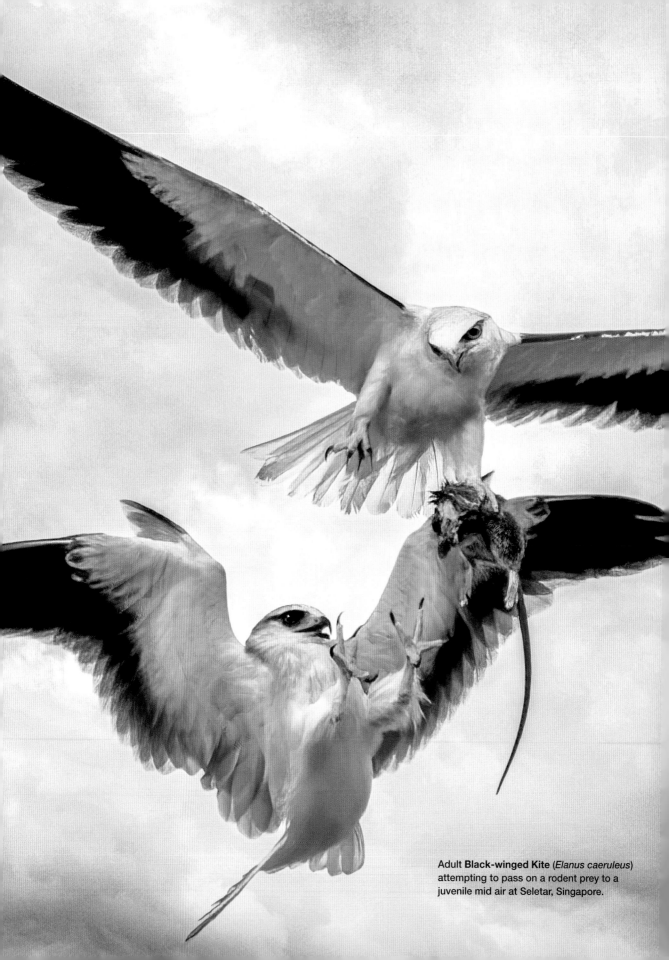

Adult **Black-winged Kite** (*Elanus caeruleus*) attempting to pass on a rodent prey to a juvenile mid air at Seletar, Singapore.

Contributing Photographers

Yann Muzika 29, 30, 31 (1st photo), 32 x 2, 33, 48 (1st photo), 50 (2nd photo), 51 (2nd photo), 57, 58

Fanny Lai front cover, 53 (2nd photo), 222, 257, 264, 276, 277 (2nd photo), 284, 288, 308

Arjin Sookkaseam (Guide A) 2, 185 (1st photo), 188 x 2

Paul Thompson/Ian Edwardes 128, 184, 194, 197 (2nd photo)

Dhritiman Mukherjee 28 & back cover insert, 239, 260

Mogens Trolle 6 & front cover insert, 10, 15 (2nd photo)

Con Foley 159 (1st photo), 174, 298
Danny Khoo 176, 177, 306
Jonathan Charles Eames, OBE 75, 159 (2nd photo)
Nicky Bay 172 x 2
Andie Ang 168
Menxiu Tong 31 (2nd photo), 36 (1st photo)
Ban Vangban Village/
Wildlife Conservation Society 205
Cheng Heng Yee (Aviancatspace) 139 (1st photo)
Chien C. Lee 135
Frank Momberg, FFI 158
Meriba Suade 82 (2nd photo)
Mike Nelson 96

Lee Tiah Khee back inner sleeve (2nd photo)
Pete Morris 95
Samarn Khunkwamdee 130 (2nd photo)
Saw Soe Aung/FFI 17
Terry Townshend 26
Ton Smits 169 (2nd photo)

Of the more than 300 animal species illustrated in this publication, we were unable to find quality images taken in the wild for three species. In these cases we have used photographs from a captive environment. The species in question are: the Giant Panda, Takin and Sumatran Rhinoceros.

Useful Websites

Avibase – The World Bird Database
https://avibase.bsc-eoc.org/avibase.jsp?lang=EN

Beijing Birding – Terry Townshend
https://birdingbeijing.com/

Bird Conservation Nepal (BCN)
https://www.birdlifenepal.org/

BirdLife International (Asia)
https://www.birdlife.org/asia/

Birds Korea Blog
http://www.birdskoreablog.org/

Burung Nusantara, Indonesia
http://burung-nusantara.org/

Chien C. Lee, Wild Borneo
https://www.wildborneo.com.my

China Wild Tour
https://www.chinawildtour.com/

Cloud Birders Trip Reports
https://www.cloudbirders.com/tripreport

Con Foley Photography
http://confoley.com/

Conservation International (CI)
https://www.conservation.org/

David Bakewell Blog
https://digdeep1962.wordpress.com/

Darwin Online
http://www.darwin-online.org.uk

Dhritiman Mukherjee Images
https://dhritiman.com/

East Asian – Australasian Flyway Partnership (EAAFP)
https://www.eaaflyway.net/

Fatbirder, Asia
https://fatbirder.com/world-birding/asia/

Fauna & Flora International (FFI)
https://www.fauna-flora.org

Field Ornithology Group of Sri Lanka (FOGSL)
https://fogsl.cmb.ac.lk/

Gloria Seow's Travelogue
http://gloriousbirds.blogspot.com/

Indawgyi Lake, Myanmar
https://www.indawgyilake.com/en

International Crane Foundation
https://www.savingcranes.org/

International Union for Conservation of Nature (IUCN)
https://iucn.org

IUCN Red List
https://www.iucnredlist.org/

Jane Goodall Institute (Singapore)
https://janegoodall.org.sg/

Malaysian Nature Society (MNS)
https://www.mns.my/

Mammal Watching
https://www.mammalwatching.com

Mogens Trolle Photography
http://www.mogenstrolle.com/

Mongabay
https://news.mongabay.com/

Nature Society (Singapore) (NSS)
https://www.nss.org.sg/

Nicky Bay's Macro Photography
www.nickybay.com

Oriental Bird Club
https://www.orientalbirdclub.org/

Panthera
https://www.panthera.org/

Paul Thompson Biodiversity Photography, Thailand
https://paulthompson.gallery/

Primate Watching
https://www.primatewatching.com/

Rising Phoenix, Cambodia
https://risingphoenix.ltd/

Saola Foundation
https://www.saolafoundation.org/

Shan Shui Conservation Centre, China
http://en.shanshui.org/

Thailand Wildlife
https://thailandwildlife.com/

Thai National Parks
https://www.thainationalparks.com/

Traffic
https://www.traffic.org/

Valley of the Cats, China
https://valleyofthecats.org/

Viet Nature Conservation Centre
https://www.thiennhienviet.org.vn/en/

Wallace Online
http://wallace-online.org/

Wandervogel Adventures, India
https://www.wandervogeladventures.com/

Wildlife Conservation Society (WCS), Singapore
https://singapore.wcs.org/

Recommended Reading

Brazil, M. 2013. *The Nature of Japan: from Dancing Cranes to Flying Fish.* Japan Nature Guides, Japan.

Carmichael, R. and Lord, M. 2007. *Indian Wildlife,* Insight Guides, London, UK.

Chandler, D. and Couzens, D. 2008. *100 Birds to See in Your Lifetime, the ultimate wish-list for birders everywhere.* Charlton Books Ltd., London, UK.

Cocker, M. and Tipling, D. 2013. *Birds and People.* Jonathan Cape, London, UK.

Craik, R.C and Minh, L.Q. 2018. *Birds of Vietnam.* Lynx and BirdLife International Field Guides. Lynx Edicions. Barcelona, Spain.

Cremades, M and Ng, S.C. 2012. *Hornbills in the City: A Conservation Approach to Hornbill Study in Singapore.* National Parks Board, Singapore.

Davies, N. 2015. *Cuckoo.* Bloomsbury Publishing Plc., London, UK.

Davison, G.W.H. 1995. *Belum: A Rainforest in Malaysia.* Malaysian Nature Society, Kuala Lumpur, Malaysia.

de Silva Wijeyeratne, G. 2020. *A Naturalist's Guide to the Mammals of Sri Lanka.* John Beaufoy Publishing, UK.

de Silva Wijeyeratne, G. 2022. *Sri Lankan Wildlife.* Bradt Travel Guides Ltd., UK.

de Silva Wijeyeratne, G. 2019. *A Photographic Field Guide to the Birds of Sri Lanka.* John Beaufoy Publishing, UK.

Fage, L-H. and Chazine, J-M. 2010. *Borneo, Memory of the Caves.* Le Kalimanthrope, Le Jonty, Caylus, France.

Hirschfeld, E., Swash, A. and Still, R. 2013. *The World's Rarest Birds.* Princeton University Press, Woodstock, UK.

Laman, T. and Scholes, E. 2012. *Birds of Paradise, Revealing the World's Most Extraordinary Birds.* National Geographic Society, Washington, D.C., USA.

Myers, S. 2016. *Wildlife of Southeast Asia.* Princeton University Press, Woodstock, UK.

Mukherjee, D. and Rahmani A.R. 2016. *Magical Biodiversity of India.* Bombay Natural History Society & Oxford University Press, Oxford, UK.

National Parks Board, 2018. *Birds of Our Wetlands – A Journey Through Sungei Buloh Wetland Reserve.* National Parks Board, Singapore.

Puan, C.L., Davison, G. and Lim, K.C. 2020 *Birds of Malaysia. Covering Peninsular Malaysia, Malaysian Borneo and Singapore.* Lynx and BirdLife International Field Guides. Lynx Edicions. Barcelona, Spain.

van Wyhe, J. 2013. *Dispelling the Darkness, Voyage in the Malay Archipelago and the Discovery of Evolution by Wallace and Darwin.* World Scientific Publishing Co., Singapore.

van Wyhe, J. 2019. *Wanderlust: The amazing Ida Pfeiffer.* The First Female Tourist. National University of Singapore Press, Singapore.

Wallace, A.R. 2013. *Letters from the Malay Archipelago.* Edited by van Wyhe, J. and Rookmaaker, K. Oxford University Press, Oxford, UK.

Wallace, A.R. 2015. *The Annotated Malay Archipelago.* Edited by van Wyhe, J. National University of Singapore Press, Singapore.

Walters, M. 2008. *Chinese Wildlife, A Visitor's Guide.* Bradt Travel Guides Ltd. Chalfont St. Peter. UK.

Yeap, C.A. and Lim, K.C. 2020. *Birds of Belum-Temengor Forest Complex, Perak State, Peninsular Malaysia: An Overview of Ornithological Research, Checklist and Selected Bibliography.* (MNS Conservation Series No. 21). Malaysian Nature Society, Kuala Lumpur, Malaysia.

Yong, D.L. and Low, B.W. 2018. *The 125 Best Birdwatching Sites in Southeast Asia.* John Beaufoy Publishing Ltd, Oxford, UK.

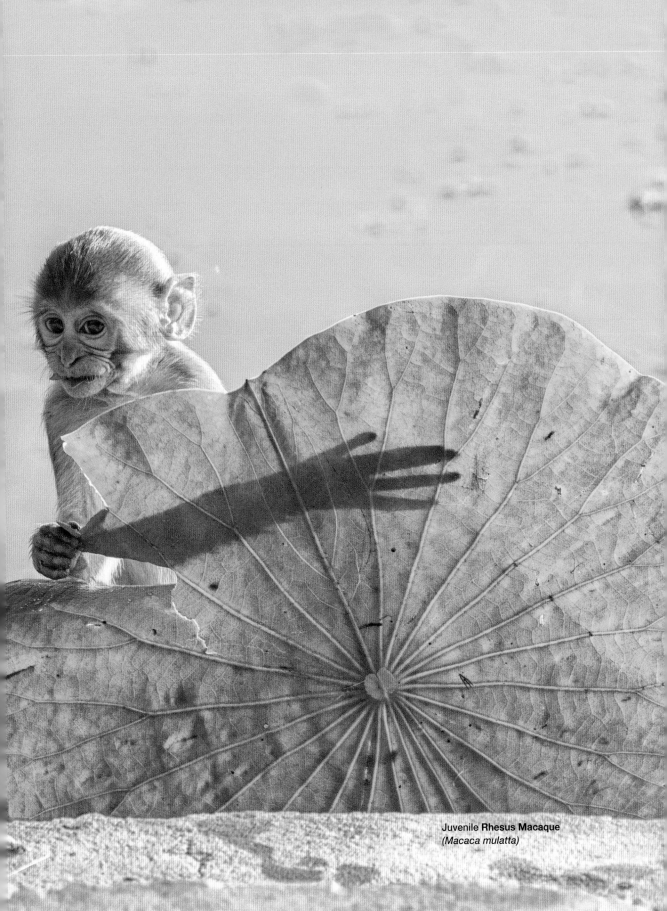

Juvenile **Rhesus Macaque**
(Macaca mulatta)

Sources and Selected References

Ang, A., D'Rozario, V., Jayasri, S.L., Lees, C.M., Li, T.J. and Luz, S. 2016. *Species Action Plan for the Conservation of Raffles' Banded Langur (Presbytis femoralis femoralis) in Malaysia and Singapore.* IUCN SSC Conservation Breeding Specialist Group, Apple Valley, Minnesota, USA.

Ang, A., Jabbar, S., D'Rozario, V. and Lakshminarayanan, J. 2021. Citizen Science Program for Critically Endangered Primates: A Case Study from Singapore. *Primate Conservation* (35), 179-188.

Basnet, D., Jianmei, Y., Dorji, T., Qianli, X., Lama, A. K., Maowei, Y., Ning, W., Yantao, W., Gurung, K., Rujun, L., Gupta, N., Kanwal, K. S. and Shaoliang, Y. 2021. Bird Photography Tourism, Sustainable Livelihoods, and Biodiversity Conservation: A Case Study from China. *Mountain Research and Development* 41(2), D1-D9.

BCN and DNPWC. 2011. *The State of Nepal's Birds 2010.* Bird Conservation Nepal and Department of National Parks and Wildlife Conservation, Kathmandu, Nepal.

Brazil, M. 2018. *Birds of Japan.* Helm, Bloomsbury Publishing Plc London, UK.

Castelló, J.R. 2016. *Bovids of the World, Antelopes, Gazelles, Cattle, Goats, Sheep, and Relatives.* Princeton University Press, Woodstock, UK.

Castelló, J.R. 2018. *Canids of the World, Wolves, Wild Dogs, Foxes, Jackals, Coyotes, and Relatives.* Princeton University Press, Woodstock, UK.

Castelló, J.R. 2020. *Felids and Hyenas of the World, Wildcats, Panthers, Lynx, Pumas, Ocelots, Caracals and Relatives.* Princeton University Press, Woodstock, UK.

Clements, T. 2009. *Conservation of Sulawesi's Endangered Mascot – the Maleo – through Conservation Incentive Agreements.* Wildlife Conservation Society, Bronx, New York, USA.

Coates, B.J. and Bishop. K.D. 1997. *Birds of Wallacea, Sulawesi, The Moluccas and Lesser Sunda Islands, Indonesia.* Dove Publications Pty. Ltd., Alderley, Australia.

Craik, R.C. and Le Quy Minh. 2018. *Birds of Vietnam.* Lynx and BirdLife International Field Guides. Lynx Edicions, Barcelona, Spain.

Das, I. 2010. *A Field Guide to the Reptiles of South-east Asia.* New Holland Publishers (UK) Ltd London, UK.

Dave, C.V. 2010. *Understanding conflicts and conservation of Indian wild ass around Little Rann of Kachchh, Gujarat, India.* Final technical report submitted to Rufford Small Grant Program, UK.

Diamond, J., Mauro, I., Bishop, K.D. and Wijaya, L. 2009. The avifauna of Kofiau Island, Indonesia. *Bulletin of the British Ornithologists' Club* 129(3), 165-181.

DNPWC. 2018. *Gharial Conservation Action Plan for Nepal (2018-2022).* Department of National Parks and Wildlife Conservation, Kathmandu, Nepal.

DNPWC and DFSC. 2018. *Status of Tigers and Prey in Nepal.* Department of National Parks and Wildlife Conservation & Department of Forests and Soil Conservation. Ministry of Forests and Environment, Kathmandu, Nepal.

Donald, P., Hla, H., Win, L., Aung, T., Moses, S., Zaw, S. and Eames, J.C. 2014. The distribution and conservation of Gurney's Pitta Pitta gurneyi in Myanmar. *Bird Conservation International* 24(3), 354-363.

Eames, J.C., Hla, H., Leimgruber, P., Kelly, D., Aung, S., Moses, S. and Tin, U. 2005. Priority contribution. The rediscovery of Gurney's Pitta *Pitta gurneyi* in Myanmar and an estimate of its population size based on remaining forest cover. *Bird Conservation International* 15 (1), 3-26.

Eames, J.C. 2015. *Western Siem Pang Hidden Natural Wonder of Cambodia.* Privately published.

Eaton, J.A., van Balen, B., Brickle, N.W. and Rheindt, F.E. 2016. *Birds of the Indonesian Archipelago, Greater Sundas and Wallacea.* Lynx Edicions, Barcelona, Spain.

Francis, C.M. 2019. *A Field Guide to the Mammals of South-east Asia.* Bloomsbury Publishing Plc, London, UK.

Geissmann, T., Lwin, N., Aung, S., Aung, T., Aung, Z., Hla, T. and Grindley, M. 2011. A new species of snub-nosed monkey, Genus Rhinopithecus Milne-Edwards, 1872 (Primates, Colobinae), from northern Kachin State, northeastern Myanmar. *American Journal of Primatology* 73, 96-107.

Gan, J., Tan, M. and Li, D. 2009. *Migratory Birds of Sungei Buloh Wetland Reserve.* National Parks Board, Singapore.

Grimmett, R., Inskipp, C. and Inskipp, T. 2009. *Birds of Nepal.* Om Books International, New Delhi, India.

Hale, R., Subharaj, S., Ngim, R., Ho, H.C., Briffett, C. and Hails, C. 1987. *A Proposal For A Nature Conservation Area At Sungei Buloh.* Malayan Nature Society, Singapore.

Hazebroek, H.P., Tengku Adlin, Z. and Sinun, W. 2012. *Danum Valley: The Rainforest.* Natural History Publications (Borneo), Kota Kinabalu, Malaysia.

Hla, H., Shwe, N.M, Htun, T.W., Zaw, S.M., Mahood, S., Eames, J.C. and Pilgrim, J.D. 2011. Historical and current status of vultures in Myanmar. *Bird Conservation International* 21(4), 376-387.

ICIMOD. 2018. *Regional workshop on developing birdwatching tourism, Baihualing, Yunnan, China.* ICIMOD Workshop Report 2019/1. ICIMOD, Kathmandu, Nepal.

Jhala, Y. V., Qureshi, Q. and Nayak, A. K. (eds). 2019. *Status of tigers, co-predators and prey in India 2018.* Summary Report. National Tiger Conservation Authority, Government of India, New Delhi & Wildlife Institute of India, Dehradun.

Jnawali, S.R., Baral, H.S., Lee, S., Acharya, K.P., Upadhyay, G.P., Pandey, M., Shrestha, R., Joshi, D., Laminchhane, B.R., Griffiths, J., Khatiwada, A. P., Subedi, N., and Amin, R. (compilers) 2011. *The Status of Nepal Mammals: The National Red List Series,* Department of National Parks and Wildlife Conservation, Kathmandu, Nepal.

Katuwai, H.B. 2016. Sarus Crane in lowlands of Nepal: Is it declining really? *Journal of Asia-Pacific Biodiversity* 9(3), 259-262.

Kinnaird, M.F. and O'Brien, T.G. 2007. *The Ecology & Conservation of Asian Hornbills, Farmers of the Forest.* The University of Chicago Press, London, UK.

Koh, J.K.H. and Bay, N. 2019. *Borneo Spiders: A Photographic Field Guide.* Sabah Forestry Department, Sandakan, Malaysia.

Li, F., Huang, X.Y., Zhang, X.C., Zhao, X.X., Yang, J.H. & Chan, B.P.L. 2019. Mammals of Tengchong Section of Gaoligongshan National Nature Reserve in Yunnan Province, China. *Journal of Threatened Taxa* 11(11), 14402-14414.

Lim, K.S. 2009. *The Avifauna of Singapore.* Nature Society (Singapore), Singapore.

Liu, Y., Yong, D.L. and Yu, Y-t. 2014. *Birds of China, Southeast China, including Shanghai.* John Beaufoy Publishing Ltd, Oxford, UK.

Loveridge, R., Ryan, G., Sum, P., Grey-Read, O., Mahood, S., Mould, A., Harrison, S., Crouthers, R., Ko, S., Clements, T., Eames, J. and Pruvot, M. 2018. Poisoning causing the decline in South-East Asia's largest vulture population. *Bird Conservation International* 29(1), 41-54.

Loveridge, R., Cusack, J., Eames, J., Samnang, E. and Willcox, D. 2018. Mammal records and conservation threats in Siem Pang Wildlife Sanctuary and Siem Pang Khang Lech Wildlife Sanctuary. *Cambodian Journal of Natural History* 2, 76-89.

Lynam, A. J., Round, P.D. and Brockelman, W. Y. 2006. *Status of birds and large mammals in Thailand's Dong Phayayen-Khao Yai Forest Complex.* Biodiversity Research and Training Program (BRT) and Wildlife Conservation Society, Bangkok, Thailand.

Maryanto, I., Maharadatunkamsi, Achmadi, A.S., Wiantoro, S., Sulistyadi, E., Yoneda, M., Suyanto, A. and Sugardjito, J. 2019. *Checklist of the Mammals of Indonesia.* Research Center for Biology, Indonesian Institute of Sciences (LIPI), Jakarta-Bogor, Indonesia.

MacKinnon, J. and Phillipps, K. 2010. *A Field Guide to the Birds of China.* Oxford University Press, Oxford, UK.

Menon, V. 2014. *Indian Mammals, A Field Guide.* Hachette Book Publishing India Pvt. Ltd., Gurgaon, India.

Meyer, D., Momberg, F., Matauschek, C., Oswald, P., Lwin, N., Aung, S.S., Yang, Y., Xiao, W., Long, Y-C., Grueter, C.C. and Roos, C. 2017. *Conservation status of the Myanmar or black snub-nosed monkey* Rhinopithecus strykeri. Fauna & Flora International, Yangon, Myanmar; Institute of Eastern-Himalaya Biodiversity Research, Dali, China; and German Primate Centre, Göttingen, Germany

Ministry of Natural Resources and Environment, Malaysia. 2015. *5th National Report to Convention on Biological Diversity.* Putrajaya, Malaysia.

Mirande, C.M. and Harris J.T., editors. 2019. *Crane Conservation Strategy.* International Crane Foundation, Baraboo, Wisconsin, USA.

Nadler, T. and Brockman, D. 2014. *Primates of Vietnam.* Endangered Primate Rescue Center, Cuc Phuong National Park, Vietnam.

Ng, P.K.L., Corlett, R.T. and Tan, H.T.W. 2011. *Singapore Biodiversity, An Encyclopaedia of the Natural Environment and Sustainable Development.* Raffles Museum of Biodiversity Research, Singapore.

Nijman, V. (compiler). 2015. *The conservation status of mammals and birds in the Imawbum Mountains, Kachin State, Northern Myanmar.* Fauna & Flora International, Cambridge, UK.

Palacios, J., Engelhardt, A., Agil, M., Hodges, K., Bogia, R. and Waltert, M. 2012. Status of, and conservation recommendations for, the Critically Endangered crested black macaque *Macaca nigra* in Tangkoko, Indonesia. *Oryx 46(2),* 290-297.

Pimid, M., Latip, A., Marzuki, A., Umar, M. and Krishnan, K. 2020. *Stakeholder Management of Conservation in Lower Kinabatangan Sabah.* Planning Malaysia 18 (3), 71-81.

Poonswad, P., Kemp, A. and Strange, M. 2013. *A Photographic Guide, Hornbills of the World.* Draco Publishing, Singapore and Hornbill Research Foundation, Bangkok, Thailand.

Pratt, T.K. and Beehler, B.M. 2015. *Birds of New Guinea.* Princeton University Press, Woodstock, UK.

Pradhan, N., Williams, C. and Dhakal, M. 2011. Current Status of Asian Elephant in Nepal. *Gajah.* 35. 87-92.

Rahman, D., Herliansyah, R., Rianti, P., Rahmat, U., Firdaus, A. and Syamsudin, M. 2019. Ecology and Conservation of the Endangered Banteng *(Bos javanicus)* in Indonesia Tropical Lowland Forest. *HAYATI Journal of Biosciences* 26(2), 68-80.

Rowe, N. and Myers M. 2016. *All the World's Primates.* Pogonias Press, Charlestown, Rhode Island, USA.

Schaller, G.B. 1967. *The Deer and the Tiger, A Study of Wildlife in India.* The University of Chicago Press, Chicago, USA.

Sharma, R., Goossens, B., Heller, R. Rasteiro, R., Othman, N., Bruford, M.W. and Chikhi, L. 2018. Genetic analyses favour an ancient and natural origin of elephants on Borneo. *Scientific Reports* 8, 880.

Shepherd, C.R., Nijman, V., Krishnasamy, K., Eaton, J.A. and Chng, S.C.L. 2015. Illegal trade pushing the Critically Endangered Black-winged Myna *Acridotheres melanopterus* towards imminent extinction. *Bird Conservation International* 26(2), 147-153.

Shilai, M., Lianxian, H., Daoying, L., Weizhi, J. and Harris, R. 1995. Faunal Resources of the Gaoligongshan Region of Yunnan, China: Diverse and Threatened. *Environmental Conservation* 22(3), 250-258.

Shwe, N., Sukumal, N., Grindley, M., and Savini, T. 2020. Is Gurney's pitta *Hydrornis gurneyi* on the brink of extinction? *Oryx* 54(1), 16-22.

Singh, K.L., Singh, D.K. and Singh, V.K. 2016. Multidimensional Uses of Medicinal Plant Kachnar *(Bauhinia variegata* Linn). *American Journal of Phytomedicine and Clinical Therapeutics* 4(2), 58-72.

Smith, A.T. and Yan Xie, 2008. *A guide to the Mammals of China.* Princeton University Press, Woodstock, UK.

Sterling, E.J., Hurley, M.M. and Minh, L.D. 2006. *Vietnam: A Natural History.* Yale University Press, New Haven, USA.

Stuebing, R.B., Inger, R.F. and Lardner, B. 2014. *A Field Guide to the Snakes of Borneo.* Natural History Publications (Borneo), Kota Kinabalu, Sabah, Malaysia.

Takafumi, H., Kamii, T., Murai, T., Yoshida, R., Sato, A., Tachiki, Y., Akamatsu, R., and Yoshida, T. 2017. Seasonal and year-round use of the Kushiro Wetland, Hokkaido, Japan by sika deer *(Cervus nippon yesoensis). PeerJ* 5:e3869.

Treesucon, U. and Limparungpatthanakij, W. 2016. *Birds of Thailand.* Lynx and BirdLife International Field Guides, Lynx Edicions, Barcelona, Spain.

Wang, G., Innes, J., Wu, S., Krzyzanowski, J., Yin, Y., Dai, S., Zhang, X. and Liu, S. 2011. National Park Development in China: Conservation or Commercialization?. *Ambio* 44,247-61

Warakagoda, D. 2006. Asian Bird: New Discovery: Sri Lanka's Serendib Scops Owl. *BirdingASIA* 6,68-71.

Wickramasinghe, M., Bambaradeniya, C., Vidanapathirana, D. and Karunarathna, D.M.S.S. 2012. *Herpetofaunal diversity in Mahausakande: A regenerating Rainforest in Sri Lanka.* Mahausakande Tropical Rainforest Regeneration Initiative, Research Paper No.1, 40 pp.

Winnasis, S., Sutadi., Toha, A. and Noske, R. 2011. *Birds of Baluran National Park.* www.balurannationalpark.web.id.

Woo-Shin Lee, Chang-Yong Choi and Hankyu Kim. 2018. *Field Guide to the Waterbirds of ASEAN: Brunei, Cambodia, Indonesia, Laos, Malaysia, Myanmar, Philippines, Singapore, Thailand, Viet Nam & adjacent territories.* ASEAN-Korea Environmental Cooperation Unit (AKECU) Seoul, Republic of Korea.

Glossary and Abbreviations

Apex predator A predator at the top of the food chain, upon which no other creatures prey on.

Arboreal Living in trees.

Asl Above sea level.

Aquatic Living in water.

Avifauna The bird assemblage of a particular region or habitat.

BANCA Biodiversity and Nature Conservation Association, a conservation non-government organisation, and BirdLife International's partner in Myanmar.

BCN Bird Conservation Nepal, a conservation non-government organisation, and BirdLife International's partner in Nepal.

Biome An extensive naturally occurring community of plant and animal species occupying a major habitat, and defined by the dominant type of vegetation therein.

Casque A helmet-like protuberant structure on a hornbill's head.

CITES Convention on International Trade in Endangered Species of Wild Fauna and Flora; a multilateral treaty to protect endangered plants and animals.

CCZ Civilian Control Zone, a buffer zone of the Korean Demilitarized Zone (DMZ) on the South Korean side of the border.

Corvid A bird species belonging to the crow family, corvidae.

Crepuscular (Describing behaviour of an animal) Appearing or being active at twilight.

Crustaceans A large group of invertebrates, which includes but is not limited to crabs, lobsters, shrimps, prawns and barnacles.

Deciduous The condition where a plant sheds its leaves seasonally. Many tree species occurring across the subtropical monsoonal, and temperate parts of Asia are deciduous.

Diurnal (Describing behaviour of an animal) Active during the daytime rather than at night.

DMZ Demilitarized Zone that defines the frontier of North and South Korea.

EBA Endemic Bird Area, a region defined by the occurrence of several species with small distributions. Many islands and mountain ranges form examples of EBAs.

EPI Environmental Performance Index.

Ex-situ Conservation Actions and activities to conserve a species outside of its natural habitat and range, e.g. in zoos or botanical gardens.

Feline A member of the cat family.

Feral An animal occurring in an apparent wild state, but having descended from domesticated or formerly captive individuals.

FFI Fauna & Flora International, a major international conservation organisation headquartered in the United Kingdom, and established in 1903.

Fledgling A young bird that is sufficiently developed for flight, but still dependant on parental care.

Flush An act of frightening an animal out of concealing cover.

Folivore An animal that feeds predominantly on leaves and associated plant parts.

Frugivore An animal that feeds predominantly on fruit.

Genus A rank of classification in taxonomy above the species level, and below the family level.

Gestation The state of being pregnant; the period from conception to birth for mammals.

Gunung Malay and Indonesian word for mountain.

Herbivore An animal that feeds largely on plants.

Herpetology The branch of zoology concerned with the study of reptiles and amphibians.

Hibernation A survival strategy used by some animals in which their metabolic rate slows down and a state of deep sleep is attained, usually in winter. While hibernating, animals survive on stored reserves of accumulated fat. Examples of animals that hibernate include bears, hedgehogs and several groups of rodents.

HKBWS Hong Kong Bird Watching Society, a conservation non-government organisation, and BirdLife International's partner in Hong Kong SAR.

Holotype A specimen of an organism used in the first formal description of the species represented by it.

IBA Important Bird and Biodiversity Areas, are regions identified by BirdLife International to be defined by the occurrence of species with restricted distributions or are of conservation concern.

Incubation period The period from when an egg is laid to the time it hatches.

Insectivorous Feeding on insects.

Invertebrate An animal lacking a backbone. Invertebrates include but are not limited to insects, molluscs, crustaceans and worms.

IUCN International Union of Conservation of Nature. An international organisation working on nature conservation and the sustainable use of natural resources, and headquartered in Gland, Switzerland. The IUCN was founded in 1948 in France, and was first known as the International Union for the Protection of Nature and Natural Resources.

Kleptoparasite An animal which habitually robs other animals for food. Skuas and frigatebirds are examples of kleptoparasitic species, as are several large mammalian carnivores such as hyenas.

Megafauna The larger vertebrate species present in a particular region or habitat, and typically include species such as ungulates, carnivores and primates.

MNS Malaysian Nature Society, a conservation non-government organisation, and BirdLife International's partner in Malaysia.

Morph A variant of an animal or plant species, usually distinguished from the normal form by colour.

Mutualism Symbiotic interaction between two species that may be mutually beneficial to both.

New World Geographical region defined by North and South America and the Caribbean islands.

Nocturnal (Describing behaviour of an animal) Active at night, the opposite of diurnal.

Non-volant Incapable of flight.

NSS Nature Society (Singapore), a conservation non-government organisation, and BirdLife International's partner in Singapore.

Old World Geographical region defined by Europe, Africa and Asia.

Orang Asli Term used to refer collectively to the indigenous peoples of Peninsular Malaysia.

Oxbow Lake A small lake that has developed from an abandoned meander loop on a river channel.

Passerine A bird belonging to the large avian order Passeriformes. Passerine or "perching birds" are defined by their distinctive foot structure of three forward pointed toes and one backward toe. Many are capable of complex songs.

Pelagic (Describing ecology of an animal) Relating to the open sea. Pelagic species are species that spend much of their lives over oceans and offshore waters.

Palearctic Biogeographic region that includes Europe, Asia north of the Himalayas, and Africa north of the Sahara. The Palearctic is the world's largest biogeographic region.

Permafrost subsurface layer of soil that remains frozen throughout the year.

Primary Forest Old-growth forest; forest subjected to little or no human disturbance.

Primeval Earliest ages.

Pulau Malay and Indonesian word for island.

Race Another widely used term for subspecies.

RDC Rainforest Discovery Centre, Sandakan, Sabah, Malaysia.

RSPB The Royal Society for the Protection of Birds, a major conservation non-governmental organisation, and BirdLife International's partner in the in the United Kingdom.

Sp. Abbreviation of "species".

Spp. Plural of the abbreviation for species, "sp.".

Substrate the natural environment in which an organism lives, or the surface or medium on which an organism grows or is attached.

Taxon (plural: taxa) Generic and hierarchically independent term for a taxonomic category (i.e. genus, species, etc).

Terrestrial Term to describe animal or plant which lives predominantly or entirely on land.

Topography The general land features and landscapes that defines a place or region.

TRAFFIC A global wildlife trade monitoring network, established as a joint programme of the WWF and the IUCN. The initiative aims to address issues of cross-border and domestic trade of animals and plants in the broader context of conservation.

Trapeang Khmer/Cambodian term for a seasonal or permanent water body usually associated with deciduous dipterocarp forest or grassland. Sometimes spelled as *Tropeang*.

Understorey The layer of vegetation immediately below the canopy of a forest.

Ungulate A large, loosely defined group of mammals, many of which possess hoofed toes. Ungulates include most large herbivorous mammals, such as horses, rhinoceros, goats, deers and antelopes.

Vascular plants Plants that possess specialised tissues for transporting food and water to different parts of the plant. Examples of vascular plants include trees, flowers, grasses and vines. Vascular plants have a root system, a shoot system and a vascular system.

Vertebrate A large, diverse group of animals defined by the possession of a backbone or spinal column. Vertebrates include mammals, birds, reptiles, amphibians, and fishes.

WCS Wildlife Conservation Society, an international conservation organisation headquartered at the Bronx Zoo in New York, the USA.

WWF World Wide Fund for Nature. The WWF is an international conservation organization founded in 1961 that works to conserve biodiversity and reduce human impact on the environment. It is headquartered in Gland, Switzerland.

Bardia National Park, Nepal.

The Team:
Fanny Lai and Bjorn Olesen

Editor	**: Yong Ding Li**
Design & Technical Consultant	**: Zinnira Bani**
Design & Layout	**: Chan Sow Yun**
Copy Editor	**: Gloria Seow**
Production Editor	**: June Chong**
Cartography	**: Yong Ding Li**
Front Dust Jacket Image	**: Himalayan Red Panda by Fanny Lai**

"Books to Span the East and West"

Tuttle Publishing was founded in 1832 in the small New England town of Rutland, Vermont [USA]. Our core values remain as strong today as they were then—to publish best-in-class books which bring people together one page at a time. In 1948, we established a publishing outpost in Japan—and Tuttle is now a leader in publishing English-language books about the arts, languages and cultures of Asia. The world has become a much smaller place today and Asia's economic and cultural influence has grown. Yet the need for meaningful dialogue and information about this diverse region has never been greater. Over the past seven decades, Tuttle has published thousands of books on subjects ranging from martial arts and paper crafts to language learning and literature—and our talented authors, illustrators, designers and photographers have won many prestigious awards. We welcome you to explore the wealth of information available on Asia at www.tuttlepublishing.com.

Published by Tuttle Publishing, an imprint of Periplus Editions (HK) Ltd
www.tuttlepublishing.com

First published in 2023

Copyright © Bjorn Olesen

© Photography: Bjorn Olesen, 2023, except for contributing photographers credited on page 307

ISBN: 978-0-8048-5634-8

Printed in China 2301EP
25 24 23 10 9 8 7 6 5 4 3 2 1

Distributed by

North America, Latin America & Europe
Tuttle Publishing, 364 Innovation Drive, North Clarendon, VT 05759-9436 U.S.A.
Tel: 1 (802) 773-8930; Fax: 1 (802) 773-6993
info@tuttlepublishing.com; www.tuttlepublishing.com

Asia Pacific
Berkeley Books Pte. Ltd., 3 Kallang Sector #04-01, Singapore 349278
Tel: (65) 6741-2178; Fax: (65) 6741-2179
inquiries@periplus.com.sg; www.tuttlepublishing.com

Indonesia
PT Java Books Indonesia, Kawasan Industri Pulogadung, JI. Rawa Gelam IV No. 9, Jakarta 13930
Tel: (62) 21 4682-1088; Fax: (62) 21 461-0206
crm@periplus.co.id; www.periplus.com

TUTTLE PUBLISHING® is a registered trademark of Tuttle Publishing, a division of Periplus Editions (HK) Ltd.

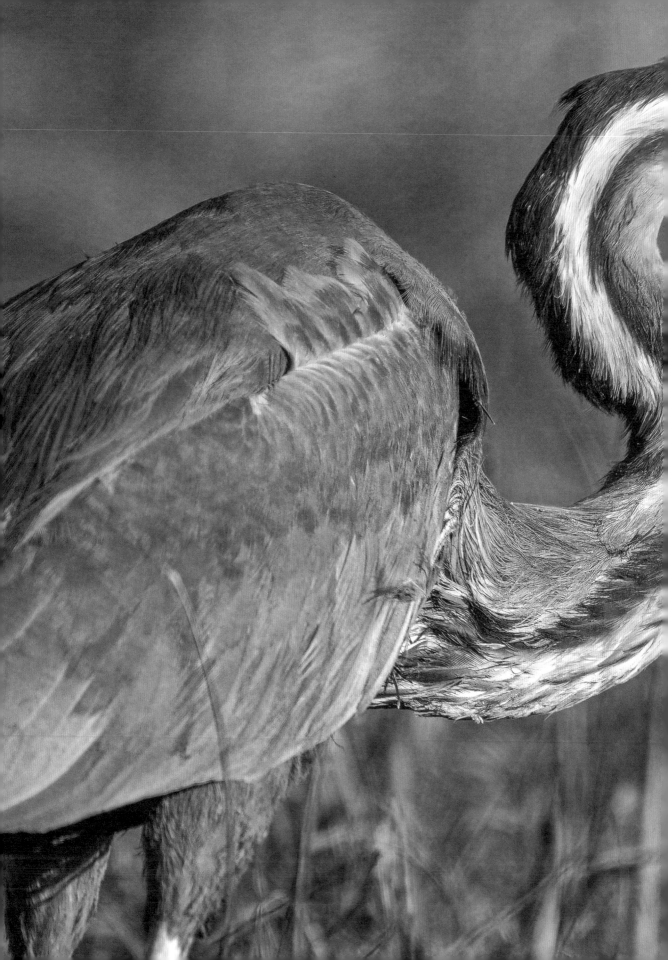